SATAN WANTS ME

Robert Irwin read Modern History at Oxford and taught Medieval History at the University of St Andrews. He also lectured on Arabic and Middle Eastern History at the universities of London, Cambridge and Oxford.

He has published six novels, all available in paperback from Dedalus: *The Arabian Nightmare* (1983), *The Limits of Vision* (1986), *The Mysteries of Algiers* (1988), *Exquisite Corpse* (1995), *Prayer-Cushions of the Flesh* (1997) and *Satan Wants Me* (1999).

He is the author of six works of non-fiction: *The Middle East in the Middle Ages* (1984), *The Arabian Nights: A Companion* (1994), *Islamic Art* (1997), *Night and Horses and the Desert: The Penguin Anthology of Classical Arabic Literature* (1999), *Alhambra* (2004) and *Lust of Knowing: The Orientalists and Their Enemies* (2006).

He is a consulting editor for the Times Literary Supplement, a Fellow of the Royal Society of Literature and a Fellow of the London College of Pataphysicians. He divides his time between Vauxhall and Kennington.

Robert Irwin

Satan Wants Me

Dedalus

Published in the UK by Dedalus Limited,
24–26, St Judith's Lane, Sawtry, Cambs, PE28 5XE
email: info@dedalusbooks.com
www.dedalusbooks.com

ISBN 978 1 903517 58 1

Dedalus is distributed in the USA by SCB Distributors,
15608 South New Century Drive, Gardena, CA 90248
email: info@scbdistributors.com web: www.scbdistributors.com

Dedalus is distributed in Australia by Peribo Pty Ltd.
58, Beaumont Road, Mount Kuring-gai, N.S.W. 2080
email: info@peribo.com.au

Dedalus is distributed in Canada by Disticor Direct-Book Division
695, Westney Road South, Suite 14, Ajax, Ontario, LI6 6M9
email: ndalton@disticor.com web: www.disticordirect.com

Publishing History
First published by Dedalus in hardcover in the UK in 1999
First Bloomsbury paperback edition in the UK in 2000
First Dedalus paperback edition 2007
First published in the USA in 2007

Printed in Finland by WS Bookwell
Typeset by RefineCatch Limited, Bungay, Suffolk

Friday, May 12, 1967

The Master has commanded me to keep a diary. It's part of
my apprenticeship in the way of the sorcerer. Yesterday even-
ing I was accepted as a probationer for Adepthood and the
Master inscribed a cabalistic-looking sigil on my diary-
writing hand. Today I went and scored this notebook in W.H.
Smith's in High Holborn. (Apparently we sorcerers use black
notebooks as diaries, but red notebooks for transcribing spells
and exorcisms.) Then went over to the LSE, but still a sit-in,
so library closed. What a drag! So split from there and went up
to Senate House and borrowed some stuff from its library. I
am indeed a 'profound and diligent searcher'. According to
The Goetia of the Lemegeton of King Solomon, **'Magic is the
Highest, most Absolute, and most Divine Knowledge
of Natural Philosophy, advanced in its works and won-
derful operations by a right understanding of the
inward and occult virtue of things; so that true Agents
being applied to proper Patients, strange and admir-
able effects will thereby be produced. Whence magi-
cians are profound and diligent searchers into Nature;
they, because of their skill, know how to anticipate an
effect, the which to the vulgar shall seem to be a mir-
acle.'** Saw from the news-stand Brian Jones was busted. The
other Stones are being tried at Chichester.

I went round to Sally with the news, but she knew all about
Brian Jones, for Mr Cosmic was already there. He too had his
black and red notebooks. What he also had was three bundles
of leafy twigs wrapped up in a damp cloth. This was qat – not
only is the u in 'qat' silent, it is also invisible. (If the Yemeni
Arabs can do without the u, then so can I. Why does there
always have to be a fucking u after every fucking q? That is my
qestion.) Cosmic scored this qat from a couple of Yemeni
sailors in Shadwell and apparently it is completely legal. Hav-
ing now tried it, I am not surprised, as it's no big deal, no big
blast and no hallucinations. Under Cosmic's instructions, we

stripped the branches of their leaves and we each stuffed them in one of our cheeks, leaf by leaf, until the three of us looked like lop-sided marmosets. Ghastly bitter taste – only drinking powdered and boiled opium is worse in my experience. Bert Jansch was moodily brooding on the record player. We kept taking sips of water as we sat with this foul stuff bulging and drooling out of our mouths for a couple of hours, trying not to gag, and all we got from this was a very mild high, plus in my case I was having lots and lots of thoughts – more thoughts than I had words for – but the trouble was that they were all sane thoughts, whereas I only really like my thoughts when they are fucking weird.

The one thing about qat was that it did make us conversational. Sally was cruelly reminiscing about some of our earlier dud trips – like the time we tried smoking dried banana skins – a real bummer that. Or the time I met someone who had got a three-hour erection from sniffing aircraft glue. So I went with Sally to a model shop to score some of this stuff and we tried sniffing this glue for hours without any payoff whatsoever. In the end we went back to the shop and bought a kit for making a Sopwith Camel, so we could use up the glue. At least making the aeroplane was a buzz. But the general rule of thumb is that legal highs are always downers.

Then Sally wanted to know about the notebooks and we explained how everybody in the Lodge has to keep diaries as part of the training and how everything has to go in, especially the bad things. Sally did not approve as she does not like being in other people's diaries (which, for her, is like being in someone else's dream when she doesn't want to be). And, besides, she has come to hate everything to do with the Black Book Lodge. But she did say that it would be nice for us to look back on these diaries in our old age.

'I am not reckoning on reaching old age,' I said. 'When Saint-Just went to the guillotine, he told the blood-hungry mob who were milling round his tumbril that he was dying at the age of thirty-three which is the age that all true revolutionaries die at, as Jesus was thirty-three when he was crucified. I am definitely not planning to live beyond thirty-three.'

Sally was unimpressed. 'Thirty-three is quite old,' she said. 'I bet you anything I die before you.'

Then there was a long silence – which, given we were on this chatty qat stuff, was unusual.

Then Sally said, 'Peter, promise me one thing.'

'What?'

'You have to promise before I tell you.'

'I am not promising anything without knowing first what it is.'

'You have to promise first. You have to be blindly committed, if you love me . . .'

I hate Sally's little tests, but 'OK,' I said.

'You swear?'

'Yes, I swear.'

Sally's eyes had a strange kind of glow to them and with all that stuff in her mouth she looked quite freaky.

'That's good,' she said. 'You have promised that if I die before you, you will screw me when I'm dead.'

'Bugger that! No way!'

'You have sworn to do it. It will be my final gift to you. You should do it while my body is still warm.' Sally was smiling faintly. 'Otherwise I will come back to haunt you.'

Cosmic was quite enthused,

'He should carry your corpse out into some park or garden. Your face is wet with tears, but they are his tears. Your body without its animating spirit is somehow heavier than when alive and he staggers a little under its weight. There is a rumble of thunder, as if God himself is angered by what is about to happen. It begins to rain . . .'

Now I chime in,

'Heedless of the rain, I lay the body reverently down on the grass and pull up the skirt, but it is difficult getting the knickers off a corpse, as the legs are so stiff. Rigor mortis . . .'

'Rigor mortis is actually a big come-on and he is surprised to find that his prick is as stiff as your body. He thrusts into you and, as he does, your body jolts upwards and your arms flop round his neck. For a ghastly moment . . .'

'For a ghastly moment I have the horrific illusion that you

have come back from Hell to claim me for the dead (who are always hungry for new members) but your apparent gesture of affection is only a final meaningless spasm caused by contracting muscles. My . . .'

'His seed is in your corpse. Under the earth, in the coffin, the foetus germinated by your accursed union begins to grow. As your body rots, the foetus feeds off your deliquescing juices and, by the time the host body has no meat left on it, this subterranean mannikin, who is your unnatural love child, will have learned to supplement its diet with worms and termites. For a long time, it will incubate in the cool earth. Then . . .'

'Then one dark wintry day the earth will crack open and it will come up blindly looking for its father . . .'

'I hate the way you two refer to our future child as an it,' interrupted Sally. 'I think she will be a girl. Anyway I just fancy being shafted when I'm dead.'

'Definitely something to look forward to,' said Cosmic.

That was the end then of my riff with Cosmic. We quite often do these fantasy riffs – like two guitarists improvising at a jam session.

Then Cosmic was talking about how he had read in the autobiography of the sixteenth-century occultist, Jerome Cardan, that demons inhabit fresh corpses in order to have sex with people. Cosmic is very widely read. Also he was saying that necrophilia might well be one of the things we have to do in the Black Book Lodge as some kind of initiatory ordeal. It is best to start thinking about such things now, so that we get used to the idea.

As I say, qat was a big disappointment. I was looking forward to lots of oriental-flavoured hallucinations, but none turned up. The coming down was as good as anything. Coming down has its gentle melancholy aspect which is generally pleasant. I grok coming down from drugs and registering the ordinary suchness of things around me. Sally, who has been reading Zen poetry recently, has picked up a whole lot of technical vocabulary in Japanese to describe the quiet moods we get when coming down. *Wabi* is the basic grokking of the

ordinary suchness of things – like seeing the kettle and the lime-scale on the kettle and accepting that as it is. Then there is *aware*, which has a quiet sense of the pastness of things – like you might be remembering the time, years ago, when the kettle had no lime-scale. *Sabi* is seeing everything as lonely and detached. Even in a room with Sally and Cosmic, I am on my own. I am not connected to anything – not even the kettle I am looking at. Finally, there is *yugen* which is a sense of deep mystery. It is a pure sense of mystery, so that even what is mysterious is mysterious.

Cosmic shuffled out, heading back to his pad and I became aware that I was very *aware*, i.e. sad about the pastness of the day, which was now gone like a bubble which was floating in the air but then has suddenly popped. In bed tonight Sally insisted on pretending to be a corpse, because she said I would need the practice. It might have been fun for her, but she made it really difficult for me. I wish I hadn't made that promise. Still, she is younger than me and women usually live longer than men. When it was over, Sally passed from shamming dead straight into sleep. Unable to sleep for her snoring, I started writing this, my diary. It has taken ages to get all this down. I doubt if I will be able to keep on writing my diary at this level of detail.

Saturday, May 13

Copied stuff from *The Goetia of the Lemegeton of King Solomon* into my notebook, but it was pretty boring, so goofed off with Sally to King's Road. Walked past Granville's shop, but he never seems to be there. It's always some manky assistant. Shopped with Sally. I was going to buy her 'Simon Smith and His Amazing Dancing Bear', but then I scored Jeff Beck's 'Silver Lining' as well, because Sally's 'everywhere and nowhere' and she wears 'a hippy hat'. Then at her pad for a bit, before going dancing at Middle Earth. This time Sally wanted to know what was the most horrific thing I could possibly imagine. I said that it was being naked and sliding

down a banister studded with razor-blades. Subsequently however, I had another thought connected with yesterday's necrophily business. What would really hang me up – what would be the most horrific thing I could imagine is not the razor-blade slide, nor for that matter having sex with a corpse, but having sex with someone who is middle-aged. It is horrible to contemplate the rubbing of paunches together, the flapping withered dugs, the worry about whether to take the dentures out before or after. She would be middle-aged, but the ultimate horror is that I would be middle-aged too. It does not bear thinking about – like one's parents having sex. Split around 4. Went over to Arts Lab and used its cinema as a crash pad as usual.

Sunday, May 14

Up at 'the crack of dawn', but, for some reason, dawn did not crack for me until three o'clock in the afternoon. More of the social construction of reality which is hard going. Also taking notes on Crowley's *Magick in Theory and Practice* and practising my fingering on the guitar. Perhaps this year will determine whether I become a sociologist or go on the road. Raining.

After I had written the above down, Sally came round with Cosmic. They had succeeded in scoring mandies. At least one knows what one is getting with mandies – a nice reliable downer which infallibly delivers an agreeable woozy feeling. Good for sex too. I often find the big white pills a bit difficult to swallow, but it's worth it. I think one of the reasons I like this drug is that the name mandrax makes me think of mandrakes. Of course, there is Mandrake the Magician in the comics, with his shiny top-hat and cloak. (I sometimes fantasise that I am Mandrake. Sally is Princess Narda and Cosmic is Lothar, my faithful companion and the three of us have bizarre adventures in Drugsland.) But there is also the fork-rooted plant which is used by witches and other folk. It used to be thought that the mandrake was the seed of a man hanged on a gallows. I haven't got round to trying mandrake

yet, but Cosmic has. He once scored it from a herbalist in the Old Kent Road. It is fairly dangerous. One can go mad on it and its smell was pretty terrible, so he only took a small amount. Mandrake was what used to give witches the illusion they were flying about on broomsticks. Cosmic got the flying sensation a bit, before he was painfully sick.

Anyway rapping on mandies was a good scene and Cosmic and I went off on another of our riffs. I had been saying that I could not understand why women ever had sex with men, as women were much nicer. Who could ever really fancy a man – all that hardness and hairiness?

'Pooves can,' said Cosmic.

'I can't stand pooves,' I replied.

'That is your hang-up,' said Cosmic. 'If you are going to make any progress on the occult path, you have to make yourself ready for anything. The astral is no place to be having bourgeois inhibitions.'

'But it is so revolting – poking about in people's arses!'

'Unnatural sex is customarily used to generate occult energies. You've read your Crowley.'

(Actually I haven't much. It's Cosmic who avidly reads all that stuff. Cosmic who, unlike me, has not had the benefit of a formal education, is a self-made freak. He has pulled himself up by his own bootstraps to become like a sort of guru on the Bardo Thodol, auras, kundalini sex and shoplifting.)

'If you are going to get anywhere in Satanism you have to get used to the idea,' Cosmic continued. 'It is an integral part of making the dark forces work for you. After all the Prince of Darkness is himself a horny poove.'

'A horny poove,' Sally muttered reverently.

'And one bleak afternoon in winter, he will come looking for you,' continued Cosmic. 'You will be walking on Hampstead Heath. You are alone and wish you were not. Then you see that you may not be alone after all. A man – the figure is a bit indistinct – but you think it is a man – is on the path below. He is looking up the hill at you and he is gesturing to you. Then as you watch you see him start to make his way up the path towards you . . .'

'I decide not to wait for him. He, whoever he is, cannot possibly want anything from me. I take a path to the left into the trees. I am walking quite fast and I am optimistic that this man will not persist in his pursuit of me – if indeed it is a pursuit. But then when I look back, I see that he too has entered the little wood and that he is gaining on me. I break into a run. When I next look back . . .'

'When you next look back you see that he has broken into a run too and there is something a little odd about the way he runs. It is a kind of stagger for the Devil has remarkably wide hips and you catch a glimpse of his long prick and wizened scrotum swinging between his legs as he lurches behind you . . .'

'The distance between us is diminishing. With a muffled sob, I throw myself off the path and plunge into the bushes. This was a mistake. The branches catch at my clothes. My face, as it becomes studded with thorns, runs with blood. I have a vague sense of tiny monstrous creatures under foot. The wood is alive with whispering things. Then I am tripped by a branch and the Devil, red-eyed and snout-faced, is upon me. I am hot and flushed. Too breathless to speak, I look up at him and with my eyes, I appeal for mercy. But he, perversely misunderstanding the nature of my appeal, rips at my silver shirt. At the last moment I muster enough breath to cry, "Get thee behind me, Satan!" . . .'

'And he takes you at your word and, rolling you over on your bed of thorns and leaves, he yanks your white flared jeans down. With his claws he pulls the cheeks of your arse apart and sets to coldly sodomising you. The Devil's prick is very long and cold, like a meat-flavoured popsicle, and, sobbing and sighing with exhaustion and shame, you surrender to its icy assault. Yeah, that's what sex with the Devil is going to be like!'

'At least it was not raining,' I said.

'Unlike the time you slept with Sally's corpse,' Cosmic added.

(It was typical of me to add, 'At least it was not raining.' Whenever anything bad happens to me, I always immediately

12

come up with an 'At-least-it's not', kind of thought. Like if I miss a bus, I might think 'At least the lecture I am going to be late for is on a boring subject'. If I ever end up having both my legs amputated, I shall probably find myself thinking, 'At least I have still got all my own teeth'. When I heard of my mother's cancer, I noticed that immediately I thought, 'At least I haven't got it too'. I am very aware of such thoughts. If it is possible to achieve total Enlightenment through sheer introspection, then I reckon I'm in the running for total Enlightenment.)

At the end of our riff, Cosmic was rabbiting on about how occultists teach that the Devil has no prick of his own, so, whenever he wants sex, he manufactures a temporary prick out of condensed vapours. Also about how the Devil's prick is very thin – just like Cosmic's. Cosmic's prick is short and thin and he was thinking of setting up a League of Men with Small Penises . . . But all this talk of pervy sex was making Sally desperately randy. So she hustled him out of my room on the pretext that we were sleepy and wanted to go to bed. Then she threw herself on me, saying that she wanted me inside her straightaway, so I hastily started picking her nose, but apparently this sort of penetration was not what she had in mind. Then I attempted normal screwing, but this was not what she had in mind either. Tonight she wanted to do it doggy style and she was woofing joyously as I mounted her from behind. Even when it was over she was still playing at being a bitch, rolling over to have her tummy rubbed and then vigorously licking my face. Next she was going to practice peeing like a dog in the bath, but I managed to dissuade her from this. Her current manner of peeing is bad enough, God knows. Sally has got it into her head that it is degrading for women to have to pee sitting down, so she now pees standing up, straddling wide and with her pelvis thrust forward, but it can be a pretty messy business. I expect she will get better with practice – plus she should give up wearing tights.

Sally made a few snuffly and whimpering noises before drifting off. I stayed awake to write this – my diary. All this on a student grant! Life is really too much! And that really is

exactly what student grants should be for – learning about life. Thanks very much Social Science Research Council!

Monday, May 15

This morning I decided that it was time to bite on the bullet and talk to Sally about how she should stop wearing tights. I was trying to sell her this notion on the basis that it would be easier for her to do her standing-up peeing that way. However, she was not fooled, as she is perfectly aware that I prefer her wearing stockings and suspenders. God knows, the mini-skirt is the greatest thing invented this century. Breathtakingly simple, but still a great invention. Surely Mary Quant must be in the running for the Nobel Prize? The mini is like the Veil in the Temple of Mystery, but a Mystery which is easily penetrated. The big trouble with the mini though is that now some women have started wearing tights, so that that entrancing gap between the stocking top and the line of the panties has been abolished. Sally was not too happy about renouncing tights, but since she is my chick she has to dress for me. As I explained to her, the clothes women wear are in a more profound sense men's clothes, since they are chosen to please men. It is men who like dresses. (However men's clothes are just men's clothes as men dress to please themselves.)

Anyway after lingering in bed a bit, so I could watch Sally put on a suspender-belt, stockings and a body-hugging jersey mini-dress, I went round to St Joseph's with a letter of introduction from Michael and arranged to start observing there tomorrow. Graffiti on the school wall: 'Death is nature's way of telling you to slow down'. All this sociological observing of the school playground could be a bit draggy. As I see it, doing research is just a way of not working – of putting off getting a job. I just can't get my head round work. The idea of doing a set pattern of actions or else one does not get enough money to eat is just so weird. I don't know how people manage work.

Tried to score an LP. Almost bought *Are You Experienced*, but didn't. Nobody seems to be producing decent music these

days. This diary-keeping is freaky, but what's the point of it? Read more Crowley. A lot of that man's stuff reads like a joke.

Tuesday, May 16

When I woke up this morning I decided that I was dead. I can't remember how I died or what my previous existence was like, but that is sort of the point. London is the Spectral City in the Afterlife. There can be no other explanation for the strangeness of London and its grey lifelessness. At every hour the big red buses ferry more crowds of the newly dead into the City of Shadows. Sally and I and the rest of us are spirits who have to hover about in this deceitful place until we wake up to full consciousness of our true state and we manage to shed any lingering attachment to our former mode of existence. Aye, and what then? I resolve to be on the lookout for those tiny clues which will prove to me that I am indeed dead. MEMO: investigate the possibility that my dreams may contain confused memories of my previous existence.

Corpse or not, I had my research to do so I went off and sat on a wall and started observing the children in the playground of St Joseph's. I can't get my head round where those kids are at. The social world of children is a truly weird scene. Took lots of notes anyway.

Dear Diary, in the evening I went up to the Lodge and *attended my first Black Mass*! Grooved on the robes and incense and the sprinkling of cockerel's blood. I was gazing hard at the shadows in the corner of the room, because I thought the spirit, Aiwass, was due to make an appearance, but apparently not. Tried to detect the auras of my fellow celebrants and failed there too − unless that faint phosphene-like glow is really some kind of spiritual emanation, rather than some kind of optical malfunction. It is so hard to be sure about supernatural matters. According to Mr Cosmic, there is a powerful Evil Spirit going about on the astral disguised as God. It is impossible for someone who has only normal human faculties to penetrate the disguise. Which reminds me, when Sally

asked Cosmic what was the most horrific thing he could imagine, he said that it was to be reincarnated over and over again for all eternity as a slug. If the Evil Spirit who is impersonating God succeeds in taking over completely, that will probably actually happen to Cosmic and, come to think of it, I will end up having sex with someone who is middle-aged. At least I won't have to do the razor-studded banister as well – or will I?

Before celebration of the Mass, we new entrants all had our horoscopes cast by Laura. (She's the old bag who is the Lodge's specialist astrologer.) Laura gave me a very peculiar look. Mine was very significant apparently. Partly it was the particular day that I was born, my being Sagittarius and, more precisely, it was the fact that Venus was in Virgo at the hour I was born. Felton and Granville came over and clucked over my birth-chart. Felton said that my birthday was my destiny, whatever that means.

'And your destiny has brought you to us,' Felton continued. 'It may well be that you are the man we have been waiting for all these years.'

He wouldn't say anything more. But wow man! It was like I was the Messiah or something. I have always rather fancied being the Messiah. Why shouldn't He be me after all? It could be that I have just temporarily forgotten my true nature. Yet I can't both be the Messiah and be dead. I shall have to keep looking for clues in order to decide which I am. On the other hand, it is very plausible that the Black Book Lodge feeds this spiel about special destiny to every gullible new entrant.

However I'm slightly fucked off to learn that Mr Cosmic, Ron and Alice have all been assigned to Laura, while I have Dr Felton as my guide during the probationary period. After the rituals were concluded I asked Alice if I could buy her a drink in the pub at the end of the road. She said no, she wasn't thirsty. I said it wasn't a matter of thirst, and that I was making a sociable gesture. She said yes, that was what she had thought, but she wasn't interested in sociable gestures. She was only interested in discovering the ultimate truth about the nature of existence. Then, seeing me look a bit hurt, she

added that it was nothing personal, but she had no time to waste on being friendly and she could see from my clothes and hair that I was not a serious person. Jeezus, it's not even as if Alice is attractive or anything. She has long frizzy hair and scowls a lot. I think the reason she is interested in the ultimate nature of existence is that she looks so awful. There has to be an explanation.

Wednesday, May 17

Awoke quite early but lay in bed for ages listening to *Aftermath* and thinking. Most people in films and books are attractive looking. But in real life, most people, the people I see on buses, are actually pretty ugly. The norm is ugliness – which is fine for Cosmic. He says that he actually prefers ugly girlfriends, since they are more natural, less glossy. (Of course, it may also be that ugly girls are readier to settle for Cosmic's small penis.) But for me, Sally represents the absolute minimum standard of beauty I am prepared to put up with. Last year, just before I met him, Cosmic was going about in the streets and stopping women to take their photos and, only when he had got his pictures, did he explain that he was photographing them because they were so fascinatingly ugly. Most of them were pretty pissed off to hear this, but incredibly he did actually go to bed with a few of them.

Can't stop listening to *Aftermath*. It really blows my mind. LPs are my spirit-guides on the journey of life. Cosmic was saying last week that the Stones are heavily into Satanism. Maybe, but I can't see them fitting into the scene at the Lodge. Had thesis supervision with Michael. He was as hung-up as ever and he kept on and on about how important it was to organise one's material. Finished reading Berger and Luckman's *Social Construction of Reality*. It's obsessive. If I could grok half of what the Stones are on about, I wouldn't be fucking around with all this sociology crap. Sally rang – a long draggy call. She was going on and on about what I had told her about the Lodge and how dangerous it is. Tonight her

question was whether I thought sexual pleasure was greater for a man than a woman.

Also she wanted to know if I really was going to submit my diary to inspection by the Satanists tomorrow? And, if so, had I put all the stuff in it about our freaky sex, drug-taking and fantasies about the Devil? I told her natch. If it's too much for them, then that's their hang-up. They have to take me as they find me, since, as far as I am concerned, they are on probation, not me. If they are too straight and stodgy to take me as I am, I have plenty of other things to try – like the Process, or Divine Light, or Ouspenskyism, or that witches' coven in Islington, or Scientology, or Esalen. I'm easy – except that, if I am going to stick with the Black Book Lodge, I would definitely like to see some demons. I have noticed that lots of young men go into occult groups in the hope of meeting and pulling birds, but with me it's demons I am hoping to encounter.

Thursday, May 18

In the morning read stuff in the Senate House library. Over lunch with Sally argued about the Lodge. We walked over to LSE to hear some of the speakers at the sit-in. After writing these lines I went over to the Lodge. I was expecting to take part in a path-working. Instead, I was summoned in to Dr Felton's study and he made me produce my diary. He, having intoned the ritual, 'Love is the Law, Love under the Will', took my notebook from me and then sat back in his chair to read it. It was really weird to watch him getting paler and paler. He was hissing with rage. I thought that all the sex and drugs stuff was getting up his nose.

Felton's eyes slitted and then closed. When he spoke it was in a kind of noisy whisper:

'You were commanded to write a diary. You were not asked to keep a scrappy mess of notes about your remarkably uninteresting days. Peter, you have seriously disappointed me – so much so that I now wonder if we should have accepted you as a probationer. You are a university graduate, yet what

you have written here is the sort of stuff a schoolboy or a housewife might write – as if it were the bare and paltry record of matches won by the house team or of shirts successfully washed.'

The eyes opened again. Then one of Felton's fat fingers descended on an entry in the notebook.

' "Sally rang – a long draggy call. She was going on and on about what I had told her about the Lodge and how dangerous it is." You were asked to write a diary and writing involves the construction of connected sentences. I can make nothing of a lot of scrappy jottings delivered in a style which, I imagine, is favoured by your sociology supervisor. "Sally rang." But she is not a bell. One should much prefer "Sally telephoned". And you have your tenses mixed. It should be "what I had told her about the Lodge and how dangerous it *was*". Also, because of the way you have constructed that sentence, it is ambiguous whether it is the Lodge which is dangerous, or, alternatively, what you have told her about the Lodge that constitutes the menace. Most readers would guess the former reading to be correct, but I am inclined to think that it is what you have told her about the Lodge that is really dangerous.'

I scowled and nodded, but Felton had not finished with the diary. It was all like the above – totally pedantic and completely blind to the content (even though I would have thought the latter was quite interesting). I cannot be bothered to record it all, but, among other things, he objected to my use of 'draggy'. He said it was just a modish bit of jargon which concealed my real attitude to what Sally was saying on the phone. He was going on and on about words like 'draggy' and 'grok' and contractions like 'don't' and 'isn't'.

I cut him short,

'Oh, for fuck's sake! This is not where it's at.'

And I got up to leave. However, the dog, startled by my sudden movement or disturbed by my anger, barked. Felton has a remarkably evil-tempered black labrador called Boy. It lay across the door with its ears pinned back, as if ready to go for my throat. I hesitated.

'I'm not a school kid and I haven't signed up for a correspondence course,' I said. 'Show me a demon or something. Prove to me that the world is not as it seems. Otherwise the Lodge is wasting my time. Show me a demon now, this evening, or I'm walking out of here and I'm not coming back.'

A slow smile spread across Felton's face. Was he going to show me a demon? Had I made a wish the granting of which I should speedily repent? Was I indeed ready for a demon?

'I shall show you something better,' said Felton. 'Give me a hand with this, would you?'

I helped him lug a small tin trunk from the fireplace to his desk. He unlocked it and, with the air of a magician pulling off his most spectacular trick, he showed me what was inside. It was full of money. He counted out a wad of five-pound notes and passed twenty of them over to me.

'This is for you,' he said. 'Each time you come to my study to have your diary inspected, you will receive a hundred pounds.'

'You aren't going to show me a demon?'

'Why should I? It is not necessary, is it?'

I was silent, but he was insistent,

'It is not necessary, is it?'

'No it is not necessary,' I said as I picked up the money.

'At last you have learned something. Now let us see what more we can learn from your diary.'

The finger moved on over the pages and Felton mouthed more of my lines with theatrical distaste.

' "If I could only understand the half of what the Stones are on about, then I wouldn't be fucking around with all this sociology crap." '

He looked up.

'I take it that the Stones are a group of Rock-and-Roll musicians?'

'Well, Rock-and-Roll's kind of died the death now. They're more of a rock band with a background in rhythm and blues –'

The fat hands waved me to silence. I was happy enough to be silent. I was thinking about the money in my hand and

only half listening to him going on about not using 'fucking' as an intensifier.

At length, sensing perhaps that I was not really paying attention, Felton put my diary down and started to play with the figurines of Egyptian gods and goddesses which he kept on the desk in front of him: ibis-headed Thoth, hawk-headed Horus, lion-headed Sekhmet, Sobek the crocodile, dwarfish Bes, Seth the storm god and other monstrous figures whose names I did not know. He had apparently forgotten my presence as the gods and goddesses moved under his fingers and seemed to commune with one another. I sat watching and feeling pretty fucked off – but no, I had better rephrase that. I was experiencing a degree of emotional turmoil. I had imagined that, when I received initiation at the hands of the Master, I should then walk through fire, control elementals, cross thresholds of consciousness and hold converse with the larvae. Above all, I should become the master of my soul and the guarantor of its eternity. Instead, it seemed that I was to get a solid grounding in grammar and English usage. I might have done better to just stick with the LSE. But then there was the money . . . Had I sold my immortal soul for a couple of hundred pounds a week? Wasn't I supposed to sign something in blood? How does one sell a soul? I had never really been sure I had a soul to sell in the first place. But, if I had one, perhaps I should aim to get a better price for it, like all the beautiful women I could possibly desire . . .

'What do you think a diary is for?' said Felton at last.

'I don't know what it's for. I never understood why people keep diaries and I wouldn't be keeping one now, if the Master hadn't ordered me to.'

'Come, come. Think. What might a diary be for?'

'I really don't know, but I suppose it might become a record of my spiritual progress along the Path – always assuming that I make any – and an account of all the weird magical things that might happen to me. But surely, what matters is what I say, not how I say it?'

Felton was impatient with my answer.

'Don't whine about it, Peter. Write your diary and as you

write it, you will find that you are changed by the mere act of writing it – of finding words for what you have done and it may be that, as you write your diary, you will find other beings writing things there too. As Crowley observed, "Magic is a disease of language." We all here at the Lodge keep diaries. Adepts are obliged to keep a record, not just of the magical workings, but also of the context in which they take place. The keeping of a diary is, or should be, a training in the art of memory, and memory is the most powerful tool of the adept, for we carry out our operations with words and those words have to be memorised. But do not think that a diary is a mere record, for, as you make progress and begin to traverse the land of shadows, there will be times when your diary is your only companion. There will be times, indeed, when your diary will seem to you like your demon brother.'

This was more like it. I would have liked to have learned more about shadow-lands and demon brothers, but Felton returned to hacking away at my awful prose. He particularly objected to my calling Tuesday's ritual a 'Black Mass'.

'A Black Mass is an act of Devil worship. Tuesday's operation, however, was an invocation to Aiwass, a way, that is, of strengthening the higher elements within us that correspond to Aiwass. The Lodge does not conduct Black Masses and it never has. If you want a Black Mass, you must turn to the pages of Dennis Wheatley's novels, for I suspect that the Black Mass has only ever existed in the pages of pulp fiction. A real man of power has no need to have horned demons parading across his drawing room. The resort to spell-making is a sign of weakness, not of strength.'

Maybe, but surely it was fun to summon up horned demons? What else was the point of magic? But could Felton read my thoughts?

'Your wanting to see a demon reminds me of something which happened to me when I was young.' As he said this, he put my diary down and began to reminisce. It was quite a long story that he told and, obviously, I cannot remember it word for word, but roughly it ran like this.

Although Felton was born in Egypt, when war broke out

he came to England and enlisted. After some initial training at Catterick, he was transferred to the Chelsea Barracks and he spent much of the war in London. At this time, he was dabbling in the occult. He was at pains to stress that it was just dabbling. Like so many of his generation, he was obsessed by T.S. Eliot's *The Wasteland*. The poem's esoterically learned endnotes directed Felton's first fumbling researches into tarot cards, the writings of Hermann Hesse, Buddhist philosophy and ancient English fertility rituals. Felton used the tarot pack to tell fortunes – it was his parlour trick. He spent his leaves frequenting seances, being instructed in yogic breathing and that sort of thing. Nothing serious. Then at the headquarters of the London Buddhist Association, he met a man called Gerald Yorke who was serious and who offered him the chance to meet Aleister Crowley. This was in the winter of 1941. Gerald would be waiting to introduce him to Crowley at the great magician's flat in Hanover Square.

Felton casually agreed. Of course, he would be delighted to meet the notorious 'Great Beast'. But when the appointed day came round, he was not so sure. Did he really want to spend one of his precious evenings making polite conversation to a bufferish old charlatan? If, by any remote chance, Crowley was not a charlatan, then he would be a genuinely dangerous person to meet, but surely he was a charlatan? So what would be the point? Besides, it was damned cold outside and there was snow on the ground. Felton vividly remembered debating with himself in the barracks. A man lying on the next bed was laying out a hand of patience. At the far end of the room a group were trading bawdy limericks as they applied blanco to their webbing and used matches to melt boot-polish, so as to get a better shine. In the end, Felton decided to go. The limericks were grating on him and, if nothing else, his having met Crowley would give him something to talk about at parties.

But it was a bleak wait for a bus in the blackout and he almost despaired and turned back to the warm barrack room. It was Gerald who let him into the apartment-block in Hanover Square and led him up to the presence of the

Master. Crowley did not rise from his armchair to greet Felton. Indeed he did not at first seem to register his visitor's presence. He just sat there wheezing asthmatically and muttering to himself. Obese and jowly, Crowley was in his sixties when Felton met him. Crowley was to die on December 1st 1947. ('Under the sign of Sagittarius,' Felton added pointlessly.) Although Crowley at first appeared the prisoner of his own memories and reflections, Gerald drew him into conversation bit by bit and got him to acknowledge Felton's presence. Crowley with a glass in his hand proved to be an animated host and set out to charm Felton with first tales from his youth and then a learned commentary on the true significance of the tarot.

Where was this going? I was thinking that it was all a bit like one of those articles in *The Reader's Digest*, entitled, 'The Most Memorable Character I Ever Met.' But suddenly Felton looked hard at me.

'You remind me of Crowley.'

I shrugged. I did not think that it was flattering to be compared to a wheezing, fat, old Satanist.

But Felton apparently did. He was insistent,

'You are a lot like him. It is nothing obvious. But there is something about your eyes. There is an admirable hardness there . . . but of course you are much prettier than he was.'

With this Felton returned to his recollections. I was not reassured by Felton's last observation. Are these diary-sessions and packets of money supposed to lead on to something which has got nothing to do with the esoteric? Anyway Felton's recollections . . . Gradually, Crowley's conversational animation had abated. Having muttered something about having to visit the bathroom, with difficulty he heaved himself out of the armchair and shuffled out of the room. Once Crowley was out of the door, Gerald nimbly leapt up and watered the decanter of wine that was on the table between them. The old man was giving himself another fix of heroin, he confided. Felton should be flattered. It meant that Crowley wanted to keep going and make an impression on his visitor.

When Crowley reappeared, he was a little pale, but

conversationally reanimated. Not long afterwards, Gerald pleaded another appointment and left them talking. Crowley had moved on to telling Felton about the Ordo Templi Orientis and its secret work in the world. It became obvious that Crowley wanted Felton to commit himself to him and to ask to become an initiate of the Ordo Templi Orientis. This was perhaps flattering. Nevertheless, from the dark hints that Crowley kept dropping, it was clear that probationership in the Order was a serious commitment, with various attendant ordeals and hours of special study. Felton had enjoyed dabbling in esoteric matters, but he had no intention of letting it take over his whole life. There was music and poetry and probably university studies to be taken up when he should be demobilised. And besides, charming though Crowley was, it was not clear that he had anything more than a fund of interesting stories to offer. Moreover, Felton thought of himself as a free spirit. It was surely not in his nature to become anyone's disciple.

In the end things grew awkward, as Crowley gave up dropping dark hints and asked Felton outright if he would become his disciple. Felton said that he needed time to think about it.

'Time is what you shall have,' said Crowley.

In the barracks, a man lying on the bed next to Felton's was laying out a hand of patience. At the far end of the room a group were trading bawdy limericks as they applied blanco to their webbing and used matches to melt boot-polish, so as to get a better shine. The limericks were getting on Felton's nerves. He had to decide whether to venture out into the winter blackout and have Gerald Yorke introduce him to Aleister Crowley. It was exactly the same choice as before. Except that this time it was completely different. The first time round it had been Felton, the dabbler, idly debating with himself whether it was worth wasting an evening visiting Crowley, the charlatan. This time Felton was having to make a choice that would govern the whole of the rest of his life. This time he knew that Crowley possessed real power. This time, if he walked out of the barracks and took the bus towards Hanover Square, Felton the dilettante would be dead forever

and another man would take his place. As one of the Hassidim put it, 'The soul teaches incessantly but it never repeats itself.'

Felton took that bus. Everything went as before – up to the point when Crowley asked Felton if he wanted to commit himself to him. At this point Felton simply said, 'yes'. Two weeks later he was inducted as a probationer in the Ordo Templi Orientis.

That was Felton's story and I rather enjoyed it. However, even assuming that it is a true story and not invented by him as some kind of teaching parable, I doubt if what happened that winter night in 1941 was really anything supernatural. I think that it may have been an unusually extended version of *déjà vu* and what Felton took to be his second visit was really his first and only visit with an underlying feeling of I-have-been-here-before. Bernard Hamilton's *Sociology of Anomalous Perception* explains such sensations of false recognition as due to a mind's mistakenly identifying social situations which are structurally congruent but not in fact identical.

MEMO I must look at the endnotes of *The Wasteland*. The way Felton has described them, they sound distinctly psyche-delic. And what about Crowley? He sounds like an ageing hippy.

I think that was all that was said in my diary-session – oh yes, he also objected to my being "fucked off" at being assigned to him, rather than Laura. He was going on about how the use of the word "fucking" should be restricted to acts of affection between two human beings. But when I told him that Laura had a reputation among those going to the Hermetic Wisdom lectures as a "sex teacher", he laughed briefly.

'Peter! Your frankness is refreshing! And I want you to be equally frank in your diary. Tell the truth and hold nothing back. Peter, dear boy, great things are promised for you. We are going to take you up to a high place and show you the world.'

He seemed to be about to say more on this theme, but suddenly decided against it. Instead he continued with a homily about vivid writing. My diary had to succeed in making him see what I saw.

Finally he told me that I was to arrive early next Tuesday evening and to bring my diary with me ready for inspection (and he of course would have more money ready for me).

'Tell the truth and confess all, as if your life depended upon it. No. Forget that "as if". Your life will depend upon it. Believe me.'

As I rose to leave, he pressed a copy of a book into my hands.

'Thomas de Quincey's *Confessions of an Opium Eater*. He published it in 1821. He was, if you choose to think of him in that way, England's first hippy. What I hope is that his little book will show you how it is possible to be "hip",' (he got his mouth round that word with difficulty) 'and yet write good prose. Continue with your study of *Magick in Theory and Practice*, but read De Quincey as well.'

It was a curious evening and I sat up late writing it all down. And now there is all this money under my mattress. Still, I keep coming back to something that Sally said earlier in the week. 'If Satanism really works, why is Dr Felton old, fat and living in Swiss Cottage?'

Friday, May 19

As I made my way to the school, I was thinking about Felton's total failure to engage with the actual content of my diary and how his reading it for grammar and style was distinctly off-pissing. (He won't like that last expression. Too bad.) Also off-pissing was the consideration that I do not think that I have learnt anything that I did not know before. It was as if he was merely a projection of my mind which was telling me things that I was aware of already. It then occurred to me, not for the first time that Felton and everybody I knew might be projections of my mind – as it were, the creations of my waking dream. I was thinking this when I ran into Robert Drapers on the bus on my way to St Joseph's in the morning. He still affects a beatnik-black, roll-neck pullover and sandals without any socks. His hands were shaking and he was looking pretty

seedy. Since I was feeling loaded, I bought him a late breakfast. He was in London for an interview at the School of Oriental African Studies where he hopes to do research on Islamic history. Also he is hustling for somewhere to live next year. He passed me a tin of shema – mouth tobacco – which he had scored in Algeria. The silver tin with its sinister oriental writing looks really pretty. But I did not think that shema and breakfast would be a good mix.

Robert asked after Sally. I think he fancies her, but he has always been too shy to tell her. Also he asked after Michael and then he wanted to know about my research and, when I told him, he said that he thought that there could be serious problems with it and that there were dangers in my methodology. Also I told him about my becoming a probationer in the Black Book Lodge. He could not understand why I should want to do such a thing and I admit that I found it difficult to explain. However, roughly what I believe is this. I am nothing until I have committed myself to something. Until now I have been just window-shopping through life. My commitment to whatever it may be has to be total. Not only that, it has to be irrational. One cannot just shop around for an ideology. One has to embrace it totally. Only through complete commitment can one ever understand a thing. One is never more alive than when one is leaping off a cliff. But Robert said that I had got it all wrong and that one is definitely dead when one leaps off a cliff. That was him being wilfully obtuse simply in order to win the argument.

He is a pretty irritating character. I told him about my latest theory that he and everybody I knew were bits of me which I had hived off in order to inhabit the cosmos which in truth consisted only of me. Robert looked at me with a big smile on his stupid face.

'Oh, well done Peter!' he said and taking my hand he shook it warmly.

'What do you mean?'

'You have sussed it out at last! I was wondering how long it would take you. Yes, I and Sally and everybody else are just

bits of your thoughts. We don't exist when you are not thinking about us.'

He was just doing this to freak me out, I think. However, he was most emphatic about it. The reason everybody I know talks and thinks the same way as me is that they are me. One of the reasons Robert is depressed is this business of when I am not thinking about him, him not existing. He said that it is horrible flickering in and out of being. The fucker! It is one of his freaky paranoia-gambits. I have known him pull this kind of mind-fucking game before.

'You could make me do more interesting things you know,' he said. 'I would welcome that.'

'You are just saying all this to hang me up.'

'So you say. But actually, if you want to, you can make me say that I am not a projection of your mind.'

'I want you to say that you are not a projection of my mind.'

He shrugged,

'OK, I'm not a projection of your mind, but I'm only saying that I am not because I am.'

(FUCK!)

As he prepared to leave, he looked back at me solemnly. 'Please think of me as much as possible. I really enjoy being one of your thoughts.'

'When shall I see you again?'

'When you next feel the need to see me.'

Anyway, then Robert had to go off and register at Senate House and I went on to my school and sat on the wall of the playground and watched the little children playing, feeling like a sexual pervert as I did so. From time to time, one of the little creatures would pause in their play and eye me curiously. What do children think they are doing when they play? What use do they think play is? Is their play, play in the sense that adult play is – like playing poker or croquet? I have no idea and, anyway, such questions are not strictly part of my thesis topic. My thesis is entitled 'Aspects of Ritualised Behaviour in the Playground', but, even as it is, Michael has warned me that my topic is too broad and that it will have to be narrowed down sooner or later.

After the mid-morning playbreak, I went off to an espresso bar on the corner of the road and fleshed out my first batch of notes. Then I went back and took more notes on the lunchtime playbreak. Already I am beginning to feel like a proper sociologist, for I am ceasing to look on the children as human beings. They seem more like ants moving about on mysterious missions. Then again, from another point of view, the children can be seen as creations of intellectual fantasy. I was stiff and cold by the time the second break was over and I decided to head back to my pad and go over some of last year's lecture notes. I also read a bit of Piaget about children's minds, but I kept drifting off to think about Dr Felton. If he is keeping a diary, am I and my diary in it? And does he discuss my diary with Laura and Granville and do they record in their diaries what he writes about my diary in his diary? It is a vertiginous prospect.

I rang Dad earlier this evening. The diagnosis is confirmed. Mum's cancer is back and they are keeping her in hospital for more tests. I am spending the evening listening to the Stones and Jefferson Airplane. Guitars weep for me. It now occurs to me, as I turn over these pages, that an outsider reading them would get the impression that I am a social animal always going about and meeting people. It is not so. Only the record-player talks to me. Now I think about it I am annoyed that I forgot to ask Robert if I was dead.

I tried stuffing a big pinch of shema in my gum, but I was only partially successful, so that the foul stuff was all over my mouth. I sat with it swilling around for as long as I possibly could, but in the end I just had to get rid of it, but, when I rose to go to the basin in order to spit it out, I found that I was too dizzy to stand. So I ended up retching over the floor in front of me. My head was all buzzy. I shall certainly try this one again. It could even be addictive.

Memo: according to Mr Cosmic, Brian Jones has the Devil's nipple. How does he know? Also Cosmic has made a hole in his scrotum, so that he can inflate it just before sex. Apparently sex with an inflated scrotum is a real gas . . .

Saturday, May 20

'Then came sudden alarms; hurryings to and fro: trepidations of innumerable fugitives, I knew not whether from the good cause or the bad: darkness and lights: tempest and human faces: and at last with a sense that all was lost, female forms, and the features that were worth all the world to me, and but a moment allowed, – and clasped hands, and heart-breaking partings, and then – everlasting farewells! and with a sigh, such as the causes of hell sighed when the incestuous mother uttered the abhorred name of death, the sound was reverberated – everlasting farewells! and again, yet again reverberated – everlasting farewells!

'And I awoke in struggles, and said aloud – "I will sleep no more!"' '

Last night I dreamed that I was sleeping in the room that I was actually sleeping in and I dreamed that I awoke and there was my mother standing in the shadows. She looked horribly thin and she was pleading with me. But I could not hear what she was saying. The thought came to me that the cancer had eaten away her tongue. Then I really awoke. I was trembling all over and further sleep was out of the question. I reached for the copy of the book which Felton had pressed upon me and I opened it at random and straightaway my eyes fell upon the passage which I have just transcribed. It is part of De Quincey's description of an opium dream of listening to music. De Quincey as the first English hippy is just Felton's little joke, I think, but it is truly eerie how that passage speaks to me – like an admonitory ghost. Shall I be haunted by dead men's books? I hope not; De Quincey's sentences, so long and feverish, are definitely uncool.

I wandered up Portobello Road buying groceries. The girl in Lord Kitchener's Valet smiled at me again. The trouble with diaries is that they are so full of 'me' and 'I'. It is precisely me that I don't want to be. I don't want to be buying

groceries. I want to be out of my skin. Probationer for Adepthood on the Occult Path I may be, but I still have to go out and buy milk, cornflakes, brussels sprouts, brown rice and so on. Perhaps one day I shall learn to do without food and learn to live on the energies in the street. On sunny days like this everything is so brilliant in Portobello Road, the exotic fruits, the West Indian women in headscarfs, the freaks in their gear, the girls in summer dresses (and it's only May!) – but somewhere, just beyond the edge of my vision, a grey and emaciated woman is standing and waiting.

In the afternoon I started to read about the 'observer effect' in sociological experiments – how by the mere process of observing one changes the nature of what is being observed. When I got bored with that, I read some more Aleister Crowley and lay on the bed and attempted to follow his instructions for getting my astral self to leave my physical body. I kept imagining how my spiritual self would look down from the ceiling on my body apparently asleep on the bed below, but it was imagination only. My will is not yet strong enough. However, as Crowley observes, 'Verily it is better to fail in the magical ceremony than it is to fail in writing down an accurate record of it.'

I put on my silver shirt to go out – after writing all the above down, that is. I can see that the problem with diary-keeping is that, in the end, the record becomes so elaborate that one spends the whole day recording the fact that one has spent the whole day writing in one's diary – another vertiginous prospect.

This evening the first thing Sally wanted to know was whether I would prefer to be dead or not yet to have been born. I met her, as arranged, at Convent Garden tube-station and we had a pub snack before entering Middle Earth. This time the people at the door stamped transfers of butterflies on our hands. The Incredible String Band was playing. (According to Mr Cosmic, they are both heavily into Scientology.) We danced for ages and then, in the corner of the basement furthest away from the Band, we got into exactly the same argument we had last week, about the Black Book Lodge and

its set-up in Swiss Cottage. She kept having to shout and this did not improve her temper.

'They're bad news!' shouted Sally. 'The whole place pulsates with bad vibes. I'm amazed you can't feel them. What do you expect to get out of it all?'

I smiled and said nothing. Sally had come with me to the first two lectures in the Hermetic Wisdom course last year, but she couldn't stand Agatha or Granville, so she gave up and she never got to hear Felton, Laura, or any of the other lecturers. Neither did she meet the Master.

'They're all so old and creepy and snobby. They're all establishment types,' she continued. 'They bang on about the higher spiritual life and opposing the forces of materialism, but the reality is that they are on a hell of a materialistic trip themselves. No way but. You've just got to look at that place of theirs with its wall-to-wall carpets and velvet hangings and all those brass and silver idols. And they, themselves, they're all so fat and sleek. It used to faze me out – the way they used to sit, bolt upright and never taking their eyes off us. They sit like they're the Enlightened Ones, but they've got really evil auras. I think they are into brainwashing.'

'Well they are not going to brainwash me,' I replied. 'I am not that impressionable. I am listening to what they say and testing it objectively.'

It made me that angry that Sally didn't believe me. She continued,

'Did you know that that creep Granville tried to pick me up? (No, I did not know that.) He kept gazing at my skirt as though he had x-ray eyes. And he kept dropping little hints about all the super-esoteric knowledge he was privy to. But then I asked him if he could tell what colour my knickers were and he pissed off. Peter, you are much brighter than he is. What do you want to go around following him for?'

I said again what I had already told her many times before that, if there was even one chance in a million that the esoteric version of the world was right, then it was worth exploring to the limit, since what was at stake was so vast – eternal life. But Sally gets really uptight about my joining the Lodge. She reads

all this mystical stuff by Kahlil Gibran and Hermann Hesse and so on, about following a Way and so on, but when it comes to actually doing something about it and, say, giving up all her worldly goods and going out on the road as a pilgrim, she does nothing. She just reads more books and gets more neurotic about not doing what the books tell her to do – especially neurotic, since the books she reads are the sort of books that tell you that real wisdom is learnt from life, not from books. It really hacks me off.

'I can't suss out why you're on the Adepthood trip at all. Isn't all this enough?'

(All this: the gyrating and bobbing figures, the pulsating lights, the drift of soap bubbles, the eerie rhythms of the sitar, her pointy breasts.)

'They go on gabbling about the Path and the Work,' Sally shouted. 'But there is no love nor laughter in them. They don't dance. I love to dance.'

And with that she drew away into the heaving throng and beckoned me to her. I followed, but I did not dance so much as watch her dance. Her wispy golden hair kept floating up and then falling over her face, then floating up again. Sally is very thin and pale. She's like an elfin princess come up from underground to dance with the lumpish humans. She had devised a dance of seduction, so as to lure me from the Path and follow her into her bed under the earth. Her eyes and her smile are so very bright, that it is as if there is a white fire burning within her.

The Incredible String Band was playing a wistful little number called 'First Girl I Ever Loved' and maybe that was an omen. The fruit-vendors were setting up their stalls when we came out of Middle Earth. We caught an overnight bus and we spent the night at my place. When I whispered to her my theory that everyone else was a projection of my mind, she was bitter.

'That means that when you make love to me, you are really making love to the person you love the most – yourself.'

Sunday, May 21

I was woken by fingers moving lightly over my face. Sally was lying on top of me and her cold, thin fingers were caressing my face, working an ice-maiden's spell upon it.

'Do you love me?' she asked in that husky voice of hers.

'Yes,' I groaned, still heavy with sleep.

'Then give the Lodge up. It's them or me.'

I closed my eyes and pretended to drift off.

We did not talk any more that morning. She put Donovan's *Sunshine Superman* on the record-player, listened to it and left. (We had previously planned to spend the rest of the day together.) I must be careful about Sally. She is the first obstacle on the Path that I have chosen. Thinking about that song last night, 'First Girl I Ever Loved', I realised that I was sad, not because I had anything to be sad about while I was listening to it, but because I knew that I would be sad in the future and then I would be hearing that song again.

I rang Dad and promised to go up on the following weekend when Mum would be out of hospital. Then I rang Mr Cosmic and arranged to go over to his pad.

'Paul McCartney's dead,' were his first words to me as I walked in.

'That wasn't on the news this morning.'

'No, he died months ago, but they are keeping it a secret. He was decapitated in a motorcycle accident and now there is a big cover-up.'

He showed me a lot of what were supposed to be recent photographs of the Beatles. Close examination showed that while some were just old photos which had been retouched, in others, which were genuinely recent, there was this thin line round McCartney's neck. All the other Beatles looked normal, if a bit sad, but there was this strange dead look to Paul's eyes.

Apart from the Beatles' clippings, the rest of the walls were covered with Red Indian and Voodoo posters. Although Mr

Cosmic's room is pretty spacious, he has decided to get rid of most of his space by building a giant pyramid of cardboard boxes in the centre of the room. The tip of the pyramid touches the ceiling. When I was last round at his place, he was telling me how yoghurt placed under the pyramid stays fresh forever. Also it exerts a field of force which sharpens razor blades. Apart from keeping his yoghurt fresh and sharpening razor blades, Cosmic's pyramid serves as a display area for his garden-gnomes. Besides the van which he uses for his removal service, he has a bicycle and he goes out at night, cycling round suburbia, and he 'liberates' garden-gnomes from people's gardens. Once they are safely back in his place, he repaints them silver and black and gives them protective magical markings, before placing them on the pyramid.

'Why are they keeping Paul's death a secret?' I wanted to know.

'They don't want an inquest, because it was not really an accident. It was a set-up in which they – '

'Who is they?'

'The Grey Ones, dummy. They killed McCartney, just like they arranged Buddy Holly's plane crash. I reckon Jagger's next. The thing is, they are afraid of our music. "When the mode of the music changes, the walls of the city shake." There's a lot of energy in the streets right now, generated by our music, and they can't handle that.'

I was looking a bit sceptical, so he put *Revolver* on the record player and, after we had listened to the last track, he started turning the record under the needle the wrong way round – what we magicians call widdershins – and he claimed that now we could hear the voices of the other Beatles predicting Paul's death and asking for help. I couldn't hear this myself.

'It doesn't do to take the world for granted,' was all that Mr Cosmic would say.

Then we started rapping about diary-keeping. He, Ron and Alice are keeping diaries too. But Laura doesn't seem bothered about how they are written. She is teaching them in a kind of joint tutorial about chakras and energy centres and

something called the Mors Osculi. Laura is apple-cheeked, bossy and very English-looking. She sort of twinkles about the place and looks as if she should be running a cake-stall for the Women's Institute. Instead, she's into seriously esoteric stuff like the Mors Osculi, which is some kind of really sinister kiss. In the meantime she's got them actually practising different kinds of kiss. Ron and Cosmic take it in turns kissing Laura and Alice. Alice is seriously uptight about it. Ron is fairly straight, but Alice is unbelievably straight. Kissing Alice is like sucking a turnip. When we started going to the Hermetic lectures last autumn, Mr Cosmic and I spotted each other as the only freaks in the regular audience – apart from Sally that is. But she stopped coming, because she couldn't stand Granville.

Anyway, according to Cosmic, Laura, Agatha and some of the others are jealous of Felton. He has a special status because he was present with the Master at the Cairo Working, when things went terribly wrong. Nobody ever talks about what went wrong at the Cairo Working. But it is said that the Master has a wife and a daughter, and the wife, who was outside the pentacle during the Cairo Working, went mad. No one has seen her for about twenty years, because the Master keeps her in chains in the attic (just like Mr Rochester's wife in *Jane Eyre*). That explains some of the strange noises one hears during the invocations and the comings and goings on the stairs. Anyway, ever since things went wrong in Cairo, the Master has relied on Dr Felton for advice.

I told Cosmic about Sally's hostility to the Lodge.

'That's chicks for you,' he said. 'They always want things to be safer. You need to incorporate her in your next pathworking – something like a mythic quest, something like you setting out on a heroic quest and leaving your cottage in the heart of the forest and her tearfully waving you goodbye. Then when you return with the monster slain, she will dry her tears and rejoice that you have accomplished your quest.'

'But she wants me to give up the Lodge. It's either that or she's going to split from me.'

'Lie to her. Pretend that you are doing something else on

Tuesdays and Thursdays – evening classes in carpentry or something.'

Then we smoked and listened to a record of Yma Sumac, the Inca goddess.

Monday, May 22

I awoke late and rushed breakfast. I had some really weird dreams last night, but I can't remember what they were, and perhaps that is a good thing. I don't believe in writing down one's dreams, for, if dreams wished to be remembered, they would not have that forget-me-quick mechanism built into them. They are aspects of the sleeping brain talking to itself and one should not eavesdrop.

Went to Dillons Bookshop and on my way stopped off at the Scientology headquarters on Tottenham Court Road to flirt with the girl at the door. I have always fancied Scientologists, as I think that they are sexy – so glowing-healthy, sparkly-eyed, clean and smiley. Not that I am any of these things, but it doesn't stop me fancying them. Last year, I wanted us to go into Scientology, but Sally vetoed this, as she said it was too scary. So we went into the Black Book Lodge instead, which, in many respects was a pity . . .

After Dillons I hurried off to my wall on the edge of the playground and took notes. Hopefully I will get a clearer idea of where this research is going soon. Today I was concentrating on the phenomenon of parallel play – that is when children look as though they are playing together, but actually they are not. They are playing in close proximity to each other, but independently, each enclosed in his or her own imaginary world. Watching the little children makes me feel melancholy. I am sorry for people who have children, because that really is a sign of defeat in life and an admission that one has given up on one's own ambitions. I reckon that people have children in the hope that the children will achieve what they failed to achieve. A person – an unenlightened person at least – is just a receptacle for the life force, and something to

be discarded once its reproductive capacity is exhausted. The prospect of middle age terrifies me. MEMO: Over the door of his pad Mr Cosmic has written 'A physicist is composed of atoms. A physicist is an atom's way of finding out about atoms.'

I returned home and read late into the night. I hope Sally forgets all that stuff about making me choose between her and the Lodge. She rang this evening and we have arranged to go to the cinema on Wednesday evening to see *Elvira Madigan*.

Tuesday, May 23

There is a demon within me, which makes me do the opposite of what I want to do. Today was one of the days of the demon. I am scared of high buildings and the edges of cliffs. My vertigo is not because I am afraid of going dizzy and so tumbling over, nor do I suppose that the cliff face is suddenly going to crumble. No, what I fear is that the demon-who-makes-me-do-things-I-don't-want-to will take over and make me jump into the void. My demon makes it difficult for me to go to parties, for fear he will make me say awful things, the shame of which will remain scorched on my brain forever. I do not often sense him inside me, but . . .

If only it was possible to wish days not to have happened. If only it was possible simply by wishing to go back in time and have another chance and have all memory of what happened erased, so that one does not even have a memory of having had to wish for forgetfulness . . . But then, if it was possible, I would not remember, would I? It is even possible, of course, that my memory of today's awful encounter with Felton, conceals an earlier memory of something inconceivably more awful. How would I ever know? Lost. Completely lost.

It was raining, so figuring that the children would not be playing out of doors today, I went to work in the library, but the day didn't really start until evening. I went up to Horapollo House at Swiss Cottage. Felton was waiting for me in the dark hallway. Horapollo House is literally a place of

shadows, for no natural light has been allowed in the building for about fifteen years. I had come an hour early, as arranged, so that Felton could hack over my diary. He had a cold and at first he was in an evil humour. There was still a lot in my prose that he finds objectionable. Like my use of the adverb hopefully in the sentence, 'Hopefully I will get a clearer idea of where this research is going soon', made Felton spit. Although my diary-writing is improved, I must pay more respect to the rules of grammar.

'Grammar is not a distraction from magic. Grammar is magic. Grammar and grimoire are the same word. Grammar is also "glamour" and the primary meaning of "glamour" is "spell", while a grimoire is a manual for the casting of spells. Through grammar we control the universe.'

There are also things I have been reticent about – for Felton is curious, why when Sally asked me about why I was committed to the Lodge, I gave her such a vague answer.

'You can lie to Sally. There is no reason not to, but you may not lie to your diary. Tell me now, why you have kissed the hand of the Master?'

I told him that it was because I wanted to be young forever – to become the *Puer Aeternus*, the 'Eternal Boy', as described in occult textbooks. 'I have maybe sixty years in which to work out a way of not dying. It seems like a long time, but I know it is not.' However, Felton seemed dissatisfied with my answer. We shall have to come back to my real motivation.

'You are playing with me, Peter,' he said. 'I know that and I know that you are cleverer than me. But in the long run your cleverness will avail you nothing. I will break you and remake you – just as I have done with countless others who are sitting where you are sitting now.'

Another thing is missing in the diary so far. Sally, Cosmic, Laura and Drapers are described, but Felton is not.

'But I want to be in your book, Peter. I want to know how you described me to Sally. I want to see myself reflected in the mirror you hold up to me. Make sure that it is a true image that you present.'

OK Felton. He is extraordinarily fat – probably because he

drinks so much red wine – and it is the sort of fat which might once have been muscle. His hair is close cropped, as if he had just come out of the army. Though the body is soft and the face wattled, the eyes are hard, octopus eyes. He emphasises the points he is making with odd little waving gestures. He wears bow-ties, of which he seems to have a considerable collection – also waistcoats. I know that he went to Peterhouse, Cambridge (that must have been after the war), but I still have not worked out what he is doctor of. Probably he's got a doctorate in Classics, since he is always strewing Latin tags about and he was really shocked to hear how I got into university without taking an exam in Latin. Obviously he was in Cairo at the same time as the Master, but I do not know what he was doing there. He has a huge collection of books on the wall behind the armchair: occult treatises like *The Kabbalah Unveiled*, *777*, *The Key of Solomon*, *The Rose of Mysteries*, but also a lot of classic English literature like Milton, Marvell and Browning. I have also noticed some rather odd titles, like *Snowdrops from a Curate's Garden* and *How Boys Bathe in Finland*. He is obviously a bachelor and he keeps that horrible black labrador for company – more like a demonic familiar. Sally is sure that Felton is a poove and that he wants me for my skinny body. I was thinking that that might be the case, but so far the only thing he had got for his hundred pounds was an inspection of my diary. But then it occurred to me that reading someone else's diary was a bit like sniffing someone else's underwear. Dead pervey.

Pervey. It was the thought that did it.

'I want kissing lessons.'

'What?'

For once I had succeeded in surprising him. He was looking at me as if I was mad. Which, of course I was. I wanted to retract what I had just said, but the demon would not let me. So the next thing which popped out of me was,

'Cosmic, Ron and Alice are all getting lessons from Laura in occult kissing and I am getting left behind. I want you to give me the same lessons that they are getting.'

Alas! Felton was surprised, but not shocked. I was freaking

myself out. Was I really hungry for a fat old man's kisses in Swiss Cottage? He rose slowly from his chair and motioned that I should stand too. I had to come closer and since I was taller I had to bend to let my mouth touch his. One of his hands went up to my hair. Then his long tongue was in my mouth, like a snake coiling about and making itself comfortable in its lair. Not so much a kiss, it was more like he was sucking and draining my mouth of saliva. Even so I got a little of the acid taste of an old man's saliva.

We drew apart, while he explained that the next time we kissed, I had to take a long pranic breath – *apana*, the down-breath – which would reach down all the way to the *muladhara* or root *chakra*, which is located between the anus and the testicles and he reached between my legs to show me where he meant. We kissed again and I was concentrating like mad on this oriental breathing, so as not to think of him. And again and again. In between kisses he was giving me little lectures about the transference of energies through the mouth, the left-hand practices of certain Red Cap Lamas and the lighting up of the *chakra* points in the body. I was going dizzy, from the bizarre breathing rhythms and the sheer horror of it all. For his part, he was having difficulty in breathing – either because he was overexcited, or because of his cold. So after only twenty minutes or so we stopped. However, he was making ominous mutterings about future lessons concerning the Mors Osculi and the Obscene Kiss.

Horrible. Horrible. Horrible. But at least it cannot have been much worse than kissing that corseted old bag, Laura. If I knew more about Tantrism than I do, I would have a better idea of what is coming next. Sally knows more about Tantric sex than I do. Last year she was talking about training to become a temple prostitute. Cosmic claims to be in love with Laura, but he just says these things to shock – part of his I-love-ugly-old-people bag.

Then Felton sat down and flourished a handkerchief and wiped his mouth and blew his nose. Then, after having debated with himself for a while, he decided that my diary was worthy (though only just worthy) of being consecrated.

Together we consulted the ephemerides tables to see if the time was propitious: Saturn chiefly in the ascendant; Mercury triune to the ascendant; Saturn and Uranus triune to the moon and Jupiter sextile to the Moon. It is a conjunction not without its problems, but it definitely has a power. Then he inscribed a pentacle with oriental sigils on the notebook's flyleaf and intoned some Latin over it. He handed the diary back to me, together with a copy of Crowley's *Diary of a Drug Fiend* (another early hippy document apparently).

Just as I was shakily making my way out of the room, he called me back,

'*Quis custodiet custodies*? I have been talking to you about the importance of memory, but I am a fine one, for I forgot to ask you. Do you have a suit and tie?'

'Yes. Why?'

'In that case, you will join me for dinner at The Gay Hussar in Greek Street at nine o'clock tomorrow evening.'

'Oh, thank you for asking. That would be really nice, but unfortunately I cannot. I have promised to take Sally to the cinema tomorrow evening.'

'Break that promise.'

'I cannot.'

'I am not inviting you to dinner. I am giving you an order. Your oath to the Master takes precedence over earlier or subsequent commitments to outsiders.'

'But what shall I tell Sally?'

'You will think of something. Why not lie to her? In the months to come you are going to need a lot of practice in lying.'

'You are just testing me!' I cried out.

'Of course I am,' he replied imperturbably. 'Don't forget to take your money . . . and do not forget to wear a suit and tie – and a clean shirt if possible. Love is the Law. Love under the Will.'

I took the money. It was a test, but what kind of test? Is it possible that Felton despises me for taking the money he offers me? Does he think that I have become Hell's rent boy?

I only just made it in time to the pathworking downstairs.

Granville was conducting it, while Agatha accompanied our meditations on the piano. God knows what she was banging out. It sounded like a Beethoven sonata as rendered by a mad and deaf Turkish dervish. The pathworking was based on *The Tempest* and it was unusually long and complicated with stuff about the storm of human emotions, the isolation of being apparently alone on a desert island, with Ariel and Caliban as representations of the higher and lower souls, and on winning through to gain the hand of the sorcerer's daughter – a symbol of the Adept's union with Sophia, or the Higher Wisdom. But I kept returning to the storm and to the song of Ariel: 'Full fathom five thy father lies . . . ' I imagined the eye-sockets of the dead looking up at me through the murky water and the fish darting among the bones.

(By the way, it turns out that Shakespeare was a leading occultist. Everybody seems to have been one. It will probably turn out that Charlie Chaplin and Joseph Stalin were leading occultists too.)

It was late when I got back and by then my mind was made up and I decided that I had to ring Sally straightaway. The morning would be too late, as she would be at her archaeology lectures by then. So I rang her and told her that I had food-poisoning and that I doubted if I would be able to make it the following evening. She sounded seriously concerned – tiresomely so, as she kept wanting details about what I was throwing up, and she even threatened to come round and look after me. She thinks that I might be the victim of a psychic attack and that it is the Lodge which is making me ill. But in the end *Elvira Madigan* got postponed till Thursday.

Before our grisly kissing session, Felton said so much that it is hard to remember it all. He said something about how I was holding back on my emotional reactions to things and people. Oh yes, he did talk again about the magical purpose of training the memory. The Lodge has many enemies and from time to time its Adepts are subject to magical attacks. The commonest form that these psychic assaults take is an attack on the memory of an Adept. If one is attacked and one loses the psychic battle, then parts of one's past will be accessible only

through the record kept in the diary. The diary then is a kind of back-up memory for use in the spiritual warfare which is to come. Felton also said that, by keeping a diary, I was training myself to think backwards and that is one of the essential skills of the Adept. He did not comment on the mysterious disaster at the Cairo Working, even though I had put that bit in specifically hoping that he would.

Wednesday, May 24

Woke early. Looking back on yesterday, it wasn't that bad. I wanted to shock myself and I succeeded in doing so. Great. What is bad is that I now have a cold. Having made up a stupid lie about food poisoning, I now find that I genuinely am a bit ill. After breakfast, put Donovan's *Sunshine Superman* on the record player to help me think about Sally. All my contemporaries seem to have their own music which is distinctive to them – kind of like a whale's song. Donovan, 'the English Dylan', makes Sally's music for her. She grooves on its gentleness and dreaminess. (But there is an undercurrent of melancholy in Donovan's songs which bodes ill for Sally's future.) Sally likes to dance as much as I do, but her dances are slow and sinuous. This new fashion for sitar music suits her style of dancing perfectly. Whereas, when I dance, it is a high voltage performance and I fantasise that my body is dissolving into waves of energy and light. The dance sets me free from the world's field of gravity.

There are no hard edges to Sally. It is noticeable that her room is like an extension of herself. One cannot see the floor, ceiling or walls for all the drapes, coloured cloths, beaded curtains, Chinese bells, mattresses and cushions. And, when the candles are not lit, the room is lit by an orange light bulb hidden under a batik cloth. She scrounges a lot of fabrics from the theatres where she works part-time as a dresser and she keeps adding new ones and rearranging them in order to redirect the vibes. Her breath is sweet.

I was disconcerted when Felton pointed out that I was

keeping myself and my feelings out of this diary. Do I love Sally? I do not want to be simplistic about this. Maybe I do. (Love is the Law. Love under the Will.) But what does love mean? We are both free spirits. We do not own one another. This business of her trying to order me not to have anything to do with the Lodge is the first time she has ever tried to be authoritarian or possessive about our relationship. It is deeply uncool.

I achieved a major triumph this morning. I took the bus to St Joseph's and practised the spell of invisibility. Since the conductor never noticed me, I travelled for free. I fancy that the faculty of invisibility could be seriously useful for a sociological observer.

At the end of the first playtime the deputy head came out for a chat. He passed on a few useful observations about patterns in children's play. Then he wanted to know what I thought I was going to do when I had my Ph D. It is the kind of question which is well-calculated to freak me out. I do not want to do anything with my life except dance and maybe play music. The thought of work is cruel. As the Stones put it, 'What a drag it is getting old.'

I have this horrid feeling that youth is on a holiday and that it is not going to last. 1967 will give way to 1968. Sally read me a poem a few weeks back – 'The Land of Heart's Desire' by W.B. Yeats. It was about

> *'The lands of faery*
> *Where nobody gets old and godly and grave,*
> *Where nobody gets old and crafty and wise,*
> *Where nobody gets old and bitter of tongue;'*

But maybe, as I advance along the Path, I will find the answer. There will be a spell to make time stand still for me, so that I dance forever in 1967, while the others plod on through the years that follow and they age with those years.

Sally reads a lot of poetry and she learns it by heart, Yeats, Donne, Blake, also Ginsburg, Corso and Ferlinghetti. She likes shopping for little things. She likes to have me break raw eggs

over her body. She's a kind of metaphysical sociologist in that she likes to suss people out by going around asking them dopey questions, like, 'What do you think is the purpose of life?' or, 'What sorts of thing do you find funny?' or, 'Do you think that intensity is a good thing?' She asks me, she asks Mr Cosmic, the postman, the man at the door of Middle Earth, anyone. Then, at the end of a week or so, she compares the answers and thinks of the next question.

Sally is an Aquarian. She looks a bit like Mia Farrow before she cut her hair. ('Every Man or Woman is a star,' as Crowley observes.) Or maybe like Nico on the sleeve of *The Velvet Underground and Nico*. (*The Velvet Underground* is my whale song.) She loves her freedom and does not want to get trapped in the channelled ways that straight people think in. Aquarian people like unusual things and they keep changing their ideas. This is her age. These are weird times – 'The Season of the Witch', as her oracle Donovan puts it.

The Lodge did not make a good impression on her. She grooves on Mr Cosmic though. They share a thing about Arthur and Guinivere. He thinks, like her, that Arthur and his knights will return and that millions now living will see the rebuilding of Camelot. I think she's probably slept with Cosmic a couple of times. That's cool.

Spent the afternoon bringing the diary up to date, while I watched my clothes spinning round in the launderette and nursed my cold. In the evening I dressed for dinner. I had not worn a suit since graduation. The knot of the tie is to me as the hangman's noose – a punishment imposed by society. I made my way to the Gay Hussar in Soho. I was feeling pretty seedy and I was apprehensive that the demon-who-makes-me-do-things-I-don't-want-to might be accompanying me to the restaurant. The Gay Hussar is all red plush and dark lacquer with deep benches, the sort of place where a colonel in the Ruritanian army might meet his opera-singer mistress. I had never eaten in such a place before, but, according to Felton, there are many more expensive and prestigious restaurants in London. We are going to visit them all, working up the list gradually. Felton was already there sipping a glass of

something green. I am not used to eating late, but, though my impatience must have been obvious, Felton insisted on doing a big winemanship number. I was there for a lesson, rather than a meal. He ordered a bottle of Montrachet and made me follow him, as he twirled the glass by the stem and peered and sniffed at the wine. Then we had to sip, making little dog's arse movements of the lips. I hate sipping. Gulping is my normal pace. Felton had to reach across and stop me from draining the glass. A Montrachet is a full-bodied, dry, white Burgundy. It has a flowery bouquet and a kind of honeyed oak aftertaste. It is such a great white wine that I was supposed to faint or something, but it tasted like white wine and I drank it. Perhaps if I hadn't got a cold I would have got more out of it. However, I have to memorise all this winemanship stuff. It is actually part of my training as a sorcerer.

'So where does Sally think you are tonight?' asked Felton, when he had finished banging on about the vineyards of the Beaune region.

'She probably thinks that I'm in bed sick.'

Felton nodded, satisfied, and turned to the waiter and asked him to bring a bottle of Haut Brion claret, a 47 if possible, to our table, so that it could start breathing while we were slowly working our way through the Montrachet – I mean so slow, it was like getting one's booze through a drip-feed. Then he started pointing out other people in the restaurant. There was an MP called Tom Driberg. And there was a writer, Angus Wilson. I was quite impressed at being in the same room as Wilson, until I remembered that the man who wrote *The Outsider* is called Colin Wilson, not Angus. I do not know who this Angus is. However, when Felton and the Master judge that I am ready, I am going to be introduced to all sorts of famous and influential people.

'We are grooming you to be part of the elite.'

'Why me?'

'The Lodge is looking for new members. They should be young and, even more important, intelligent and with qualifi-cations. Your first-class degree is a powerful recommendation.

True, it is only in sociology and sociology is just socialism dressed up as an academic discipline –'

I started to protest, but he made those funny waving movements with his fat hands.

'Peter, no scowls! They do not suit your pretty face. Let us not quarrel about sociology of all things! Even you must admit that practitioners of that arcane 'science' have no literary style – or any other sort of style. It is a subject for people who like wearing duffel coats.'

I put my ear to the bottle of Haut Brion and pretended to listen to it breathing. Felton looked displeased, but he continued nevertheless,

'But my point is that the Lodge wants you to continue with your studies, so that you get your Ph.D. in sociology. After that, we shall see. In thirty years time I should expect to see you as a Fellow of All Souls, a Permanent Secretary in the Civil Service, or the director of a publishing company. Something along those lines will be achieved by you and the Lodge working together. We already have rich and powerful 'sleepers' in high places and they will assist you in joining them. Did you know that among the ancient Egyptians poverty was regarded as a disease?'

(No, I thought, it is old age that is the disease. How can Felton bear to be himself, flabby and falling apart? However, I said nothing and he, unaware of what I was thinking, continued talking. Whatever occult powers the learned Doctor may possess, telepathy does not appear to be among them.)

'Our Prime Minister may bleat about the "classless society". The reality is that the future lies with a new aristocracy of the spirit, whose members shall be drawn exclusively from those who find honour in serving the purposes of the Great Work. To know, to will and to be silent.'

'Oh yeah! Who gets to decide who is in this new aristocracy?'

'We do. There is no need to be bashful about it.'

'Will Mr Cosmic be one of the new Lords of the Spirit then?'

'Mr Cosmic? Oh you mean David Hargreaves. Well, he is a bright young man, but he has no culture. You disagree?'

'I definitely do. He has got rock culture.'

Felton was impatient with this.

'Oh yes, yes. Perhaps rock is a culture in some hideous sociological sense – or, no, what's that horrible new word? A 'subculture', a 'subculture' of the lazy, the unwashed, the inarticulate and the deafened. Yes, certainly a 'subculture', for doubtless it has its own traditions, ceremonies, high priests, relics, ritual sacrifices even. However, in a serious sense, the pabulum provided by the popular-music industry is a betrayal of three millennia of *Hochkultur* – of Homer, Virgil, Dante, Paracelsus, Goethe. To switch on a television set is to gain a glimpse of moral chaos.'

Now, of course, I wanted to argue with all this fat-headed, right-wing rhetoric. My experience of switching on a telly is that one usually then finds oneself dopily watching some old codgers playing a quiz game called *What's My Line*, or a handful of teeny-boppers listlessly bobbing up and down on a programme called *Ready, Steady, Go*. No glimpse into moral chaos then. I wish it was. However, the topic of cultural politics was dropped for the rest of the evening.

Felton said that he had come to the conclusion that Cosmic probably did take baths, but he then caked the dirt on afterwards. Then, having observed that the Lodge did have plans for Cosmic, though not of the same sort as it had for me, Felton started to teach me about the pacing of a glass of claret and precisely how long it took to flare into the full grandeur of its taste. Allegedly, the experience is like listening to music. Then he turned abruptly to questioning me about my research. The intensity of his interrogation was most curious. The wine was forgotten – well not exactly forgotten, but he was drinking it rather than sipping it as he cross-questioned me about my observation of the children in the playground. Although I tried to explain about ritual conceived of as a formal action which is primarily symbolic, he was not interested in any of that sort of 'bogus academic jargon'. He wanted to know what the playground looked like? How many children

were there in it? How old were they? Could I describe some of the individual children? Did I know any of their names? Were they all taken home by their parents? I did my best to answer, but I was and am uneasy. There are two ugly possibilities – but, no, I think some things are best left unwritten. After a while, his interest in the children subsided and, I, not seeing why I should always be on the receiving end, started to cross-question him. I did not get much for my pains.

I wanted to know if Felton really thought what astrological sign I was born under was significant? Why was it so important for him to read my diaries? What was the Black Book Lodge set up for? What was its Work? Why had Felton stayed with the Lodge and what had he got out of it? What was his relation to the Master? Was it true that Felton was born in Alexandria? What was the Cairo Working? What if anything happened between Felton and Crowley?

It was no use. Felton was like one of those politicians who, instead of answering the question he has been asked, prefers to answer his own questions.

The Work is something one only fully comes to understand as one advances on the Path. The truth about the Cairo Working was buried within myself and I should recognise it when I was ready for it. Magical knowledge is like that. It is extremely difficult to say how many people are affiliated to the Lodge, since there were so many different degrees of belonging. Nor could one pin down a firm foundation date for the Lodge, as it evolved out of and gradually broke away from the Ordo Templi Orientis. Felton had continued to visit Crowley after the Lodge's breakaway, but, in his last years, Crowley's powers were fading. There always were problems with his sex-magic techniques, but, in the end, 'the trouble with Crowley is that he went to a minor public school.'

Really! That is precisely my impression of Felton – that he went to a minor public school. Unlike Granville, for example. Granville is a Harrovian – and he keeps letting you know it. I know that Laura went to one of those experimental private schools where children are encouraged to run wild. Agatha gives the impression that she received a university education,

though by now it is overlaid with all sorts of dottiness. As for the Master, he stands outside the British class system. According to Mr Cosmic, the Master was born in Damascus, the son of Christian missionaries, but he was educated in Tibet, at Shamballa, or some such place. Felton, I now learn, got his doctorate in music.

Perhaps it was the effect of the claret. Suddenly Felton was excited, lit up – like a jelly on fire – if that is possible.

'Music can take a man along the Path. Music is the image and the foreshadowing of the harmony that pervades the world and organises its secret hierarchies. The motions of the spheres in the heavens are in conformity to harmony and proportion, so that, though their passage is made in perfect silence, that passage is musical. The Adept who seeks to make his life a work of art will comport himself in conformity with the harmony that is in all things. Even today's debased popular ditties, redolent as they are of vaudeville shows and dance halls, speak of higher truths. As Sir Thomas Browne put it, music "is a Hieroglyphical and shadowed lesson of the whole World".'

I made a mental note to think of this when I next listened to Martha and the Vandelas.

A little later, Granville joined us for sorbets and coffee. I had not known that we were expecting Granville. He had walked over from the Opera House, after a performance of *Idomeneo*. He and Felton started to discuss how my education should be taken in hand, talking about me as if I were not present. I was to attend operas on a regular basis. Also the theatre . . .

At length Felton turned back to me,

'Tomorrow afternoon, if it does not get in the way of your researches, Granville will take you to Savile Row and get you fitted for a dinner jacket.'

'I could also take him to Trumpers and get his hair cut,' volunteered Granville.

'Oh Granville, no! Peter's hair is beautiful. It makes him look like a cavalier – Rupert of the Rhine perhaps. No, I have always loved long hair on men – so delightfully boho!'

Granville, intensely apologetic, turned to me. He feared that he might have hurt my feelings. He was accustomed to regard a visit to Trumpers as a treat. Granville's own hair is not so short. It is thick and curly. Like Cosmic, Granville has a gypsy-ish air about him, but he is an older and cannier gypsy and his movements are smooth and controlled, not Cosmically wild.

Over coffee we argued over music – opera at first, but then, as the conversation drifted, I was astonished to learn that Granville was a fan of the Beach Boys and the Grateful Dead. However, he has no time for British groups, even though some of them patronise his shop. Granville was asking about Sally and why she no longer came to the lectures, when Felton broke in and asked,

'How much have you told Sally about the inner work of the Lodge?'

'Nothing much. But it is not secret, is it?'

'Oh, secrecy is vulgar,' replied Felton. 'We are not school-boys engaged in some surreptitiously illicit activity, such as puffing on the weed behind the cycle shed.'

'Even so, there is such a thing as the discretion which is part of good manners,' added Granville.

And with that, the evening broke up. I could not taste the wine properly because of my cold. However, it occurs to me that my cold, unsensational though it seems, might well be an illness of initiation, like Hans Castorp's TB in *The Magic Mountain* or those strange fevers that shamans get prior to becoming shamans. Being ill may be a kind of *rite de passage* into a new life.

Thursday, May 25

Am I a latent homosexual? If I am a latent one how would I know? It seems to me that I exist only in my face, mouth and a little bit of the top front part of the skull. The rest of me is a complete mystery to me – a dark continent full of exotic horrors.

I returned to studying the children in the playground, but

now it is as if I have become the eyes of Dr Felton. As if he is using me to watch these children. Why is he so interested in them? I do not think that the children like me very much. Every now and again one of them looks up from its play and scowls at me. For sure, it is my gloomy humour this morning, but there now seems to me to be something sinister in the play of these little urchins. It is not play at all, but a series of secret messages, coded in the gyrations of their arms and legs, and directed at the adult world. Their games are deliberate parodies of what adults do – going out to work, marrying and dying. Above all dying. 'Here comes a chopper to chop off your head!' These kids have one message, only one message, and that is that I and my generation will die before they do. The dangerous thing about small children is that they are still close to the void from which they have so recently emerged. They remember what it is like not to have existed.

I left my place on the wall and headed back to my pad. Sally turned up a few minutes later and we headed off to the cinema as arranged, but then we got into an argument. Sally had wanted to see *Elvira Madigan*, but I am not fond of foreign films and I wanted to see *The Devil Rides Out*, which was playing at the Electric in Portobello Road. I won the argument. I wish I had not. I grooved on the film, especially Charles Gray being sleek and unctuous as the Satanist Mocata and the scene where Christopher Lee (playing the Duke de Richelieu) faces out the forces of Evil from within the pentacle, but I could feel Sally sitting beside me hating it. Actually it was not so much the film she hated as my attitude to it. I could see she was in a mood and when we got back to my room I put Donovan on the record player. I was hoping to change the vibes, but I did not have much luck there.

'I think that you see yourself as some sort of trainee Duke de Richelieu,' she said. 'Or what's the name of that hero in the comic books you keep reading?'

'Dr Strange.'

'Dr Strange, that's him. You dream about becoming some high-powered white magician ready to do battle against the forces of evil. Whereas the truth is that, in signing up with the

Black Book Lodge, you are aligning yourself with precisely those forces of evil.'

'You have got to listen to yourself Sally. Your voice is all jagged. You are sounding hysterical. The Lodge has nothing to do with forces of evil.'

'They're everything to do with darkness. Peter, why are you playing with me? They are fucking Satanists. Look at me and tell me that they are not.'

I pulled her close to me and began to fondle her.

'Come off it Sally. The Black Book Lodge people are nothing like the people in the Dennis Wheatley novels. In the Wheatley books, people like Mocata and Canon Copely actually worship the Devil. The Lodge's members, on the other hand, simply believe in developing powers that are innate in man. They – we do not worship anything. There is no commitment of belief, either asked for or given.'

'If you do not believe in it, then you can easily give it up.'

I noticed that her hand was straying up my leg.

'I do not believe in it. I am simply going into it in a spirit of scientific enquiry. I find it interesting from a sociological point of view. One of these days I might even get an article out of it – "Internal Group Dynamics in a North London Lodge of Occultists", or something along those lines.'

'You are not being straight, Peter, with yourself, or with me. No way have you joined the Lodge in a spirit of sociological enquiry or anything like that. I don't know what it is, but you are after something hidden, something not for humans, something you will never find. Show me your palm.'

She was all over me. One of her hands held up my right palm for inspection, while the other was playing over my leg.

'Your palm is changing,' she said. 'It is different from when I last looked at it a few months ago. The life-line is threatened.'

'That's not possible.'

'Oh yeah, it's possible.'

Her hand was playing over my groin. Donovan was singing "Three Kingfishers" to a sitar and tabla accompaniment. I was listening with my eyes closed to the music which seemed

to suggest the rippling of flesh and the infinite play of possibilities in life.

'Isn't what we have enough?' she whispered.

I said nothing, just nodded. I was entering a fantasy about Krishna playing his flute before the gopini milkmaids.

'Let's go to bed.'

She was testing me and it was pleasant to be so tested. It felt like I had a great lump of iron between my legs. I liked to think about surrendering to her desire. But . . .

'I can't. There isn't time. I have got to get ready to go out to the Lodge and be formally robed as a Probationer for Adepthood.'

There was a hiss of 'Bastard!' and she was out of the door so fast that I never even saw her leave. I put Procol Harum's 'A Whiter Shade of Pale' on the record player, sensing that its rich melancholy would be the right accompaniment to my own and I set to writing this all up in the diary.

I arrived early at the Lodge to have my diary picked over by Felton. He started in on me, even before he had looked at the most recent entries.

'Peter, it occurs to me that you may have been thinking that because I am so old, in your eyes at least, therefore I am not best fitted to give you guidance on the Path. Do not be deceived by appearances, for I am still young. In myself, I am no older than I was on a certain day in 1948. True, I do not appear to be as slim as I once was. Well that, I am afraid, is one of the occupational hazards of becoming a sorcerer – in that respect we resemble wrestlers and opera singers.'

Then he handed over a wodge of five-pound notes and lowered his eyes to the diary. There were the usual gripes about syntax and punctuation. I was holding my breath, waiting to see how he would react to my description of him and of the tantric kissing, but as usual he only had eyes for errors in punctuation and syntax. What upset him most though was my use elsewhere of the word "prestigious".

'Yeeugh. I am tempted to give these pages to Boy, if I did not think that they would make him sick. You cannot

possibly mean that the restaurants I was talking about were "prestigious" and I could never have said such a thing. "Prestigious" is the adjective derived from prestidigitation (which means conjuring). "Prestigious" therefore means "fraudulent" or "deceitful". Only the vulgar and ignorant use it in the sense of distinguished or famous. "Prestigious" is part of the threadbare vocabulary of approbation favoured by used-car salesmen, remittance-men and the vendors of snake oil. Such people are lavish with the use of such adjectives as "sumptuous", "generous" and "discerning". What was in your head, Peter, when you used this word?'

Actually I was trying to hold back my laughter. I had deliberately used that word because I guessed that it would wind him up. I was desperately wishing that I had put in more stuff like that and I kept asking him questions about the hyphenation and the semicolon in the hope of delaying the inevitable horror of a second lesson on kissing. To no avail . . . After a while even he became bored with the semicolon and, rising from his chair, he motioned that I should rise and come to him. But, I made no move towards him. Instead,

'Dr Felton, do you think that I am a homosexual?'

For only the second time in our acquaintance, I had succeeded in surprising him. He was silent for a while, trying to decide, I guess, how much he could tell me. In the end, he settled for very little.

'How can you be? It is clear from your diary that our last kissing session filled you with revulsion. Besides, for the future purposes of the Lodge it is essential that you be a heterosexual.'

There was a cruel smile on his face as he beckoned to me once more. Then we closed for a kiss . . . and another and another. I kept trying to make it OK by telling myself that Felton was just a projection of my mind. This time there was less work on the breathing more stress on the exchange of saliva. Felton was explaining some of the weird magical uses that saliva can be put to. Human saliva is really very like snake venom. They share a lot of the same enzymes. Saliva is one of

57

the most precious substances in the Filthy Dispensary of the Hermetic Temple.

I thought the session would be over when we finished the kissing lesson, but no. He then turned to my account of Sally in the diary.

'I wonder if you quite realise how she emerges in these pages. As I read in your little book, she is a dim-wit who believes in fairy tales about the return of King Arthur. She is a slut who sleeps around. She is a manipulator who tries to use her body to win you round to what she wants.'

'That's not true. You do not know her.'

'You are right that I have never met the lady in question. However, it is not I who accuses her, but you do in your diary. You have been telling me that she is not good enough for you.'

'You are telling me to get rid of her?'

'You are telling yourself that.'

'But she's my girlfriend!'

'The Lodge will find you another.'

'You cannot seriously expect me to give up my girlfriend for two hundred pounds a week! You just can't buy people like that!'

I was actually wondering if he would up the offer. And I was wondering if I would be happy to give Sally up for, say, a thousand pounds a week. After all, I could give her some of the money – pay her a sort of rent for not being my girlfriend, just like US farmers sometimes get paid by their government not to grow alfalfa.

But Felton insisted that the money was only for the inspection of my diary. That was our pact. He would not dream of bribing me to give up anyone or anything. That would be pointless, for I had to learn to discipline myself. Unless I renounced Sally, I would be unable to take a single further step along the path. How could I achieve Adepthood, unless I died to my desires? And so on and so on.

But I was impatient,

'Yes, but why all the mystery? What exactly is the Path? What would I be if I became an Adept? All you ever offer are dark hints. Why not spell out exactly what are the gains and

losses of following the path of the sorcerer? What will I gain when I give up Sally?'

Felton could not suppress a quick thin smile when he heard the words 'will' and 'when'.

'If the reward of the Adept could be put into words, it would not be worth having, would it? All I can tell you is that the person you will become – if you follow the Path – will be a person who will not be able to understand your present self with your humdrum, limited and conventional desires. Still less can your present self understand the man of power you are going to become.'

I was not really convinced, but it was close to the time for the robing, so I bowed my head and rose to leave. But he called me back.

'Oh yes, Peter. There is one thing. You have misspelt the name of the popular music group on the last page. Procol Harum should be Procul Harum meaning 'Far from These Things'.

'No. They spell it with an o.'

Felton groaned. I was humming to myself as I walked out of the door. 'We skipped the light fandango, turned cartwheels across the floor.'

> *'A mouth that has no moisture and no breath*
> *Breathless mouths may summon;*
> *I hail the superman;*
> *I call it death-in-life and life-in-death.'*

This last is not Procol Harum. That was Mr Cosmic quoting Laura, quoting Yeats. Cosmic has a truly amazing memory. It allows him to connect anything he hears with anything else he has ever learnt. So that he carries around in his head this vast cosmological encyclopedia constructed around energy waves, ley lines, chakras, Sephirotic trees and mandalic maps. He had just come out of another of Laura's lessons on strange kissing and, while we waited to be robed, we chatted. Cosmic was beginning to get worried about the direction Laura's teaching was taking them.

'It's like the living man lies down with the dead woman and kisses her, but when their union is over, it is not always the man who rises and walks away. According to the seventeenth-century neoplatonist Thomas Vaughan's *Magica Academica*, "It is written of Jacob that he was asleep, but this is a mystical speech for it signifies death, namely that death which the Kabbalists call *Mors Osculi* or the Death of the Kiss, of which I must not speak one syllable." Also there is something horrible called the Obscene Kiss which the Knights Templar used to be keen on. Laura says she is looking forward to being on the receiving end of this extreme form of occult kissing. I don't like it man. It's very heavy.'

I do not care for the prospect myself. I am not admitting to Cosmic that I am getting instruction in lethal kissing too, as that might get back to Sally. At least Cosmic has Laura whom he claims to find really cuddly. But he was saying that he had a big problem with his penis. I was all agog to hear what this could be, when we were interrupted by Ron. Ron is such a moany drip that we have as little as possible to do with him. One of his problems is that he speaks so slowly that it seems somehow insulting – his cool assumption that we have all the time in the world to listen to his drip-by-drip monotonous rubbish. This evening he was saying that he had had it with the Lodge and he was going to drop out from the apprentice-ship and that we should do the same. He thought he might be able to make some money in the process by selling the story of what went on here to the papers. As politely as possible we told him to get lost. Then we returned to Cosmic's big problem which turned out to be that he is panicking that his penis is actually shrinking, because he has contracted some oriental disease called koro. He keeps checking it with the little ruler he has in his pocket. At this rate he will even have to resign from his position as Founding President of the League of Men with Small Penises. I suggested that he attach a clothes-peg to his foreskin to stop the penis vanishing altogether.

We were still discussing the problem when we were summoned to the threshold of the Chamber of Rituals.

One by one we were summoned into the Chamber. I was

the first to be so summoned. I rapped five times on the door as instructed. The thirty or so cowled brothers and sisters saluted me,

'Do What Thou Wilt Shall be the Whole of the Law. Love is the Law, Love under the Will.'

The Master, who was acting as Lord of the West, struck the floor with the butt of his lance. He told me to strip. The Master was flanked by Felton, who, as Deacon, was robed in white and yellow and carried the book. On the other side of the Master, a woman in white, blue and gold carried the sword of the Priestess. Other figures carried candles or swung thuribles. For a moment I thought that I was succumbing to an attack of *déjà vu*, but then I remembered that there was a scene a bit like this in the film which Sally and I had seen only a few days ago. The ritual of the Black Book Lodge is certainly theatrical, but it is theatre with a serious purpose.

It is rare for the Master to participate in the rituals. (Incidentally, it is not true that obesity is an occupational hazard on the Path, for the Master is tall and quite thin. Lean, keen-eyed and bearded, he looks as though he might have returned from months wandering around in the Gobi Desert.) Even more remarkable than the Master's presence was the fretted-wood screen which had been erected at the far end of the Chamber behind the Statue of Isis. I think that there may have been another cowled figure behind that screen, but that may just have been my fantasy.

Once I had stripped myself, Granville, I think that it was Granville, conducted me from point to point along the Tree of Sephiroth painted on the floor of the Chamber, until I came before the Master. He formally questioned me about my worthiness to be admitted to the Lodge – the whole thing being a ceremonial re-affirmation of the commitment which I had made to him a couple of weeks previously. (It reminded me of Dennis Wheatley, but it also reminded me of the Oxford degree ceremony.) I was questioned about the Nine Barbarous Names which I had been given to memorise. Then I was reminded that death is the penalty for the man or woman who enters the Lodge for impious purposes. Death is

also the penalty for anyone who profanes a chamber which has been purified. Death is the penalty for anyone who seeks to invoke Choronzon or engage in intercourse with the larvae without the permission of the Master. Lastly, death is the penalty imposed on anyone who seeks to leave the Lodge. (We are not talking about literal death, of course. We are dealing with a metaphor here. One merely dies a little inside, if one transgresses the rules of the Lodge.) Finally, I knelt to kiss the Master's hand once more and he pronounced my new name. A little bell rang and two zelators dressed me in a black robe bound with a white cord. My new name is 'Non Omnis Moriar'.

One by one the others, headed by Cosmic entered and were formally inducted into the Lodge. They were all very nervous and they trembled as they did when they spoke with the Master. Alice in particular was in agonies about having to appear naked before us all. Ron took part in the ritual, even though he had told us that he was getting out of the Lodge. Cosmic's penis, though small, was not so very terrible. He received the name 'Vigilante', which means 'Be Watchful'. The whole thing did not take very long and was concluded by the Master declaiming the hymn which begins,

> *'Thrill with lissom lust of the light,*
> *O Man! My Man!*
> *Come careering out of the night*
> *Of Pan! Io Pan!'*

The hymn concluded, most of those assembled departed, but we apprentices were left with the woman who had served the Master as Priestess in the Ritual, Sister Dolorosa Mundi to us, but Maxine to those outside the doors of the Lodge. She set us to meditating on a row of consecrated mirrors. With her hands on her hips, Maxine walked up and down in front of the mirrors. She has a strong South London accent,

'We are consecrating this exercise to Indira. According to Hindu lore, a mirror is Indira's Net. In this exercise you must seek to see yourself as you really are, without preconceptions.

And at the same time you must seek to see the reflection as it really is.'

We squatted cross-legged in the easy *asana* position with the cowls of our hoods thrown back and gazed into our private mirrors. As I began to gaze, I started to meditate upon myself, my reflection and the nature of reflection. Or no, that is what I thought that I was doing, but in reality my head was crowded with distracting notions – like: How long is this meditation scheduled to last? What would I look like to another person squatting in front of the same mirror? Do I like my new name? What is that faint creaking and clanking noise above me? Is 'yes' a noun? Should I not have eaten before coming on to the Lodge? How long has my mother got to live? If the image in the mirror inverts my face in a left-right way, should it not also show me upside down? And Felton. I wish I did not find myself thinking about him so often. When I think back on what is in these diary pages, he seems to be taking over my life.

At least I am not falling into the temptation of thinking of Sally's slinky body, I thought, and then I realised that, in thinking that, her slinky body was precisely what I was thinking about. So there was a second level of distraction, when I recognised these distractions for what they were, temptations, or in Hindu parlance *sidhis*. How should I get rid of these distractions? I must not think these thoughts – and I must not think that thought either. But perhaps the point is not to try to get rid of these thoughts, but calmly to recognise them for what they are.

Ten or twenty minutes ago, standing about with my fellow probationers, I had felt like a normal person, but no sooner had I been instructed to sit down and meditate than I become a latter-day St Anthony, assailed by all sorts of fantastic and horrible thoughts. The mirror vanished in front of my face, as I kept thinking of Sally's thighs and, as I kept thinking about those thighs, I realised that I was always like this and that I thought about sex many times an hour, every hour, every day. It is nothing to do with meditation, except that the meditation makes me more aware of it. I cannot look at a young

woman without thinking about sex. It is how I am and one of the many things that this diary has hitherto concealed.

The grim face in the mirror, dissatisfied with the small amount of attention that I was paying it, looked back at me. I struggled to keep that face in focus, so grim, so pure, so young, so unmarked, so perfectly designed as a mask to conceal the thoughts which raged within the skull behind the face. A mirror is a thing in which one sees everything except oneself. This thought seemed already familiar. Then I realised that I was paraphrasing Felton's remark about the diary. It is never going to be possible for me to see myself. We all share Dracula's fate, invisible in the mirror.

Beside me, Alice had freaked out completely and was crying silently in front of her mirror. Another distraction. I sat on and meditated in the midst of rioting phantoms of death and desire. I shall never see my face, for my face is not where I think it is. My face exists only in the eyes of others. My face is something which Sally sees. At the end of the exercise, we rose pale and stiff and performed the ritual of minor banishment over the mirrors. The whole thing had lasted only an hour and a half, but an hour and a half is a very long time in the Looking-Glass World.

I was feeling pretty serious as we left the Chamber of Rituals and in that serious frame of mind I turned to Alice,

'You have got me wrong, you know. I'm really serious about all this.'

The reason I said this was because I had got the impression that she did not like me. Now, in a sense, this was fair enough, as I did not like her either, but, setting all that aside, it really upset me that there was actually someone in the world who did not like me. Surely, if she got to know me, then she would like me?

Alice just shrugged. So I felt that I had to stumble on,

'I mean, when I invited you to have a drink, it was not like I meant we should have a good time and get drunk or anything. I really meant that I wanted to talk seriously about what is going on here and what is the purpose of it all.'

But Alice replied,

'In that case you should have said what you meant. People spend far too much time saying things they do not mean and being polite.'

And with that, she hurried on ahead. So I still have no idea why she does not like me.

I returned home in a very sober frame of mind and set to writing this all up in the diary. The image I had looked at in the mirror had no soul. Therefore it looks like me when I am dead. Therefore I had spent the evening contemplating my corpse and had not even known I was doing so.

Friday, May 26

Having slept fitfully, I awoke with a tune playing silently in my head. It was hours before I could place it and the group. It was driving me mad, but just before leaving the house I got it. It was 'Mirror' by Spooky Tooth and at last I heard the lyric, which was about some guy who when he looks into the mirror, finds that the Devil is smiling twice. I have noticed this before, that one is walking along, humming a tune and not even aware that one is humming a tune. Then if you stop to notice that there is a tune in your head and you think hard about it, there always is a reason for the particular tune that is playing. Always. If I am on my way to see Sally, then Jeff Beck's 'High-Ho Silver Lining' might be put on the silent turntable in the skull. But, if I am worrying about my parents, then the ghostly juke-box may be playing the Stones' 'Have You Seen Your Mother Baby?' And so on. Wherever I walk, I am accompanied and commented on by a melody.

As I made my way to St Joseph's and without my noticing it when it happened, the Spooky Tooth music was replaced in my head by Jefferson Airplane's 'White Rabbit' and I hear without quite hearing its rhythm building to its hallucino-genic crescendo. I am on a crazy high. It has come upon me from nowhere. I am on a fantasy riff. If only all the people in the street around me, these grey little people inhabiting their grey little lives, realised that an initiated sorcerer was striding

down the same street! If only they were aware of the unseen occult energies which fill the same space as the dust, winds and car fumes! If only they realised that London is one of the chosen battlefields in the unseen warfare that has been going on for centuries! A fantasy riff is what it is. It's a Blues thing basically. I continue to play around with this same image – the sorcerer passing undetected through the drab London landscape again and again.

I spend the morning making sociological notes about the children in the playground. If this diary accurately reflected how I spent my time, then it would be full of summaries of note-taking and thesis ideas. But I cannot be bothered with it all. It is too technical and very boring for the layman. So boring – like me describing how it was for me every time that I went to the lavatory.

This morning a little gang of children came over to me to ask me what I am doing. I try to explain in very simplified terms. Then a little later, they come over again wanting to know if they are playing properly. The drive to conformity of small children is pretty weird. It blows my mind. It really blows my mind. *What blows my mind? It is a dark wind from the North, a solemn wind, which has spent centuries blowing across the steppelands without encountering anything that can stand against it. It is this wind which strips my thoughts from me, like leaves from a winter tree, leaving the ultimate structures of thought exposed, as in those old medical textbooks in which one may contemplate, with fear and dreadful resolution nevertheless, the flayed heads of men who have been tortured or treated by doctors. My poor scattered thoughts are driven in sudden and arbitrary gusts across a dark, sunless sea – a sea whose rolling waves stretch on and on forever, without finding a shore to break upon. I would weep tears of gratitude, if only I might recollect those scattered thoughts which float so precariously over the dark green waves. I conceive that the height of pleasure might lie in the quiet and patient reconstruction of my blown mind, working within the sutures of the skull to reassemble its spiralling bifurcations and cross-loops and trompe l'oeil perspectives. Yet this pleasure is beyond all possibility. The wind can blow the leaves off a tree, but, twist and turn how it may, it cannot blow them back on again. Nor is the*

formation of a cloud to be reversed. Oh, who will deliver me from this body of death? Then there are the children at play in front of the mind that is blown, the skull whose sockets are filled with the eyes of Dr Felton. In those eyes, how delectable the flesh of very young children is, how cherishable. One would not wish them any real harm, only to offer them a taste of pleasures they can never have heard of . . .

I read what I have just written and I scratch my head. It is not me. It is not what I think, or how I think. I hate long sentences. I lunched at the Mangrove for a change. Then I went back to my pad and packed for the weekend. I am taking the rest of the day off from research, as I have a meeting with Granville. He takes me to a nice place in Savile Row. The walls are oak-panelled and the assistants are in pin-striped suits. Being fitted for a dinner jacket turned out to be a fantastically elaborate business. The main man, a Mr Simmons, kept tutting and clucking about how slender I was. It was like dressing a wraith, he said. He stretched the tape measure every conceivable way across my body.

'Why he is so thin that he hardly casts a shadow!' he cried out.

And then a little later, just when I thought he had finished, he whispered in my ear,

'And which way does sir hang?'

And I see the gibbet at the bottom of a wooded valley, and the grey clouds scudding above and, coming closer, the structure of iron hoops and chains which encloses the corpse of Peter . . . poor Peter . . . '

But Granville interrupted,

'He means which way do your testicles swing, you muffin-head!'

I had never given this question a moment's thought and therefore I now had to put my hand inside my jeans for a feel and then to confirm the matter by marching around the shop with my hand continuing to monitor the hang of my balls. Granville was convulsed.

The whole business lasted almost two hours. Granville paid, or rather he put it on the Lodge's account. I hurried on to Liverpool Station and waited for the next train to Cambridge.

I have now, once again, embarked for a destination which I never wish to arrive at. I would rather just sit here in the railway carriage, scribbling and forever travelling without arriving.

Having finished bringing my diary up to date, I carried on my reading of *Eros and Civilization* by Frankfurt philosopher, Herbert Marcuse. But my reading was interrupted by a tiresome old man who sat next to me. He tapped me on the shoulder,

'Young man, young man, you don't want to be reading that young man. It is about sex, isn't it? Excuse me, but you don't find sex in books. It's a girl you want. They're the best teachers and a book is a poor substitute for a girl.'

I could not think of anything to say to him. I could have told him that I had a girlfriend, but he never would have believed me. It was obvious that, for this old codger, my interest in neo-Hegelian philosophy was a pathetic sublimation of the sex-drive. So I just sat there red-faced, while he carried on,

'I used to read books,' the old man announced in a loud voice for the whole carriage to hear. 'But then I met my Nancy and I stopped. I had no need you see . . .'

Only slowly and by degrees did he fall into silence.

Getting out of the train at Cambridge, it occurred to me to wonder if I might not now be beyond the range of the psychic forces of the Lodge. Certainly I sensed nothing as I walked towards my parents' house. Dad let me in. Mum was in the living room watching television. Her hair . . .

I do not want to write about this. I do not have to. It is none of my diary's business – nor the Lodge's. Enough. I am writing this in my old room. Although I have spent quite a lot of time here on and off since going to university, the room still looks as though it was suddenly abandoned in 1964 – the dinosaur posters on the wall, the cycling magazines, the Buddy Holly and Connie Francis records. Although the old records are still here, my record player travelled with me to London. This is a house without music. (It feels like a machine for dying in.) Mum and Dad have 'no time' for music. That is how they put it. Instead, they watch television with the

volume turned down low. And recently, since Mum has become too tired to hold a book for any length of time, Dad reads to her. Currently it is *Of Human Bondage* by Somerset Maugham. I understand without anything actually being said that, while I am here, I should attend these sessions and, as I listen to Dad's low-voiced mumbling rendition of Philip Carey's ill-fated passion for the waitress, Mildred, it seems to me that these readings have taken on the nature of a prayer meeting.

But now, as I write, the house is quiet. It is a new house and everything here is white and silent. By contrast, the Black Book Lodge is all creaking staircases, dark corners and heavy drapes. Just inside the door of the Lodge a sculpted black-amoor holds a silver tray for the reception of visiting cards and a stuffed tiger glazedly looks down on the doorway from the top of the great staircase.

According to *The Function of the Orgasm* by Wilhelm Reich, cancer is the product of passion repressed. That is what Mr Cosmic told me anyway – I have not read the book. Cosmic says that Reich was murdered by the FBI (just as they dealt with Buddy Holly). The FBI wanted to suppress Reich's orgone box. According to Cosmic, cancer is a judgement on a life that has failed. It is a sort of punishment for not living in accordance with the natural harmony. Cosmic is always smiling when he talks about things like natural harmony and part of me always thinks that what he is saying is absolutely ludicrous. Suppose that Mum had spent the last few years going round the houses and passionately offering herself to every man who fancied her, would she now be in harmony with the world? Would she be plump and apple-cheeked? Would she be constantly inventing excuses ('I'm just off to borrow a cup of sugar', 'I'm just taking the dog for a walk', 'I'm popping round to the shops now') in order to conceal her life-enhancing fucks with the neighbours. On the other hand, there is part of me which believes Cosmic. Certainly cancer is very mysterious. I have the superstitious feeling that one can contract cancer just by thinking about it – or writing about it. Enough.

Saturday, May 27

Over breakfast they quiz me. They worry about me. They worry about my long hair – or rather what the neighbours will say about it. They worry about Sally. They are sure that she is unsuitable and a bad influence and that I spend too much time with her. Inconsistently, they also worry that I may be lonely. Am I taking drugs? Am I eating enough? What about my studies? From Dad's perspective, that of a research chemist, sociology is not a real science. I try to soothe them and bore them into silence. If they ever found out that I was in an organisation like the Black Book Lodge it would freak them out totally.

This business about Sally being a bad influence is a bit unfortunate. Last year she came up to Cambridge to stay a couple of nights (separate bedrooms of course). At first things went OK. Although Sally had her period, there is a glow about her at such times and she claims that my big problem is that I, like most men, have menstruation-envy. Anyway on the Saturday my parents announced that they were going to be out for most of the day, so Sally and I decided to trip. Sally had been getting me to read some of her Arthurian stuff, so the trip we shared was confusedly centred round the Grail Mysteries. Sally was the Moon Priestess of the Grail Castle which was located in the midst of the Wasteland, desolate under an enigmatic curse. I was the questing knight who, having penetrated the Castle, saw a procession of dancing youths and maidens (bearing a remarkable resemblance to Pan's People) and this dance troupe whirled and jived around a lance which dripped blood and behind the bloody lance came the chalice of the Grail which was overflowing with blood. In order for the Wasteland to be renewed, the question had to be asked, 'The cup that bleeds, what is it for?' To attain Gnosis I had to become the 'red man' of the alchemists. Stuff like that. All well and good. Except that Sally and I were not then as used to LSD as we are now and we had slightly underestimated the

70

length of time our trips would take. By the time my parents returned we were coming down all right, but we still were not one hundred percent straight. This meant that I had not removed all the blood from my face. Also I was talking very slowly and carefully, as I was checking myself all the time in case I let something psychedelically mad out. Ever since then Sally was marked down as a bad influence. Things were not helped by my parent's mistaking a joss-stick for hashish.

Grail Mysteries Day in Cambridge just does not bear thinking about – any more than does the bloody day Cosmic came round to my pad with a bottle of whisky and a hand-drill. I do not like whisky, but Cosmic made me drink more than half the bottle before he explained what he had in mind. He had just met a Tibetan Buddhist monk in Gandalf's Garden and this monk had explained to him, how one could enjoy a perpetual mystic high if only one had the resolution to let oneself be trepanned. Cosmic wanted me to drill a hole in the side of his head. If it all turned out to be as wonderful as the monk said it was, then he would do the same for me. Cosmic removed my glass of whisky and put the drill in my hand. The thing had a spike which I was to thrust resolutely into the side of his skull. The spike would hold the drill steady in the bone while a circle of saw-teeth went round and round until they had cut a neat little ring in the skull. This ring of bone I should be able to prise out with a penknife. Then oxygen would rush into Cosmic's brain and give him a perpetual high. Fine. So I had another whisky while Cosmic stretched himself out on the floor. I offered to hoover, so that the place might be a bit closer to operating-theatre standards of cleanliness, but Cosmic was in a hurry to be high. I plunged the spike down onto his skull. First time round I could not bring myself to stab down hard enough. So I had another go and this time the spike went in a tiny bit and I started to turn the hand-drill. Blood was spurting out all over the place and Cosmic was whimpering a bit when I fainted and the whole thing had to be abandoned. Not a memory to dwell on.

Having written the above, I put my biro down and, closing my eyes, I concentrated on counting backwards from 1,000, in

case any other gruesome memories were queuing up to be recalled.

Enough of these unpleasant digressions. I escaped my parents as soon as I could and, on the pretext of looking for some sociology textbooks, I walked into town. Just as I was about to enter Heffers Bookshop, I belatedly noticed the tune which had been playing in my head. It was 'Strange Brew' by the Cream – 'Strange brew killing what's inside of you'. I shook my head to clear it of this sinister music. On the way back to the house, I collected a shopping list's worth of food and, as I paid for the food, I noticed that the tune was still with me, like a familiar dogging my steps. As I envisage it, such fragmentary silent tunes and lyrics inhabit the ether, like larvae from the world of the dead. They want to communicate, but they are not all there and they are not quite sure what it is that they want to communicate.

In the afternoon Dad went off to a football match. He never used to be so keen. He must have been desperate to get out of the house. I am left alone with Mum. She obviously wanted to resume her interrogation about my unsuitable life in London. But this deathly interrogation was interrupted by the phone ringing.

Sally and I are a number once more! She was ringing to make things up. The telephone was in the living room where Mum was sitting, so all Sally's tenderness and passionate remorse had to be met by calculatedly downbeat, monosyllabic responses from me. Fortunately she swiftly twigged. We have agreed to meet on Monday. Sally says that she is, after all, prepared to share me with the Lodge.

'I suppose it's part of you and I love all of you.'

Then I am alone with my mother. The sickness and the treatment, working together, have turned her into a witch with straggling locks and cadaverous cheeks. Every time she opens her mouth to speak there is an exhalation of foul air. Surely I am too young to have a dying parent? I paced about the room filled with a mad anger at Mum's weakness. Soon after I first met him, Felton showed me a passage in a book by the seventeenth-century divine, Joseph Glanvill: **'And the**

will therein lieth, which dieth not. Who knoweth the mysteries of the will, with its vigour? For God is but a great will pervading all things by nature of its intentness. Man doth not yield himself to the angels, nor unto death, utterly, save only through the weakness of his feeble will.'

At length – God it was long – Dad returned from the football, like a prisoner who has just finished a brief outing on parole. At dinner we talked politics – the LSE sit-in, the Greek colonels' coup, the Vietnam War. We are not really interested in these things, but we have nothing else to talk about. Mum and Dad have no interest in rock music, occultism or sociology. Indeed, they actively dislike these things. There is only one topic which obsesses the three of us and we do not talk about that.

Sunday, May 28

Sunday is like Saturday only more so. It is like as if it is the same day with only the name changed. There was a thick morning fog. It seemed to be prowling round the house looking for a way in. I tried to read Marcuse and all his stuff about civilization's repressive, monogamic supremacy, but I kept thinking about Sally. Perhaps the old man on the train was right after all. Sally rang again today. This time it was to ask if I thought animals had souls. It was her question of the week.

Some of the time passes helping Dad to prepare the dishes that he will serve up later in the week. While I was chopping up vegetables, he asked me if it would be possible for me to transfer my research to Cambridge? I promised to think about it. At last it is time to leave. I kiss Mum tentatively. Why so tentatively? Is cancer indeed infectious? Dad drove me to the station. He was querulous. Did I really have to leave this evening? I really did. I have a supervision on Monday. I promised to return next weekend.

On the train now, writing this, I am gleeful, set free, like a

man who has escaped from a plague-stricken city. Suddenly it occurs to me to wonder if I really can be their son?

Sally met me at Liverpool Street. I stepped off the train into a cloud of soap bubbles. The bubble-blowing kit was a present for me to remind me of the transience of *maya*. She danced ahead of me down the platform, leaving me to follow her train of iridescence. Outside the station, she took my arm and started to question me about my mother. Although she was all sympathy, that sympathy was muddied by various loopy ideas about how the universe works. If I have got it right, Sally believes that my mother has allowed herself to fall under the influence of Cancer, the astrological sign. This sign of the Zodiac is negative and governs the stomach in an adverse way. Cancer and the moon preside over the grave. In order to heal herself, my mother should align herself with a positive fire sign like Leo, wear warm-coloured clothing, eat lots of curries and sunbathe. It is that simple.

Back at my place, she has my jeans off in seconds and is down on me, performing a hum job, so that my penis thrills to the mantric hum of Aum, Aum, Aum. Later, while strains of Hapshash and the Coloured Coat are coming from the record player, she produced another little present. It is a crucifix which I am to wear under my shirt, in order to protect me from the baleful influence of the Black Book Lodge. Once again she asked me to give the Lodge up and once again I replied that I had only signed up with them in the spirit of sociological enquiry.

'So you are writing it all down?' she wanted to know.

'Yeah, I'm a writing a diary.'

'Am I in it?'

I nodded.

'Can I read it?'

I shook my head.

'Why not? What's to hide? We ought to be open with one another you know.'

'It would cramp my style showing it to anyone. I don't want to have the feeling while I'm writing it that there is a reader over my shoulder.'

'Screw that,' she replied. 'Now I'm always going to have the feeling that you are spying on me and writing me down in your reports.'

'Sally, it's not like that. Even I am not allowed to read my diary.' (I am lying.) 'I am saving it all up − bottling it, as it were, saving it up to read in old age. You can read it then too.'

Sally was satisfied with that. Thank God for that. I could not have her discover how its writing is being directed by Dr Felton, nor those frightful kissing lessons, nor what I think about some of her nuttinesses. As for us reading the diary together in old age, the hell with that − old age is another country, inhabited by foreigners speaking a language I can't understand. Also, I do not know why, but I have not told her about all the money I am accumulating. We used to be completely open with one another, but now just the bare fact of having a secret inside me is changing me. It is like I am secretly pregnant.

For a moment, though, I was tempted to show her my notebook. There would have been an adrenalin kick in such a gesture of total honesty − letting her see these pages, to be psychologically as well as physically naked before her . . . it definitely has an erotic buzz.

But then, no, this diary belongs to the Lodge and it is to the Master and those who serve him that I owe the debt of total honesty.

But then, as I continue to think about this, I think that maybe, after all, I will show this notebook to Sally. I like to play with the thought of it. It even gives me an erection. Her reading my diary might destroy our relationship, but, then again, total honesty with one another, might bring us closer together. Love is a risk and I think that I want to take that risk.

Anyway, the diary business was forgotten as we played the usual game with the cucumber before turning the light out.

The day gets off to a bad start. Over breakfast of corn-
flakes lightly laced with soap bubbles, we agree to meet on
Wednesday to see *Elvira Madigan*. It is still early when Sally
leaves my bed and all tippy-toes heads towards the front door.
I roll over in bed, but only moments later I hear a commotion
on the stairs. Melchett has intercepted Sally on the staircase
and is raging at her, calling her a tart. Still pulling on my jeans,
I come out onto the landing in time to see Sally blow the
landlord an ironical kiss as she flits out of the door. He turns
on me,

'OK, you, you piece of hippy vermin with your girly hair
and your jigga-jigga music! It's all up with you! I want you
out, out, out! I'm giving you until the end of next week to be
out of here.'

Strictly he does not have the right to do this, but, as I have
no rent book, I am in no position to resist. There are unpleas-
ant tales about what happened to some who clashed with
landlords in this area.

This morning I have a supervision with Michael. Since the
sit-in drags on, it is in his flat in Camden Town. Although he is
not much older than I am, in academic terms he is a whole
generation older than me – old enough to be suckered into
buying the theoretical constructs of Talcott Parsons. He riffles
frantically through his notes and keeps pushing his spectacles
back on his nose. He is so nervous about my research. But
what's there to worry about? He keeps warning me not to get
emotionally involved with the subjects of my thesis. Only
after I have repeatedly reassured him about this does he relax a
bit and start talking in that jerky way of his about alternative
modelling systems and the four paradigms of Parsonian
modelling of groups: values, norms, collectivities and roles.

Then he starts to fret that I may not be classifying my data
effectively. He shows me what he calls his 'data base', all stored
in racks of file-card trays, cards with holes through which long

wires can be passed. It is, he explains, the new information technology. Everyone, not just the universities, but big businesses also will be using them.

'In twenty years time or so every major institution will be using this sort of information retrieval system! Punched cards are the shape of the future!'

I try to tell him about my lodgings problem, but he is not interested. If a problem is not an intellectual problem, then it is not a problem.

I have lunch in Senate House and spend the afternoon working in its library. The place is built like a mausoleum and I have fantasies of myself as a library-wraith hiding forever in its stacks and subsisting on sandwiches and chocolate biscuits stolen from librarians. It could be the solution to my accommodation problem. Another fantasy: somewhere in this library is the book of power, the key to all knowledge.

By evening, I have had more than enough of sociology, so, before finally crashing, I start reading Dennis Wheatley's *The Haunting of Toby Jugg*. It has an ominous epigraph:

'Should any of my readers incline to a serious study of the subject, and thus come into contact with a man or woman of Power, I feel that it is only right to urge them, most strongly, to refrain from being drawn into the practice of the Secret Art in any way. My own observations have led me to an absolute conviction that to do so would bring them into dangers of a very real concrete nature.'

What a wonderful come-on . . .

Tuesday, May 30

I spent part of the morning on my accustomed spot on the wall of the playground, meditating on Talcott Parsons for the under-10s, but really I was too worried about where I was to live next to concentrate. So I spent the rest of the morning trudging around the Goldhawk Road area looking for to-let signs in newsagents' windows. There were places, but I was

feeling too idle to go and check them out. Since I was feeling flush, I went to Oxford Street and the HMV shop where I bought the Beatles' single of 'Strawberry Fields' and 'Penny Lane', plus LPs of Pink Floyd's 'Piper at the Gates of Dawn' and the Stones' 'Between the Buttons'. I would have bought more, if it were not such a bad time for new music.

I buy music to match my mood and tell myself who I am each week. Thus my record collection, from Connie Francis onwards, is an archive of emotional development, a storehouse of past loves and depressions preserved, as if in jam jars. More emotional preserves are being added all the time. Twenty years from now, I shall play 'Strawberry Fields' and it will all come flooding back to me – Sally blowing that kiss at Melchett, me standing on a corner of Goldhawk Road on a sunny day, the Work of the Lodge still a dark mystery which I had yet to understand.

I arrived at the Lodge a bit late and I had the records with me as I entered Felton's study. He insisted on examining my purchases. He turned the LPs over with distaste. But when he saw the photograph of the Stones he was transfixed. For fully ten minutes he sat rocking to and fro as he contemplated their image.

'Natural barbarians . . . those faces . . . that simian vigour . . . and a touch of the reptilian too. Remarkable, really remarkable. No brains of course, just latent energy . . .'

I pointed out that Jagger had been to the L.S.E., but this weighed nothing with Felton. As far as he was concerned, he was contemplating beautiful animals. He reluctantly passed the record back and turned his attention to my diary. I interrupted his reading to ask what my name meant. He sighed heavily,

'A gentleman is a man who knows Latin. *Non Omnis Moriar* means "I shall not entirely die".'

I am pleased with my new name, I think. He studied the diary. Then, after a few pages,

' "Sally and I are a number again!" he quoted derisively back to me. 'Setting aside again the ghastly colloquialism of "a number" – by which presumably you mean that she is once

more your mistress – the use of the exclamation mark in such a context is hideously vulgar. You are making a statement of fact, and facts need no such punctuational garnish. You may well be excited by being "a number" once more with your young floozie, but you should not expect to convey any of this feeling of yours merely by scattering exclamation marks over your prose like fairy dust. I thought that I had told you to get rid of her.'

'Well, not in so many words.'

'In just so many words I am now telling you to get rid of her. Your oath to the Master commits you to obey me also. When do you next see her? Wednesday . . . that is tomorrow is it not? I do not care whether you tell her before or after entering the cinema, but you will tell her. How you make the break and how you explain it is entirely up to you, but you are not to involve the Lodge in your explanation. Once you have sent her away, we shall take steps to find a replacement for her.'

'What gives you the right to give me such orders?'

'You did, Peter. You did. All I am doing is asking you to obey your own will.'

I said nothing and bowed my head.

'Do cheer up,' he said. 'I have arranged a treat for you. I am taking you off to a country-house this weekend. You will enjoy yourself.'

'But I promised my father that I would go home this weekend and look after my mother. She is very ill.'

'Your oath takes precedence over your private concerns. For that matter, the healthy and the vigorous take precedence over the sick and the dying.'

'You should not be forcing me to make such a choice.'

'There is no choice. Tomorrow you will ring your father and tell him . . . let's see . . . that you have a "work crisis" and consequently that you will be unable to go up to Cambridge this weekend.'

'I cannot do that.'

Felton does not trouble to reply. He continues to leaf through my diary, looking ostentatiously bored as he does so. Sally's second little gift to me gives him pause.

'This crucifix she gave you, are you wearing it?'

I shook my head.

Felton smiled,

'There is no need to be ashamed of such an emblem. Jesus ranks with Apollonius of Tyana as one of the greatest sorcerers of late antiquity.'

And he returned to correcting my punctuation. Only when he reached the part about Melchett and my expulsion from my digs did he become animated – weirdly so, like electrified jelly.

'Fate has taken a hand,' Felton cried. (I refrain from vulgarising his cry with an exclamation mark.) 'Your accommodation crisis is solved. You can live here in the Lodge. A room will be found somewhere on the second floor. You can live there rent free in exchange for performing certain services around and about the place. It will fall out very well, for this will assist you in your speedy progress along the Path.'

'I will have to think about it.'

'You will find that obedience serves you better than thought. Get your things ready and packed. I will make arrangements for you to be moved out of your place on Friday.'

I had told Felton that I would think about it. This was not really true. I had already had an instantaneous think about it and I knew that Horapollo House was not where it was at. All this psycho-esoteric bullying was making me seriously uptight. I thought that I would attend this evening's pathworking – that would cost me nothing – and then split for good. I was not going to give up Sally and my family and friends and move in to this gloomy old pile where no sunlight ever entered. Ancient, muttered mysteries were doing nothing for my mind. The more money I took from Felton the more deeply implicated I would be in whatever creepy thing it was that he wanted me to do for him. There was nothing he could do for me. I was sure of that. Thinking all this was like taking a blast from a Vick's Inhaler and my head was now much clearer.

The kissing business was as weird as ever and this time there were ominous hints in Felton's instructions that the mouth is

not the only thing that gets kissed if genuinely powerful dark forces are to be aroused.

This evening it was also Felton who was conducting the pathworking. It is the first time that he has done so since I joined the Lodge. This time it was a controlled imaginative sequence based on a narrative found in the *Westcar Papyrus*, a tale of the Nineteenth Dynasty of the New Kingdom. As usual there is a brief preliminary period of relaxation, during which we lie with eyes closed and we focus on the various parts of our bodies, starting at the extremities, and relax them stage by stage.

Then Felton addresses us,

'You are over Africa. The Africa you look down upon is as it was three thousand years ago. You descend to the great lake which is the source of the Nile. Along the river, not far from its source, you find a boat equipped with both sails and oars. As soon as you step on board, the boat begins to move. Helped by the current and the wind, it is scudding north and its progress is so astonishingly rapid that you barely have time to marvel as the boat sails on past Elephantine, Thebes, and the Singing Statues of Memon, then Dendera. Finally, your boat reaches its destination, the necropolis of Memphis. Stepping ashore you advance purposefully down the long, stone-flagged avenue, flanked by granite obelisks, heading towards the funerary temple which lies in the shadow of the Pyramid of Wenis and . . . '

And Felton continues to narrate in a low monotone, I suppose, but I am no longer conscious of hearing him. I am too far away in old Memphis. I am Setem Khaimwese, a priest of Egypt, and I have come to the necropolis at nightfall in search of the *Book of Thoth*, possession of which will confer knowledge of the language of the winds, as well as allowing one to enchant the earth and one's own sleep. This book, which can even be used after death, belongs to the wizard-prince, Neufer-Ka-Ptah, and he is dead.

I have been studying the tombs of the Great Ones, gathering the clues, and so prepared I have no difficulty in locating the entrance to the wizard's tomb in a store chamber attached

to the funerary temple. The descent is steep and I am very afraid of the Night of Nothing, but the prize is greater yet, for it promises the end of fear. Without my being aware of having passed through a door, I find myself in the funerary chamber of the wizard. I raise my taper over the body of Neufer-Ka-Ptah, who lies on a marble slab with his arms folded. His wife, Ahaura, lies on a slab beside him. Canopic jars, containing the couple's visceral organs, have been placed below their feet. The *Book of Thoth*, recognisable by the image of the ibis-headed god painted upon it, lies on the floor between the slabs. I reach down to pick it up, but, as I do so, the wizard and his wife sit bolt upright.

'Please leave us our book,' says Neufer-Ka-Ptah.

'We who are dead have more need of it than you,' says his wife.

'It would be sacrilege to take it,' he adds.

'I have to take it,' I reply. 'It is what I have come for.' (Dimly I am conscious of other voices beside me, echoing my words.)

'We shall play for it,' says the wizard calmly and his wife places a squared board at the foot of the wizard's slab. I do not want to play, but I must. I play and I lose, but I insist on another game. I lose again. The third game shall be the determinant. However, I lose this one too. No one can win against sorcery. So I shall take the book anyway.

I scoop up the book and I hurry up the steep and narrow passageway. The gibbering of the corpses becomes fainter behind me. By the time I find my way to the Temple precinct of Memphis, it is morning. Baboons look down from the roof of the Temple. A young maiden, Tbubi, approaches and displays her body to me. She invites me to kiss her nipples and this I do. She has been waiting a long time, she says, a very long time, and this body of hers belongs to me and to me only. Unfortunately, there is a condition – and it is a condition that she fears that I cannot fulfil. She turns her back and starts to walk away. I briefly contemplate her waggling hips before following her. What is the condition? She tells me that I must kill my children. My children? She insists and promises that she will give me other children.

'That is why you must kill your children, O Setem Khaimwese. So that they do not compete with mine.'

I bow my head and follow her to my house. In an upstairs room she hands me a glass of wine and I look down on the dogs chewing on the flesh of my children. She spreads herself out on a bed of ivory and ebony and I lie beside her. She opens her legs, but then, as I ease myself into her, she opens her mouth in a foul-smelling scream. The stink of her breath reminds me of something. Perhaps I am reminded of the smell of the wizard's wife, for it is certainly her whom I am lying with. Her rib-cage has buckled under the weight of my body and I withdraw from her in holy dread. My wits are confused, but I know that I now have no hope of using the *Book of Thoth*, for it is closed to the man who has committed the sacrilege of sleeping with a corpse.

Then I hear a voice calling me back, back to the source. No time has passed on this quest. The children are alive and the dogs still hungry. Above the great lake, my spirit begins to rise and draw away from Africa, so as to answer the summons of a voice from another time. Back in the Meditation Hall, there is, as usual, time for us to lie quiet and reflect on the significance of our pathworking. I lie there quiet and afraid. I am certain that tonight's exercise was directed at me and only at me. Although the seductive maiden, Tbubi, had dark hair, I can see that she is an earlier incarnation of Sally. As in ancient Egypt, so in modern London. Sally is a seduction on the path, sent to prise the book of secret knowledge out of my hands. Although the kisses of yesterday morning were sweet, it is certain that, in time, Sally's breath will carry the stink of carrion, for that is what is entailed in ordinary mortality. Those who cannot break free from the cycle of birth and death are condemned to rot. Now that I knew what it was like to embrace a corpse, I was more than ever afraid of death. I was also afraid of Felton and his power to take me where I did not want to go.

The pathworking had finished earlier than usual. I shakily got to my feet and started to follow the others hurrying out of the Hall, only Felton barred my way with a ceremonial flail.

Behind him stood Granville and Granville was clutching a copy of *Penthouse*. What was going on? I must have looked apprehensive. Seeing this, Felton smiled benignly,

'I said that the Lodge would find you a new girl and it will. There is no time to lose.'

Granville followed Felton in mugging a reassuring smile. They insisted that I return with them to Felton's study. Felton spoke.

'A girl, but not any girl. A consort fit for a future Adept of High Magick. Where shall such a girl be found and what is her name? There are so very many girls. Place your ear to the ground and it may be that you shall hear the clacking of their heels on the pavements of the world's cities. Their pretty shoes all drum out messages of seduction. Yet there is one pair of heels which beats out a tattoo which is destined to be heard by one man and one man only. There is one particular girl, preserved by destiny as a virgin, whose steps take her, as if sleepwalking, towards your bed. One girl among so many millions. We shall find her for you, Peter. Do not doubt it.'

Felton's monotonously intoned, crazy speech increased my fear. Granville, though, was more matter-of-fact. Having opened the copy of *Penthouse* and pressed it flat on Felton's desk, he beckoned me over.

'Here it is. The latest thing. A computer-dating form. If you fill it in now, it will catch the first post tomorrow morning.'

The double-page advertisement spread in the middle of the magazine consisted of a long series of questions with boxes to tick, interspersed with matchbox-sized photographs of happy couples who had already found happiness through computer-dating. Granville pressed me into the chair and put a pen in my hand. My first thought was that I was to tick the boxes I chose, thus, stroke by stroke, shaping my perfect woman, a bit like Pygmalion. I was swiftly put right about this. I was to tick the boxes they chose.

'It is most important that she be a Scorpio,' said Felton. 'And even more vital that she be a virgin.'

Box by box, under their guidance, my perfect consort was constructed. She will be a virgin Caucasian, tall with long

dark hair, aged about twenty. She lives in London. She will be looking for love or marriage rather than friendship. She is not close to her family. She reads avidly, is politically indifferent, but well-groomed. She is serious, shy and beautiful. Her interests include wining and dining, theatre, cinema and astrology. I wanted rock music to be included, but Felton and Granville were adamant that she should only care about classical stuff.

'She will be nothing like Sally,' said Felton.

'It must be someone you have never met before,' explained Granville unhelpfully.

'And she must be a virgin,' Felton reiterated. 'Eventually you will bring her to the Lodge and we will welcome her as your consort.'

Felton, still in his Egyptian priest's robes, performed the ritual of the Nine Barbarous Names over the completed form,

'I am Ankh-F-N-Khonsu, thy Prophet, unto Who, Thou didst commit thy Mysteries, the Ceremonies of Khem. Thou didst produce the moist and the dry, and that which nourisheth all created life . . . '

And while Felton stood there in hieratic pose and continued to invoke the Borneless One, I sat at his desk, wondering why was I going along with all this craziness. I had had it in my mind for some time that if there was even the shadow of a chance that the magical version of the world was the right one, then the prizes would be incalculable. But now I also sensed that the penalties for leaving the Path or failing on the Path were unthinkably nasty. (Visions of the banister studded with razor blades and of the slug condemned to eternal life flitted through my mind.) And yet curiosity competed with fear. I was terribly interested to see what would happen next. Among other things, I find it hard to imagine how I am going to strike up a relationship with a virginal lover of classical music and then, having done so, induct her into the path of sorcery. I picture myself a Hellfire seducer in an eighteenth-century novel whispering into her innocent ear. It would be good if my blind date turned out to be a Scientologist, but I doubt if I shall be so lucky.

Granville addressed the envelope and said that he would

post it off straight away. Then he added that he would be sending one of his men round with the shop's van to move my stuff from Notting Hill to the Lodge on Friday afternoon. So I have a new name and very soon a new address and a new girlfriend too. At this rate the old Peter, the Peter who began this diary, will have vanished in a matter of weeks.

Come to think of it, Ron was not at the pathworking. He is not someone I am going to miss.

Wednesday, May 31

It is sunny but unreasonably cold for May. I did a session on the playground wall, but I was not really concentrating. I kept thinking about the previous evening. Belatedly it occurs to me that last night's pathworking might relate in some way to the Cairo Working which the Master and Felton performed in Egypt so many years ago.

I spent most of the afternoon in my pad, throwing some stuff away and putting the rest in cardboard boxes cadged from the grocer round the corner. I rang Dad and told him that I was moving. I lied to him and told him that the move was taking place at the weekend. He said nothing, except that my new address sounded rather grand, but he sounded disappointed. He will expect me the following weekend.

I met Sally under the statue of Eros. I was going to tell her before we went into the cinema and saw *Elvira Madigan*, but I chickened out. So I spent the next hour and a half watching a sequence of brightly coloured images: period uniforms, lacy dresses, pretty faces, blossoms, and twirling parasols with no idea of what connected them all, for I was rehearsing my lines. Sally was unusually clingy and she nestled up against me with her head on my shoulder.

We practically never go to pubs. Sally does not like the noise and darkness, whereas I am not very fond of the taste of beer. But this time I insisted. In the pub, she tried to talk about the film, unfazed by the fact that I was incapable of making any coherent comment about what had been going on in it.

But she kept trying. There was really something rather frantic in her determination to talk about Swedish films.

'Sally, I have something to say.'

'Oh yes?' She did not look at me. How could she have known what was coming next? She did.

'I am moving out of Melchett's place. Obviously I have no choice about that . . . Well the Lodge is taking me in, for a while at least.'

'So that's it? Well, OK – if that is what you want.' She looked sulky, which did not suit her. 'Personally I wouldn't spend a night there. The place gives me the creeps.'

She shrugged. I pressed on.

'And it is not going to be so easy for me to see you in the future. The Lodge has strict rules and I shall have duties.'

She shrugged again. The cow was determined not to make it easy for me.

'Well, whenever,' she said. 'I am always around for you. When shall we go out again? Not a film next time. Let's go back to Middle Earth.'

'Maybe. That would be really nice, but first I have to sort my life out. You know how'

At last, this was too much for her. She crumpled and started crying.

'You are evil!' she cried out through her tears.

'What is evil? I can't get my head round this "evil" you are talking about.'

'Oh Peter, you really do know what I mean. People used to talk about evil and I thought that it was something abstract – and therefore, in a way non-existent. I was so very wrong . . .'

Her voice tailed off in a whisper. I sounded indignant,

'If you think that I am evil, you can't possibly have loved me then.'

She was crying buckets and everyone in the pub was looking at us, though some were pretending not to.

'I feel so sorry for you, Peter. So sorry.'

'I'm sorry too.'

And I hurried out of the pub.

I wish that, at some time before we finally split up I could

have got her to release me from my oath to screw her when she is dead, but obviously it would have been inappropriate to raise the matter this evening.

Thursday, June 1st

A great day! Having woken early, I reached the HMV shop in Oxford Street soon after opening time and, after queuing for about twenty minutes, I secured my own copy of 'Sgt. Pepper's Lonely Hearts Club Band'. The sleeve gave me a start, for there, standing towards the left in the Beatles' fantasy entourage, was a scowling Aleister Crowley. Maybe Cosmic is right about the Beatles after all. Anyway there seems something fated about this record. In some way, I do not yet know in what way, this record is part of my destiny.

Back at my pad, I played the record again and again. This is a need with me. I have to hear music again and again in order to internalise it. 'Sgt. Pepper' is this summer's record, yet by autumn I know that all its tunes will be dead and lifeless in my ears. Only perhaps in returning to the record years later will I be able to capture some of that initial summery enthusiasm. For now, on a June morning, the record is amazing – that wall of sound, the tracks sliding one into another, and the kaleidoscopic tumble of lyrical images and sound effects. The music is as brassy and percussive as the sleeve is gaudy. At first, as I listen, I am fiercely elated, but slowly it comes to me that the themes are really rather sad – about getting old, dying in car accidents and things like that. This is the music of the summer of 67 and by putting it on the turntable I shall always be able to return to that momentous summer. But then who will I be when I play this record in twenty years time?

In the course of packing to leave, I found a tiny stash of opium which I had totally forgotten about. I hesitated a bit, because the thing is that opium gives me the most frightful constipation. On the other hand, it is a subtle drug and I can still operate effectively under its influence. So I rolled the stuff into a joint for a farewell blast. It went great with the 'Mr

Kite' track. Straights just cannot hear our music, since it is written to be heard on drugs. The tamburas and sitars give an eerie trippiness to some of 'Sgt Pepper's' tracks – like my life, the music is out of control. I play it as loud as the speaker will allow, as part of my farewell to Melchett. Besides, music is no good unless it is played really loud. I think that I had listened to 'Sgt. Pepper' seven and a bit times by the time Phil arrived with his van. Phil has a military haircut and a trim little moustache. He apparently does odd jobs for Granville, shifting antiques around the country, and he vaguely knows Cosmic, since they are in the same line of business. Phil helped me get my stuff into the van. There was not all that much to shift, but the records were heavy. As we drive out of Notting Hill, I notice that 'She's Leaving Home' is silently playing in my head.

Strictly Black Book Lodge is the name of our esoteric Brotherhood and not the name of the house which is the headquarters of the Brotherhood. My new address is actually Horapollo House, Urqhart Street, Swiss Cottage. As we drive off, the plangent strains of 'Sgt. Pepper' are still running in my head and I find myself thinking of Sally. Was it indeed love? Or was it just sex? After my encounter with the death-maiden Tbubi, I am not sure that I would ever dare to go to bed with a woman ever again. I know I am not a brave person. The illusions of Dr Felton make me afraid. And because I am afraid, I am about to place myself completely in his power. I am not a logical person either . . .

Although Phil has done bits and pieces of work for Granville, he is not an Adept or anything and he is immensely curious about the place and what goes on there. I was surreptitiously looking in his wing-mirror to see if my pupils were dilated when he began to engage me in unwelcome conversation. Fortunately I was not hallucinating – merely thinking strange thoughts.

'Horapollo House, that's some kind of educational institute, isn't it?'

I nodded and then, seeing that he is expecting more, I add, 'They have lectures and seminars on philosophy.'

'A philosophical education is a fine thing. Everybody connected with the House seems to be rich.'

'I'm not rich.'

'I know you're not. Don't worry. Your removal bill is being paid at the other end. No, but – don't get me wrong – they're a funny lot up there, aren't they?'

I shrug non-committally.

'No, but you know what I mean. They are all very polite and cultured and everything, but there is an atmosphere. They are not like ordinary philosophers, are they?'

All drugs have their inbuilt paranoia and I was getting more and more paranoid that, if we kept on talking, he would rumble that I was not quite on the same planet as him. I allowed some irritation to sound in my voice.

'I don't really know what an ordinary philosopher is like. But they are fine. They are just ordinary people.'

The subject is dropped and I look out of the window at the girls in their summer dresses, until Horapollo House looms up ahead of us. Then I am inside Horapollo House and inside me are the opium and ghosts of chords played upon the sitar. The effect is pretty potent. Fortunately Phil and Mr Grieves are there to help to get my stuff up to the room on the second floor. Taking drugs is like going shopping for a different brain. The brain I had picked up this morning is overwhelmed by the hallway and the staircase of Horapollo House. The place is like a cathedral sculpted out of darkness and at the heart of the darkness is this tumble of staircases, balustrades and corridors going all over the place. The eye is led onwards by the dull gleam of brass and crimson woodwork until it is lost in the upper gloom. The carpets I tread upon are very soft and decorated with small, bright, ornamental designs, so that it seems to me that I walk upon human eyes. Then I am amazed by a moth fluttering in the stairwell. It was . . . amazing. It was a blazon in the heraldry of drugs. A hieroglyph maybe. Really quite amazing, but one has to accept that there are no words for this kind of thing.

Phil makes the most of his brief *entrée*. He has picked up a fair knowledge of antiques and his eyes dart about the place.

'That's a medallion Ushak,' pointing to the carpet on the hall floor. 'They've got some nice stuff here.'

He rubs his fingers along the intertwining gold and vermilion serpents which form the banister of the central staircase. On the first floor, he pauses in his lifting to take in the frescoes and, having done so, he recoils a bit. The frescoes are faithful copies of those painted by Crowley for his Abbey of Thelema at Cefalu: a naked man sodomised by a goat god, and his spunk spraying over the Whore of the Stars, and a Kundalini serpent preparing to devour headless dancers. Phil was so distracted at the sight of these images that he almost fell over the stuffed tiger on the next landing. By the time he had carried up his third load, he was eager to leave. And I was desperate for him to leave as every noise he made grated most horribly on my heightened sensibility.

'Good luck,' he said as he shook my hand. I almost fainted at the pressure of his grip.

So now I am alone in my new room. I wonder who had it before me? It is austerely furnished and decorated. There are two beds and a wardrobe and a high-backed chair, but no table. So I am using the second bed as a desk. A copy of Aleister Crowley's second novel, *Moonchild*, has been left on the chair between the two beds. Above me there are only the attics. The ceiling creaks from time to time, as does the whole house, which is like a sailing ship in a heavy swell. Now I wish that Sally had been able to stick with the Lodge's lecture programme and that she too had kissed the Master's hand. I wish that the bed I am writing this on was going to be occupied by her. I tried to doze for a bit, but first I find that faces, hundreds of faces, thousands of faces of men and women I have never seen before come crowding in on my inner eye. The faces are angry, plaintive, amused, hungry, supercilious, half-asleep, terrified, pompous, joyous, inscrutable. They rush on by, totally without purpose. Then, as I watch this stuff and wait and hope for the river of faces to dwindle and vanish, I become aware that there is a terrible itching in one of my ears. I poke at it as best I can, but I have caught nothing with my fingernail. The conviction comes upon me that an insect has

got into the inner chamber of my ear and from there it is going to eat its way through my brain. Finally I do doze off a bit and find myself the victim of geometric dreams, full of abstract promises and menaces. If the reverse of A is A to the power of ten, is the contrary true? And, if I am A to the power of ten, is the same true of my bride-to-be? And, if I and my bride join forces, is this an additive increase or is our power multiplied? Asleep, I am helpless to fend of these problems, but, when I awake, I have my old brain back.

Just before six I went down to Felton's room, taking my diary with me. I knocked and walked in and was greeted with a ragged chorus:

'Love is the Law, Love under the Will!'

'Welcome, Peter!'

'Welcome, Non Omnis Moriar!'

Most of the senior members that one sees around the Lodge – Granville, Laura, Agatha, Marcus, Rio, Maxine and tonight's speaker, Colonel Chalmers – had assembled in Felton's study and, crowded behind his desk, they raised glasses of sherry in my direction.

'There will be no inspection of your diary tonight,' said Felton. 'That can wait until next week, for tonight we thought that we would make you welcome to Horapollo House.'

Maxine wanted to inspect my diary-writing hand and this led on to talk of diary-keeping. Laura claimed that keeping a diary forced her to do interesting things, because otherwise it was too boring reading what she had done later. Granville quoted *The Importance of Being Earnest*, 'I never travel without my diary. One should always have something sensational to read on the train.' There was talk also of Colonel Chalmers's recent holiday. He had gone back to India to revisit old postings. He was gratified to find that, everywhere he went, there were Indians eager to tell him how much the British were missed.

'Things have gone downhill so badly that they want us back. We will have to return in order to save the Indian subcontinent from heathen darkness . . .'

I was listening and not listening to Chalmers. I was thinking about how sad it was that it had come to this – a group of mostly elderly men and women sipping sherry and talking about diary-keeping. I suppose that I am now living in a kind of commune. This ought to be exciting, but the trouble is that everything exciting – Horapollo House's 'OH-WOW-MAN!' period – happened twenty or more years ago, when Aleister Crowley was alive or only just dead. From the photographs, Felton was then still slim. Laura as a chick must have been quite something. Chalmers, who these days is barely functional as a human being, may still have been sane then. The Master was promising his followers great things. (We hardly see him now.) Whatever it was that went wrong for all of them was connected with the Cairo Working. That was where they blew it. And now here they all are poring over each other's diaries.

Towards the end of our Satanist's sherry party, Felton suddenly became brisk,

'Just a few house rules, Non Omnis Moriar. Nothing that you will find excessive, I hope. First no overnight guests without our knowledge. If you are going to miss dinner, you must tell Grieves or leave a note in the kitchen. You must, of course, observe the Lodge's fast days. You may play your record-player in your room, but only at civilised hours and at a sensible volume. If you take drugs, the results must be entered into your diary. No sleeping in the daytime in Horapollo House or in its garden. Be careful about that.'

'No masturbation,' Granville added. 'Masturbation feeds the Qlippoth.'

Laura and Rio laughed, but Felton did not smile. (MEMO investigate the Qlippoth.)

'You will be expected from time to time to help Grieves and his wife in the kitchen, but first I thought that we should put you to work cataloguing and dusting the Lodge's library. Just an hour or two each day when possible. Think of us as your new family and, once again, welcome, Non Omnis Moriar.'

With that we dispersed. Only Granville came along with

me to Chalmers's lecture. Granville sits at the back and I think that his function is to observe and report on the rest of the audience. Tonight's audience was alternately restive and dozy. I noticed that Ron is indeed no longer with us. Chalmers is not a good lecturer. He was supposed to be talking about the first principles of Kabalism and the hierarchies of the Tree of Sephiroth. However, once Chalmers had pointed out that a tree was something to be climbed and that an Adept on the Kabalistic path was like a mountaineer inching his way up to a peak that was hidden in the clouds, his eyes began to mist over. He was back in his beloved Himalayas and we, his audience, were left behind scrabbling about on the lower slopes. The lecture concluded, the colonel rushed out to catch his train to Reading.

While we were standing about after the lecture, I had an odd conversation with Cosmic.

'What do you think of me, Peter?'

I was nonplussed. I could not think of anything to say.

'Do you take me seriously?' Cosmic persisted.

'Of course I do.'

'Do they take me seriously?'

He meant the senior members of the Lodge. I shrugged. Cosmic took my shrug as meaning something.

'Yeah, it's kind of heavy. I'm not sure that they do trust me. I think they suspect that I'm some kind of infiltrator. That's why you're on the inside now and I'm not. Put in a word for me will you?'

'That's not necessary, Cosmic. You're just being paranoid.'

And indeed he did look and sound paranoid, whispering like that to me in the hall. Cosmic is a man who always sees his life as directed by conspiracies. All druggies are prone to paranoia. It comes with the substances. Even so, Cosmic was unusually twitchy tonight and I wanted to get away from him as fast as possible, for who knows? Perhaps paranoia is contagious. I was just about to walk away from him, when he grabbed my sleeve and said,

'The word is that you've split up with your chick.'

I just nodded.

'That's a bad trip . . . really heavy. But so you won't get hung up, if I give her a buzz and maybe go over and rap with her and give her some comfort. I mean, I really like Sally, but if it hangs you up, me seeing her, then just say the word and I'll keep my distance.'

I find that I still cannot speak, but I make a thumbs-up sign and break away from him.

'Stay cool!' he calls out, as I head towards the dining room. Surely he will not be allowed to hang out with Sally if I am forbidden to do so?

At dinner that night, I helped Grieves put out the dishes. All the permanent residents, except for the Master, were at the table – Felton, Laura, Agatha and Marcus. After the ritual blessing of the meal and the silent meditation on the first mouthful, conversation at table was subdued and I was not really listening. I was thinking about Sally and her questions. Robert Drapers told her that the worst thing he could imagine was having a cat hanging on to his face with its claws.

Friday, June 2nd

The rustles and creaks of an old house take some getting used to and I drifted in and out of sleep. I am afraid – not of the house, but of what I am, or what I am becoming.

One thing you can say about Satanists, they are great readers. There are thousands of books here. God knows how many, ten or fifteen thousand. I sit writing this in the library. I have spent almost all day here, examining the books, scribbling on cards and watching the shadows creep across the floor and enter my mind. I had been planning on another session at the playground today, but since I awoke to steady drenching rain, I decided that today would be a good time to go about starting to earn my keep here.

The standard texts are all on the shelves: Knorr von Rosenroth's *Kabbalah Denudata*, *The Book of the Ibbar*, Glanville's *Saducismus Triumphatus*, Court de Gebelin, the

Voynich Facsimile, *777*, *De Praestigis Demonorum*, Barret's *The Magus*, Papus, Sinistatrari and so on. Then there is a lot of serious Egyptological stuff by Maspero and Wallis Budge and what may be a complete run of the *Bulletin de l'Institut Archéologique en Egypte*. And some badly out-of-date reference works, including the *Almanach de Gotha*, and *Crockford's Clerical Directory*. I have created a special section for novels. They are all pretty dated, romances by Bulwer Lytton, Marie Corelli, Dornford Yates and Dennis Wheatley; also Dekobra's *Madonna of the Sleeping Cars*, Meyrink's *The Golem*, Cazotte's *The Devil in Love*, Arlen's *The Green Hat*, Huysmans's *Là-Bas*, Charles Williams's *War in Heaven*.

So now I have become a librarian! Maybe I can get a book out of my experiences – something along the lines of *Adventures in Librarianship* or *Memories of Heroic Librarians*. After hours spent surveying my dusty empire, I take a break for lunch – sandwiches in the kitchen with Mrs Grieves. She doesn't talk much. Then I return to the library. There are some pretty strange books here – like John Campbell's *Hermippus Revived*, which turns out to be about the rejuvenating power of the breath of young girls. I am like a medieval scholar immured in his study, while on the road beneath his window the motley-coloured throng stream down the road with flutes, drums and bells – jongleurs, pilgrims, squires and ladies bearing hawks on their wrists. But I, the sorcerer's apprentice, have no eyes for them, as I am close to discovering the Elixir.

Although it is still raining, I am tempted to rush out and go for a walk. But an absurd and fantastic fear restrains me. I have this nutty fantasy that Sally is lurking beyond the threshold, waiting beyond the cypress trees, waiting for me to emerge. Then she will fall upon me and overwhelm me with her anger and her grief. I am safe, I tell myself, but only so long as I stay within the library. She said I was 'evil'. What is evil? I do not grok evil. Good and evil are social constructs. There are higher realities and I am about to enter a territory in which I cannot bring any passengers with me – not Sally anyway.

I reckon that I did Sally a favour by leaving her. I mean seriously. She wanted to possess me, to take over my time and my tastes, but real love must go beyond the desire to possess. Just as I have given her freedom, so she must give me mine. Love is the Law. Love Under the Will. Now she is thinking that I am a shit. If I am honest, that does bug me a bit. It should not. I have not been put on this planet to live up to her expectations. What I am is me. For that I came.

I felt drowsy while writing this and for a while I was tempted to put my head down on the table and take a nap. Sleep is so seductive, but then I remembered Felton's warning about not sleeping in the daylight in this house. Something to do with the larvae, I guess. I force myself to stand and move around the library, sorting books into subject groupings. So many grimoires and magical diaries here. Is Satanism more than a reading mystery? Suppose the *Book of Thoth*, the book which instructs one in the language of the winds and on the power to enchant one's sleep, was to be found in this library . . . What I think is this. There are so very many ways that the world may not be what it seems that, from a statistical point of view, it is downright improbable that the world actually is as it seems.

For example, Horapollo House could be a mirage, a castle of Fair-Seeming Welcome, a sort of spiritual obstacle set in my path. At the utterance of a certain word, the whole structure will dissolve in gusts of air and flame and the black demons will arise shrieking into the sky, leaving me standing bewildered in the middle of some empty space somewhere in the vicinity of Swiss Cottage tube station.

Or the Black Book Lodge could be a front for a British Secret Service operation.

Or Sally, instead of being the dippy, hippy flower-child that she seems, is really a senior figure in a rival organisation of Satanists and that is why she has been trying to persuade me to leave the Lodge.

Or then again, as I have heard Mr Cosmic suggest, the whole earth is just a kind of maze in a vast laboratory and the

aliens in charge of this laboratory are running various sorts of tests on us.

Or it seems to me to be perfectly possible that this instant of time in this library is the only instant of time I shall ever experience. My memories of the past are fakes and, in the same way, my anticipations of the future are unreal.

The alternative is that eternal recurrence is true and that I am the millionth Peter to have entered the millionth version of Horapollo House and whatsoever I shall do in the coming months and years I am destined to repeat in every detail for all eternity.

Then again, I may not be what I seem to myself to be. I may be a larva that has forgotten its true identity. Or I might be 'Peter', the imaginary boyfriend of a girl called Sally who suffers from acute schizophrenia. I may be a pet labrador on an extended fantasy that it is human.

It seems to me (whoever I am) that if so many alternative realities are possible, then the obvious becomes downright improbable. Bearing this in mind, then one would be a fool not to seek the Key with which to unlock the World's great Mystery. Magick is that Key.

Felton was present at the dinner table tonight. He keeps nagging me to read *The Moonchild*. He claims that Crowley has been underestimated as a novelist.

'A great man, Crowley, a novelist, poet, swordsman, mountaineer, chess-player . . . You will find that you have a lot in common with him.'

Towards the end of the meal, Felton warned me to be up early in the morning with an overnight bag packed and ready to set off for Julian's place. I have no idea who this Julian is. I started reading *Moonchild* in bed. I am not sure about it. It is a bit preachy and it is full of stuff about the generation of a magical child and about the Fourth Dimension, but it does not actually explain how to enter this dimension. I slept badly, for I had no alarm clock, and I wanted to be sure that I would be awake in good time.

Saturday, June 3

Once I have packed, Granville checks my packing to make sure that I have a suit and tie in my case, as well as a clean shirt – plus of course my ritual robe. During the drive out to Herefordshire, he and Felton give me an intensive and patronising tutorial on how to behave during a country-house weekend. Stuff like:

'On arrival, do not unpack your suitcase. Julian's butler will do that for you.'

'When Julian says "Make yourself at home", this does not mean that you should take him literally and put your feet up on one of his Louis XV chairs.'

'When you sit down to lunch today, you will find more than the usual amount of silverware (and it is silver). The general rule is to work from the outermost utensils inwards.'

'We will give you money with which to tip the butler when we leave tomorrow.'

'Also, do not forget to sign the visitor's book.'

'Also, on your return, you must write a letter thanking your host.'

Seeing me become more and more gloomy, Granville mischievously wound up with,

'And do smile and be relaxed. The courteous house-guest will always wish to appear relaxed, for, if he appeared otherwise, his host might take it as a signal that he had failed in his duties.'

Julian came out to greet us on the drive. I guess that he was in his sixties. His hair was white and wispy and his complexion was a blotchy pinkish white. There was a curious sheen to that skin, as if he had had cosmetic surgery. He was very nervous. He was even nervous of me.

'So this is the chosen one,' he said, as he timidly shook my hand.

The butler, who had the build of a pugilist and who wore white gloves, stood close behind Julian and, at a nod from him, went over to the car and took our luggage inside.

Half an hour later, we all met for a game of croquet on one of the lawns at the back. Croquet was new to me. It is a vicious game for it comes close to being what I think is called a "zero-sum game", a game in which one gains and only gains by damaging one's opponent, so that your wins are precisely the sum of his losses. The point of croquet is not so much to get one's own balls through the prescribed sequence of hoops as to knock one's opponent's balls out of play. In croquet, the joy of winning pales by comparison with the joy of ensuring that one's opponent is losing. Despite its viciousness, we played as if we were courtly and well-tempered gentlemen.

At the end of the game (which Julian and Felton won) we moved on to pre-dinner drinks on the terrace. The gins were pretty strong, but Julian was drinking the stuff twice as fast as Felton and Granville and I had been trying to keep pace with Julian. I walked over – staggered, maybe – to sit on the stone parapet and looked over the grounds. Julian was conducting a muttered argument with Felton. He wanted something to be 'finished with'. Granville came over to join me.

My *Doctor Strange* comics have lots of small ads offering things like 'AN ATLAS BODY IN SEVEN DAYS, thanks to the dynamic tension method', 'Earn big money and respect as a locksmith', 'Impress your friends with your phenomenal memory powers', and 'Silently command, control, dominate anyone. Say nothing, watch even perfect strangers do what you wish willingly and cheerfully. Absolutely uncanny! Awe-inspiring details revealed in SUCCESS Manual Review Folio. Send $1 for postage to SCHOOL OF SUCCESS SCIENCE.' Granville makes me think of the people who actually answer this sort of small ad, for he joined the Lodge with the sole aim of acquiring power over women. You would not guess this to look at him, as he does not look like a lonely heart. Saturnine, bronzed and with thick curly hair, he actually looks like the hero of a romantic story in a woman's magazine. But apparently not all women go for his kind of sultry looks and only a 100% success-rate would satisfy Granville. He believes that this was the deal he got when he took the hand of the Master.

He has been in the Lodge for almost four years now. Initially he set himself to learn a special type of ogling called the *Mordo Dolorosa*, whose magnetic power infallibly draws chicks to him and makes them hot for it. He only has to look at them and breathe in a special way and they cream their jeans. But that is just apprentice stuff. (I can't wait!) More recently, the Master has been instructing Granville in the *Ars Congressus cum Daemone*, as it is described in a certain treatise called *De Nuptiis*. It is pretty arcane stuff, but basically it seems to be sleeping with shades and demons. I remarked that this did not sound like fun, for surely demons had horns and hair coming out of their nostrils and boils all over their bodies and stuff like that? But Granville put me right on this. All demons are naturally beautiful with bodies that shine like Lucifer's. They only assume those hideous forms if they want to escape the control of the sorcerer, but, if the sex is good, there is no reason why they should wish to leave the sorcerer's bed.

It really is quite weird that I know all this, for Granville gives the air of being a man of mystery. However, being a man of mystery seems to involve him in dropping lots and lots of dark hints about everything he is doing, so over the last few months I have actually got to know quite a lot about him and about sleeping with demons. I think that what he thinks is that, if no one is told a secret, then it would be as if the secret never existed at all. So, through piecing together Granville's crypticisms (Is that a word? If not, it ought to be), I have got to know quite a bit about things I am not supposed to know about yet – like the uses of sperm deposited in sealed jars underground and how, during intercourse with a demon, a man's mouth may become a vagina . . . but, no, there are some things it would be better not to report in the pages of my diary.

On this occasion too, as we waited for dinner, Granville dropped a number of crypticisms about Julian and how he became the way he is. It all seems quite freaky. I asked how anyone got to be this rich and I was expecting to be told something ordinary about either inherited wealth or good contacts on the stock exchange. But the story that I have so far

101

put together from Granville's rushed series of give-away hints is stranger than that. Julian is only rich in name, for, despite his impersonation of the lord of the manor, he is really more a kind of steward for the Black Book Lodge's wealth until the Lodge has a better use for it. This house and its grounds are on loan to him. But it is even weirder than that. It seems that in some way Julian's life is also on loan to him. Although Granville was not very clear about this, as the evening developed, I was better able to understand how this might be.

Felton went indoors for something. Julian came over to us and his butler followed close behind him with the silver tray loaded with more gin.

'Mr Dunn really gives very satisfactory service, but staff are so hard to get nowadays and I am so frightened of losing him that, whenever I address him, I am conscious of walking on egg-shells . . .'

Talk moved on to the difficulty of getting servants. I helped myself to more gin and switched off from it all. As I looked over the deer-park and the lawns, 'A Whiter Shade of Pale' was playing in my head, for its stately, baroque harmonies and nonsense lyrics seemed just right for this place. Then I began to think of setting Granville on to Alice. What fun it would be! Such mischief! (The Unstoppable meets the Immovable.) Alice distracted from her sulky meditations on the Ultimate by Granville's rhythmic breathing and his gaze directed at her navel . . . Granville having laboriously to explain to Alice what the point of sexual pleasure was . . . And so on. A wonderful fantasy, but how to achieve it? I would have to become very cunning, like the pander in some intrigue-sodden Jacobean tragedy.

In the meantime, while I had drifted off into fantasising along these lines, Granville and Julian had got into a sort of argument about the Americanisation of the culture of servants and of the working class in general. I say 'a kind of argument', because Granville, smiling politely all the time, kept trying to withdraw from it. Whatever point Julian made, Granville agreed with it, but this was not good enough for Julian . . .

'You can take that smile off your face Granville! I love this

country. I really love it. There is an English way of life and there is an English tradition and it goes hard to see it destroyed piecemeal and replaced with something so crass and so garish as the celluloid culture of the United States. It sticks in my craw. The old deferences and customary politenesses are going – no one can deny that – and it is sad. And I'm not talking about anything abstract. I'm talking about an England of wood and stone and water. I'm talking about an England shaped by men who had the patience and the public spirit to plant avenues of oak trees, even though they knew that they would not live to see those trees grow to maturity. I'm talking about an England of lych-gates, village smithies, brass-band fanfares, cathedral precincts, hop-picking, fox hunts, May dances on the village green and the old gods waiting under the hill. One can still touch, smell and taste the England I love, but only sometimes, for it is fading fast and I ask myself will it last my time?'

Julian concluded in an exhalation of regret. I thought, 'Oh for Christ's sake! Olde Worlde kitsch will certainly last your time – and my time too, unless I get lucky. Bloody old England goes on forever.'

I happen to know that Granville is quite fond of American culture, particularly the music of the Beach Boys and Jefferson Aeroplane. But on this occasion, Granville just shrugged his shoulders, yet even this non-committal gesture was a provocation to Julian.

'You wait and see – this island will have become nothing more than the fifty-first state of the United States of America. I now think that we would have done better to have fought with Germany against America and the commies. I tell you this beatnik thing, which has reached us from America, offers a much bigger threat to the British way of life than does communism. At least the communists are men who know how to work for a living, whereas beatniks – '

Granville smoothly interrupted,

'Julian, please, you will not find any beatniks in either Britain or America today. Perhaps it is hippies that you are thinking of?'

Julian looked momentarily baffled. It had not occurred to him that there could be any fine grades of distinction between the various kinds of youth-scum. While he stood there, perplexed and speechless, the dinner-gong sounded. As Julian led the way towards the house, Granville fell back to walk with me. He told me that I was not to get into an argument with Julian or upset him in any way. Julian is 'temperamentally frail'.

Well, 'frail' is one way of putting it.

We sat down at the table. Julian took one look at the soup and said, 'I wish I were dead.'

Then he abruptly turned to Felton,

'But, then again, I sometimes think that I am dead already. You would tell me the truth wouldn't you?'

A horrible kind of creepy coldness crept over me, for this was just the same as one of those strange thoughts I had been playing about with only yesterday.

Julian rose to his feet and with his arms in supplication, he chanted over the soup,

'What I doubly detest, I will not eat; what I detest is shit, and I will not eat it; excrement, I will not consume it. It shall not fall from my belly, it shall not come near my fingers, and I will not touch it with my toes. "What will you live on," say the gods and spirits to me, "in this place to which you have been brought?" I will live on seven loaves which have been brought to me; four loaves are with Horus and three loaves which are with Thoth. What I detest, I will not eat; what I detest is shit and I will not eat it; what my ka detests is shit, and it shall not enter my body, I will not approach it with my hands, I will not tread on it with my sandals. I will not flow for you into a bowl, I will not empty out for you into a basin. I will not take anything from upon the banks of your ponds, I will not depart upside down for you.'

Then he sat down again.

'There is plenty of life in you yet, Julian,' said Felton.

We three continued to spoon away at our soup in a sort of embarrassed, surreptitious fashion. Julian tried to get the butler to remove his bowl, but Felton countermanded this and forced him to consume every single spoonful. Julian made the

most horrible faces. Although Felton had told Julian that he was still alive, the tone in which this was said had not been reassuring. Julian looked terrified. Perhaps he was right? If so, I had never had dinner with a dead man before. And, if Julian was dead, then quite likely I was dead too. Perhaps this dinner in a country house with its ordinary-seeming menu and napery was a kindly illusion which might soon fade. Then Julian and I would see things as they really were and we would find ourselves in the Antechamber of the Final Judgement. It really was shit being dished out to us in the soup-bowls. Anubis-Granville would hold us by our arms and Felton-Thoth would point to the scales. Together they would watch and see our hearts weighed against the feather of Maat. And just beyond the next threshold the Eater of the Dead would be waiting to mangle and chomp on our bodies.

However, unlike Julian, I did not really believe any of this. It was just a drunken fantasy. I was woozily back on my favourite fantasy trip of being dead and what I was playing around with in my head was a very peculiar sort of crime novel in which the detective-narrator discovers that it is he who is the victim of the crime he is investigating and that he is already dead. I just like to play with such nutty ideas – just as I think from time to time about sliding down the razor-studded banister. I was in no real danger of joining Julian in a *folie à deux*. Spells from *The Book of the Dead* and from other ancient Egyptian papyri play a large part in the pathworkings of the Lodge and quite a few of our meditation fantasies involve encounters with the gods of the Afterlife, but they are strictly fantasies. Anubis and Osiris have no objective reality. They are exteriorisations of the internal workings of the sorcerer's psyche.

All of which is not to say that fantasy-exteriorisations are not frightening. They are. If I allow myself to think of how I bedded down with the carrion body of Tbubi, a queasiness steals over me and I hear again that scream which was also a stench. I find myself paddling a flesh which gives way under the pressure of my hands. Tbubi's rupturing skin goes livid and her panting for sex has given way to cadaveric spasms. (I

imagine that she is what Sally will actually become at the very end of her life and that is the real horror of the thing.) The fact that Tbubi is *only* a creature of my mind makes things worse, not better. Worse yet, Felton knows exactly how to force such things out of me. Knowing myself to be afraid of Felton's powers, I was not surprised that Julian was similarly afraid. But what astonished me was that Julian seemed to be even more afraid of me than he was of Felton. This was to manifest itself in a bizarre burst of aggression towards the end of the meal.

After the soup, things quietened down a bit and Julian did not seem to need to ritually curse the courses which followed. He was, however, drinking heavily – which, since I was matching him drink for drink, I was well aware of. For a long time the talk at table was about such things as the opera season at Glyndebourne. (I was right out of it and contentedly fantasising about myself as a dead detective.) But then Granville was stupid enough to mention that *The Times*'s music critic, William Mann, had compared 'Sgt. Pepper' to the symphonies of Beethoven. Then Felton made some sneer about it being impossible to take popular music seriously, particularly stuff produced by a group who could not even spell their own name properly and suddenly, Julian remembered his earlier difficulty in understanding what beatniks and hippies were.

'Hippies! Hippy ! What a silly name! Do they waggle their hips like girls? Yes, perhaps I did mean hippy, though I should be most grateful if you could explain to me the difference between a hippy and a beatnik, and explain to me also what is the good of either, and, while you are at it, explain why you have to go around with girly long hair.'

I came to with a jolt, suddenly aware that Julian was addressing these last remarks not at Granville, but at me. Granville put his hand on my arm. I suppose that he was signalling that I should not reply to this, but Julian pressed on,

'I take it that the excessive length of your locks is intended as some kind of badge of commitment to the work-shy hippy ideal, whatever that may be?'

I was so very drunk and (as the newly-invented dead

detective) in such a benign mood, that I was not immediately aware that Julian was trying to insult me. I actually thought of him as some kind of amateur sociologist who was intending a serious enquiry.

'As far as I know "hippy" refers to some kind of drop-out who opposes establishment values. I am doing a doctorate in sociology and planning to have an academic career. I live in a fair degree of comfort in Horapollo House and I'm not politically active. Therefore, it would be inaccurate to label me a hippy.'

I was vaguely aware of a bell pealing somewhere in the house.

'I am pleased to hear it,' Julian said (though he did not look pleased at all). 'A hippy is, I think, a kind of white nigger. He has embraced nigger values, their tom-tom and banjo music, and their loose morals. The popular songs, which have emerged from that sort of environment are about copulation – nothing but. Hippies are Britain's unwanted white-nigger changelings. They are the ungrateful, unwashed, drugged and sponging children of an affluent age – '

Julian's drunkenly dyspeptic ravings were interrupted by the reappearance of Mr Dunn, the butler.

'A message for Mr Keswick,' he said.

'Yeah, yeah. Just let me finish this first,' I replied, for I had now worked out that I was indeed being insulted. 'It should not take too long to establish the realities of the matter. As for "work-shy hippies", forgive me, Julian, but you don't strike me as being a horny-handed son of toil yourself. How much work have you done in your life?' Without pausing to let him answer, I rushed on. 'What I should have said to you just now is that, although I am not a hippy, I am ashamed of not being one. The hippy way of life embodies a wholly admirable set of ideals: peace, love, liberty, tolerance, and a readiness not to judge by conformist standards. As for "work-shy", the sort of work you are thinking about is used by society to drill people into conformity. I think hippies are right to use drugs in their quest for self-discovery, as well as in a more generalised investigation of the ultimate structures of the universe. The

best hippies are engaged in an all-consuming quest for enlightenment and ultimate truth.'

I sat back with arms folded. Mr Dunn, the butler, said that there was a phone message for me. Felton tried to stop Julian replying, so that I could leave the room and answer the phone, but, having got a rise out of me, Julian was gleeful,

'Now at last we are hearing what you really think! And it is such thin, wet stuff! The British hippy preaches peace from behind the protection of the bayonets of the British army. The liberty he espouses is assured, not by his poetic musings, but by the hard work of policemen and courts. His love is funded by the administrators of the dole. Decent, ordinary people instinctively recoil from a hippy. It is not just a matter of the dirt, the drugs, or the half-witted inarticulacy, which are all endemic among people of that ilk. It is that hippies and popular musicians have turned sexual perversion into an ideal of life. There is a sick softness, an effeminacy about these young men with their long hair and their flowery shirts and beads. They are actually advertising their desire to become girls. It is all so shameful! Well, why don't they go to Morocco and have the operation? Why don't you?'

'Do not answer that, Non Omnis Moriar,' Felton commanded. 'Go and answer the phone.'

'OK, I'm going, but I'll be back.'

I staggered behind Mr Dunn, the butler, trying with no success to imitate his stately roll. He led me to the antique sedan-chair in the hallway, which doubled as a phone kiosk. I picked up the receiver and said 'Hi!' to whoever it might be at the other end of the line.

'It is your mother, Peter,' Dad said. 'She really is very ill. You must come – tonight if possible. If not, you should start out tomorrow.'

'I'll see what I can do, Dad. It could be difficult. This is a very important conference, I am at.'

'Forget the conference. Come. I – we need you now. Peter, for Christ's sake!'

'OK, OK, but I doubt if it will be until tomorrow. We are a bit remote here.'

'Very well but Peter, I think that she may be dying.'

After quite a bit of random opening of doors, I managed to find my way back to the dining room. They were deep in some argument.

'I cannot understand why you chose him,' Julian was saying.

'We didn't choose him,' said Granville.

'Try to look behind appearances,' said Felton.

They fell silent and looked to me.

'To pick up where we left off, Julian, there is an answer to what you just said.' As I said this, I stood dramatically framed in the doorway and I was trying to remember what that answer was. 'Oh yeah, you were saying about why don't I have a sex-change operation? Well, I am on a student grant, Julian. I cannot afford the trip to Morocco, still less the operation. But please, please give me the money and I will go and have it done. But please don't think of me as an ungrateful sponger, putting the make on you for that sex-change operation that all we hippies desire. Having had the operation, I'll come back here and pay off my debt to you by working as a maidservant. It is an offer you can hardly refuse, not when servants are so hard to find these days – and particularly not when you will be able to show your bayonet for me to clean with my tongue and you may exercise *droit de seigneur* over my body and, after screwing me senseless, you can take me dancing on the village green to the sound of brass bands. Come on Julian, let's make it happen –'

I paused to see if he had a reply to this, but he just said, 'I wish I were dead.' (That was the second time that evening. Maybe, if he says it three times, the Good Fairy will make his wish come true.)

'What was the phone message, Non Omnis Moriar?' Felton was impatient, but I thought that he might at least have offered me another drink. I helped myself from the decanter, while I remembered what the message was. It was a bit of a shock. I had thought it was going to be wine, but I think it was actually port.

'I'm sorry about this,' I said eventually, 'but I have just had

a message about my mother. She is really very ill and I need to get home as soon as possible.'

I had been expecting some sympathy, however perfunctory, but Felton shrugged.

'I have to go,' I persisted. 'Whatever it is that you want from me, and I'm damned if I know what that is, it cannot be spiritless obedience. I'm going now.'

I helped myself to a final glass, a stirrup-cup.

'The door is over there,' said Felton.

I rushed out of the dining room, along the hall and managed to make it to the sweep of gravel in front of the steps before I threw up. There are things called epiphanic moments. Points of glory in an individual's life which have a mysterious but unmistakably heightened significance. One can even sense, however dimly, the flow of the Tides of Destiny during such unbidden manifestations. This was one of those epiphanic moments. I stood in the peacock-infested grounds, looking up at the stars and then down at my vomit and then up at the stars again. My vomit, little bits of quail and vegetable, was all pinkish from the amount of wine and port I had drunk and it was really beautiful, just like the stars. And I felt cleansed. I was still high from the alcohol, but it was a purer sort of high. If one can go with the roll, vomiting is like sneezing –quite a good experience.

As I staggered about on the lawn, I kept going over the argument about hippies and I kept thinking of extra crushing things I might have said. People like Julian talk as if hippies ran the country and as if everything that happens happens either in Carnaby Street or Kings Road. But the England I live in is not run by long-haired youths operating out of the Arts Lab or a recording studio. It is run from big offices by people who are old or middle-aged. Sixties Britain, like fifties Britain, like forties Britain, is run by company directors, generals, bishops, MPs, bank managers and wardens of colleges, and if anything is going wrong in sixties Britain, it is their fault, not my fault, or the fault of the Beatles. I wish the streets were crowded with young men in colourful, flowery shirts. In fact, England is amazingly dowdy and repressed. One travels a long way to

find sitar music or a Dr Strange comic, but Brylcream, Typhoo tea and Woodbines cigarettes are everywhere at hand. It is like living in a continuous drizzle. If there is to be a hippy revolution, let it come soon.

Let what come soon? Let the storm from the East come, and, hurrying ahead of the storm, the raggle-taggle, Bohemian rout of the hippies, marching or dancing beside their wagons to the rhythm of oriental drums. Their banners are decorated with tantric sigils. Their faces are tattooed with boasts of sexual slavery. The hippies have started on their bad trip towards the cities of Christendom. The wheels of their wagons break the limbs of those of their number whom drink and drugs have made insensible to the pains of living, but, though many are lost in such a fashion, this hardly matters, for the legions of hippydom are so numerous and there are always more of them coming up from underground to join the crusade of eternal children. There are boys dressed as girls and girls dressed as boys and many of both sexes who are dressed in nothing at all. This is no ordinary march; it is a perpetual party, which moves through clouds of incense and butterflies. Menacing outriders scavenge the wherewithal for the travelling festivities, while grapes, intoxicants, candles, dildoes, and kisses are passed from laughing person to laughing person down the dancing line of march. Everything is free, including their bodies. The hippies' faces are flushed and their eyes are glazed, but they are pleasant to look upon, for they are still young. Their uprising is instinctive and beyond all reason, a locust invasion of Western civilization. They are coming in their broad-brimmed hats, Indian scarves and leather boots and, though they are still far away, I already hear cries of 'An end to Church and King!' and the jingle of little bells, and, behind that, the throbbing bass notes of the dance of Yama, the Death-God. Let them come, the wild horde from the East and, after them, the dark rains. Bright Lucifer welcomes his people.

This last paragraph is a bit weird. It came oozing out of my biro without me thinking. It certainly is not what I was thinking on the lawn last night. It is a kind of automatic writing, I suppose. I must watch out for this, or I could be taken over by this freaky sort of prose style.

What freaky prose style? The Devil with style! And huzzah for freakshows! There is, it may readily be conceived, a kind of prose

whose slow-falling cadences make it serviceable for the investigation of such curiosities as the half-understood funerary practices of pagan English antiquity, as well as for the sombre digressions which may arise from such an inquiry. In the same manner, it is sure that the perverted sports of Tiberius and his ephebes are best related in a language which resorts to the veiled licence to obscenity afforded by ironic periphrasis; the long exhalation of a dying fall will best evoke the slaughter of the victims of imperial lust, as well as the final requitus of the emperor himself. For this is a style whose blend of formality and innuendo panders to depravity, by speaking of vice with grace and circumspection. Its marmoreal sentences have been crafted against criticism. Lovers of fine writing may be seduced by fastidious diction into applauding opiate fantasies of child prostitution in the slums of London, or philosophical investigations into the nature of adultery conducted by cosmopolitan Alexandrian debauchees. Baroque paragraphs of balanced antitheses reverberate with internal echoes, symmetries and parallels. So death is a play upon words and crime a pretext for ornamental disguise. Witty doubles entendres allude to the seduction of the innocent or the desecration of graveyards, while yet simultaneously denying that any matter of weight is being written of. Words fall like snow upon a wasteland empty of moral meaning. Punctuation is like breathing and, in such a passage as this, one can hear the Devil breathing.

There it is again! My hand mocks me by writing about itself. But I now force it, against its will, to scribble the line, 'If thine right hand offend thee cut it off.' Having been threatened with the biblical sanction, my hand is under my control again and writing what I want.

No. I did not think about the Wild Horde from the East nor did I hear the Devil's breath last night. Instead, having dealt with Julian's rubbish to my own satisfaction, I started to think about what I should do about Dad's message regarding my dying mother. There was no way I could leave this remote place last night. Apart from anything else, I was too drunk. Tomorrow morning would be Sunday. To undertake the journey from the backwoods of Herefordshire to Cambridge by public transport on a Sunday would be incredibly wearisome, if it was possible at all. Being honest with myself, I had

to recognise that I found the idea of sitting beside the sickbed of a querulous old woman deeply unattractive. There were also grounds for suspicion. Dad was angry at me for postponing my weekend visit to them and so he was manufacturing this health crisis to get back at me. He was trying to claim his emotional pound of flesh. If I gave way on this, his first test would be followed by other tests. My mother was an emotional encumbrance and, on the path of the sorcerer, one cannot afford encumbrances. What I needed more than anything else was to learn to obey my own true will.

Having made all these points to myself, I then realised that they were exactly the sorts of points that Felton would have made to me, but he no longer needed to make them, for it was as if I had my own Felton growing in my brain. My meditation about sickbeds and bus-journeys to Cambridge, not to mention Felton in the brain, had quite ruined my epiphanic moment. It was gone beyond retrieval and so I went back inside.

I found them in the smoking-room. Felton was going over Julian's diary, just like he does with mine. There was stuff in it about Julian's recent attempt to escape the surveillance of Mr Dunn, the butler. This was obviously going to be interesting. So I stretched out on a chaise-longue, eager to hear extracts from Julian's diary read out as some kind of bed-time story. Unfortunately I fell instantly asleep. I have no idea how I eventually ended up in my proper bedroom.

Sunday, June 4

I was awoken by the cry of peacocks on the lawn. It is all very grand and beautiful, but I now realise that Maddiscombe Hall is a kind of mental hospital with just one patient, Julian. There was of course no breakfast until the service to Aiwass had been celebrated. So I lay in bed, writing my diary and brooding about what had been said yesterday. Up to a point, Julian is right about the subject-matter of today's pop-music, though 'copulation – nothing but' is putting it too crudely. But the

songs are about love and hardly anything except love. Taken as a whole, the canon of pop songs constitutes a kind of encyclopedia of modern love: loveless loneliness, love at first sight, chatting up, shyness, the first date and the first kiss, all the way through to breaking up, trying to make up and, finally, looking back on lost love across the years. The mnemonic rhymes and rhythms of pop music tell us how to comport ourselves in our mating rituals, what to say and how to feel. The lyrics annotate the movements of our hearts. The hippy revolution is love, plus songs, plus electricity.

Julian is right too about hippies being effeminate. So is a lot of the pop music. Consider The Who's 'I'm a Boy'. But surely it is a good thing to be effeminate? On the subject of sex, assuming reincarnation is true as Cosmic says it is, I have always wondered why do so many souls, just over half of them, choose to be reincarnated as females rather than males?

The Invocation to Aiwass was held in the deconsecrated oratory which is next to the house. A statue of Ahriman stands where the Christian altar once was. Serpents coil round Ahriman's contorted body. A couple of local members of the Lodge drove in for the service of Invocation. Most of the Magick rituals I have participated in so far have been pretty boring. (Which fool was it who said that the Devil has all the best tunes? Not someone acquainted with the rituals of Crowleyanite Magick. I have yet to hear anything to match 'Onward Christian Soldiers', or 'Jerusalem'.) This service was only enlivened by the escape of the goat before Felton could take the razor to its windpipe. So, while Julian, standing beside Ahriman, continued to intone the names of the astral servants of Aiwass, the rest of us were chasing the goat between the benches. Finally, Granville lunged for its haunches in a kind of rugby tackle and managed to hold it, until Felton was able to get his hands on its halter. The red-eyed goat, the embodiment of baleful maleficence, had its throat slit to consecrate a forthcoming 'Consecration of the Virgin', whatever that may be, and, as on previous occasions, we all drank the blood of the sacrificed beast.

To breakfast on goat's blood is not a pleasant experience. Fortunately, this was followed by a proper breakfast back in the house. I had kedgeree and black pudding – the first time I have ever had these things. My enjoyment was slightly spoilt by Felton coming up behind me and remarking that my poor old mother was probably going to get better quicker without me dancing attendance upon her.

After breakfast, Felton had Julian show me over the house and its grounds. This Julian did without any enthusiasm. He was rather like a bored estate-agent showing an unlikely customer round the place. It was a big property, but there was nothing to interest me particularly, except that I noticed that all the upstairs windows had bars on them. Our tour ended up in the gun-room. Julian got Mr Dunn to unlock one of the cupboards and Felton and Granville joined us and we all went out to do some clay-pigeon shooting beyond the tennis courts. Then there was lunch. After lunch, Felton slipped me coins with which to tip the butler and we all went off to collect our bags. I was first back down into the hallway where Julian was waiting and looking just as depressed and anxious as when I first met him. I offered my hand to him and prepared myself to utter some words of conventional thanks for his hospitality. But instead he thanked me, albeit in a somewhat half-hearted way.

'I suppose I should be grateful to you. You are the one who is going to set me free,' he said, but he did not take the proffered hand.

(Obviously Julian loathes the sight of me. Here is another person who, like Alice, hates my guts. It is oddly disturbing to experience oneself as hateable. And maybe now Sally has also joined the club of Peter-haters. I do not like to think about this. Yet I will think about it – just like I think about sliding down the razor-sharpened banister.)

In the car on the way back to London, Felton casually asked me,

'Would you really like to be a hippy, Peter?'

'No. It was a debating point. Julian just got on my nerves that's all.'

'Good, the Lodge has no need for hippies, or any other kind of drop-out. What the Lodge wants is people in positions of influence. It is prepared to make great sacrifices and to wait a long time in order to get its chosen candidates in the right places. As a drop-out, you would be useless to us, Peter. We want you to have a job, to marry and have children.'

Then casually,

'What did you make of Julian?'

'Well –'

I hesitated and he, seeing this, laughed. 'Oh don't bother. I will find out soon enough after I read your diary entries for the weekend.'

'Actually, I did not care for him very much and I don't think he likes me either.'

'Perhaps you will change your mind when you learn that he has decided to make you his heir. The house, the estate, the money, it will all go to you.'

Are Felton and Granville pulling my leg? I did not exactly get the impression from Julian that I was the son he wished he had had but never did have. All the same, it was a good fantasy and I sank back into my seat and imagined what it would be like to inherit Julian's house. It would be fun to turn the place into a hippy colony, where all we freaks would be waited on by butlers and maidservants. We could turn over the maids, while the butlers might service the chicks with our permission. Then the servants would pass round post-coital joints on silver trays. In the summer there would be marquees on the lawns for rock concerts. Upper-class living is wasted on the stuffy upper-classes; only the hippy really knows how to get full value out of pleasure . . . Then there was Julian's remark about me being 'the chosen one'; this was the springboard for another fantasy about me being the Hippy Messiah. That has a fine apocalyptic ring, does it not? I should play the guitar like Dylan, heal the sick and make the dead walk again.

From there I drifted on to thinking about the difference between hippy and beatnik. Robert Drapers claims to be a beatnik. That is why he wears black roll-neck pullovers. Also he reads depressing existentialists and claims to suffer *nausée*

116

and *angst* and other things with foreign names. He really is 'beat' in the sense that life seems to have beaten him. Whereas I really am more interested in the hippy thing. Beats strike me as being really pretty straight. I have seen a photo of the archetypal beatnik, Jack Kerouac. He has short hair and he is standing on the porch of his mother's house, wearing a check shirt and drinking beer from a bottle. He could be auditioning for a part in *Seven Brides for Seven Brothers*. I mean, how straight can you get?

With a jerk, I suddenly remembered something which all the business of the last few days – what with the move, the break with Sally, my father's telephone calls and the country house weekend – had driven out of my mind. I had to go to a conference on the sociology of cognition at Leeds the following day. A couple of weeks ago I had even prepared a paper on 'Cognitive Dissonance in Children's Play Fantasies' and I was supposed to be giving it on Monday afternoon. I told Felton about this. I thought that maybe he would forbid me from going to the conference as well, but it was all right with him.

We were later getting back to London than we should have been and, having got to London, we had to first drop Granville off in Kensington. We had missed dinner at the Lodge, but Grieves had put sandwiches out in the kitchen. I had hardly finished the last mouthful when Felton urged me to take a bath. If I was making an early start tomorrow, it would be better if I took a bath now. There was no reason to argue and I went upstairs, got in the bath and lay back and thought about my seminar paper and then about the events of the previous couple of days. I was looking forward to writing my diary in bed.

I was wandering back down the dark corridor in my pyjamas when I heard something which made my skin prickle and my body feel cold all over. It was the sound of a woman singing opera. The sound was coming from my room and from my record player, but I had put no record on and this was not my music. I pushed the door open. Although I had left the light on when I went for my bath, the room was now in darkness. I stood there hesitating and thinking of turning and

running, when a match was struck and a candle lit. It was Laura who sat on my bed and held the candle up to my face. She was smiling.

' "*Voi che sapete.*" You who know about love. It is Mozart, Peter. "Love is the Law. Love under the Will".'

She spoke in clear bell-like tones. She was wearing a tweed skirt and silk blouse. She patted the bed, motioning me to sit beside her. I did so and we sat close but without looking at one another.

'Peter, I want us to play a game of pretend. Let us pretend that I am a virgin and I want you to seduce me.' She paused and reconsidered, 'Or rather that I might want you to persuade me that I want to be seduced.'

I could hear her breathing. She was tense. What was I supposed to do? And never mind what I was supposed to do, what did I want to do? Looking at her properly I saw that she was quite a bit older than I was, but not actually old. She was in her forties, I suppose, and vaguely attractive in a matronly sort of way. Without looking at her, I placed a hesitant hand on her stockinged knee. She brushed it off.

'I don't want a grubby feel. Talk to me. Persuade me that you love me and that I should sleep with you.'

'Well, I don't and I'm not into pretend games,' I said. 'Look sorry, Laura, it's nothing personal, but I don't need your sex lessons. I've slept around and had a lot of experience.'

'Now, don't be so graceless, Peter. Simple politeness should have dictated a more courteous response to an older woman who is proposing to go to bed with you – eventually, if you play your cards right. I am sure that you do not need sex lessons. That is not the point. We could be mistaken, but we suspect that you do not know much about courting – about how to make a woman feel special.'

(Courting? Get real.)

'We are not interested in whether or not you can get it up with any dolly bird. The question is whether you can court a respectable, innocent girl and, not to put too fine a point on it, seduce a virgin. Now do you have experience with virgins?'

'No, well, I admit that I don't go around collecting

maidenheads. But I can't do this. It's silly. What am I supposed to say?'

'You have to understand that I am a virgin, so this first time I will be afraid. You will need to reassure me about it. You will also need to persuade me that you are serious and that this is not some casual affair, but that you really care about me. Tell me I am beautiful. Tell me how much I will enjoy my first full experience of sex. Promise me marriage. Promise anything.'

'This is just so weird. I can't.'

'Don't be chicken, Peter.' She reached out to me reassuringly. 'You've had plenty of experience at role play during the pathworking sessions. This is just another sort of role play and one that will be much more enjoyable than most, I promise you. It's really not that hard a thing. You must have had a lot more experience in seducing girls than I have at playing at being a virgin. It does not matter what you really think about me. Just make something up. Obviously I want to go to bed with you, otherwise I would not be sitting here. But, as far as the pretence is concerned, I'm young, inexperienced and emotionally insecure. So I just need to hear some words that will make it seem all right for us.' And suddenly, in an artificially high, schoolgirlish voice, 'Oh Peter, are you sure it's all right, just the two of us being here alone?'

Some play acting and then, at the end of it, a good fuck. It was freaky, but I decided to enrol in this impromptu course on how to seduce virgins.

'We really have to be alone, Laura for me to tell you how much I love you. I would be too shy to do it in a crowd of people. Besides, isn't it pleasant being here on a summer's evening in the candle-light and listening to Mendelssohn?'

'Mozart,' Laura corrected me instinctively.

' – listening to Mozart. This is our night, our moment and nothing is more important than our love – at least nothing is more important than my love for you. I still don't know how you feel about me.'

'I don't know,' she replied. 'Perhaps it is not so easy for a girl to know what her feelings are.'

I took her hand. With half my mind, I was trying to

remember seduction lines from films like *Alfie* or *The Knack*. Trying, but not succeeding. I was on my own.

'That is something I just can't understand, Laura. I know how I feel. Whenever I see you, I feel weak. I didn't ask to fall in love with you, but, now that I have, I am in perpetual pain. Perhaps it would have been better if I had never met you. Then I would not be in this terrible pain – '

I stopped and turned anxiously, as Laura was leaning forward, bent double. Only as I looked closely did I see that she was convulsed with laughter.

'What is it darling Peter? Is it the gallstones again?' And shakily trying to pull herself together, 'Oh, I'm sorry I know that's not fair, but really you were going a bit over the top. Sorry, sorry. Take it from "Perhaps it would have been better if I had never met you". '

She composed her face and struggled to gaze back at me gravely.

'Perhaps it would have been better – '

It was no good. She creased up with laughter again. Something inside of me did a flip. Hitherto, she had been to me a Lodge teacher and a strange old bag. Suddenly I found myself sitting next to a living, breathing, laughing human being and I desired her intensely. I had a hard on.

'Oh this is hopeless.' She managed eventually. 'No, go on Peter. Give it your best shot.' But she was weeping at the ridiculousness of it all.

'Perhaps it would have been better if I had never met you. But though I am in pain, it is still a very sweet pain. Laura, may I kiss you?'

She nodded,

'Of course you may,' and hastily wiping away the tears of laughter, she turned her face to me.

From what Mr Cosmic had been saying, I was expecting Laura's kiss to be like a blowtorch on the mouth. However, she was still trying to act out the part, and she only opened her mouth a little and she did not allow my tongue to get very far.

'Laura darling, you have such a beautiful body. It is a pity to keep it covered in clothes. Will you let me undress you? Just

that and nothing more? I only want to look at your glorious body unclothed and worship it with my eyes.'

'Aaah, yer father's moustache!' she replied in a croaky voice. 'Sorry, sorry. Well Peter, I don't know. Won't Daddy be angry?'

'He need never find out.'

As I said this, I was grimly fumbling at the zip of her skirt. Unfortunately the zip had snagged.

'Let's both be naked. I too would like to stand naked before you so that there are no pretences between us.'

Now Laura who had been watching my struggles with the zip with interest, just threw herself back on the bed and howled.

'Oh Laura Wilkins, how on God's earth did you ever get yourself in this fucking stupid, stupid, ridiculous situation?' And then, 'Oh, let me do the zip. Yes, I definitely think you've persuaded me that I ought to yield my maidenhead to you. I'm bored with being a virgin. Come on let's get our clothes off and fuck.'

We stood to strip in front of one another. She was wearing a corset and the straps of the corset dug into the flesh of her shoulders. I was already fancying her, but this pathetic physical detail made me fancy her rotten. I was on my knees in front of her and I was not acting as I unclipped her suspenders and murmured endearments to her mute but glorious legs. Then I rose to kiss her and she ran her fingers down my ribcage.

'You have an amazing body,' she said wonderingly. 'It's like the body of a flamenco dancer. I wonder if there can be space for a heart in such a skinny body?'

Then,

'Oh Peter, you will be gentle with me, won't you?'

Her whole body was rippling with laughter as I entered her.

Laura was a good lay – no, let me rephrase that. She was a sensational lay. She knew about things that Sally had never dreamed of and some of those things were seriously weird. After sex, she produced cigarettes. I had never seen her smoke before.

'Well, we cocked this one up – to coin a phrase,' she said finally. 'The Master is not going to be pleased.'

'Need he ever know?'

'Unless Aiwass strikes him blind in the next twenty-four hours, he will know all right. He will read about it in my diary. Just as Felton will read about it in your diary. They will probably compare notes.'

'Oh.' (I had thought that we would keep the details of tonight's encounter secret. Stupid, but that is what I thought.)

'Tell the truth and shame the Devil,' said Laura. 'That's what I say – not that I've ever seen the Devil ashamed.'

She was now very brisk, smoothing down her skirt and touching her hair. Seeing my horrified expression, she allowed herself a little smirk.

'Things have not worked out quite as planned. Still tonight's encounter has brought us closer together. I hope that soon you will come to regard me as your new mother.'

' My real mother is dying.'

'Yes, I know.' She paused at the door. 'If I were you Peter, I would not go to sleep yet. It will be better for you if you write your diary now, while every detail is fresh in your memory. You have to tell the truth in your diary. The penalty exacted by the Lodge for not doing so is pretty grim. Take it from your new mum.'

So I did set to work straightaway bringing my diary up to date and it was late before I could set my alarm clock and allow myself to drift off to sleep.

Monday, June 5

I set off as early as the trains would allow to the conference in Leeds University. I only missed the speech of welcome and a couple of short papers. Michael was also at the conference and we talked over coffee. I had to explain a bit about my new address and although I was studiously vague about what sort of set-up Horapollo House was, he still twigged that I was tied up with some sort of occult group and he was caustic about it.

'All these kinds of esoteric set-ups are after one thing and one thing only and that's money. They will milk you dry.'

'I don't think that it's like that with my lot, Michael. Pretty much the opposite, in fact.'

'It's your funeral.' He shrugged. 'I suppose it could be interesting from a sociological point of view. You could do a paper on it, "Inter-group Dynamics in a North London Organisation of Occultists", or something like that.'

'No way, Michael. I'm really serious about this.'

'More fool you. What do you expect to get out of it? If these people really have got amazing mystical powers and all that stuff, why aren't they ruling the world, instead of preying on gullible young students?'

'How do you know that they are not ruling the world?' I retorted. 'Outer appearances are not the same as inner reality.'

Still he had a point.

My paper was at the end of the afternoon. I gabbled it a bit, but it went OK, I think. Nobody could understand what I was saying, so there were no questions, so it was successful in that sense. I would rather not be understood than be asked difficult questions. We were all supposed to be talking about 'cognitive dissonance' in society, but none of us seemed to be clear what that was. I feel terribly young, compared to the other researchers here. Well I am young to be doing a doctorate, I suppose. Conferences are hectic affairs and I hardly had a single minute to think about Laura's night visitation, or about Mum's illness. I felt somewhat guilty at not being in Cambridge with my parents. However, at least, the Lodge wants me to advance myself and encourages my work, whereas Dad does not take my studies seriously. Things overran at the conference and I had to spend the night in a sleeping bag on the floor of a lecturer's office.

Tuesday, June 6

I awoke, stiff and uncomfortable. I decided to spend the greater part of the day in Leeds, talking to other sociologists and

exploring the faculty library. Leeds is a bleak, grey place. My train got me back to London too late for dinner at Horapollo House. I went straight to bed exhausted. This time I had no company.

Wednesday, June 7

I looked for Laura at breakfast, but she was not there. Shall we have another opportunity to play at seducer and virgin?

This morning, for comparative purposes, I went to a different school playground. The stumpy and aggressive little children reeling about in play reminded me of figures in a Brueghel painting of a carousel at some village fair. The purpose of the fair's centuries-old celebration has been long forgotten. It is playtime and for half an hour the world has been turned upside down. I think that I should not like to be trapped with these sinister little monsters, stunted incarnations of violence and folly. I watch a ring of infant bullies close round their chosen victim and I hear the taunting rhythm of 'Neeurgh, neeurgh, neurgh, neurgh, neeurgh' and I shudder. Felton is curious why I cannot find a playground more conveniently close at hand in the Swiss Cottage area. I suppose that might be a good idea, only I already have so many notes based on the St Joseph's playground.

On my way back in to Central London, I see that the newspaper headlines are full of the Israeli attack on Egypt and the Middle East conflagration in general. I remember Felton saying that Damascus is the prophesied birthplace of the Antichrist. Perhaps the Apocalypse has begun. I have to return for the second fitting of the dinner jacket (this time without Granville). The little man measures bits of cloth against my body. I hate this black thing that he is making for me. It feels like my winding sheet. Perhaps my dinner jacket will be ready in time for me to attend the Apocalypse wearing it. Correctly dressed and with champagne glass in hand, I should watch the fires pour down from the heavens. (Cosmic told me a few months ago that he was hoping that the world will end on a

Wednesday. After thinking about this for a bit, I asked him why. He said that it would break up the week.)

By the time the fitting was over, I decided that I had had enough for the day and I made my way back to Horapollo House. Unusually, there was no one about. So I decided to explore the place – not the private rooms or anything like that, for, after all, I am not a spy but a resident. So I confined my investigations to the communal areas and those bits of the house which did not seem to be used for anything in particular. I was just orienting myself in my new home. Despite the innocence of my intention, I kept having this fantasy about the overbold sorcerer's apprentice taking advantage of his master's absence. The apprentice would proceed, all wide-eyed and tippy-toes, from room to room, pushing the doors open and finding marvel after marvel, each room more marvellous than the last – until, that is, he comes to the last door. He knows he should not go near it, but it swings open of its own accord and then the horrified apprentice beholds a room full of naked bodies hanging on meat-hooks. There is just one meat-hook on which there is no body . . .

Well, I found no meat-hooks, nor any skeletons in cupboards, but what I did find was, in an odd sort of way, almost as disquieting. The centre of the house and its east wing are in good repair and recently decorated. There are those antique carpets and the candelabra in the hallway and the modern furniture for the two lecture rooms, and so on. But the west wing is so very different. Once I turned in that direction, I found rooms with no lights but only loose wiring, holes in the floor, broken window panes, in one room a dead bird surrounded by shattered glass and in another signs that it had been camped in and that someone had tried to start a fire in the middle of the floor. I believe that this wing was once properly occupied by the Lodge, for there are flaking Thelemic frescoes in the corridor on the first floor – a naked man making the sign of the *manu cornuta*, a black beast sodomising a white nymph, a cat crucified on an ash tree. The frescoed corridor seemed to go on forever – I think it might even run on into the next building – but I turned

125

back rather than press on through the murk to the end. I returned to my room very thoughtful. It is just so odd – the brilliantly lit opulence in the hallway and all that squalor and dereliction in the wing – as if Horapollo House were just a stage set.

What is it with the west wing? *What was it with the west wing? The wind blows up in the west and beats against the walls and windows of the house, requiring entrance. It will not be denied. It will find a way. It always does. Is not the house an emblem of a man's mind and of necessity a place to dream in? He who dreams is like a man who squats in his skull and takes his pleasures in the world and hopes for power and wealth and entertains his acquaintance at his comfort. He stands at the entrance of his head to welcome his friends and neighbours into his private place, bidding them take their ease within and telling them that there they may find shelter from the howling, angry wind. Yet, though it is certain that the walls of the house are very strong, its windows are eyes which cannot be shielded and when the Enemy comes riding on the wind, he will set his lance and gallop pell-mell, heading for an eye. No man can deny entrance to what comes in through his eyes. So you may conceive of the man of the house and his feasting companions making merry in the dining hall and heedless of the Enemy within. And the Enemy, having made his entrance and found a private room in some upper part of the house, he too makes a feast and having invited the moth and worm to join with him, they set to consuming the fabrics and furnishings of the house. Then, invigorated by his mouldy banquet, the agile Enemy will set to digging pitfalls in the floors and laying snares for the night. Is not this the very figure of an ageing mind?*

Such stuff is daft. As soon as my hand had written the above, I dropped the pen and decided to think about Sally instead, in the hope that thoughts of her would drive out thoughts of the Enemy – whoever he is. I put Alan Price's single, 'Simon Smith and His Amazing Dancing Bear' on the record player. A repeated phrase on the piano introduces the insouciantly innocent lyric. As I listen with my head in my hands, I fantasise that a ghostly Sally, materialised by the call of the music, is with me in the room. 'Oh, who could think that a boy and bear could be well-accepted everywhere?' A year ago Sally

and I were at a Christmas party at which the Alan Price number was played again and again, and every time it was played, we danced. We were like possessed by the tarantella or something. We just had to. Now once more 'Simon Smith and His Amazing Dancing Bear' is played again and again. The music is jaunty, yet its joy is not for me, yet, when I think of her moving to the music, I cannot get it out of my head that her last words to me were, 'You are evil!' Breaking with Sally was kind of heavy. Heavy? What kind of heavy? *Oh, it is a heaviness which weighs upon the breast and squeezes out the heart's juices. It is a weight which, once it presses upon the cushion of the heart, never shall be shifted.*

After writing those words, I hurled my biro away from me. I ran to the bathroom, for I thought that I was close to vomiting. I hung over the bowl of the lavatory, watching my reflection and waiting for the spew to come, but nothing came. I considered putting my finger down my throat to force the sickness out of me. All this crazy stuff I find myself writing in my diary. It is as if I am being dictated to by something which wants to think my thoughts for me. If I find that I keep on writing things like that, I may have to cut my right hand off, so that I may not end up as the slave-stenographer of the Unseen. I was roused from thoughts of scribal servitude by the ringing of the phone.

It was ringing in an empty house. Where was Grieves? I decided to leave it. But it kept ringing and ringing. It was like an accusation. I should not have been there to hear it. I crept down to the hall and picked up the receiver. It was for me. It was dad at the other end and I started to explain how I hoped to be able to come up this weekend. But he cut me short.

'There is no need. She is dead.'

He waited for me to say something, but I could not. I had my fist in my mouth. He sighed heavily,

'Well, try to come to the funeral at least. It is on Monday at the Baptist Church – you know – the one she started going to when she became ill. If you are going to be in the cortège, you need to be here about an hour and a half beforehand.'

'I'll be there. Dad, I'm sorry.'

He put the phone down without replying.

I walked out into the garden and paced about in the sun. Though the sun was now low, the light was still very bright and, besides, I did not want anyone to see my eyes. So I put on the shades. *Though the garden is summery, the young man is cool in his shades. His darkening vision takes in the creatures standing in the shadows, who wait and hide from the sun and he senses that they, like him, are waiting for the descent of the Black Light and the door which swings open on Eternity.*

The Hell with Eternity. I was worrying about Felton and what his likely reaction to my news would be. I thought that he would probably try to forbid me from going to the funeral. But when eventually, just before dinner, I found him, he seemed affable – even, perhaps pleased that I sought his permission to go to my mother's funeral. Perhaps it was the fact that I sought his permission. Perhaps it was that he was pleased that my mother, an obstacle on my occult path, had been removed by fate. Perhaps he thinks that funerals are good for one. I do not know. He merely wanted to know in which cemetery my mother was being buried.

Before switching the light off, I committed the Mass of the Phoenix to memory. Although I had feared that I would not sleep, I drifted off almost immediately. I do not think that I had been asleep for very long before I was awoken with a kiss. Only half awake, I was almost choking on the tongue in my mouth. It was Laura. I must have been crying in my sleep and in the pitch darkness I felt her hands touching the wetness on my cheeks. Silently we made love.

'Laura?'

'It is not Laura who has been lying with you, it is your new mother, the Lady Babalon.'

When I next awoke, Laura was no longer there. It was still the middle of the night, but there was a terrible noise coming from somewhere in the house. I lay there listening and trying to decide what the noise above me was – a mixture of screaming and banging. Then, since there was no chance of drifting off, I decided to get up and have a pee. So I padded off down the corridor to the bathroom. I was on my way back to my

bedroom when I became aware that the sound was much louder and closer. I turned and was just in time to see a naked man come clattering up behind me. His screaming red mouth was open wider than I have ever seen on any human being. I got smartly out of his way and watched him go past and turn to go clumping down the stairs. It was all very fast, but I just caught a glimpse of his disappearing feet. They were bloody and shod with horseshoes. The noises died down and I went back to bed and eventually got back to sleep.

Thursday, June 8

There is no way that I can work today. Sometime after breakfast I give Cosmic a ring. He sounds bleary and it is clear that I have woken him up, but I arrange to go round to his place for lunch. (The honour of a freak is like that of an Arab tribal sheikh, for a freak never refuses hospitality. His records can be borrowed, his food must be shared, his joints may never be hogged. If you want his old lady, be his guest.)

Almost the first thing I say when I get there is,

'My mother is dead'.

Cosmic does not bat an eyelid. It is like he already knew.

He passes me a joint. He had six joints all ready, rolled and lined up on the wooden altar at the foot of the pyramid. He finds me a light, before speaking,

'It's nothing to be bugged about. "Dead" is a straight's word. "Dead" is like a line drawn at the bottom of a bank account that has been closed, but a person's life is not a bank account. It is often overdrawn, but it is never closed. We all go on forever and ever.'

I inhale and then reply,

'On Monday they are going to put her body in the earth. In a matter of a few more days, that body will start to rot and liquefy. My mother is dead.' My words come out all mixed up with smoke – like that scene in the film of *The Golem*.

Cosmic shakes his head. He is seriously shocked,

'You should not talk about her like that. Quite likely she is

129

listening to us now, hovering about on the astral. She isn't going to want to hear you describing what will happen to her body. That is irrelevant to her present state. You have heard the news in the lectures. The soul travels from body to body. Your mother will spend about six weeks in the astral plane before reincarnating. She will probably decide to become a man this next time. Remember how Aleister Crowley was a Cretan temple priestess called Aia in a previous incarnation.'

I pass the joint to Cosmic and he draws heavily on it, as if for inspiration. Then he crawls over to the record-player and puts some music on.

'Many years on from now,' he continues, 'you will pass a young man in the street and he will look at you as if you are strangely familiar to him, and you, when you look at him will think that, yeah, there is something familiar about him too and yet you are sure you have never met. You will put it down to *déjà vu*. You can't argue with *déjà vu*. We have all had it and it is proof that we have all had previous existences.'

This is a shouted declaration of faith, as 'Highway 61 Revisited' is really loud on the record-player and Dylan's sarcastic snarling fills the room. Last year, heads I knew were going around saying that Dylan was 'the God that had failed'. After 'Blowing in the Wind' and 'Masters of War', he had sold out and turned his back on his authentic folk roots. It was not on to accompany protest songs with an electrified guitar and do so in good faith. Could it be possible! The people in the market-place hath not yet heard of it, that God is dead! But after Dylan's motor cycle accident last July, now people are not so sure. Sally (who is a Donovan freak) still thinks that Dylan is evil, a ruined archangel punished for the arrogance and excess of his genius. There are rumours that he is now hideously disfigured. Cosmic reads things differently. He thinks that Dylan, following his appointed path, has gone into occultation. It is like when Wotan left Valhalla and submitted to being hung for nine days and nine nights on the Tree of Ygraddisil so that he might learn the wisdom of the Norns. Soon, very soon, Dylan will emerge from occultation with the new higher truth.

Once we have got down to the roach of the joint, Cosmic brings out lunch. Lunch: brown rice, hot green chillies and a couple of cans of beer. But first there is a preprandial drink – Cosmic is really pushing the boat out – and we each swallow a whole bottle of Dr J. Collis Browne's Chlorodyne. The thick brown liquid tastes disgusting, a bit like drinking stewed opium (another thing which sometimes emerges from Cosmic's cocktail cabinet) and the chillies are partly there to take away the aftertaste. Chlorodyne is supposed to be taken by old ladies for rheumatism or something, but, according to the label, it has opium in it, plus all sorts of other interesting substances. It produces a really good woozy blast, especially if one follows it up with hash.

Cosmic is really very, very generous with the joints. The room is full of smoke which I try to sculpt with my hands. Listening to Dylan, it comes to me in a flash of illumination how good music is. It is a whole lot of sounds all strung together. On their own they would not mean anything, but when they are strung together, they make really nice patterns. It is really good that . . .

We get on to talking about my guitar-playing, which Cosmic says is not so hot. He is coughing and giggly and really apologetic about it, but no way do I sound like Dylan. I have to agree. I say that I have to find time to practice more.

'Practice is not necessary,' replies Cosmic. 'Your problem is that you have not come to terms with the elementals in your guitar. You don't know how music works do you? Can you explain in scientific terms what is happening when you hear some music?'

'No, but I don't have to be scientific in order to hear music.'

'Yeah, but to play properly, you have got to work with the elementals. Let me spell it out for you. Musical instruments are made of wood or metal and all such natural substances contain elemental spirits trapped inside of them. Elementals give organic things their shape and signature. It is all explained in the alchemical writings of Paracelsus. Now your guitar is full of dryads – wood spirits – who can only escape

from the wood on the wings of tune and these spirits are only finally set free in a person's ear – the person who is hearing the music that is. Meanwhile, the music in the air, acting as a kind of siren song, traps other elementals and locks them into the musical instrument. Remember that pathworking we had, based on *The Tempest*, and how the witch Sycorax confined the spirit, Ariel, in a cloven pine and how the magician, Prospero, freed the spirit? That's an allegory about the entrapment and release of music. You've got to learn to free the spirit.'

'You are telling me that all the time when I play my guitar, that invisible little spirits are leaping in and out of it, like my guitar was a sort of sonic swimming pool? You are having me on. You are saying that that is music?'

'That is a fairy-tale, but it is a fairy tale which happens to be scientifically true. The mystics have always known this, because it is part of the ancient Bardic tradition. Modern scientists are only just discovering the same thing and confirming ancient musical truths.'

I think about this. Then I spot a flaw in his argument and I pounce. I prod him in the chest,

'Well that's my guitar-playing sorted out. But how about the music which comes out of the record player? How are you going to explain that?'

We are high as hawks, discoursing on a really elevated plane. Cosmic smiles and scratches his nose. Looking at him a bit out of focus, I find that his face is all yellowy and rubbery and it keeps stretching into strange shapes – like he cannot control his appearance any more. It looks simultaneously demonic and entirely normal. It makes no sense, but it is a bit like if one keeps repeating the word 'dog' over and over again, it ceases to have any meaning at all or maybe it has all the meanings. Who knows?

Suddenly Cosmic's face pulls itself back into its normal shape,

'Got a magnifying glass?' he asks.

'No.' (I do not normally take a magnifying glass out with me, when someone invites me to lunch.)

'Oh well, we will have to manage with the naked eye. Look closely at the surface of this disc.'

He takes 'Highway 61 Revisited' off the record-player and moves it up and down to catch the light in different ways.

'Look here! See the tiny shimmering patterns on the surface. These are the shadows of the elementals we are looking at. Aren't they beautiful! If we concentrated, we wouldn't even need to play the record to get a buzz out of it. This is recorded music, so they are all of them dead – the lifeless replicas of living elementals. They were constellated in the air and then fossilised in vinyl . . .'

Cosmic keeps talking, but I drift off, gazing at the oily shapes which shimmer over the grooves of the record and I think about Dylan's near-death experience. Perhaps his recording all those LPs brought him into too close a contact with dead elementals? Perhaps Sally is right about him? Sally used to inhale and then blow the hash smoke into my mouth. I wonder if Cosmic has been to see Sally yet? Will she start getting at him too, to try and get him to break with the Lodge? I want to ask him if he has been to see her, but then again I do not really want to know. It would be ironic, if she breaks with me because I am tied up with the Lodge, but then shacks up with Cosmic. For after all he is as deep into this occult thing as I am and he too is under the obedience of the Master. Still, it's a worry, for Sally swallows everything that Cosmic tells her, whereas I do not believe that all this elementals stuff really is in Paracelsus. For Christ's sake, they did not have record-players in Paracelsus's time. Cosmic is just making it up as he goes along.

Cosmic pulls me out of my reverie. He is saying something on the lines that owning a record collection is like being the manager of a haunted cemetery. I would like to sleep and I have lost the thread, but I lunge desperately,

'So how do we hear these elementals if they are dead?' I ask.

'How do you normally hear what is on a record?' He is speaking to me as if he is addressing a dummy.

'Well, I put it on the record-player and switch the record-player on. Is it the electricity that wakes the elementals?'

'No, that's crazy! If that were true nobody would be able to hear music coming out of wind-up gramophones or musical-boxes. You dope, it's obviously the stylus which releases the music! You've got a sapphire stylus, haven't you? Since it's mineral, it will be inhabited by tiny gnomes. The dead sylphs, undines and other elementals on the record are liberated by the gnomes. If only you could see them, you would behold them come floating out of the speaker and circulating in the air before trying to find your ears.'

'If only I could see them . . .'

Cosmic lights the last of the six joints. Watching its tip begin to flare, I get a sudden pang, experiencing the transience of all things. He takes a hard draw, hands it to me and watches me as I nurse the joint. It is like a sacramental chalice passed between us.

'We're mates, right?'

I nod warily. I sense that what is coming next is not good.

'Well explain this to me. You know fuck all about music, and fuck all about most things. You spend less time on the meditation exercises than I do and yet you are Felton's blue-eyed boy. Don't get bugged by what I'm saying. It's nothing personal. I'm just curious. I want to know. It's not just Felton. It seems that Laura has got the hots for you too. And now I hear that they are going to make you a zelator soon.'

This is news to me. I do not think that it can be true. I smile propitiatingly at Cosmic. A mistake. He does not respond well.

'What are you smiling for? Don't tell me. I'll tell you. You're smiling because you think I'm stupid, so stupid that I don't even guess that you think I'm stupid. It's the same with Felton and Laura. They don't take me seriously because I'm not of their class and I didn't go to university.'

He stands up and spreads his arms out like bat's wings. He hovers over me,

'But Peter, I want you to put this down in your diary, so that Felton can read it. I am not quite the fool that I seem and if I suspect that someone does not like me or even, maybe, likes me but does not take me seriously, then I can generate

very powerful vibes. It's natural in me. I can project vibes outwards and hex people just by thinking bad thoughts about them. So I try not to get bad thoughts, because I know that they can mutilate or even kill. Anybody who has ever crossed me has come to a bad end.'

Kneeling in front of him, I make the sign of the *manu cornuta*, the horned hand and I cry out,

'Lucifer defend me from the Cosmic Master! By the powers of Ashtaroth and Asmodeus, I take refuge in the Satanic One from all bad vibes.'

It looks like I am horsing about, but actually Cosmic in his present state is freaking me out, so, though I am play-acting, it is serious play-acting. He grins uneasily and sits down again.

'Yeah well, you don't take me seriously. But I'm being really straight with you. The main reason I joined the Lodge is so as to learn how to control and channel the powers that are already within me. I only need the knowledge . . .'

At this point, heavy with beer, chillies and dope, I nod off briefly. Then, when I come to with a start, I find Cosmic kneeling in front of me, watching me intently.

'I'm sorry man,' I say. 'I didn't sleep much last night and I've got to crash. But I can't do it back at the House.'

'Yeah, because the horrid lurgies will get you if you do. It's no hassle. You can crash here. In a minute I've got to go out and score, but you can sleep here and let yourself out, if I'm not back when you wake.'

'Thanks man. See you this evening.'

'And then again on Sunday evening.'

(I had forgotten there is to be a special ritual, a Consecration of the Virgin on Sunday. It will be a closed meeting of the Lodge – all very big deal.)

Cosmic puts 'Hapshash and the Coloured Coat' on the record player at top volume in order to help me get off to sleep, which I do almost instantly, carried off into the deep by the strange half-oriental chanting.

When I awake, it is again with a sudden start. Cosmic is no longer there, but there is what at first seems to me like a feeling of a presence in the room. Only slowly do I become

aware that the 'presence' is really the feeling of an absence. My mother is dead.

I'm a bit groggy from the Chlorodyne, so I walk about the room. Then I catch sight of a black notebook, a schoolkid's exercise book, lying on the floor. I know instantly what it is. It is Cosmic's diary. To open it would be an abuse of friendship. But I have no hesitation, since, for a sorcerer, knowledge takes precedence over friendship. I pick the book up. There is a painted silver talisman on the cover and then beneath it in decorative calligraphy a sort of curse is inscribed: 'We Aratron, Bethor, Phaleg, Och, Hagith, Ophiel, and Phul, ruling spirits above and below earth, true possessors of its wealth, do hereby command all persons, if they wish to avoid our disfavour, in no way to breach this book's secrets without its owner's freely given permission. Whoever infringes this law will be banished to the realm of Pluto.'

The Hell with that. I do not think that Cosmic has enough rank to work such a curse. I open the book, but, after the words on the outside, the words inside are a distinct disappointment. There is not much in his diary and it is not written up in the way Felton has been making me write my diary. Mostly, it records his removal jobs, plus attendance at the Lodge's rituals, but there is hardly anything that is personally revelatory. Although Cosmic is an intelligent person, his diary is semi-literate and his spelling is awful. Still there are a few points of interest. Cosmic, who listens to the Stones a lot, has taken a strong dislike to Brian Jones, whom he regards as too weedy to be a proper Rolling Stone. So he has been spending a lot of his spare time directing hex spells at Brian Jones and he reckons that Brian's recent arrest is the first result of his maledictory labours. I see that Cosmic also made the mistake of being polite to Alice. A casual 'How are you keeping?' from him drew half an hour's vitriolic diatribe from Alice, about people wasting her time by asking how she was when it was obvious that they did not care one way or the other how she was; also how Cosmic should stop trying to be nice to people so that he could discover his own true nature. It totally wrecked Cosmic's evening. He knows that he is not as sure of

himself as Alice is and he got really depressed thinking about what she had said. Also Cosmic had an audience with the Master a couple of days ago. However, he does not say anything about what transpired. Also he has been to see Sally. As far as I can tell, she would not put out for him. Cosmic notes that 'she is seriously hung up, and its not just busting up with Peter. There's something else going on in her head, which I can't suss out. She wants me to be patient.' Cosmic goes on to speculate that she has always been afraid of me, just as he is. (I find this pretty astonishing, particularly as Julian was also afraid of me.)

I let the diary drop where I picked it up. I feel uneasy about having looked at it. Not that I think that Aratron, Bethor and the rest of them are going to look after Cosmic's grotty little notebook, but it certainly seems to me possible that he does have naturally bad vibes like other people naturally have bad breath. I hurry out of his pad. I am going to be late for my session with Dr Felton. Also I'm still a bit stoned and there is nothing I can do about it.

I was more than usually apprehensive when I knocked upon Felton's door. I cannot work out how far on we are with these ghastly kissing lessons and how far off I am from being introduced to the Obscene Kiss. True I am going to get another hundred pounds. But then is it just the diary that I am selling to Felton for this price?

There is a lot to go through in the session with Felton: the pathworking based on the Westcar Papyrus, my move into Horapollo House, the parting with Sally, my work cataloguing the library, our country-house weekend with Julian, Laura's visits to my room, my talk at Leeds University, the death of my mother, the screaming man with horseshoes on his feet. I guess many people would have been totally freaked out by the horseshoe man. However, I am confident that there is a rational explanation. In fact there are two perfectly rational possibilities. First, it is notorious that anyone who takes LSD runs the risk that his trip does not totally finish when it seems to. Years later odd bits of acid hallucination can suddenly surface. It is one of the accepted hazards of tripping.

That's cool. Secondly, it is quite possible that what I saw had nothing to do with drugs, but was a genuine manifestation of the supernatural – a materialisation of the Qlippoth, or perhaps some soul in torment in the afterlife. So then Horapollo House is going to deliver what was promised and I will find myself sharing my space with such unearthly visitants as elephant-headed monsters with skewers for hands and crab claws for feet. That would be really tremendous. To know for sure that the supernatural really exists . . .

However, to get back to the point, as usual Felton misses all the important issues raised by my last few days of diary keeping. He just had his little grumbles,

'I see that you describe last Thursday's little drinks reception as "this Satanists' sherry party". Now, I know that you are perfectly aware that we are not Satanists and that you know that we regard the worship of Satan as a childish and perfectly pointless activity – something that does not really exist, except in the minds of popular journalists and pulp novelists. I know that you know this, just as I know that you are only writing such things to tease me.'

He keeps leafing through my diary as he talks. Every now and again, he looks up to see if I want to argue with him, but I am much too stoned.

'Of course, humour is supposed to be a good thing. That is an article of English, middle-class faith. In reality humour is an obstacle to thought. For example, it is evident from what you have written here that you are disturbed by Sally's description of you as "evil". Your clowning pretence that you are involved with a group of Satanists who worship and promote evil has actually prevented you from thinking clearly about what Sally might mean by the word "evil" and what evil really might be. As you describe her, it seems that Sally is not interested in thinking about evil. She is using the woolly and ill-defined concept either as a term to abuse you with, or to manipulate you by. We in the Lodge, on the other hand, have been trying to make you think about evil – and good – and to understand both the commonplace morality and the higher morality that lies beyond. Sally's notion of evil is embedded in

138

a morass of unexamined notions about humanity and human morality. On the plane we are moving to, there is no place for the sickly deceptions of self-sacrifice and consensual morality. Evil and, for that matter good, must in the end both be over-ridden by the imperative of love. In the dark lands you are about to enter the only ones who laugh are the exultant.'

The matter seems closed, but then, a few minutes later, he is sighing heavily,

'That blasted sense of humour has wrecked what should have been an entirely serious exercise with Laura on Sunday night and turned it into just a laugh and "good fuck". Yet what is at stake is terribly serious – But I forgot . . . I shall no longer be instructing you in the occult arts of the kiss. It has been decided that Laura should take over this part of your instruction. Your lessons with her will normally take place late on Tuesday and Thursday nights.'

My face split open in such an enormous grin, that I thought my head might split apart like a melon which has been slashed by a machete. Felton was presenting this latest development as a mere matter of administrative redeploy-ment, but he did not look at all pleased. He busied himself with my deplorable prose and bad attitudes. How serious everything was, but I would only know just how serious when I earned their trust. All the usual stuff.

I was vaguely aware that I ought to have been arguing with him, but I just sat there smiling. Everything made me happy. Listening to all this high-flown talk made me happier than anything. Even when he started talking about my mother's death, or rather my account of hearing about my mother's death, it did not faze me, for it seemed to me that life and death were, after all, part of a continuous flow – part of the transcendent vision which is love. Kissing Laura was going to be such a buzz and yet it was being imposed on me as work!

'You are still being selective in what you record,' Felton was insisting. 'You are still holding back, particularly with regard to your emotional response to your mother's death. Your diary is your brother. Trust your brother! If not, you will

carry the corpse of your mother on your back forever. You must let brother diary share the burden.'

I thought I knew exactly what he meant and I smiled back. It seemed to me that I was being terribly benign and so was Felton. There was this enormous feeling of benignity which even the dog was feeling, I could see that he was benignly smiling too. If only we could always understand one another like we were all understanding one another now. Then Felton broke another piece of amazing news,

'However, I do detect encouraging signs of a different kind of voice in the diary. It is clear that something is stirring within you . . . The necessary energies are being generated. I have been consulting with the Master and we have agreed that you should be raised to the rank of zelator on Sunday, after the ritual of The Consecration of the Virgin.'

A zelator! So Cosmic was right! I know that I am not supposed to use exclamation marks, but how can I not use an exclamation mark at such a prospect? And some more exclamation marks! A zelator! A man of power! The first real step on the occult ladder!

Seeing my big grin, Felton spoke more coldly,

'Frankly I am not really sure that you are ready for it. However, there is not much time. And, to come to present matters, though there is quite a lot more in your diary that I should like to go over with you, it is now time for the lecture. You had better hurry.'

I hurry downstairs to find that I am first in the room. This evening's lecture is a closed one, for initiates only. Tonight's lecture is special, a rare event, for the Master is to give the talk, which is on 'Thinking Backwards'. Laura enters, followed by her pupils, Cosmic and Alice. I notice that Alice is looking rather strange – yet even more intense than usual. Then Granville comes in and takes his accustomed seat at the back of the room.

The Master, Robert Kelley, enters and advances to the lectern. He always moves slowly, as if it were painful for him to move, but yet as if it is still possible for him to surmount that pain through the sheer power of his will. Both the pain

and the power come to him from whatever happened at the Cairo Working – so Granville told me. Once he has reached the lectern, the Master stands there silent a while, gazing at each of us individually. Alice trembles with concentration as she gazes back up at him.

'Love is the Law. Love under the Will.'

At last the Master speaks. He does so without any notes and the first thing he tells us is that he does not want us to take any notes either, but he wants us to memorise as much as possible of his lecture and to reproduce it later in our diaries. The training of the memory is of the first importance for the initiate, for the pursuit of memory is basic to thinking in reverse. Diary-keeping can serve as a basic exercise in helping to think one's days backwards. As Crowley observes in *Magick in Theory and Practice*, thinking backwards is an aspect of *Dharana*, which is control of thought. According to Crowley, by learning to remember backwards and suppress the more easily accessible thoughts, we 'strike deeper strata – memories of childhood reawaken. Still deeper lies a class of thoughts whose origin puzzles us. Some of these apparently belong to former incarnations.' In such a manner, Crowley was able to remember that in a previous incarnation he had been the great French Magus, Eliphas Levi, who once summoned up the spirit of Apollonius of Tyana. In point of fact, Crowley was born just six months after the death of Eliphas Levi, and, as a general rule, the ego of a dead person usually seeks to be reincarnated in a six-month old foetus.

Abruptly now, the Master changes tack.

'I want you to close your eyes, as you would in a pathwork-ing. Now picture yourself by a waterfall at the end of an autumnal afternoon. You are at peace, for I am with you. A fiery red sun is rising in the west, taking, as it does so, its light from the beams of your eyes. The water at the foot of the rocks in the distance foams briefly and descends to water before shooting up the rock face in a great vertical column. However, you have joined me in standing over a pool at some distance from this commotion and we have been watching over the pool's placid surface and waiting. At length, our

waiting brings results, as you see, first, a large rippling circle forms on the surface, before diminishing rapidly in a smaller series of circles, and from the centre of these circles a sharp chiselled flintstone is ejected and this flint travels in a perfect parabola to settle in my hand. You now tread backwards with sure-footed steps away from the water and ascend the hill behind you. Flint in hand and also walking backwards, I follow you.

'At the top of the hill we turn to contemplate the corpse clad in rags that lies stretched out before us on the great sacrificial stone slab. The corpse's neck has been slashed in crude, bloody strokes. But we look on this ugly sight with serenity for I carry the magic stone which alone can heal the wound in the throat. My robes seem to fall off me, as in a complicated series of gestures, I strip. You see me advance naked towards the corpse and slice repeatedly at the wounds on the throat and, as I do so, the blood lifts off the corpse's skin and rags. The blood gathers itself and streams back into the veins, reanimating the twitching body. The skin also heals itself behind the passage of the wonder-working stone from the water. The corpse, but it is no longer a corpse, screams, for I have given the woman her voice back. Now you come forward to help me by pinioning the woman's arms behind her head. I enter between her legs and, having done so, seek repeatedly to withdraw in a decelerating rhythm of withdrawal and thrust. A cry of rapture from the new-made virgin and the joy of the exultant . . . '

'Peter, wake up! Open your eyes! Wake up and look at me!'

It is Sally's voice calling me to wake. I do not want to leave the hilltop and the ceremony of the consecration of the virgin, for I am like one who still clings to heavy dope-soaked, sleep. Even so, I can longer hear the Master's guiding voice and Sally is very insistent. Reluctantly, I open my eyes.

She is standing at the door behind the Master. God knows how long she has been in the room. She is barefoot. (She likes to go barefoot quite a lot.) She looks so pretty. She reminds me of a 'sweet-cream lady' from that song by the Box Tops. Pretty and afraid, she is appealing to me for protection.

'Come away with me, Peter. Stop listening to all this perverted rubbish. I have come to take you away. Cosmic, please, you can come too.'

The Master wheels slowly round to contemplate the intruder. He has never met Sally and does not know who she is.

'Young lady, you are trespassing on a private meeting. I would like you to leave now.'

'I am not going . This is an open lecture.'

'You are mistaken. It is a closed meeting at which you are not welcome.'

'You hear that, Peter? I am not welcome. Whose side are you on? It used to be you and me against the world. Come on, you can just walk out with me.'

I sit there, saying nothing and doing nothing, acutely conscious that everybody's eyes are upon me. The whole scene seems completely unreal. Sally seems to shake in the incense-laden air, like she is a trippy hallucination. What I am thinking is that, if eternal recurrence is true, then this precise scene will repeat itself trillions of years from now. I really am a bit too stoned to go with Sally this time, but I think that next time I probably will, as she is quite seductive . . . But she, seeing that I am not making any effort to rise and join her, is becoming angry. Normally she is ice-pale, but now she is flushed. She is a beautiful fiery angel, but such beauty, in the present context, is a dangerous distraction. I really need to know how to think backwards through time. I need the wisdom of the Master. And there is something else wrong with Sally . . .

'You are vile! You are, all of you, witches!' she cries out. 'You are being brainwashed. But you can just walk out, if only you will listen to me. It's now or never. Peter, in the name of your dead mother and for the sake of your father, will you not leave these hideous people. For the sake of me, if you ever loved me . . .'

The Master smiles and, ignoring her, addresses me,

'What shall be done about this young woman?'

The Master is counting on me. I have to speak. I am aware of a fatuous grin on my face as I do so.

'Sally, it's all right. You've made your point. Please go now.'

Sally is breathing in great gulps, now at a loss for words. Cosmic sits with his head in his hands. (I blame Cosmic for this ghastly scene, for he must have mentioned something to Sally last week about this evening's meeting. Also, I wish that he had not got me so stoned.) Only Granville has the will to do anything. He rises and advances on Sally and reaches out to take her arm. He mutters something about helping to see her off the premises. She looks at him distraught. She will have nothing of his proffered aid and she eludes his grasp. Her head swivels weirdly until her eyes are once more fixed on me.

'Peter, help! Help me someone! I'm going to the police. You are brainwashers. Black filth. Perverts. Pederasts. Satanists. Crooks.'

I am not moving and, seeing this, she shrieks in despair. She claws the air, as if she sought to snatch more insults from it. Then it is over very quickly. Grieves, alerted by the shrieking, enters. Together, he and Granville each take one of her arms and they give her a courteous version of the bum's rush out of Horapollo House. The whole episode was like a kind of hallucination . . .

The Master, unruffled, straightaway resumes his talk. However, we do not return to the encounter with the newly-made virgin on the hilltop. Instead, with eyes open we listen to the Master explain how by thinking backwards we may understand the way in which the world actually works. I try to concentrate as hard as possible, but Sally's interruption was unsettling and I find I am shaking. What the Master is saying is now quite hard to understand and I am distracted by thoughts of Sally so slender and helplessly appealing, weeping for her lost love. However, I pick up as much as possible of the Master's words and I hope that I am accurately summarising them in these pages.

The initiated master seeks to control the chaotic entropy of the future. In order for things to be the way that they are now, they will have to be a certain particular way in the future and the initiated one will draw on his memories of the future in order to predict the past. Why is the universe the way that we

see it? If any one of its fundamental physical laws were to be altered, even fractionally, we would not be there to see the universe that we find ourselves in. In this way then there is a sense in which our existence has caused the universe to exist. To bring the matter down to a microcosmic level, and to take an example which is easier to understand, if my father had not met my mother, then I would not be here, but I am here. Therefore my present existence has caused their past meeting. Or, to take an even more homely example, it is a commonly observed psychological phenomenon that one sets an alarm clock to go off at a certain set time, but then one finds oneself regularly waking up, say, five minutes before the alarm clock goes off. The conclusion is inescapable, the alarm-clock's ringing in the future has caused one to wake in advance of it. So it is that a skilled sorcerer may make a spell to change something in the past. Obviously, if the unknown thing in the past had not already changed, then he would not be able to make the spell.

Space and time are acknowledged by scientists to constitute a continuum. One can move backwards in space and therefore also in time. It is simpler to think forward, but that does not mean that it is correct, for those who travel forward in time are sleepwalking through life, moving from summer to autumn to winter, heading towards their death. Death, it is death which causes old age, sickness, mutilation, car crashes, drownings, ritual sacrifices. Finally, he who works backwards through time, has to face certain moral implications and, in concluding, the Master invited us to reflect once more on the ceremony on the hilltop, in which he not only gave a young woman life, but, in repossessing his seed, he rendered that woman a virgin for the first time, sealing her hymen and making her the inestimable gift of her innocence.

Once the Master has finished speaking, he hands over to Felton, who dictates to us the ritual procedures and responses for the forthcoming Consecration of the Virgin for transcription in our red notebooks. The dictation is hard going for some of the procedures are in Latin and these Felton has to spell out letter by letter. Then we are dismissed.

145

I was about to hurry up to my room when I was stopped by Alice,

'Why do you and your hippy girlfriend always have to spoil everything? We practically never get the privilege of hearing the Master speak, but now when we do, you and that dolly bird have to stage one of your lovers' tiffs.'

'Alice, please. She's not my girlfriend. That was the point.'

'She seems to think that she is. Anyway, you are two of a kind. All style and no substance. You only went out with her because you thought that prettiness is important. Why do you men find brainlessness so attractive? I have no hesitation in telling you that I'm worth a hundred of her sort.'

With that Alice turned and stomped off. (Poor Alice.)

That was the weirdest lecture I ever attended. I have some difficulty getting my head round it, but I think it is a bit like the words of that Dylan song, 'I was so much older then, I'm younger than that now'. 'Eh ma I.' Are we going to be taught to write backwards, read backwards, walk backwards? I sit up late into the night to write my diary and, when I have finished, I reread it anxiously looking for jokes. I don't think there are any. My visit to Cosmic seems to me, if anything, rather sinister. I must learn to live in a world which has been leached clean of humour.

Not long after I had finished writing the above Laura came to me in my bedroom. My strict new teacher. I put it to her that this time round we should reverse roles. So then she became a predatory and tarty schoolmistress, while I was a clueless schoolboy, unaware of what she was after when she placed her hand on my flies and began to tug at the zip. Just a school medical inspection apparently. She was assuring me that it would not hurt as her mouth closed round the knob of my penis.

Later that night I suddenly snapped awake. Laura was no longer with me in the bed. I had been woken by a thought. The bloody creature with horseshoes on his feet had had Ron's face. It took me a long time to get back to sleep.

146

I sat up so late writing my diary that I am a bit short of sleep today. I have to force myself to write in it, but I know that I have to and then, once I start writing, I find that it is difficult to stop and that is what I am afraid of. Then I find myself writing things which I do not really think at all. They are things which brother diary is thinking. The diary is my 'brother', but he is a poor substitute for a girlfriend.

Felton passed me coming out of breakfast and told me that I had been assigned to help Granville in the afternoon. Then he passed on down the corridor. So I only had the morning to do research on playground activities.

I suppose that I ought to be infuriated by the way I am being ordered around, but I actually take pleasure in it, for I now realise that, since I have given my oath and kissed the hand of the Master, it is really me who is imposing discipline on myself and consequently I take pride in being my own fierce taskmaster. Therefore, as instructed, I met Granville for lunch at Wheelers. Granville was in one of his dark moods when I arrived and at first I had to make all the conversation.

'Talk to me,' was what he said. 'I'm fed up with having to do all the talking. It is time that you learned how to make conversation like a normal civilised person. Come on, I'm bored.'

With that he sat back scowling and waited for me to make my first conversational pass. I have often seen Granville St John-Jones leaning against a wall or sitting with his head resting on his cupped hands, looking sullen. Looking as if only the End of the World could relieve his hopeless boredom. The sullenness goes with his looks – the deep-socketed eyes, the thick lips and the dark, curling, gipsyish hair. For Granville, who is invariably sharp-suited and who wears a foulard scarf, the sulks are also a kind of fashion-accessory – a part of his style.

'Come on, talk to me,' he said again, but nothing could

have been better calculated to make my mind go blank. There was nothing in my head that I wanted to talk about and I sat there, silent, flummoxed. Granville was impatient,

'Oh tell me about that dippy girl who gatecrashed the Master's lecture last night . . . I forget her name . . . Sally. What does she do? Where does she live ? How did you meet?'

(Now I am a bit behind with my diary-writing and I am writing this after having talked to Cosmic on Sunday and after having attended to my bleeding foreskin. When Granville asked all these questions, I did not know what was behind the interrogation. I thought that it was just a product of his general obsession with sex and women. I know better now.)

Anyway, I told him the story of how I first met Sally, how I was drinking coffee in the Indica Bookshop, when I saw this golden-haired girl floating like an elf from customer to customer and whispering something to each of them. At last she came to me,

'Do you think I'm pretty?' (It was her question-of-the-week.)

I nodded emphatically.

'That's good,' she said. 'That makes 87 per cent so far,' and she moved on, but I grabbed her arm.

'Do you think that I am handsome?'

She sat down opposite me and set about studying my face. An hour and a half later, she was in my bed and examining the rest of my body.

I thought that Granville wanted to know about Sally because he knew that she did not like him. But more than that, he was genuinely curious about how my generation manages to get laid and plated so easily. Granville is eight years older than me. It is a crucial chronological gap. It means that, when he was my age, he was having to go through old-fashioned rituals of courting and seduction and sex was wrapped up in circumlocution. *Lady Chatterley's Lover* was still banned and the mini-skirt not thought of. He arrived at the party too early and he knows it.

Granville, having found my tale of an easy lay unenticing,

was discoursing (in his usual oblique way) on the excitement of gazing in a certain way at women who do not like him, in order to force them to go to bed with him. Almost the best blast there is for Granville is to feel a woman shudder underneath him and to know that in those shudders the pleasure of orgasm mingles with a self-reproaching revulsion. Only bedding a virgin is a better blast, for there is a kind of occult charge acquired from sleeping with virgins. Although I did not actually believe that Granville does have this occult power over women, I saw my opportunity,

'Alice is a virgin. What is more, she does not like you. She told me that you were too frivolous and too sex-obsessed. I should think that it would be pretty rewarding to get her to go to bed with you.' (I had in my mind's eye the gleeful image of Alice's myopic scowl melting under the Luciferan gaze of Granville.)

He was silent. I thought that he was offended because I had described him as frivolous.

'Yes,' he said. 'It would be a challenge.'

'Why not then?'

He looked patronisingly at me,

'Who do you think is the virgin in Sunday's ritual Consecration of the Virgin?'

'Alice?!'

'Yes, Alice is reserved for the Master.'

'She will never do it.'

Granville smiled.

'First the Master (and, here, have some more wine) then she will offer herself to you . . .'

I did not hear what he said next, I was so stunned. It seems I am to be blooded. That was the real purpose of this lunch. To break it to me. I am to assist the Master and then, watched by every member of the Lodge, I am to have sex with Alice.

But she hates me. And I don't fancy her. This is some weird kind of magical ordeal. Alice is a sort of Loathly Lady, like the one in a story Sally was telling me. In the story (which I cannot remember properly), foolish King Arthur has been trapped into promising to marry the Loathly Lady.

She is all fat and warty and generally disgusting. Then Sir Gawain nobly steps forward and offers to take the King's place. Since Gawain is young and good-looking, this is OK with her. So then, the hitching ceremony having taken place and they are about to go to bed together and presumably Gawain can feel his scrotum curdling between his legs, but he gives her a quick kiss and, lo and behold, she turns into a beautiful damsel. While he is still gawping at her, she explains that she is a magical kind of chick and she can be beautiful half of the time. Either she can be beautiful in the daytime, in which case everyone will admire him for the glamour of his consort, or she can be beautiful at night, in which case his sex-life will be greatly enhanced. But Gawain after pondering a bit, said that no, she should be the one making the choice. Then she said, 'Knight, since of your perfect gentleness, you have given me the choice, the curse is lifted from me and I am able to remain beautiful both by day and by night'.

All this was fine as a story. However, in real life, I was pretty sure that Alice was going to stay as she was – lo and behold, hideous day and night! There is no way I will be able to get it up. I said as much to Granville.

'Oh yes, you will,' he said. 'And I envy you.'

'Oh fine! Well, you are welcome to take my place. You must be having me on.'

'I don't mean screwing Alice.' He shuddered briefly. 'Of course not. Alice is just the start for you of something much more serious. No, I mean that you have a destiny, whereas I have none.' Then he recited a couple of lines by Yeats,

> 'Those who have chosen second best,
> Seek to forget it all on a young girl's chest.'

I think that I had envisaged Sunday's ritual as some kind of love-feast and I certainly had not anticipated that I would be anything more than one of the chorus who stood around chanting and watching. Now I was sitting in Wheelers, speechless and trying to think of some way of getting out of

all this. A dentist's appointment, for example . . . but dentists weren't open on Sundays . . . a session with the exorcist, booked weeks ago, too late to cancel now . . . I could wait till Sunday morning and then feign death . . .

Then the pudding came and Granville and I talked of indifferent things, like his plan to take me over to Le Mans for the 24-Hour Race later in the month. He patronisingly takes it for granted that I want to accompany him on this annual ritual trip – literally patronising, for I think he does actually see himself as my patron.

'I should not have talked so much. It will all go down in that bloody diary of yours, plus, of course, I'll have to put it all in mine. It's all such a bloody bore.'

We have a series of missions, all of them in the St James area. There are the crates of wine to be ordered for delivery in time for Sunday's ritual. Some shirts that the Master has had made have to be collected. It is boring, but it did not take as long as Granville had been expecting.

'We have time in hand,' he said. 'I propose to devote it to your further education. We are on the edge of Soho. I can take you to a prostitute or to a casino. Which shall it be?'

'A casino then. I have never been inside a casino.' (Not that I have ever been with a prostitute either. Perhaps I was saving myself for Alice?)

We left the brilliant sunshine for a place of shadows. The Four-Leaf Clover Club occupied a not particularly large Soho basement. Drinks were on the house and I was drinking madly to forget Alice. Will demons make themselves manifest at Sunday's ritual? What need for demons when we are behaving so badly anyway? When the chips are down, they are so pretty – big pink squares, yellow ovals, ivory oblongs and small circular green counters – all spread out on the green baize in pools of low light. Granville elected to play chemin-de-fer. As he took over the bank, he shot his cuffs. (I wonder if I dare ask him if he would teach me how to shoot my cuffs?)

Slept badly, thinking of Sunday's ordeal. I would drop off briefly, then come to, shuddering at the thought of being in the arms of Alice and her toad-like face rubbing against mine. Now, things have been made worse by not having a record-player any more. Felton told me at breakfast that people had been complaining about the noise of my record-player in the evenings. (Agatha, I'll bet.)

'Your handing over of the machine will of course be appreciated as a gesture of good faith.'

Another of their little tests. But every sacrifice I make makes me stronger. What does not kill me makes me stronger. After surrendering the record-player, I spent most of the morning in the Lodge's library drawing up index-cards. A bit before midday Granville entered and seated himself on the table, dislodging a pile of file cards as he did so.

'It's the weekend and I'm bored. I knew I would be. What are you going to do to entertain me?'

I thought for a bit. Part of the thinking was why was he spending so much of the time with me? Partly I was thinking about how to entertain him. Should I make him a reciprocal offer to treat him to a prostitute? Finally, I came up with,

'I'm going to take you to the Arts Lab.'

He looked suspicious, but shrugged his shoulders.

Over the door of the Arts Lab, was a freshly-painted notice in bright, blobby colours: MAGIC THEATRE. ENTRANCE NOT FOR EVERYBODY. FOR MAD-MEN ONLY! Granville was sneering as he stalked inside. In the Arts Lab's restaurant, I introduced him to macrobiotic food – macrobiotic brown rice sprinkled with sesame seeds, Tibetan barley bread, soya-bean salad and peach tea. After a couple of mouthfuls, Granville leant back in his chair and balefully contemplated his plate,

'This is a bloody bad start, this stuff. Probably why you are so thin. What next? Where shall we go?'

The people at the other tables had been looking at Granville in awe. In their dopily paranoid minds anyone in a suit is normally reckoned to be a police spy – but not a suit like the one Granville was wearing.

I told him that we were not going anywhere, because there was an afternoon- showing of Kenneth Anger's *The Inauguration of the Pleasure Dome* here at the Arts Lab. Granville had never heard of Anger – which was no surprise. The Lodge members up in Swiss Cottage are a bit out of touch with developments in the American underground cultural scene. When I told Granville that Anger was an experimental film-maker, his lip curled.

'In my book "experimental" is just a polite word for cheaply made, boring and pretentious,' he commented.

The programming at the Arts Lab is full of surprises. Jack Smith's *Flaming Creatures* was not on the advertised afternoon programme. How could it be when it is a banned film without a Board of Censorship certificate? Nevertheless, it is shown before the Anger film. Granville was quite shocked by the transvestite cavortings and the climactic cunnilingual rape. To be honest, I was too, the first time I saw it, but this was the third time that I have seen *Flaming Creatures*. It is the fifth time that I have seen *The Inauguration of the Pleasure Dome*. Apart from Granville and myself, the audience consists of amateur cinéastes who think that they are watching a film. But the truth is that Anger has mounted a ritual which has been designed to damn their souls. *The Inauguration of the Pleasure Dome* is an occultists' happening. After the smoky credits, the invocation of Horus, the Crowned and Conquering Child, begins. The Great Beast, Shiva, and his consort, Kali, welcome their guests to the ritual. Lillith, Isis, Pan and Astarte are among them. The role of Hecate has been taken by Kenneth Anger himself. Cesare, the somnambulist from *Dr Caligari's Cabinet*, has been resurrected and called into service as butler and the ghost of Crowley, manifest in a bluish back-projection, haunts the proceedings. The eye is raped by so much glitter and flesh. It is like a cut-down psychedelic musical, set in a junk shop, in which every object has been

polished and burnished. Yet the body language is not just actors' business, for I recognised the hieratic gestures as deriving from the same source as the Lodge's ceremonies.

As the guests on the screen began voicelessly to toast the success of their invocation with yage, (a drink simultaneously ecstatic and poisonous), Granville beside me produced a silver cigarette-case opened it and urged me to help myself. The cigarette- case was full of neatly-rolled joints. Since Granville regards the hippy habit of passing the joint from mouth to mouth as disgusting, we each smoked our own. As I drew on my joint, worked on by the glut of images, by the hash and by the Slavonic passion of the film's soundtrack, I floated off into reverie. The hash smoke, drifting up across the screen and coiling along beneath the low ceiling, resembled ectoplasm massing for some kind of psychic manifestation. The celluloid phantasmagoria was a cheat. No, a double cheat; the magic is a lie and cinema is a lie – respectively ancient and modern ways of peddling illusions – rituals of the darkened crypt. The cameraman and the sorcerer working together on the manipulation of dark and light. We, the watchers, have been buried alive in a dark sepulchre of ancient illusion.

It is a short film. When the lights came up Granville was grudging,

'It's just a psychedelic blow-out. And nothing quite happens in the film. A long fuck without a climax. Still, it has given me an idea. This Anger man obviously knows a bit about High Magick, but only a bit. Basically he is an amateur filming people who haven't a clue. Whereas tomorrow's consecration is the real thing . . . I'll have to clear it with the Master of course . . .'

When we get back to the Lodge we join the others in working on the fumigation and purification of the ritual chamber. There is no dinner, as the sun has set and from now on until the consummation of tomorrow's ritual, we all have to fast. (Probably that was why Granville was so fed up that his last meal before the fast was macrobiotic.) Alone in my room at night I set to work at memorising the words of the ritual responses.

Looking back on the last two days, I think that the reason that Granville has been with me so much is that tomorrow's ritual Consecration of the Virgin is very important – as is my presence at that ritual – and they are afraid that I may bolt before it. The story is that the Master is younger than he looks because of his consorting with virgins. Regular ritual defloration seems to be viewed by the Lodge as a kind of keep-fit course.

What is it about virgins? Both vir *(man) and* gyne *(woman), the virgin is the holy androgyne. The virgin's slender form is a bent bow whose arrow is as yet undelivered. The freshness and power of the virgin's breath sends -*

When I saw that my diary-writing hand was going to launch itself into writing one of those ornately-written yet sinister pieces of fine writing, I bent down and bit it hard, drawing blood. Then I bashed it repeatedly with my left hand. I do not want to be instructed in the occult power of virgins. The right hand still twitches, but I am writing these last few lines with difficulty, with the left hand.

Sunday, June 11

I am back to writing with the right hand today, though it is painful. I trust that it is sufficiently cowed to write what I want and only what I want.

I ought to be in Cambridge comforting my father. I know that. But there can be no question of my being allowed to miss today's ritual – nor do I want to. The details of the central ceremony are somewhat obscure as a lot of the key stuff is in Latin. I am bloody hungry, but there is no breakfast to go down to, so I stay in my room writing the infernal diary and continuing to work on memorising the ritual responses.

Soon after writing those words, I was interrupted by Cosmic banging on my door. He had arrived at the Lodge early and he wanted to use my room in order to change into his robes. That was the pretext, but I first thought that the

reality was that he was curious about my new pad. (Not that there is anything to see really.) We chatted and, as we did so, I came to realise that Cosmic was in a funny mood and that he had something important that he wanted to tell me. For a bit, he rambled on in his usual way about the Tibetan Bardo Thodol, the pseudo-death experience and recent advances in psychic photography. At last he came out with it. He had been round to see Sally, and they had been talking and now he was here as her messenger. And, having been briefed by Sally, Cosmic dutifully set out all the arguments against my continuing further on the dark path.

But I was not really interested in Sally's opinions about the Lodge. I had heard all that before. There was just one thing that I wanted to know.

'Did she put out?'

'Naah, she's too hung up on you. Besides, she is still upset about all that stuff with Granville . . . Anyway Sally and I were just talking about how the Lodge uses mind-fucking techniques in a really stealthy way in order to – '

'Granville? Granville?'

'Hey, I thought you knew, you two having such a free and open relationship. I swear, I really thought she would have told you. Oh shit! She was really screwed-up about it and needed quite a lot of comforting, but I swear I just gave her a bit of a cuddle. She should have told you. That was ages ago . . . It is not that she fancied him or anything. He just used that look of his and it was inevitable. Granville, Errol Flynn of the Astral. It was seriously freaky, because, once she felt his gaze melting the inside of her belly, she heard herself begging for it – all against her will, of course.'

I had not believed that Granville really did have this sort of power. I listened in a daze to Cosmic. He was now talking in his usual disorganised way about an ancient treatise he had been reading called *How a Woman Who Is So Big Penetrates the Eyes Which Are So Small* and he was lecturing me about mesmeric eyebeams and rarefied pranic fluids, as well as how messed-up Sally was. According to him, Sally knew that afterwards she would despise herself for what she was about to

do with Granville, but she found that that was exactly what she wanted – to despise herself and be abased.

Why should it matter to me what Sally did ? That is all in the past. She is nothing to me now. I could calmly contemplate Sally giving herself to Granville. It was not a razor-studded contemplation. Certain things which have happened make more sense now that I know. That is why she stopped coming to the Lodge and why she did not take the Master's hand. She did not want to be gazed on in that way ever again. It also explains the look of utter revulsion she gave Granville when he hustled her out of the Master's lecture. Of course, it does not matter now, but I was blind to quite how hung-up she was, before we finally broke up. According to Cosmic, Sally now senses herself to be defiled, tainted, even evil. She thinks that, because of this lapse with Granville, that when she dies, she will be reincarnated as a dog or a lizard, to work out her bad karma.

What is it with this thing called the *Mordo Dolorosa*? According to Cosmic, when Granville first met the Master, he was forced by the Master's gaze to go to bed with him. So it must work between males and I tried to get Cosmic to demonstrate it to me. Cosmic's eyes bulged madly as he gazed and gazed at my belly, but it was no good and after a few minutes we giggled a bit and gave up. Cosmic admitted that he was not yet the master of his pranic currents.

Then he sobered up,

'Come on man, Sally needs you. She's your old lady. You can't ditch her just like that.'

I was thinking that if Sally meant little to me before, she meant even less to me now. But, on the other hand, I had had a very convincing demonstration of the power of the Lodge. Granville is not very bright, nor is he so far advanced on the Path, and I had thought that he was deluding himself about those occult powers. But, if even Granville possessed such occult tricks – birds bedded at will – what must be the powers at the disposal of such a one as the Master? And, getting back to Sally, of course, she is free to sleep with whomsoever, but she should have told me. She was always accusing me of not

being straight with her . . . I thought also of the rotted sex of Tbubi, the death-maiden, but what I said was,

'Today's ritual is the beginning of great things. Now that I have set my foot upon the Path, I can never leave it.'

Cosmic was not convinced,

'Things are getting kind of heavy, man. This whole Lodge business is seriously heavy. I have been studying today's Consecration ritual and it's one big, bad trip I'm thinking of defecting and going on the run. The thing is these people may be dangerous. Sally is right. That evening when she interrupted the Master's lecture, it got me thinking, and that's why I went to see her, and now I'm thinking that maybe we've been very stupid indeed. Maybe we should leave and contact a newspaper and expose what is going on. Once we get further in, as we are going to today, there will be no turning back. For fuck's sake, it may be too late already! But maybe I'm just being paranoid. What do you think man?'

'That wasn't Sally.'

'Huh?'

'The thing which interrupted the Master's lecture was not Sally. It just looked like her. It must have been a manifestation of the Qlippoth. The Qlippoth has been feeding on the images of desire that I (and maybe you too) have for Sally, as well as on the neurotic fears we both have about the Lodge. We were warned that there would be things like this as temptations on the Path. That definitely wasn't the real Sally. The real Sally will have been at work in the theatre that evening. I bet if you go and ask her, you will find that I'm right. It cannot possibly be just chance that the Qlippoth should seek to materialise itself as Sally's *Doppelganger* just a few days before we are about to take a crucial step along the Path.'

Now, for a moment, it was Cosmic's turn not to know what to say. He stood there looking impressed, but doubtful. It seemed that I had outparanoided him. Am I mad? Is he mad? Probably we both are.

But Cosmic's silence was only for a moment. He is rarely at a loss for words,

'That was no *Doppelganger*,' he insisted. 'It was the real Sally.

I went to see her last night and she definitely did come to that lecture and try to rescue you from the Master and she was crying about it. I could touch her face and I felt the wetness of her tears.'

'Yes, and you were comforting her, but how do you know that you weren't cuddling a *Doppelganger*?'

Cosmic looked a bit uncomfortable at the thought of having been petting a sexual fantasy, a synthetic creature created from spells, sexual odours and masturbation fantasies, but he persisted valiantly,

'In that case I suppose that Granville may not have slept with Sally, but only with her *Doppelganger*, but then it is also possible that it was not the real Granville, but only his *Doppelganger*. "And all that is solid melts into air." The whole thing is so freaking crazy! The fact that we are having this conversation kind of makes my point for me. We both seem to be going a bit mad. The more we get involved in the Lodge, the more we lose our grip on reality. We are running real risks here. Come on, we are mates. Let's leave together – cut and run while the going is good. It's all got much too risky.'

I nodded grimly,

'Yes, there are risks in proceeding further in the Black Book Lodge, but that is the whole point. Without risks, there is no adrenalin, and without adrenalin there is no life. Adrenalin is the true Elixir of Life. And, OK, we have already learnt a fair bit from the Lodge's masters, but so far we have only been offered scraps. We have to stay on the Path if we are to learn more.'

Cosmic was doubtful,

'Well OK, I can relate to that . . . If adrenalin is your kick, then maybe today is your lucky day. Let's talk again after the Consecration of the Virgin.'

I had spoken boldly about adrenalin, but now I was thinking about Alice. The adrenalin was fierce within me, but it was fear, not desire, that was pumping the stuff out, so that my whole body felt squelchy with chemical fear.

We were silent for a bit. I guess that Cosmic was depressed by thoughts of a world populated by *Doppelgangers* and, for my

part, I was communing with my fears. The new meditation on public sex with Alice was giving the old one, about the razor-studded banister, a fair run.

But then *Doppelgangers* made Cosmic think of zombies and he got going on a manic rap about voodoo and the use of zombie huntsmen to pursue the living and voodoo music. When I complained about not having a record-player any more, Cosmic told me it did not really matter.

'You can *see* the music in the patterns made by the dead elementals trapped in the vinyl.'

He got a Dylan record and a Donovan record out of their sleeves and showed me how different the patterns were on the discs recorded by two superficially similar artists. We spent an interesting time catching the sunlight on the vinyl and silently 'playing' 'Highway 61 Revisited' and 'A Gift from a Flower to the Garden'.

I was thoroughly absorbed in all this and my impending ordeal was momentarily forgotten. But then there was a rap on the door. It was Grieves.

'The Master wants to see you.'

Just like being back at school again! I struggled hastily into my robes and hurried to follow Grieves down to the Master's office. Cosmic stayed in my room to change at a more leisurely pace. The Master's office was just like the office of a wealthy banker. There were no hints of arcane rites and obscene practices. I guess that, from time to time, the Master used this room to receive outsiders visiting Horapollo House on business. Today, however, the Master, sitting behind the big desk, could not have been mistaken for a wealthy banker, for all he wore was a black loincloth and a pharaonic head-dress crowned with a rampant cobra. With that lean and muscular physique, the Master could easily have been taken for a film-star. Grieves, who was standing beside him, was dressed in his ordinary working clothes. In front of them on the desk was a low lamp, just like the ones in the casino, and in the centre of the pool of light cast by that lamp there was a snuff-box and on its enamelled lid shepherdesses were courted by their swains.

I wanted to know exactly what was going to happen. I wanted to be given my script, but I was much too afraid to ask. Or maybe it was that I had the sense that the Master already knew exactly what I was thinking and, if he thought that I needed to be told anything, he would tell me. Or maybe he would not even bother to speak. He would just transmit his instructions directly to my brain. I was dead in the hands of the Master. He was gazing steadily into my eyes. At first I thought that he was trying to hypnotise me, but then I thought that it was more as if he was looking for something in my soul. I do not know anything worth knowing about the Master. All I know is that I am afraid of Felton and that Felton is afraid of the Master. 'Know Thyself,' say the occult masters. For me, acquiring self-knowledge has mostly been the discovery of my cowardice. I was dead-scared in the hands of the Master.

There was a knock on the door and Alice entered. She was conventionally veiled and dressed as a bride. The Master indicated that we should sit. Then he muttered something in Latin over the snuff-box and Grieves leant forward to open it. It was full of a white powder. At first I thought that it was a Satanic powder – a special powder concocted from the ground-up bones of unfrocked priests, or something. Well it was a Satanic powder in a way. Grieves filled an oddly-shaped little silver ladle with the powder and raised it to my nostril. I snorted hard. Then it was Alice's turn. She raised her veil and sniffed determinedly, but she sneezed and had to try a second time.

Hitherto I had experimented with hash, speed, heroin, opium, LSD, mescalin and amyl nitrate. But never cocaine. It was just one of those things. I had never got round to it. But this was obviously what was racing round my body like an animal looking for a way out. Cocaine is rather an old-fashioned drug, but it seems to be the drug of choice at the Lodge. (Horapollo House is a counter-culture phenomenon, but it is old-fashioned counter-culture.) My nostrils tingled and there was a metallic feeling in the throat. I recall that Cosmic, who has tried the drug, said that the thing with both cocaine and heroin is that it is not exactly that they give positive pleasure, but rather that these drugs achieve their

effects by suppressing the normal pains of the body. Without drugs, we are in agony every minute of our lives, as bones, muscles and veins press and scrape against one another. Merely living is very painful indeed. Only the pain of the physicalness of our existence is such a basic thing that we are not really aware of the day-by-day, minute-by-minute agony of our bodies. Our pain is just like the hum of a busy refrigerator; one does not realise that one has been hearing it until it stops.

The Master had left the room without me really noticing. Grieves stood against the door with his arms folded. I could hear the sound of muffled chanting, so the ritual invocations must have already started. I looked to Alice. Her veil was thrown back over her chaplet of flowers and her eyes were weirdly bright and she was licking her lips and smiling. In the Dennis Wheatley novels, the women who are about to be sacrificed to the Devil are always beautiful. I can now report from experience that this is not invariably so. With those bright eyes and big smile, Alice looked just like a white golli-wog. I could not bear to look at her, partly of course because of her natural hideousness, but also because of the effects of the drug which was making me twitchy, so that it was hard to look at anything in particular. My heart was ripping away. Jefferson Airplane's 'Go Ask Alice' was silently pounding in my head. Also there was a feeling of little animals rippling under my skin which was not unpleasant. My courage was coming up. I felt clever, good-looking and powerful. I was ready for a party. Feeling this mounting self-assurance (and I use those words advisedly), I was even ready to bless Alice with my seed.

I glanced swiftly at her and away. She was trembling. I tried to think of something reassuring to say. The best I could come up with was,

'In a couple of hours it will all be over.'

She moved closer to me and placed a trembling hand on mine. I could feel my flesh creep – really creep, as if it was trying to crawl away from under her touch.

She brought her mouth close to my ear and whispered,

'It is already over. We would not be the persons we are now,

if we had not already given ourselves to the Master in the future. The universe vibrates at a certain rate. In order to exist, to truly exist, one has to pulsate at the same rate.'

(Cosmic was right. Her breath was turnip-scented.)

Her words were freaky and not what anyone in their right mind would have thought of as sexy, but, in my toxic dream, I knew exactly what she meant. Also, despite my raging physical aversion and her leguminous breath, I found that I had a hard-on. I would like to have concentrated more on my cocaine-high, but there was a rap upon the door and Grieves moved aside. Felton in the doorway crooked his finger. We were to follow him.

We were caught on camera as we entered the hall which had been prepared for the Consecration. Granville, operating a hand-held cine-camera, cautiously trod backwards in front of us as we processed towards the central altar which was also a bed. Junior Lodge members wore monkishly cowled robes. But the Master, Felton, Granville and others were dressed as ancient Egyptian hierophants. It now strikes me that most of the Lodge's business consists of charades and impersonations. We all find our identities in the dressing-up box. Crowley was the same. There are framed photos of him in the dining room. In them he appears dressed as an Egyptian, as a Scottish laird, as an Indian mahatma, as an English gentleman. He took on his personality with the clothes. Magic is about appearance, style, glamour. There is no reality.

Alice was made to sit on the black sheet draped over the altar. I was directed to my place in the circle of celebrants gathered round her. Now Colonel Chalmers pointed the Sword of Exorcism at the four corners of the room to drive out any of the larvae which might be gathering on the edges in the hope of feeding off the energies generated by our ritual. When this operation had been completed, the man standing to the left of me began to intone the opening catechism. I recognised the voice as that of Julian. (I had not known that he would be here today.) In a ragged chorus, we gave him the required answers.

'What is the hour?'

'When time hath no power.'

'What is the place?'

'At the limits of space.'

'What God do we wake?'

'The Lord of the Snake!'

'With what do we serve?'

'Brain, muscle and nerve.'

'The shrine in the gloom.'

Then Felton walked into the circle and, turning to the Master, he declaimed,

'Son of Astaroth and Asmodeus! My Lord! My secret self beyond self, Hadith, All Father! Hail, On, thou Sun, thou Life of Man, thou Fivefold Sword of Flame! Thou Goat exalted upon Earth in Lust, thou snake extended upon Earth in Life! Spirit most Holy! Seed most Wise! Innocent Babe. Inviolate Maid! Begetter of Being! Soul of all Souls! Word of all Words, Come forth, most hidden light!'

The Master paused in front of Felton and bowed his head so that the latter could remove the head-dress. Then he tore off his loincloth and, turning in all directions, he displayed his erect and swollen penis to the celebrants. And what was I thinking while all this was going on? I was wondering if he was on cocaine too. Yes, of course, what was about to happen was shocking in terms of conventional morality, but Ashtaroth and Asmodeus are princes of love, and what we were about to witness was an act of love at the highest level. And the love-making had to be in public, because what was taking place was no mere physical act, but more a celebration of loving bonding which involved all of the Lodge's celebrants. It is true that for a moment, just for a moment, I caught myself thinking, 'Dear God, what have I got myself into?' but then I answered myself, 'I have got myself into the robes of a sorcerer and I have at last left the world of the ordinary and made my way to a place where something is happening.' The coke-fired adrenalin, surging within me, told me that. To know, to dare, to will, to be silent.

The Master pulled Alice's skirt up and mounted her.

Alice cried out, 'I am with the angels!' (Her voice was muffled, but I think that was what it was.)

At this point, if God existed, He would surely have brought the proceedings to a close, but the Master thrust into Alice and, as he kept thrusting, we celebrants clapped in time to his thrusts and our rhythmic clapping reminded me a bit of 'Whenever a Teenager Cries' as rendered by Reparata and the Delrons. (It should not have done, but there it is.) Besides the clapping, there was a lot of hissing and sighing in the circle of robed and cowled diary-keepers. (Tomorrow, if the Master so chooses, he may find his dark rapture on the altar of Asmodeus, reflected in so many diaries and in Granville's hand-held filming, as in so many shards of a splintered mirror.) I kept trying to think the ritual backwards, as I had been trained to. Working backwards, Alice and I and the rest of the celebrants might return to an age of wholesomeness and innocence – an age of good-hearted films like *Genevieve*, of cartoons of the Gambols family in the *Daily Express*, of *The Reader's Digest*, cheerful bobbies on the beat, Connie Francis, skiffle and flared skirts. However, my mental powers are still weak and, as far as I can see, we are all still trapped in 1967. Intellectually, I knew that the Master was investing Alice with the gift of virginity. Suddenly, in the midst of being fucked, she turned her head sideways and looked directly at me. Her red mouth was wide open, unbelievably wide. It was like one of the mouths of Hell in one of those old Flemish paintings.

Then Chalmers came forward with the cockerel and the sword and, as the Master climaxed, he slashed at the bird's throat and held it over the entwined couple, showering them with blood.

And we chorused, as instructed by the ritual,

'Lo! the out-splashing of the seeds of Immortality!'

The next section of the ritual was one of those bits in Latin, so I was wondering what was scheduled to happen next. Alice was lying back peacefully with her head turned in my direction. She was leering at me. Then the Master, who still lay on top of her, crooked his finger. So I came forward and he rose

from the altar and presented his still-erect penis to me for a kiss of homage. Then he gestured me towards Alice who lay there looking very strange under a sheen of sweat, a bit like a doll whose face was cracking and losing its paint. The bridal dress spotted with blood was hoicked up round her hips. Everything was so weird, like being in a strange film – and of course it was being filmed. As I struggled out of my robe and clambered on to the altar, she put a hand out to slow me down, then rolled over and looked back at me. Again I thought of a doll, as I was surprised how far back her neck could turn.

'The first was reserved for the Master,' she said. 'You use the tradesman's entrance.'

And, lest there could be any doubt about what she meant, she pulled the cheeks of her arse apart. Our coupling was an act of mutual loathing. My hatred for her was so powerful, so fierce that it was exhilarating and I guessed that Alice was similarly moved. Somebody brought the Master a chalice and he stood drinking from it and watching over me as I sodomised the bride. It was hard and pleasureless, but when I finally penetrated her, the celebrants broke into the 'Dirge of Isis', as if Alice's screams had given them the cue. The Master passed the chalice to me. It was soma, or sarcostemma, the Indian god-drink and bitter to taste. There could be no doubting that Ashtaroth and Asmodeus were in the room and their wings were fanning up a storm. We were, all of us, caught in this storm of incense, silk, chanting, blood, soma and sperm. Whatever I had been in the past was now changed beyond all recognition, for I was now embarked on a mighty and perilous adventure.

'How was it for you then, darling?' I shouted to Alice as she was led out of the room.

She pretended not to hear.

The circle began to disperse and Granville came up to me and said,

'Not very gentlemanly, Peter. Still at least now we have the energy which may serve us for the important events in the days to come. Now, you need a bath.'

The sweat was coursing down my body and my eyes were stinging from the salt, but Granville pointed to my penis. The foreskin was all raw and bloody. In fact I realised that I would not be able to put my hairy robe back on. Granville passed me a towel and, wrapping it carefully round my waist, I made my way up to the bathroom. The cocaine was a fire in my veins and I was madly elated. After what I had done this evening, I was capable of anything. Perhaps I should have talked to Granville about Sally, but what should I have said? And, after all, what is Sally to me now? I have been thinking that my occult name, Non Omnis Moriar, is a bit of a mouthful. Sitting in the bath it occurred to me that I should let my friends call me Non for short, but then I realised that, since joining the Lodge, I no longer have any friends – apart from Cosmic of course.

Once I was out of the bath, I immediately set to writing all this down. What will I think about today when, thirty years from now, I unlock an old tin trunk and open this old diary and read this entry? Who will I be, reading these words scribbled in faded ink? Will I be the Master? It is eerie to think that tomorrow I shall be at my mother's funeral. I forgot to mention how terrified Julian looked throughout the ritual.

Monday, June 12

I rose very early this morning and reached Liverpool Street in time to catch the first train to Cambridge. I felt really grey and at first I thought that it was the grey suit I was wearing- or perhaps it was the comedown from the cocaine high. Certainly that. But then on the train I also remembered that I had not eaten anything for over twenty-four hours, so, once I reached Cambridge, I scored a lorry-driver's breakfast at a cafe on the corner of Station Road, before walking on to the house. My aunt was already there. Dad nodded, but he could hardly bring himself to speak to me. I was not saying much either. Felton had warned me that my family might use the occasion of the funeral to seek to detach me from the Lodge.

There was a small cortege to the chapel. Our car followed immediately after the hearse. Sitting next to me in the car, Dad felt he had no alternative but to speak to me,

'How is Sally?'

'She is well I think.'

'I had thought that you might have brought her along today. She seems to be the leading figure in the perpetual, swinging party which has kept you so busy in London in recent months. But I suppose funerals aren't her sort of cool scene.'

'Actually, Sally and I have broken up.' I thought that this would lighten my father's spirits a bit, but it hardly seemed to register, and he returned to brooding. Probably he was brooding about the loneliness to come.

We stood outside the chapel. I looked at its grey walls. I was madly hoping to find salvation in them. I thought that I could see ghostly Egyptian hierophants, coloured smokes and Alice's white flesh quivering – all superimposed on the chapel's walls like a transparent film. These were not pleasant things to contemplate on a coke comedown. My skin itched and there was a raw pain between my legs. Was it possible that Divine Providence had brought me here on this day of all days? Could the Baptists help me? As we entered the chapel, the mad thought came to me that I might pray to God for forgiveness for what I had done. Of course I did not believe in God, but even so, despite my unbelief, God might take pity on me and grant me the grace to believe in Him. Then all the demons who were invisibly walking beside me would be silently wailing and gnashing their teeth. There was still hope.

So when the service commenced and everybody inclined their heads to pray I really started praying, 'O God, help me in my unbelief. Have mercy on me, a miserable sinner. Give me a sign that I am forgiven.' But it was impossible to pray with all this noisy Christian ritual carrying on around me.

At last I found myself standing with Dad at opposite ends of the pit in which they were burying Mum. The grave yawned beneath me. I yawned back at it. It was all so drab. If the Lodge had been organising this, we would have been resplendent in

our robes. There would have been censers and candles, invocations to Choronzon and the Goat of Mendes, billows of coloured smoke, queues to kiss the corpse. We who are initiates feed upon the energies of those who have been dead.

In a way, I would like to have discussed these matters with some of the people who came back to the house after the funeral. But no way. They stood chatting quietly and smiling at one another. I think that each one of them in his or her heart was secretly pleased to have outlived yet another person.

Things only became a little lively when the minister came over to me. He was a big, beefy man and I caught a glimpse of his braces under his jacket. I thought that I would ask him what hope of salvation there might be for a practising Satanist who could not bring himself to believe in God. That might make our chat a bit livelier, for I presumed that he had come over to offer the conventional condolences, but what he said was,

' "If a man have long hair, it is a shame unto him".'

'Pardon?'

' "If a man have long hair, it is a shame unto him",' he repeated. '1 *Corinthians*, 11:14. Your hair, Peter, is an insult to the occasion. To turn up looking as you do on this day of all days . . . I happen to know that the length of your hair was a matter of great distress to your poor, dear mother.'

'I don't see why. Her hair was long enough – at least until she started getting the radiotherapy.'

'If a man have long hair, it is shame unto him.' The Lord Absalom, who was son of King David of Israel, wore his hair like a living crown. The heaviness of Absalom's hair on his head was as the glory of women's hair, yet it was no glory to him, for he raised his hand against his father in unfilial revolt. And when it was the day of battle between father and son, 'Absalom rode upon a mule, and the mule went under the thick boughs of a great oak, and his head caught hold of the oak, and he was taken up between the heaven and the earth; and the mule that was under him went away.' And Absalom, suspended by his raven locks and hanging from the tree, was like the Fool on the Tarot card. The man who has raised his fist against his father is like one who mocks and curses his God and it was for this

169

that Absalom was hacked about and slain as he swung by his hair from the tree.

Surely it is vain to seek salvation in the Church, when its ministers are heirs to the witchcraft of ancient Israel and the latter-day slaves of snakey-haired Jewesses? The curse of Saul, sinful King of the Hebrews, runs as poison in the bloodline from generation to generation. Saul said, 'Seek me a woman that hath a familiar spirit that I may go to her, and inquire of her. And his servants said to him, Behold there is a woman that hath a familiar spirit at Endor.' And the Witch shook out her hair and tied knots in its tresses and blew upon those knots, so that Saul might hear Samuel, who was dead, speak. Thus the kingdom was infected, the kings tormented and the Holy made desolate from the corpse's stinking breath: the seduction of Bathsheba, the murder of Uriah, the rape of Tamar, the butchery of Absalom, the bringing of Abishag the virgin Shunamite to David's bed, the whoring of Jezebel and the murderous dance of Salome. Belial has set up his pulpit in your heart. The Devil can quote the Scriptures, those tales of ancient darkness, for his own purposes. There is no hope outside the church – nor inside it.

The minister stiffened and turned away when I made that crack about radiotherapy. Which was fortunate. Otherwise we might have had a real argument on our hands. I am not buying selective observance of the Scriptures. Sure there is all that stuff in *Corinthians* against long hair. That does not mean we have to pay any attention to it. After all, it is quite some time since the Church has stopped purifying the houses of lepers by killing a bird in an earthen vessel over running water, even though that is exactly what *Leviticus* orders us to do. Times have moved on.

As for all that stuff about Absalom and the long-haired Jewesses, I am trying to pay no attention to whatever it is that my writing hand is trying to tell me. It is nothing to do with what was happening at the time. My writing hand has become a tiresome companion, like a witch's familiar. I shall give it a name – Pyewhacket.

Then Dad came up. I thought that I might have counted on him to support me against the minister, but what he said was,

'You are no good to me here, Peter. You might as well go back to your funny friends in London.'

So it was that. I was cast out of my father's house on the day of my mother's funeral and I was set loose like Satan to walk backwards and forwards on the earth. Now I am sitting writing my diary on the train back to London. As for the minister's intemperate outburst, that is precisely why I grew my hair long – so as to alienate the sort of people who would be alienated by that sort of thing. Life is too short to waste on uptight straights. Looking back on that drab funeral, it just seems so sad that the mystic teachings of Jesus the Sorcerer should have degenerated into the mingy morality of the Baptists – a matter of paying your bills on time, never drinking more than a couple of glasses of sherry, of washing milk-bottles out before you put them on the doorstep, and not indulging in much heavy petting before marriage. What good did all this do my mother?

Tuesday, June 13th

All mail received at the Black Book Lodge is opened and read aloud at the breakfast table. (The only secrets which the Lodge tolerates are its own.) Either Felton or Agatha reads the letters. This morning there was a letter for me and it was Agatha who read it to the six of us assembled at breakfast.

Dear Peter Keswick,
I have recieved your address from the computer-dating agency. If you would like to meet me, please telephone me in the evening, so that we can arrange how to meet. I am in most evenings. I am looking forward to meeting you.
Yours sincerely,
Maud Boleskine

It bodes ill that the girl cannot even spell 'received'. The phone number given at the letterhead told me that she lives in

Camden Town. If she is in most evenings, it suggests that she is not exactly a swinging chick. I really am most unkeen about the whole business. But Felton and Laura are excited and they are insisting that I ring her this very evening.

I spent the greater part of the day at the playground and tidying up my notes in the cafe nearby, but I kept thinking about Maud and what she would be like. Maud, Maud, Maud! The resonances of thy name . . . She sounds like something left over from the Victorian age, as in the poem (or is it a song?) 'Come into the garden, Maud, for the black bat night has flown.' In my mind's eye, I see her entering the garden, veiled and in a long, high-buttoned, black dress. She works as a governess and there is tragedy and a broken heart somewhere in her past. I do not really fancy the idea of Maud and I would rather be going out with a Caroline, a Helen, a Susan, a Gillian, a Georgina or a Daisy. Not Maud.

In the evening, Felton practically has to drag me to the phone. I was praying that she would be out, but my prayers never seem to be answered these days.

'Hello, is that Miss Boleskine? This is Peter – Peter Keswick.'

'Oh yes,' her voice is cool. 'How good of you to ring. I just got in from work.'

(What work? A governess. A python-handler. A masseuse. A policewoman. One of the Queen's ladies-in-waiting.)

'Er . . . I suppose we ought to meet or something. I don't know when you are free.'

'Well how about tomorrow?'

(She is not exactly playing hard to get.)

'Well, yes, I suppose tomorrow would be fine. I could take you out to dinner or something.'

'That would be lovely. Where shall we meet?'

'Um . . . How about Piccadilly Circus under the Statue of Eros and we will go on from there to dinner.'

'How will we recognise one another?'

I said the first thing that came into my head,

'I will be carrying a copy of Aleister Crowley's *Magick in Theory and Practice*.'

'Oooh! Are you a conjuror or something?'

'Or something. Let us talk when we meet.'

'OK. Bye for now.' And she put the phone down.

Felton had been standing near me while I made the call and I now followed him into his study for the regular diary session. Another hundred pounds changed hands. Am I being corrupted by the money? It is obviously possible, but I keep checking – as it were rummaging inside myself. The money makes no difference. Before Felton could start in on his grumbles about my wonky grammar, I attempted to derail the session by observing that, after all the pathworkings and meditations I had been doing, I still had not seen any demons and that consequently I did not believe in magic.

But then Felton pointed to what I had written in my diary and said,

'You do not believe in magick, but yet you believe that Odi Profanum has a special magical gaze which forced Sally to sleep with him?'

I was about to say no, and then I wanted to say yes. I did not know what to say. The thing is, either magick is true, or, if it is not, then, when Sally slept with Granville (Odi Profanum is his magical name), she betrayed me of her own free will, because at that moment, at least, she preferred Granville to me.

Seeing me sitting there, tongue-tied and wrestling with myself, Felton leant over to whisper in Boy's ear,

'Fetch Odi Profanum. Boy, go fetch.'

Then he walked over to open the door for the dog.

We sat there silent and waiting. My eyes came to rest on a photograph on the mantelpiece. It showed two slender young men standing on either side of a goat in a desert. One of the men held a shotgun. With a start I realised that his companion was Felton – a Felton who was slim and young. Who was the other? Not the Master.

After a few minutes the dog reappeared and Granville was with him. Felton silently passed my diary to Granville. It was open on the page where I wrote about Cosmic telling me about Granville's seduction of Sally. Granville scowled down

on what I had written. Not that he was particularly angry. The scowl is just his usual expression.

'Fucking awful handwriting!' he declared and lapsed into silence.

Felton looked to me.

It took me a while to find the words,

'Is what Cosmic says there true?'

'Do you want there to be demons? Then there are demons,' replied Granville, and then, seeing that I was expecting more, 'Yes, I used the power of the *Mordo Dolorosa* to bring Sally to my bed.'

'And that is the truth?'

'If that is what you want it to be, Non Omnis Moriar,' said Felton.

This was like punching air. But I had an idea,

'Can I see the page of Odi Profanum's diary for the relevant day?'

Granville immediately protested,

'I only show my diary to the Master!'

'Shall I call the Master?' Felton's hand rested on the telephone.

'No, of course not. But is he really so important?'

It was not necessary for Felton to reply. We, all three of us, knew that I was so important. Only I did not know why this was so.

I smirked up at Granville. After a long silence, he said that he did not have his diary on him. Felton said that that was fine. He was sure that I could wait until Thursday. Granville went out, not quite slamming the door. Hitherto I had thought of the Lodge as a single body, an organisation of totally like-minded people dedicated to a single thing. But I now see that this may not be the case.

Felton moved on to the next thing. He still felt that I was holding something important back. How did I feel about Brother Vigilante (Cosmic to profane mortals) coming to my room on Sunday morning to propose that we did a joint bunk? Was I not tempted? I said it was all just as I had reported.

Felton's smile was cold. He stuck doggedly with his point. When I wrote up Cosmic's visit to my room and his proposal that we should flee the Lodge, I knew that he, Felton, would read what I had written and that there would be consequences. Felton wanted to know how it felt to have betrayed a friend?

But I replied,

'I have no friends.'

As I left the room, that song by the Loving Spoonful, 'Do You Believe in Magic?' was running in my head. This evening we were scheduled to hear a lecture by Agatha on extraterrestrial forces and then to do a short pathworking on the same subject, but things turned out a bit more interesting than that.

First the session started late. We all hung around waiting for Agatha or one of the senior Lodge members to appear. Alice was one of the circle. I tried to think myself back to the drug-intoxicated state in which I had actually desired her body, but that was a seriously bad trip which went nowhere. It was a bit like meditating on the razor-studded banister and I swiftly gave it up. Eventually Granville and Grieves entered and took up positions on either side of the door. They were shortly followed by Felton, Agatha and the rest of the senior members. Then Laura went over to Cosmic and demanded that he fetch his diary and Granville escorted Cosmic as he went off to fetch his diary from his bag which he had left outside Laura's room. At this stage Cosmic was looking merely puzzled. When they returned, Granville again took up a position beside the door. Now I noticed that he held a sword by his side.

Then Felton asked Cosmic to read from his diary his account of the morning of Sunday, June 11th. We formed a circle and listened to him read,

'Sunday, June 11th. Got up early enough to walk to Horapollo House. Got changed in Peter's room. Peter hung-up on not having a record-player, but I put him right on that. Then we went down to the Ritual Room and waited for Alice and – '

Felton cut him short and, turning to me, asked me to read my account of what happened that morning up to the point

at which we descended to the Ritual Room. So I read my version. Then Felton stepped into the circle of Adepts and turned to each of us as he spoke,

'What should be done with someone who has been planning to leave the Path and betray the Lodge? What is the penalty for such a thing? Non Omnis Moriar, you must speak.'

'He shall be as one who is dead to the Lodge,' I replied.

'Peter – Non Omnis Moriar is lying,' Cosmic swiftly protested. 'I never said any of those things that he has put in his diary. I am completely loyal to the Lodge, whereas he is lying. He is cunning and dangerous – '

Felton cut him short,

'Non Omnis Moriar has delivered judgement.'

At that, Granville and Grieves advanced on Cosmic and forced him to lie face down on the floor. Then Granville brought the sword down to tap the nape of Cosmic's neck with the point. Only after this was he allowed to rise and told that he could leave.

'You are dead to us now.'

I had thought that Cosmic would feel relieved when he was 'killed' merely in a symbolical sense, but in fact, as he looked back at me before leaving the room, he looked grim.

The Nine Barbarous Names were invoked and we all went outside briefly to witness first the burning of the Athanor and then the casting of Cosmic's diary into the same brazier. After that most of us returned inside for what turned out to be a rather dull lecture by Agatha on the winds that blow in outer space and the screaming spirits that travel from planet to planet. However, I was not paying much attention to the lecture. I kept thinking about Cosmic, for it now occurred to me that he was another temptation set to lure me from the Path. Not that he was a manifestation of the Qlippoth as Sally was. I was toying with the idea that I had been dealing with the real Cosmic, but something had got into his head and he was being manipulated by some higher power that did not want us to advance further on the Path. And I kept wondering what he would do now that he was expelled from the Lodge.

Would he go to the press? One thing I was pretty sure of was that he would go to Sally and tell tales against me. I was never seriously tempted by Cosmic though. I could never leave the Lodge, for I am just so curious to see what will happen next.

Over the last few weeks one thing has been preying on my mind more than I have let on in these pages. It is the business of being made to learn the Obscene Kiss. The Knights Templar performed it on one another as part of their weird Gnostic initiation rituals. I have been wishing that I had kept my mouth shut about getting lessons in kissing right from the first. I need not have worried. It was a gas. This evening it was Laura who performed it on me. I was trying to protest and suggest that it was not really necessary to go through it all, but she said that it was and that it was necessary that it be her who paid me homage as I outranked her. All quite weird. Fun though.

Wednesday, June 14th

I woke up worrying about absolutely everything – even including things like why did I have a vision of a man shod with iron shoes? I wish I had the same idea about life as Sally. Sally was always going on about how in reality there is no causation. Just because one thing happens after another, it does not make any sense to say the first caused the second. According to her, the Trobriand Islanders have no words for 'why' or 'because' and they are much happier as a result. When I pointed out that, if the Trobriand Islanders' happiness was as a result of not having those words, then that was an example of causation, she got pretty ratty. She said it was typical of the way white men used rationality and causation to make the world work for them. Rationality is a male power thing, whereas Sally was into something more witchy and intuitive. But if I did think like Sally, then I would not be worrying about why, when Laura and I made love last night, she was looking at me with love, yes, but also with such pity and concern. Also I still worry a bit about the possibility that I may be a homo. Is it a

regular male thing to enjoy being the recipient of anilinctus? But on the whole, I do not think I can be a homo. Felton seemed pretty emphatic on the point and, besides I have taken so much LSD in the course of the last year and, according to Timothy Leary, LSD is a cure for homosexuality. But it would be good to just switch the brain off and be intuitive.

Towards the end of the afternoon I returned to the Lodge and wrote up my diary. Then I started to get ready for the evening's date. Now I am feeling pretty grim. First, I do not want to meet this girl and, secondly, I hate wearing the suit. I already wore the suit at the funeral, so this will be the second time in a week that I have worn the suit, and my forthcoming date feels more funereal than the actual funeral was. I have to be dead to my own desires. This evening I have to dress up in such a manner as to impersonate a respectable person, in order to impress a girl whom I have no desire to impress – particularly if respectability is the sort of thing that impresses her. Another thing I hate about suits is that I wear them so rarely that I can never remember which pockets I have put things in. I keep resolving to put everything in a single pocket, but then I invariably forget my resolution, so that by the time I actually need, say, my wallet, I have to slap at every pocket, as if I was frisking myself for a hidden weapon. And then at the end of the day when I am quite likely to be very tired, I have all that fag of hanging the damn thing up and hunting for creases. Why cannot tailors make the creases run along the seams?

But the suit it has to be, as Felton has insisted on booking a table at the Gay Hussar for my date, and, just as I was about to go out, Laura caught me in the hallway and told me how smart I was looking in my suit and she ran her hand over my hair. I made my way to Piccadilly and took up a position under the Statue of Eros. I was surrounded by agreeably scruffy-looking registered addicts nerving themselves up to take their prescriptions across the road to the chemist. Whereas I, dressed in a suit and prominently displaying my copy of Aleister Crowley's *Magick in Theory and Practice*, felt a complete idiot. Fortunately I did not have to wait long.

'Peter Keswick? I am Maud.'

178

Maud was wearing a mini-dress with some kind of peacock's feather pattern and shiny, black boots which come up to her thighs, and a feathery boa round her neck.

There are hundreds of girls dressed like her walking up and down the King's Road on any evening of the week. But the very short mini did not work on such a big girl. Maud is tall and thick-thighed. She is not exactly ugly, but she is not attractive either. Her face, which is alabaster-white and with thickly applied eye-make-up, makes me think of a clown. Only her hair, heavy, dark and lustrous, is OK. The instant I saw her I knew that I did not fancy her. So that was it. Except, of course, that we had the whole evening ahead of us. I saw her sizing me up too. There was a just barely perceptible shrug.

We shook hands awkwardly and I told her where we were going for dinner. As we walked along towards the Gay Hussar, we talked about travelling about in London and restaurants and stuff like that. Only once we were seated at our table, did we begin to exchange serious information about ourselves. I thought Maud's life sounded pretty dull, but, to be fair, I do not think mine sounded all that interesting either (for I was hardly going to tell her about kissing lessons, satanic rituals on cocaine and the sound of horseshoes and screaming in the night).

Maud works as a hairdresser's assistant. She had wanted to be an air-stewardess, but she failed most of her O-levels, but then she is really pleased she failed, because being a hairdresser is so nice.

'Every person's hair is different and needs different treatment, but it is not so much the cutting, shampooing, blow-drying, shaping and perming. It is working with people that is so nice – I mean good manners and remembering to smile are so important and they make all the difference in a well-run salon.'

She went on and on about the salon and the nice people she met there. It was so boring. I half wanted to tell her to shut up and to listen to me instead, so that I could tell her about the emissaries of Satan, Choronzon's power, ritual invocations,

placating the Qlippoth and the importance of virgin sacrifice and I wanted her to realise how much more interesting I was than her. But then again, when I thought about it, I did not really want to make myself interesting to her. Basically I just wanted this wasted evening to be over and not to see her again. So I let her lecture me about stand-up pin curls, roller curls, barrel pin curls, reverse curls, finger waving, backcombing and perms, without my letting on how spectacularly bored I was. And I watched her eat. She had quite an appetite and the chomping of her heavy jaws made her seem distinctly bovine. There was something a little eerie about the whiteness of her soft flesh in the candlelight. Sally was pale enough, but Maud looks as though she has spent her childhood living under a large stone.

Eventually she did get around to asking me about myself. She was disappointed that I was a student.

'I was hoping that you would be a soldier, or a professional sportsman, or something like that. Or a doctor, I think doctors are interesting. My pa wanted me to become a university student, but I didn't want to. Students are scruffs. I'm sorry ... I didn't mean to be rude. You are quite smart, for at least you are wearing a suit and, even though your hair is terribly long, it looks quite nice. I do think that one of the wonderful things about being young is that long hair hangs naturally and usually looks good. Who do you get to cut your hair?'

'I cut it myself.' (This was a lie. Sally always used to trim my hair, but I did not want to talk about her.)

We talked a bit about the boxes we had ticked on the computer form. Maud likes Gilbert and Sullivan and Strauss waltzes and so on. When she went on to remark that it was not just classical music she liked, but she liked anything with a good tune, so she thought some pop music was nice too, I briefly entertained the hope that we might have something in common to talk about, but when she listed her favourite artists as being Manfred Mann, Lulu, Sandy Shaw and the Seekers, I felt a terrible despair.

For her part, she was disappointed that I was not sporty. She

is mad about karate. Apart from hairdressing, karate seems to be the only thing which interests her. As she went on enthusing about karate and how she got into it at school and, as she went on about the inter-school karate matches which she had won, I felt a jolt of surprise. I had been assuming that Maud was lower class. The fact that she went into hairdressing after failing her O-levels made me think this. But actually she failed her O-levels and took lessons in karate at Roedean.

'It is difficult to be really good at karate, if one is a woman,' she said. 'I hate the way my breasts get in the way of everything. I would rather have been a man. I hate my body.'

'It's a very nice body,' I said out of politeness rather than conviction.

I do not get the impression that she has had many boyfriends. Perhaps she has not had any. Perhaps she scares them off with her talk of karate chops and kicks. She is certainly a virgin. This came out when she was talking about how she believed in old-fashioned values. She was mildly curious about where I lived. I told her that I was living in an esoteric community (I had to explain the meaning of 'esoteric'), but that I was only living there for the purpose of studying it. I tried to sound offhand about it – as if it was just some really dull thing that I was doing. I need not have bothered, for she obviously did think it really dull. She prattled away about how she always looked at the horoscope page in the back of a magazine called *Honey*, but it was evident that she has not the slightest interest in occultism. She was just disappointed that my copy of *Magick in Theory and Practice* did not have any conjuring tricks in it.

I do not think that there is anything more of interest to write about Maud. She is amazingly vague about her family. Her 'pa' is some sort of teacher. Her 'ma' has been ill and she doesn't see her any more. ('I don't want to talk about it.') She shares a flat with a law student in North London. She continues to go to karate classes. She keeps a diary in which she records interesting things which she hears in the salon.

'Oh dear, I shouldn't have said that.' She put up her hand to her mouth in comically simulated dismay. 'You know what

Tallulah Bankhead said, don't you? "Only good girls keep diaries. Bad girls don't have time."'

Maud was pleased to hear that I kept a diary too. (Perhaps she took it as a sign that I might be as boring as her.) Undeterred by my frequent lapses into silence, she kept trying to be jolly.

'What is high, white and has ears?'

'What? I don't know what,' I replied.

She leant across the table, her eyes wide with triumph.

'A mountaineer!' she declared.

I thought about it. Then,

'I don't get it. A mountaineer isn't necessarily particularly high or white.'

'No, that's the mountain. Er . . . no . . . damn. What I meant to say was that a mountain is high and white and has ears . . . and . . . er, let's see, you would probably say that you didn't think that a mountain had ears and I would point out that you must have heard of mountaineers. Still, you can see it's jolly funny.'

Undeterred by her failure with this one, she kept telling jokes, but she kept getting the delivery wrong, or she forgot some crucial point before the punchline, so that it was almost impossible for me to join in her laughter. This whole evening has been a mad aberration. There is no way I can ever see her again, even if it was only for the estimable purpose of luring her into the Lodge so that she could be sacrificed to the Master on the Altar of Choronzon.

Throughout the dinner the waiters, alerted by Granville's big tip the last time I was here, had made a big fuss of me. When the time came to pay the bill, I had the usual frantic search for my wallet. Panicking madly, I started emptying my pockets on the table. Maud thought the whole thing uproarious until she saw that one of the papers on the table was the order of service for my mother's funeral and then she looked horribly embarrassed. I walked her to Leicester Square tube-station. At the top of the stairs down into the tube, she awkwardly lunged to kiss me, but I suppose I did not look responsive, for at the last moment she lost her nerve and her

lips failed to touch my mouth (I think that was what they were aiming for) and then she stood back. The great kiss not having come off, we ludicrously shook hands.

'Well this has been a pleasant evening,' I said. 'OK I've got your number. I'll call you sometime soon, probably next week, or maybe the week after.'

I could hear my voice. It reeked with insincerity like a television compere.

There was a stricken look in her eyes, but she nodded humbly. I pecked her on the cheek and walked smartly away.

I was practically dancing as I walked away. I was free of the pallid frump. I could, of course, have taken the tube at Leicester Square, but since I did not want to spend a minute more with Maud, I walked up Charing Cross Road revelling in my freedom and took the tube from Tottenham Court Road. Back at the Lodge, I sat up late writing this all down in my diary. (I reckon that I am losing sleep as a result of all this diary-keeping.) Goodnight and good-bye Maud.

Thursday, June 15

Despite some strange dreams, including one of exploring the nest of a great white worm, I was at first cheerful this morning, for I was glad to have got the previous evening's ordeal over. At breakfast Felton asked how my date had gone. But then, before I could reply, he decided that we should have the day's diary session early, straight after breakfast. He decided that it would not matter if I was late in taking up my observer's post at the playground.

I was fed up at this, for if we had the session this early, it meant that Granville would not be around to show me his diary, but I followed Felton into his study. I try, but I rarely succeed in guessing which word or sentence it will be which will draw Felton's fire. This time it was 'fancy'.

'"The instant I saw her I knew that I did not fancy her." How could you have brought yourself to use that verb in this context, Non Omnis Moriar?'

'What's wrong with it ? That is how I felt.'

'But you surely did not feel that this somewhat solid young woman was merely the product of your fancy, or fantasy – something conjured up by your imagination. Nor did you mean that you were breeding her, in the sense that a pigeon-fancier fancies pigeons . . .'

And Felton went on and on about the horrid vulgarity of my use of 'fancy', before asking abruptly when I was proposing to see Maud again.

'I thought that I had made it pretty clear in my diary. I am not going to see her again.'

'But you have to. What on earth was wrong with her?'

'Maud is stupid. She is impossibly stupid. The Lodge could never have any use for her.'

'And you suppose that you are clever . . . And you are clever. But forget cleverness. On the Path you are taking cleverness is as much use as a rubber duck. Resolute obedience will serve you better,' said Felton. 'I am ordering you to ask Maud for another date.'

'Don't ask me to do this. She is a real turn-off – not good-looking at all.'

'The demon Choronzon is not good-looking either, but I know, from reading your diary, how badly you want to see him.'

'Yeah, but I was not planning to take Choronzon out to dinner or to kiss him. Maud just isn't my type. Nothing could come of it.'

'Come, come. To take a young woman out to dinner or the cinema is not such a great matter, after all. The Lodge might have tested you with a much harder ordeal.' Then something came into Felton's mind and he paused before resuming, 'Oh, but I forgot to tell you the sad news. Julian is dead. He had an accident in the grounds of his house yesterday. He seems to have tripped and his gun went off in his face. Probate will take some time, but I think that you will find that he has named you as the main beneficiary in his will.'

'Why me? We hardly knew one another and, insofar as we did, we did not like one another.' This was true. What I felt

hearing Felton's news was definitely not regret. It was more like fear.

'But Non Omnis Moriar, it is your future need to be rich which has caused Julian's death now.'

What does he mean? I cannot relate to being rich or successful. Those are outward things which have no value in my eyes. In that respect, I am quite different from Felton – or indeed my father. They are all so boringly hung-up about things like property and status. I have no need of Julian's money. But Felton is waiting for a response from me, so,

'You say it was an accident with a gun?'

'Accidents tend to happen to people who resist the flow of the energies generated by the rituals of the Great Work. Now I really think that you should ring Maud as soon as possible. Since it is already past nine, I presume that she will be at work at the hairdressing salon. Give her a ring there now. Make a date with her for as soon as possible.' And pointing to his desk, 'Here, use my phone.'

I lifted the receiver, but still I hesitated.

'Do it, Non Omnis Moriar,' Felton insisted. 'If not, you will revert to being Peter and you will be dead to the Lodge.'

I dialled and waited.

'Gear Shears Salon. How can I help you?' The silly voice sounded like hers.

'Is that Maud?'

'Yes, who is this? Is that Peter?'

She sounded a bit surprised. I think that, as much as anything, it may have been the tremor in my voice. As I continued to speak on the phone, I was thinking about Julian's death and asking myself what had I got myself into and, come to think of it, what was Felton planning for her?

'Thank you so much for dinner,' she continued. 'That was really nice. I was going to write you a thank-you note.'

'Maud, I would like to see you again – as soon as you have a free evening.'

There was such a long silence at the other end, that I began to wonder if we had been cut off or something.

'I'm sorry, Peter,' she said at last. 'I'm not so sure that that would be a good idea. Pardon me, but I got the impression that you didn't really want to see me again. I thought it must be that I wasn't your type.'

'Oh yes, you're my type, Maud. At least, I think you might be. Let's get to know one another a bit better. Let's meet again. I would like to take you to a film or a concert or something. When are you free next?'

'Well ... I don't know ... OK Peter. When do you suggest?'

'How about tomorrow evening then, say about six?'

'Well, OK, but I don't actually stop working until six. Come to the salon around closing time – six or a little before and we'll take it from there, shall we?'

It is a grey day. On my way out of Horapollo House heading towards the bus-stop and ultimately the playground, I thought that I caught a glimpse of Cosmic lurking at the end of the road. But then he vanished, maybe because he did not want to be seen by me. If indeed it was Cosmic, that is so sad, him walking around the area, an outcast, longing to be readmitted to the Lodge. However, I do not think that there is anything I can do for him. He has become like one of the larvae, a relic of a human being, dead, but unable to accept that he is dead and therefore unable to sever all ties with his former world.

I only reached the playground in time for the second session. My research is becoming more focused. I am taking a functionalist approach towards the formation and dissolution of playground gangs and I am establishing the normative parameters of inner-directed and outer-directed motivations for joining the said groups. A subtheme in my thesis is social deviance as a source of dysfunctional strategies in gang formation. I am not ready yet – there is still a huge amount of research to do – but by the end of it, I should be able to set out the integrative functions of in-group and out-group behaviour as a pair of quadratic equations – with n signifying need, I.F. signifying the integrative function, and so on. The power of the analytical tool that I am in the process of

establishing is so strong that I do not really need the empirical data from the playground any more.

Since I already had had my diary session in the morning, I arrived a little late at the Lodge and, having donned my robe, I proceeded straight into the Meditation Hall. I was expecting another pathworking, but the Lodge always confounds one's expectations. What we got was a showing of Granville's film of 'The Consecration of the Virgin'. When Granville saw me, he smiled and spread his hands out in a mock apologetic gesture. I think he knew how pissed-off I was about not getting a look at his diary that evening. Then the film began. The title was crudely scrawled on a placard at the beginning of the film and, underneath it, the subtitle 'Demon est Deus Inversus'. There was no soundtrack, so all I heard was the whirring of the projector and occasional sighs of satisfaction from the watching Adepts. Granville proved to be a much less professional film-maker than Kenneth Anger, so the camera swooped and dipped awkwardly, pausing and then bumpily moving on. So, despite Granville's contempt for trendy film-makers, what he had produced felt much more experimental than the films we had watched at the Arts Lab.

But there was more and I was so fazed out that it took maybe five minutes before I could suss why the film had such an alienating feel about it. I saw myself bright-eyed and sweaty, simultaneously triumphant and shifty. A strange liquid spewed out of my mouth into the chalice which I then passed to the Master and he drank from it. As he continued to drink, I descended, almost floating, towards Alice's dark cleft and sodomised it. Then having risen from the ritual couch, as if pulled by invisible strings, I retreated. My robe rose from the floor and draped itself about me. The movements of the cele- brants around the couch were also weird, almost as if they were flying and they and I were all in the middle of some freaky dance of the insects. I am slow. Of course, what was happening was that the film was being run backwards, so that we could learn with our own eyes how virgins are made. To see the odd swooping gestures of the celebrants, the ritual objects rising from the floor and inserting themselves in the

hands of Adepts and the clouds of incense pouring back into the censers was all somewhat unsettling. But what was worst was the expression on my face when I finally turned again towards the camera. It had to be me, but I hardly recognised myself. Last year Ron, Cosmic, Alice and I all signed up for lectures at the Lodge. Then, sometimes, pathworking exercises took the place of lectures. Next we found ourselves participating in rituals – not very interesting rituals at first. Now this . . . and they have me on film.

I turned to look at Alice who had been in the row behind me. Although she was trembling, I do not think that it was from fear or anything like that. It was more like fierce pride and delight. She is a freaky chick. I had hated what I saw of myself on the film and I wanted to leave the room as fast as possible, but Felton caught me at the door.

'You must woo Miss Boleskine. Tomorrow you will take her flowers and you will pay her the thousand little attentions that any young lady desires. Take an interest in her work. Laugh at her jokes. Tell her that she is beautiful. That she is, as far as you are concerned, neither beautiful nor clever is neither here nor there, for Miss Boleskine is a bridge, not a goal.'

'So what is the goal?'

'I can tell you this much. It is your task to draw her into Horapollo House and, once inside the House when the time is propitious, you shall take her virginity.'

So now I sit in my room writing this all up. The idea of making love to a bridge strikes me as somewhat bizarre. Why not to a lift-shaft or a tower-block? More seriously, the prospect of seducing the innocent and the undesirable appals my imagination: her frumpish coyness, my struggles with her bra and tights, her entreaties for reassurance, her hungry mouth on mine, her large anxious eyes, her arms flapping about, her last panicky struggle to prevent me penetrating her, her breathy moaning, her renewed entreaties for post-coital reassurance and the final summary report in this infernal diary of mine. But I am too deep in now. There can be no turning back.

Back on the wall of the playground, I watched the children. Theoretically it is really interesting, for they are playing games whose origins are as ancient and whose forms are as ritualised as anything that the Black Book Lodge can offer. Yet I am so depressed at the thought of my coming date that I cannot concentrate. I go back to Horapollo House early in the afternoon and read until it is time to don the hated suit once more.

Gear Shears is in Camden High Street. Its large picture-window is partly painted over with images of Art Nouveau women posing amidst chains of flowers and snaking rainbow-coloured tendrils. Seeing me at the window, Maud beckoned me inside. I shook my head, but, since she was insistent, I cautiously entered and, as I did so, almost gagged at the smell of perm lotion. Maud put the roses I presented her with in one of the basins. With obvious pride, she introduced me to her fellow-assistant, Phyllis. Then without any further preamble, she turned back to me and said,

'Peter dear, if you think that I am going out with you again with your hair still in that condition, you are very much mistaken. Don't you ever comb your hair?'

'It is my theory that it's combing their hair that makes men go bald,' I replied.

'Well you may think of me as an old bossy-boots, but I am going to have to give your hair a jolly good combing, before we are going anywhere.'

She did indeed sound fucking bossy. She looked it too, standing there with her hands on her hips. But then I thought of something that would freak her out.

'Yeah, it does look a bit of a mess, but I think what I'd really like is to have it permed.'

She gave a yelp and Phyllis looked horrified, but I was insistent.

'I have always wanted to have it permed.' Apart from

freaking Maud out I thought that this would be something different – better than going to some dreary foreign film and then making pretentious conversation about it in the restaurant.

Maud shook her head.

'I can't do it. This is a women-only salon, as the boss disapproves of unisex.'

'So get the boss. I am happy to pay extra for a good perm with all the works.'

'The boss isn't here this evening.'

'There you are then.'

'I can't do it. You would look so strange.'

'It is just a little thing. If you really cared about my hair, you would do it.'

I inclined my head in Maud's direction. She put out a tentative hand and seemed about to stroke my hair, but she held off and took a step back, as if she was resisting the temptation of the devil. But then Phyllis suddenly said,

'Go on, Maud. Give him the works.'

'Why not?' said Maud doubtfully, as she reached out again for my hair. 'Are you sure you really want this, Peter?'

I thought that I had seduced the technician in her. I walked over to one of the chairs where I was enveloped in a white gown. The woman under the drier in the next chair looked at me curiously. Maud ran her fingers over my head in an exploratory way and, as she did so, I felt my gooseflesh rise. Was it a ripple of apprehension? Maybe. It was a weird thing to be so fondled by someone who physically repelled me. I watched her in the mirror as she played with my hair and dreamily brooded over its knots.

'I am only surprised that your hair looks as good as it does,' she said before fiercely attacking it with a comb. Then she took a scissors to the ends. I observed her in the mirror half-way through the trimming, putting one of the snipped-off locks of my hair in a purse in her handbag on a nearby chair. Seeing that she was observed, she scowled, went red and said,

'It is for my locket.'

Then Maud wanted to give me a shampoo. By now the last

customer, the old bag in the chair next to me, had left and Phyllis came over to help Maud. Hitherto I had not noticed, but all this time Radio Caroline had been piping into the salon – 'Good Morning Little Schoolgirl' by Rod Stewart, 'Surprise Surprise' by Lulu and the Luvvers, 'We Love the Beatles' by the Vernons Girls and more stuff like that, the music of hell. Phyllis was humming along to the nightmare sounds, while Maud spoke with laborious intensity about the prescribed stages in handling a client's hair. First there was effleurage which is stroking. Then she gave my scalp a petrissage, or kneading, before rubbing in shampoo. Finally, she gave me a second soothing effleurage. The whole process was indeed quite hypnotic and I was in some kind of trance when Phyllis said that she would be off then and Maud, having finished the rinsing and drying, bent low to fiddle with the edges of the white gown and tuck me in tighter. I was distracted by the heavy swing of her breasts as she leant over me.

Then she straightened up, but I could watch her in the mirror as she stood back to approve her handiwork. She came closer and ran her fingers down the back of my neck. Again I felt that creeping sensation. Her reflection seemed to hover over my head like a bird of night. Her own hair, lustrous black, billowed over her shoulders and then swung across her face when she tilted her head at an angle and announced,

'Petting is OK, but a girl should keep her virginity for marriage. Don't you agree? I know that I've got lots to learn now that I have my own boyfriend. It is your job to teach me about love . . .'

I am sure that when I filled in that blasted computer-dating form, I did not tick the box saying that I wanted to meet up with a mad girl. Yet here I was alone with a mad girl in a salon.

'Dear Peter,' she continued, 'I promise that you have found a willing student in me. I have so much to give a man. I just know that I have. All I want in exchange are little things . . . like a photograph of you that I can keep in my locket and . . . maybe you could show me your diary and I will let you look at mine and maybe we could write in each other's

diaries. And I want you to tell me about all your previous girlfriends and I can tell you about all the boys I used to fancy. And we can have dinner parties where we will meet each other's friends. And one day, we may talk about babies, but of course there is no hurry about that . . . '

The mad girl set to sectioning my hair, combing it into strands and winding those strands around plastic curlers. I remember that Adrienne Posta was singing 'Shang A Dang Doo Lang' when Maud began work on my perm. Songs come round so rapidly on Radio Caroline that I heard that song twice more before she had finished with my hair. Just the rollers alone took an hour and a half. Actually, if I consider the question of madness carefully, surely I was as mad as she to get myself in this position. What had possessed me to demand a perm? Once Maud had finished the back sections of my head, she came round to seat herself heavily on my lap, so that she could work more comfortably on the front. Her perfume, Chanel No 5 probably, almost made me choke. She planted a kiss on my sealed lips and, as she worked, she kept talking in a crazy way, only occasionally breaking off to stroke and kiss my face and the 'Shang A Dang Doo Lang' stuff which continued to play in the background was part of the horror of it all. After the sectioning and rolling, it took three quarters of an hour to apply the perm lotion. (How do women put up with this on a regular basis – all this, plus the morning ritual of applying make-up?)

While she continued with her deranged girly babble about love being forever and stuff, I was deep inside my head. I do not think that either Asmodeus or Choronzon will be satisfied with heavy petting. I will indeed teach Maud about love. 'Love is the Law. Love under the Will.' Yes, a girl should indeed save her virginity – for the demons. I will bring her shy and trusting to Horapollo House and hand-in-hand we will enter the Ritual Chamber together. Then other Adepts will roughly strip her of her dress. Next I will force her down on the altar and take her virginity and, as I do so, Felton will cut the throat of a pig, so that its blood cascades onto Maud's face. Then it will be the Master's turn to have her. Then I will have her

again, but this time up the arse. Then I will pass her on to Granville and one after another the Adepts will have their way with her and slowly her screams will become fainter. Then I will come forward again and force her to take my cock so deep in her mouth that she gags on it. Finally, I will force the bloody and weeping bitch to kiss my feet and declare her gratitude to all those assembled there for teaching her about love. And the demons will feed upon her madness.

The perm lotion was washed off and my head went under the drier. Finally, I was released and, standing before the mirror, I shook my hair out. I looked like Struwelpeter. She came up behind me and rested a hand on my shoulder.

'See, your hair has got more body now,' and passing her hand over my new curls, she continued,

'I have never had a boyfriend before, but now I've made you mine. I know it sounds silly but I think of the perm as a sort of magic spell,' she added. 'If you don't like it the way it is, it will grow out in a few months. It is what you wanted, isn't it?'

'Yes,' I said, but I no longer had any idea what it was that I had wanted. I must control these loony impulses in future. The next time it might be circumcision, a tattoo of Choronzon, or trepanation, or all three together.

'You are pleased?' she persisted.

'It is what I asked for,' I replied.

'Then kiss me,' and she closed her eyes and waited to be kissed. As I kissed her, I was thinking how soon, very soon I would force my cock into her mouth.

She clutched at the lapels of my suit, (the accursed suit which, as it turned out, I need not have troubled to put on) and asked me when our next date should be.

'How about tomorrow?' I replied. 'Why don't you come to Horapollo House and I could show you where I live. I promise you that you will find it fascinating.'

She hesitated. Then,

'All right, that would be nice. But you must collect me from my flat. That way you can see how I live too. Let's be together all the time.'

And having collected the flowers, she followed me out of the salon and locked up behind me. A final kiss and I was free. But all the way back to Swiss Cottage I was conscious of people looking at me curiously.

Felton was lurking just off the hallway of Horapollo House. Seeing my hair, he raised his eyebrows.

'I see that Miss Boleskine has made her mark on you,' he said. 'You look like the Archangel Lucifer. Do not tell me now, but write your diary tonight and show it to me after breakfast.'

So, having foraged for something to eat in the kitchen, I sit up in my room – my cell effectively – writing this all up. Curiously, I find that thinking about my plans for Maud has a certain erotic charge.

Saturday, June 17

Laura at breakfast was simultaneously enchanted and entertained by my hair. After breakfast, Felton tossed me a bundle of notes and seized my diary, feverish in his eagerness to find out what had happened last night. There were the inevitable sneers at my 'jargon-laden sociological claptrap'. But this time the main problem was the way in which I had described what I would do to Maud once I had lured her into the Lodge.

' "Then the other Adepts will strip her Next I will force Then it . . . Then . . . Then . . . Finally And the demons will feed upon her madness." I see that you like your squalid, erotic fantasies to be paratactic, Non Omnis Moriar.'

I did not reply, as I had no idea what he was talking about. Did 'paratactic' mean 'in the nude', or 'convulsive', or 'sex involving pig's blood', or what?

Felton paused before putting me out of my misery.

'I mean that your sentences are placed one after another, without one being dependent on the other. It is just like a small child describing a film. "And then a big man came into the room and he shot the woman who was in the room. Then she was dead. And then the other man who was in the room shot the first man dead . . ." '

Then he went on about how my stuff resembled pulp fiction by the hands of someone like Dennis Wheatley. Not only that, but my fantasies of what I was going to do with Maud resembled the nefarious thoughts of a preposterous, lip-smacking villain in a Wheatley novel. But I was thinking, if Felton despises Wheatley's novels as much as he says he does, how come he is so familiar with their contents?

'When the astral conjunctions are favourable and all our preparations are in place, you will indeed deflower Miss Boleskine,' Felton said, (as if this was some wonderful promise he was making me). 'But in the meantime,' he continued, 'you will wait upon the word of the Master and you will treat Miss Boleskine with all the respect that a young lady deserves. Kiss her, embrace her, dance with her, but you will proceed no further without our permission. I see that you have invited the young lady to Horapollo House today. That was perhaps a little premature. However, I suppose it would seem strange to call that off now. I suggest, though, that her visit should be a brief one and that you take her dancing afterwards. It is a Saturday after all. Why not telephone her this morning and suggest it?'

So I did as I was told (and she got terribly excited at the thought of going dancing). Sick with dread at the thought of the evening ahead, I went upstairs to work on the equations of inter-group dynamics. Felton is wrong to carp at what he calls 'sociological jargon', for all disciplines have their specialist vocabularies. Occultism is no different in this respect: grimoire, larva, Qlippoth, arcana, pathworking, zelator, athanor, shakti, mutus liber, Mother of Abomination, thurible, elixir, congressus subtilis. Half the task of a sorcerer is to master the language of sorcery. I found it hard to concentrate on my work. I kept trying to work out what use the Lodge has for the frumpish hairdresser. I will work it out eventually. In the meantime, I wish that Sally had not first left the Lodge and then me.

I arrived at Maud's flat soon after seven. Maud was dressed for dancing – at least she thought she was. She had struggled into a tight, shiny, dark-blue, long, sheath-dress with a design

of curvy, smoking dragons on it. It was the kind of thing that a Chinese concubine might wear – if, that is, the concubine was not planning on dancing that night. I was briefly introduced to her flatmate, a hollow-eyed and nervy law student. I seemed to frighten her, but, then, everything seemed to frighten her. It is no fun being a law student. They all have to work too hard.

They share a sitting-room, kitchen and bathroom. Maud's bedroom is pretty austere and nothing special. On the walls there is a blown-up photograph of Honor Blackman posing in black leather and a poster for the film of *Barbarella*. There is a full-length mirror on the door of the wardrobe. Maud has an amazing array of cosmetics on her dressing table. Her karate kit is strewn carelessly over a chair. Beside her bed she has a plastic clown's head. The head is full of earth and has grass growing instead of hair. Once a week or so Maud gives the grass a trim with her nail scissors. Also beside the bed there is a great pile of women's magazines and an Alistair Maclean novel in paperback. Having fetched a shiny, black, PVC coat out of the wardrobe, Maud said that she was ready to set out for Horapollo House. As I followed her downstairs, I noted with dismay how the shininess of the coat just emphasised the broadness of her bum.

We took a bus over to Swiss Cottage. I was wondering what Maud would make of Horapollo House. If Sally who was pretty wild and heavily into esoteric things did not care for the Lodge, I cannot see Maud, who is much straighter, responding more favourably. Maud for her part seemed somewhat apprehensive. I think that she hoped to make a favourable impression on my fellow residents, but she could not work out what sort of people they were going to be. Wide-eyed and timorous, she entered Horapollo House. She was like a pantry-maid who had been invited to enter the big house by the front door. Yet Mrs Grieves, who happened to be sweeping in the hallway stepped back respectfully, as if Maud was rather a visiting princess.

I showed Maud the dining room, the library and a couple of lecture rooms. Crossing the hallway, I noticed Laura

looking down on us from the first floor landing. Her face was inscrutable. When I next looked for her she was gone. I avoided showing Maud the Ritual Chamber as I did not want to have to explain about the pentacles all over the floor and the sacrificial altar at the centre. Apart from anything else, it is such an effort explaining anything to Maud. She wrinkled her nose at the frescoes on the first floor, but the sum total of all she had to say about Horapollo House was that it was 'a bit gloomy'. It would be easy to keep any sort of secret from Maud. She is just so amazingly incurious.

My room was subjected to the most cursory of inspections. She picked up one of my Dylan records and remarked that she found him 'kind of droney'. Then she sat down heavily on one of the beds and patted the space beside her for me to join her. She ran a hand through my curls, before burying her head in my chest. I could feel her trembling ever so slightly. I thought of all that nonsense that Laura tried to get me to practise saying: 'We really have to be alone . . . for me to tell you how much I love you. I would be too shy to do it in a crowd of people . . . This is our night and nothing is more important than our love,' and stuff like that. But, that was all pointless now. On the one hand Maud, so soft and trusting, would obviously be a pushover, but on the other hand, I am on a leash until the astral conjunctions are favourable. Unable to think of anything to say, I pulled her head up and kissed her vaguely, thinking as I did so that my kisses were only a foretaste of the much fiercer embraces of the ritual Consecration of the Virgin. I am a kind of sex-demon of the Dark Annunciation.

She ran a hand down my chest.

'You are so thin. I think that you worry too much,' she said.

I shifted restlessly, for I was impatient and anxious to be moving on to Middle Earth. I was about to say this when she placed a finger on my lips.

'I think that we should be straight with one another,' she said. 'As you know, I am prepared to go all the way – except the last bit. However, I don't want you horny all evening.' She smiled nervously as she fumbled for my zip and, having got a

hand inside my trousers, she began a frantic, arrhythmic rubbing to which I was unable to respond. She stared at me in a panicky sort of way. Then she opened her mouth wide before lowering her face between my legs. It was like watching a sea-monster diving – a monster hungry to devour what lay beneath it. To see Maud like this, her face twisted and deformed by sexual hunger, was even a bit scary and at that moment I could no more have achieved an erection than I could have levitated.

'Maud, this isn't necessary.'

'I think it is.' Her voice was muffled. 'Anyway, I want to.'

In order to spare her further embarrassment, I tried to concentrate on memories of Sally and her hum jobs, but, since I was distracted and terrified of being permanently unmanned by Maud in her frenzy, Sally's ghost was powerless to work any magic for us.

I raised Maud's tear-stained face from my groin.

'I want to please you,' she said.

'I know you do, but we have to get to know one another better. These things take time and I want it to be special between us,' I said (momentarily enjoying my new-found role as vestal virgin).

She nodded humbly,

'You're so beautiful, Peter, but I know that I don't understand you at all. You have to keep telling me what you are thinking all the time, because I am no good at guessing.'

Only after another half hour or so of inanely reassuring conversation was I able to persuade her to set out with me to Middle Earth. That stuff in my room was all just so ghastly. Nothing ever quite works with Maud. She always gets everything a bit off-key. It's not just the timing of jokes she gets wrong. It's social situations too. Like at first she will not have the confidence, then she will suddenly get her courage up and charge in – at just the wrong moment. Thinking about Maud's incuriosity about Horapollo House, maybe it is that she is nervous of revealing her stupidity by asking the wrong questions.

Anyway, we reached Middle Earth with me desperate to

lose myself in sound, light, movement and clouds of dope, but Maud was reluctant to follow me down onto the floor. She sniffed the air suspiciously. She seemed a bit shocked by the noise and the mass of heaving dancers. The Nuclear Hedgehog (all dressed in scarlet guardsmen's uniforms) were playing. I do not think that they are as good as the Incredible String Band. Despite Maud's reluctance, I drew her into the dancing throng. She was shouting something, but she had to keep shouting before I managed to guess that what she was mouthing was that she could not dance. It was ridiculous, for she kept asking me where to put her arms and legs and where she should move to next, as if we were dancing the mazurka or something. I just told her to follow my movements and copy them and then I tried to forget that I was with her. Yet this was difficult, partly because Maud following my movements was like a soldier mastering a difficult drill and partly because she kept looking at me so adoringly. Also, she, panicking, embarrassed and longing for the music to stop, was so tall that she stood out amongst the other dancers. It did indeed look as though she was ashamed of her body and wished that she was in another one. The Nuclear Hedgehog moved on to a slower, smoochier number and Maud closed in upon me. Her body rubbed against mine and her arms curled round me, so that I was like a doomed Indian villager caught in the coils of a fat python.

I could not bear to be so smothered and broke away and headed towards some cane chairs in the next room. But it was not so easy to escape from Maud's coils and, instead of sitting on the chair next to me, she planted herself upon my lap and those deathly-white arms curled round my head as she began to stroke my hair. I was seriously down – down like a man lying on the floor who wishes that the floor would give way so that he could lie on the floor below. This place had been fun with Sally, but only with Sally. How long before the astral conjunctions would set me free from my current role as Maud's cavalier? Seeing my despondency, Maud playfully tweaked at the corners of my mouth.

'Give us a smile, Peter. Anyone would think that you'd just been at a funeral.'

As soon as the words were out, she realised what she had said and clapped her hands over her mouth – too late.

'Oh God, Peter,' she said at last. 'I am so sorry. I forgot that it is less than a week since your mother's funeral. Oh God, I am so very sorry. Look in the circs, should we be here at all? This has just been an unqualified disaster.'

I shrugged.

I hoped that the evening was over, but it was not quite. We had a very long wait at the bus-stop and, while we were waiting, Maud started to interrogate me about my previous girlfriends. She particularly wanted to know about Sally and why Sally and I had split up. She seemed to be doing a PhD thesis into the topic of why all my previous girlfriends had turned out unsatisfactory. I kept stonewalling on the precise reason why I had broken up with Sally. I could hardly tell Maud that it was because Sally had decided that I was evil, could I? After suffering this interrogation for some time, I told her that the subject was now closed and I stood apart from her.

Silent and sulking, she leant against the bus-stop. Then she called over to me,

'OK, I apologise. It's just that I don't want to go the way of Sally, that's all . . . But what do you like about me best?'

Before I could think of what to say, someone spoke, as if he was answering for me,

'You are all gorgeous, darling. You look like God Almighty has sculpted your curves so as to give us men perfect delight. You've got great hair. And that's a fab dress you have on. A girl like you is not safe out so late on her own.'

The speaker moved out of the shadows. He was a straight, with a short haircut and wearing a jacket and tie. He had been sweating and maybe he had been to a dance too, though he was definitely not a Middle Earth type.

'She is not alone,' I said.

He turned on me with simulated surprise.

'Oh I see, it's girls' night out together,' he said. 'Hello darling. But shouldn't you have stayed in tonight and washed

your hair? You look a fright and that's a terrible thatch of curls you got there.'

The next instant he was bent over, wheezing. He should not have said what he said while standing so close to Maud. She had delivered one of those controlled karate punches into his belly. While he was still doubled up, Maud hit him a second time, this time catching him on the side of his head. He went down on the pavement. It looked more as if he had decided to lie down than that he actually fell. Perhaps he thought that he would be safer on the ground.

'It's a bloody good perm,' said my dragon-lady standing over him and, still not satisfied, she kicked him in the head, though not very hard, as the tightness of her dress would not allow her to get a good kick in. But she kept kicking and I had to pull her away from the twitching and retching man. I made her trot beside me and we followed a zigzag route through the streets of Covent Garden until I was sure we were in no danger of being pursued by the police or anyone else. Despite my anxiety, Maud beside me was smiling and relaxed in a way that she had not been on the dance floor. Once we reached another bus-stop, she got a handkerchief out and, bending awkwardly wiped smears of blood from one of her shoes.

After a while, she took my hand and squeezed it.

'You should have let me finish the job, Peter. It's good fun fighting. Fighting is nice. What I like is the adrenalin, the speed of movement and the putting out of strength and I like winning. At the classes I go to, the teacher is always telling us that karate is an art form, like Japanese flower-arranging or something, and that the greatest karate masters are the most gentle and all sorts of rubbish like that, but for me that is not the point. I like hurting – plus of course taking the risk of being hurt. It's nice. That was why, before we met, I was hoping that you would be a soldier or stunt-driver or something like that. But you, being a student, wouldn't understand how I feel about fighting and you probably think I'm being stupid, don't you?'

'I can relate to what you are saying about adrenalin,' I replied, deftly avoiding her question. 'Adrenalin is the sweetest

drink there is and it's like it's always on tap within the body, always available on demand, and it's really good, because, whereas beer makes me sleepy, adrenalin makes me fly.'

I went on talking about adrenalin and the other neuro-transmitters in the body, like serotonin and the various endorphins. Inside my head – inside all our heads – there is a sea of chemicals. And it is we of the 1960s who are the blessed generation, for, thanks to the new pharmotechnology, thanks to LSD, methedrine, and other drugs, for the first time in human history, we have the means to navigate upon this strange sea. We can become as gods. Is this not the most wonderful thing to have happened ever?

I was gabbling a bit. I was so flabbergasted by what had just happened at the bus-stop. I kept seeing the blood on Maud's dancing-shoe. But it was not just Maud's attack on the man. (Maybe the Lodge will have a use for her delight in blood and action?) After all, I knew that she was good at karate. No, what really amazed me was that that man, whoever he was, drunk or not, seriously fancied Maud.

Myself I fancy – no Felton will not let me use 'fancy' – I worship from a distance at the altar of the slender, leggy woman. Her icon is everywhere displayed, as she is made manifest in the guise of Jean Shrimpton, Julie Christie, Charlotte Rampling and Twiggy. Whereas looking at Maud is like looking at the photographs in a biography devoted to some worthy or another who flourished around the year 1900 and one is told in the text that the POET Y or the GENERAL X married one of the most notable beauties of the age, but then, when one looks at the relevant photograph, what one sees is a bulky bundle looking a bit like an upended sofa, with a jaw like a bullmoose and a nose like a meat-cleaver, and you wonder if all the men were mad in 1900, or what. Maud could have married POET Y, for she is florid in a way that is definitely no longer fashionable. She might have been a courtesan in the Second Empire or a fleshy mistress of Edward VIII or something. She was born out of her time. She could even have been a Victorian lady explorer, slapping the native bearers about a bit or kicking an unfortunate Kurdish

brigand in the head. But this is 1967 and, dancing at Middle Earth, Maud just looked like a female yob – a yobbess, I suppose. I was glad when the bus came along. I felt a bit shaky waiting alone with her and holding her hand. Who knows when or why she will next turn violent?

As for myself, I have caught myself reflected in the eyes of Sally, Laura and Felton. I am beautiful. Does the mirror ever lie? Is it possible to be beautiful and evil? Clearly. Think of the wicked witch, all curvaceous and sexy, in the cartoon version of *Snow White and the Seven Dwarfs*. I drift off to sleep thinking of the wicked witch.

Sunday, June 18

The day was heavy and overcast. I went downstairs to do some more work cataloguing. I have discovered that some of the library is double-stacked, so that there are ranks of books behind books. Many of the books concealed in this way are red notebooks – that is to say they are hand-written anthologies of spells. Their ink is somewhat faded and I guess that these books were produced by Lodge members who have since died. (Crowley's Astrum Argentinum broke away from the Golden Dawn in 1905 and the Black Book Lodge in its turn broke away from the Astrum Argentinum in 1914). I suppose it is possible that their black books, the Lodge members' diaries, are also stored somewhere in this room, but I have not come across any yet. Although I was eager to study in more detail these hand-written grimoires, some of which were half a century old, I was getting tireder and tireder, and the rustling of the leaves in the garden outside was like tiny whispering and it seemed to me that the whispering was urging me to sleep, and I thought that, if only I closed my eyes for a few seconds and rested for a moment, I should, after that rest, be better able to stay awake.

I had a whole series of confused dreams. First there was a meeting with a yellow dwarf who liked destroying things. Then there was something about werewolves in the trenches

of the First World War. Initiated werewolves fed on the corpses of the Somme. I found myself sharing a trench with Julian. He was no company at all, for the lower half of his jaw had been shot away. I had to do some deal with the werewolves which involved Julian, but the only dream I can remember properly was the last. I dreamt that Maud and I had decided to drop in unexpectedly on Cosmic. We entered his flat to find his head on the floor and beside it a big sword. Blood continued to gutter down his naked torso. Maud went over to sit beside the torso and she smiled invitingly at me as she cradled Cosmic's head and crooned over it. It was as if she had just given birth to his head. I thought that it was all very well for her to take this so easily, for she was unaware that Cosmic had been executed by the Lodge. But there were other Lodge members in the room and I learned from them that this was not in fact the case. Cosmic and a pair of assistants had been engaged in a voodoo experiment. The idea was to cut Cosmic's head off and then swiftly replace it, using voodoo chants to reseal the gash made by the sword. The trouble was that the experiment needed total commitment and complete conviction. Cosmic's assistants had lacked the necessary faith and, besides, they had been disturbed by our arrival. Just before I was shaken awake, someone else said, 'He who wishes to see the child of the beast must be prepared to lose his head. Would you like to see the child?'

It was Alice who was shaking me awake.

'You have been talking in your sleep. You are not supposed to sleep here. What have you seen?'

'Nothing. It was a stupid dream.'

But Alice then gave me this schoolmistressy lecture on how if one slept in Horapollo House in the daytime, one did not sleep alone, for the daytime was also when the larvae choose to sleep. The larvae, half-souls of those dead who have insufficient strength of will to detach themselves from terrestrial existence, dream in this room and elsewhere in the house. If one sleeps with them, the madness of their dreaming and their hopeless longing to be alive once more will infect one's dreams. It is like taking dictation from hundreds of dead men

and women talking in their sleep and, if they perceive that they cannot ever really re-enter the world that you are in, then they will try to persuade you to join them in theirs.

Obviously there was a gloatful note in Alice's voice as she described the horrors of the unseen to me. But I also thought that I could detect a note of yearning as if she actually wished to be embraced by the shadowy larvae. She was also gloating when she told me that she would have to record my nap in the library in her diary. I told her that it must be a really dull diary if she was putting things like that in it. But then, come to think of it, my diary is not exactly a rip-roaring adventure story, if I am recording my tiffs with Alice in it. I think that one of Alice's problems is that she is jealous of my newly permed hair. It makes her wild fuzz look even worse than ever.

So now I sit alone in the library once more – alone that is except for Pyewhacket, the writing hand, and my diary, who are always with me these days. I think the diary is a 'who', for my book feels more and more like a person to me – my unreliable, hypocritical, little brother. The word on larvae is quite interesting. It seems that they are similar to but different from the Qlippoth. From what little I can gather from my reading and odd remarks by Lodge members it seems that the Qlippoth does not feed off dreams like the larvae do. Instead it draws its power from sexual fantasies and masturbation images. It is especially dangerous to repeat a masturbation fantasy, for the next time that scantily-clad young woman or, perhaps, some great hunk of a man appears in the mind's eye, there will be something of the Qlippoth in that image and in the longer run, such fantasy images – curvy, pouting, swaying and beckoning – become wholly the slaves of the Qlippoth. The consequence of this is that the fantasist is no longer the master of his imaginary harem. Instead he has the Qlippoth in his head and, through becoming a slave of his fantasies, he too will become a slave of the Qlippoth.

After dinner I went to bed early with a book. Last week, bored with a continuous diet of Aleister Crowley and Dennis Wheatley, I went into a book shop, looking for something else to read. I ended up buying a copy of *Howard's End* by

E.M. Forster, which I have now started reading. It's not my sort of book, so I have no idea why I bought it or why I am reading it now. My desire to read this book must be caused, I suppose, by some event in the future. Alternatively, I conceive that it is possible that I do things which have no motive or reason behind them. It could be that, like Sally was saying, causation is utterly phoney. From now onwards, whenever I find myself doing something I cannot explain, I shall record the inexplicable action here in my diary and then alertly wait to see if the future will throw up the explanation. In the meantime, all I can say about *Howard's End* is that it is an extremely boring book.

Reading a novel is a bit like being in the Lodge. Lodge members keep telling me to stop asking questions. They want me to suspend my critical faculties and commit myself completely to the Lodge. This, it seems to me, is like reading a mystery novel. The pleasure of reading the novel will be spoilt if, all the time one is reading it one is conscious that it is a novel, and one keeps analysing its narrative strategies and one keeps asking awkward questions like, 'Why don't the hero and heroine go to the police?' Mind you, the only mystery about *Howard's End* is how famous it became. I cannot see what Forster wanted to say in it. But, to return to the Lodge, it wants to become the story of my life. The attraction of this is that at least my life will have some kind of plot, whereas, if I just did my PhD and got an academic job and got married, and had children and got old, it would be just one thing after another and no plot. It has taken me ages to write all this down. I wish I could hire a secretary to write my diary for me. Come to that, I wish the secretary could live all the events described in my diary for me, so that I could just lie here and read about them later.

Monday, June 19

Slept badly, dreaming of Julian and his brightly polished gun again.

I had thought it possible that by now the trouble at the LSE might have eased off and the library might be open again. This proved not to be the case. Instead I wasted a morning sitting on the steps of the LSE listening to a teach-in on academic freedom. Who can get interested in a subject like 'academic freedom'? The only freedoms that matter are things like freedom from conventional morality, freedom to travel on the astral, and freedom from old age and death. All this political stuff is just dreck. At the moment I just seem to proceed from boredom to boredom – the boredom of reading E.M. Forster, the boredom of the politics of the LSE and, soon, the boredom of a date with Maud. Going out with Maud is like dragging a cow to market. How much longer do I have to string her along before I can deliver her into the hands of the Master? People at the sit-in were looking curiously at me and for a while I thought it might be because they could read my Satanic thoughts. Then I realised that it was just my hair which was attracting their attention.

In the evening I met Maud at the Statue of Eros. We went to see the film of *Camelot*. This was Maud's choice. Her friend, Phyllis, had recommended it. Once the film had started, it was pleasant not to have to talk to Maud. *Camelot* consisted of a lot of middle-aged tunes about being middle-aged, having affairs and looking back on young love. I did not bother with watching it much. I spent part of the time contentedly compiling my personal list of the ten worst films ever made: *The Carpetbaggers*, *Those Magnificent Men in Their Flying Machines*, *Wonderwall*, *Genevieve*, *Il Deserto Rosso*, *Blow Up*, *Youngblood Hawke*, *Smashing Time*, anything with Norman Wisdom in it and *Camelot*.

Maud came out of the cinema humming 'Where Are the Simple Joys of Maidenhood?' Although she really liked the songs, she had been flummoxed by the film's flashback-structure and had not understood that at the beginning of the film Arthur (Richard Harris) was looking back on how, as a young man, he first met Guinevere (Vanessa Redgrave). I suppose that if one does not go to the cinema very much it is easy to be foxed by flashbacks. Her only other criticism of the

wearisome, soggy mess we had been sitting through was that 'the fights weren't up to much'. On the plus side, she liked Mordred, played by a smirking, twitchy David Hemmings. I thought this was original of Maud, until I understood that she had not realised that he was supposed to be a 'baddie'. She just thought Hemmings looked very nice. I think Maud is probably incapable of regarding anyone who looks nice, plus having lots of nice hair, as potentially evil – not that she is capable of articulating that opinion. I have to think it for her. Maud does not have articulated, general opinions and she is not used to critically examining a film – or a book, or anything.

Sally would have hated the film – this despite her craze for King Arthur and the Knights of the Round Table. For Sally, the meaning of Arthur was tied up with Glastonbury being at the heart of the Western Mystery Tradition and with the Grail Quest being a kind of pathworking in which one is questing for the 'inner self'. Sally regarded the Arthurian legend as something that is being re-enacted in our own times. President Kennedy was a reincarnation of Arthur, while Jacqueline Kennedy is Guinevere and together they presided over an American Camelot. Kennedy is the *Rex Quondam et Futurus*, 'The Once and Future King', who, having been murdered by Mordred, will return when the world in crisis most needs him. Sally's fantasia about the reborn King Arthur never made any sense to me and, to take just one little thing, Jackie hanging out with Onassis does not match up at all with Guinevere entering a convent. None of this has anything to do with the musical, by the way.

I saw Maud back to her flat and got a big messy kiss on the doorstep. In view of what is coming to her, I could almost feel sorry for her.

Tuesday, June 20

Another morning and afternoon observing the playground. Who could have guessed that sociological observation could

have *a refined charm such that it might actually become the preferred pursuit of the aesthete? Yet it is so. It is peculiarly sweet to drink to forget the bitterness of adulthood and a fierce joy in trampling the fences which the adults have made for their protection. How the tears of children — their plump little faces studded with pearls — play havoc with the most hardened heart! Their laughter mocks the weariness of the world. The eyes of the watcher on the edge play over the soft, downy skin of the children, their long-lashed, trusting eyes and their chubby, pumping limbs, and the watcher feels himself melting, longing to be drawn into their little world, so touching in its small concerns. He is purified in their soft, sweet breath. Children are wise with the wisdom of innocence. They are aware, without even knowing that they are aware, that the rose can only be plucked from a hedge of thorns. Pleasure can only be found in the midst of pain. The taste of childish sweat is simple, yet refined in its simplicity. There is something peculiarly poignant in dying young . . . and something exquisite in filling one's mouth with childish fluids and spitting up at the dark and rolling heavens.*

Pyewhacket again. I do not pay any attention to him.

Now that Felton is satisfied that Maud and I are properly launched, he seems to have reverted to holding regular Tuesday and Thursday diary sessions. Today's session was full of surprises. The first that Granville was there, waiting for me to inspect his diary. By now I had forgotten that this had been promised. Granville passed his diary to me, I passed mine to Felton and Felton passed me a bundle of money. Then Felton and I set to reading. I was only allowed to look at the two pages in Granville's diary dealing with that one particular evening with Sally. What I read was quite strange:

April 14
That night vision of the Washer at the Ford again. I awoke thinking of Sally. This was the third morning running. K.O.K.I.X. has Leo on the ascendant and Leo is on the cusp of my sixth house (Virgo, the bowels). I performed the seventh-degree operation on the body of the Hawk-Headed One. I then performed the ritual of

banishment. It was useless however. I descended to examine Palliser's table. It has been long in the sun and the patina on the top has faded slightly. Its grain is somewhat pronounced. The grain on the leaves matches. Obviously I cannot afford to pay what it is worth. We shall just have to see. I put the chandelier in the washing-machine. All the while I kept busy, I thought of her. First she is a hippy slut. Secondly I love her. She is a bunny rabbit. I went over the accounts thinking of her. Clearly nothing may be done that imperils Peter's status. But Peter need never know. I lunched at Sheakeys. Back at the shop I performed the coffin meditation. The chandelier has come out nicely. While I was at lunch the Chinese rug was delivered. Its colours include cherry, apricot and yellow. I am certain that it is pre-twentieth century. The problem will be to find the buyer who can see that too. Thoughts of that girl crowded in upon me. I left the shop. I went to that pub in Pimlico. There was a woman at the bar. I used the Gaze upon her. She came to me. After a few moments of conversation for appearance's sake, I made her follow me into the Gents. I had thought that her sucking me off might clear my head. It was not so.

Sally is a hippy slut. She is also an unattainable Snow Queen. I love her kookiness. I love the fact that she despises me. By now Peter is on his way to the lecture at Horapollo House. As I write these lines my hand trembles. I have just realised that there is no need for me to be there too. I will visit Sally. I have no idea what will happen.

I rang the bell. Her face was hard and hostile. I told her that I happened to be passing. She did not believe me. She said something polite and tried to close the door on me. Then I told her that the real reason for coming to see her was that Peter was in danger. She showed me into her room. It was full

of hippy kitsch. I made myself as comfortable as I could. She wanted to know about the danger Peter was in. I told her the truth that it was I who was in danger. I would die if I could not have her. She was unmoved, my darling slut. I would rather she had given herself to me of her own free will, but this was not going to happen. I used the Gaze and she came forward to undo my trousers. "Wow, gaiters!" She was excited by them and made me keep them on while we made love. Afterwards, as we lay beside one another panting, she asked me if I liked the smell of my own farts.

A few minutes later she wanted me to leave. I told her again that she was adorable. She turned a cold ear to me. She told me that if I did love her, I should never tell Peter. She told me to go away. I must never return. Why did she ask me that question? Did I fart while making love to her? It is anguish to me to think of it. I cannot bear to think of my future life without my darling slut.

I was not allowed to read any more. Granville, who had been watching me coldly, took his diary back. I had at first thought that the diary entry might have been faked — just as the dog had been trained in advance to find Granville the previous time. Granville had plenty of time to fake those pages after all. I would have liked the story of his magical seduction of Sally to have been a lie, but, in fact, I was pretty sure that this was not the case. 'Do you like the smell of your own farts?' was one of Sally's questions-of-the-week that April. My feelings about what I had read were confused. In principle, Sally was nothing to me now, since we had split up. Even before we split up, she was always a free agent, free to sleep with whoever she chose. That was no big deal. On the other hand, on this occasion, she was not free. Confusing, but I suppose it is not really important.

Felton passed my diary to Granville and showed him a page. Then,

'See to it,' he said and Granville left the room.

If we are all going to be reading each others' diaries then it will be like living in a nudist colony with everything dangling out. Felton took me through my recent diary entries. First he was grumbling about how he had been unable to find the school I was working at in his *A to Z* and he was muttering about how my diary had made him curious to see these little children whom I had evoked so vividly in my writing. Then, he pounced on, 'I can relate to what you are saying about adrenalin' and harangued me on the hideous imprecision of the verb I had used. Did I mean that I actually agreed with Maud? If so, why not say so? Or did I merely mean that I could understand what she was saying without agreeing with it? Or did I vaguely empathise with what she had said without even fully understanding it? Or did I have something to contribute on the subject of adrenalin without necessarily agreeing with her contribution? Was I 'relating' emotionally or intellectually, or was some other kind of relationship being posited? Felton went on and on until I felt quite dizzy contemplating the multiple levels of unintended meaning and ambiguity in what I had written.

While Felton was talking, the door swung open behind me. He raised his eyebrows, but continued talking. I did not dare look back. Felton abruptly stopped nit-picking at my use of language.

'I can see that I do not emerge as an impressive figure in the pages of your diary. Ah well . . . Years ago I was faced with a great test, the greatest test of my life . . . which I failed. You, when your testing-time comes, must not fail.' Felton was speaking rapidly and urgently. 'People come to the Lodge for all sorts of reasons. Not all those reasons are worthy ones, but that does not matter. Some come to scoff, but then stay to be converted. Others come to us because they hope that the Lodge will provide them with good business contacts, or sexual gratification, or simple entertainment that will brighten up their otherwise rather dull days. These are naive and mistaken motivations, but we can work with the people who have them. Some come to us because they are lonely. We

provide these people with new friends – some visible, some invisible. But really only the End matters. . . . What I am saying, Non Omnis Moriar, is that you can speak the truth about your reason for kissing the hand of the Master. It does not matter what initially brought you into the Lodge. The only thing that matters is what we are going to make of you.'

What is all this rubbish? He has been reading the truth in my diaries for week after week. I was going to point this out to him, before asking him how much longer before the farcical chore of courting Maud could be concluded? I never got a chance to ask my question.

'Charles dear, could I have a word?' The voice was a woman's.

'Bridget, can't it wait? As you can see, I am in the middle of a diary session with this young man.'

I turned round. Bridget was immensely tall and wiry, with thick black eyebrows, dark eyes and long white hair.

'Not really,' she replied. 'The exorcism and the Shibboleth exercise will start in a few minutes and the matter is really rather private.'

'Oh, very well. Oh Bridget, this is, as you must have guessed, Non Omnis Moriar. Non Omnis Moriar, this is my wife. Bridget's name on the Path is Dolor Mundi. She is just back from a tour of our Lodges in the United States.'

I rose to shake hands with Bridget, before she went out with Felton into the corridor to confer. The door was not fully closed and I heard them muttering something about the Church of Satan, Anton La Vey and 'that insufferable Mansfield woman' and 'all those groups which lost their way after the death of Crowley'. But what they were muttering was not so important to me. So Felton has a wife! And Felton is Charles Felton!

A mad thought strikes me and, while they are still on the other side of the door, I ease *How Boys Bathe in Finland* off the shelves and swiftly flick through its pages. Dark waters lap the shore of the sacrificial island. The water spirit, Vu-Murt, is always hungry for human sacrifice. Finnish waters are dangerous to young men, for the pools and rivers are infested with

female water-spirits. The Swan of Tuonela floats on the infernal river as the guardian of the Lands of the Dead. And so on. The book turns out to be a commentary on certain esoteric aspects of the *Kalevala*, Finland's national epic, and, in short, it is not what I thought it was at all.

'She will pay. There is always a price,' was the last thing Felton said (I suppose that should be Charles Felton, or Charles now), before he bade Bridget farewell and rejoined me in the room. Bridget's complaints, or whatever they were, had apparently driven my problems out of his mind and all he said was that I should make more effort to understand why Maud and I had been brought together. Then he told me to hurry to get changed and descend to the Ritual Chamber.

Granville opened the session in the Ritual Chamber by announcing that Dolor Mundi, just returned from America, would be introducing us to a different sort of pathworking technique – a technique which Lodge members in the States were having some success with.

But then Granville continued,

'Before that, the Lodge has some outstanding business to attend to. On the evening of Thursday, June 8th, a young woman called Sally Vernon disrupted a meeting in this room. It is necessary now that we not only complete the purification of the House and purge it of all defilement, but that we also offer propitiation to the spiritual presences who have been so grievously insulted.'

Granville looked grim, but there was no break in his voice. He was speaking like a robot. In retrospect, I think that one of the things that was going on was that I was being given a lesson in obedience. Granville was passing another test on the Path.

We started with an opening invocation in which we sought the blessing of the Headless One, 'who is Light in the Underworld'. As the coloured smoke rose from the brazier, it struck me, not for the first time, that I had entered a different world from that inhabited by the men in grey suits. 'The few and secret shall rule the many and known.' The rituals of the Path

are very beautiful. There is a kind of natural music in the mingling of muttered incantations, the crackle of burning herbs and hiss of silken robes. It was even so a thousand years ago — and a thousand years before that.

A dirty milk-bottle was produced and placed in the middle of the pentacle. A Lodge member had nicked it from Sally's doorstep. The milk-bottle was there because it was something which had recently been touched by the object of the exorcism. It was joined by a photograph of Sally. (Where did the Lodge get that from?) The photograph was, of course necessary to provide an image which could act as a focus for our concentration. Granville and I were first to spit on Sally's portrait. By the time everyone had had a go, she was practically invisible in a storm of spittle. Then we around the Pentacle combined our spiritual energies and summoned up half a dozen of the larvae one after another. As the presence of each was sensed, Granville chanted the refrain,

> *'I entered in with woe; with mirth*
> *I now go forth and with thanksgiving,*
> *To do my pleasure on the earth*
> *Among the legions of the living.'*

Then Alice entered the pentacle and, taking the bottle in one hand and the soggy photograph in the other, she assumed the Death Posture. We are to understand that the larvae came crowding round her and that they sniffed the milk bottle and they studied the photograph, so that Sally's image and smell become part of their confused dreams. The larvae will serve as sort of bloodhounds running ahead of the Lady Babalon.

We then moved on to the commencement of the raising of the Lady Babalon, in order that she may mount the Beast and ride off in search of her prey. This is, of course, a lengthier and more perilous business. It is an operation, which, though begun this evening, will take weeks or perhaps even months to complete. It is not lightly done.

'There is no grace, there is no guilt. This is the Law. Do What Thou Wilt.'

Is it possible that this sort of thing actually works? Even now that I know about the potency of the Gaze, I still find the power of magic at a distance hard to believe in. Obviously, if I had really thought that Sally was going to die because I had spat on her photo, I would not have done it. The freaky thing is that Sally does believe in vibes and voodoo stuff. If she ever found out that she had been ritually cursed in this way, I think that she might indeed just curl up and die. However, that is not going to happen.

Since the exorcism ritual was concluded, Bridget took over the direction of the pathworking. We sat round the edge of the Ritual Chamber, while she explained how we were to engage in a performance of Shibboleth. In Shibboleth one is supposed to achieve catharsis by identifying with the person one most hates and acting out those of his or her character-istics that one most detests, for hatred is like a cancer that gnaws within one, unless one acts it out.

Bridget was first to step out into the centre of the Chamber. She was Jayne Mansfield. It was eerie. I have seen Jayne Mansfield in films and Bridget looked nothing whatsoever like her. Yet in an odd sort of way, Bridget did not just resemble the bulgy film star. She was her. Bridget drifted in and out of focus before my eyes. Sometimes, I saw a glittering-eyed, skinny, old woman. At other times, I was conscious only of a hyper-sexed bimbo parading her enor-mous breasts. Then 'Jayne Mansfield' was joined by Granville. Granville had chosen to parody his saintly, but much-detested father. One by one we all followed him onto the floor.

Up until the second I stood up and opened my mouth I did not know who I would be.

'I am Maud Boleskine,' I said.

I had spent so much time with her in the last couple of weeks that it was not difficult for me to get inside her skin. I was confused and embarrassed to be among so many strange people. Faced with Jayne Mansfield, I found myself stumbling and muttering. First I claimed to have seen all her films. Then, when pressed, I had to admit that I could not remember a single one that she had been in. The only film I came up with

was one in which Shirley Eaton, not Jayne Mansfield, had been the star. I turned and plunged away and continued to nervously edge round the room, looking for people to talk to, attaching myself to the edges of other people's conversations, saying things that were simultaneously nice and pointless and dull. I knew that I so desperately wanted to be the life and soul of the party. I kept telling wonky jokes and, since no one else would laugh at them, I went into wild peals of laughter all by myself. There was something about 'Maud' that made people nervously edge away.

Shibboleth was like a nightmare cocktail party. Apart from 'Mansfield', 'Mother Theresa' was the only famous person I met. Otherwise the room was full of nice people – solid, unassuming, well-meaning, clean-living, prim, outgoing, responsible. They were parents, brothers, teachers, employers and they were dull and ghastly. I loved it – and I loved being Maud, so eager to please, so desperate for love.

I was having a really good time, until I encountered Alice. I could not work out what role Alice had chosen at first. It was obviously a man. But who was this aloof, sly person, so fond of using pompously long words, yet so keen to pose as a hipster? It came as a horrible cold shock to realise that Alice was playing me. Not that I thought she was portraying me at all fairly. Her mimicry verged on the unrecognisable. No, it was the renewed shock of coming face to face with someone who hated me more than anyone else in the world. Her hatred was simultaneously mystifying and hurtful.

I just had to step out of character to ask why.

'Why? I just hate you, that's why,' replied Alice. 'I don't have to have a reason. You just make my flesh creep.' And, resuming her parody, 'Rationality and causality were yesterday's bag – just crazes which had their day in the nineteenth century. If you are not into non-causational, emotional lability, you are just not where it's at, man. Intelligence is the most powerful aphrodisiac and most chicks really dig my brains . . .'

I would have liked to have turned away, but I felt trapped in my portrayal of 'Maud'. If I was to stay true to my version of 'Maud', I had to cling to 'Peter' and hang on to his every

word. I had to bat my eyelashes and interrupt from time to time to get 'Peter' to explain difficult things. So I stayed there for my verbal flagellation. Alice's version was so madly exaggerated as to make me look seriously repulsive, but it was clear that this was how she actually saw me and she put all her heart into the impersonation. So I was having to ask myself how Maud, the real Maud, could ever have cared at all for the real Peter?

Pathworkings do not come any more gruesome than this. After it was all over, I came upstairs to write this all up, thereby tasting it again in all its nastiness. My participation in Shibboleth is supposed to have purged me of my hatred of Maud, but I do not think that things work like that and if, for example, you tell someone that you hate them, it does not mean you stop hating them, just because you have told them so. Hitler kept shouting that he hated Jews and he hated them until the day he died. And what is catharsis anyway?

It is late now. I am depressed and worried, but really too tired to think. Another dreary day at the playground tomorrow and Maud has a day off on Thursday, when I have promised to take her to the Zoo. Soon Laura will be here. She has promised to wear shiny leather boots tonight. After the Obscene Kiss, what?

Date? God knows what day.

There is a gap in the record since my awkward diary meeting with Felton and Bridget and my participation in that hideous game of Shibboleth. I am writing this by torch light in the middle of a wood, somewhere, I don't actually know where. Sally is dancing around me and imploring me to close this little book and be finished with it forever. Yes, I had thought that when I left the Lodge I would be able to ditch all this diary-writing. But I now find that I am unable to say farewell to my *Doppelganger*. Indeed, the White-Night Scribe of Mysteries, I am madly driven to write all night. My writing hand, like a mutated breed of racing spider, runs across the

diary's pages, faster, ever faster. Blood and ink rage through me. I am burning up in life and faint with longing to fill all the blank pages that are before me. Speed, fierce and intoxicating, courses through mine and Sally's blood. There's methedrine to our madness.

But I suppose I better go back and fill in the gap in the record. Perhaps, when I have done so, I shall be better able to understand how me sitting in the middle of a dark wood (through which the right way remains obscure) can have caused the things which happened before this and how, in reverse causation, my present condition can have led to that confrontation with Felton and his wife two days ago now. Jeezus! I am confused.

As I have already noted, on the night of Tuesday June 20th, I sat up late writing my diary. I then sat up later yet, trying to get my thoughts in order, trying to decide what to do next. I came to no decision. On Wednesday morning when I went down to breakfast, I noticed that there was an odd atmosphere. Grieves was standing by the front door as if he was on guard. I sort of noticed this, but did not pay attention to it. As I ate my breakfast, I was thinking about last night and about the game of Shibboleth and what it must be like really to be Maud. Felton's desire to see the children in the playground seemed so creepy. And I was trying to come to terms with what I had learned about Granville and Sally. I kept coming back to the image of those gaiters on Granville's white legs.

But then after breakfast Felton said, 'Well, Non Omnis Moriar, let's be off then.'

And Bridget took me by the wrist and said, 'Take me to the little children. I want to see them.'

'We think that it is time for us to visit your school,' Felton added.

'Sure thing,' I said. 'No sweat. But I need my research files.'

I went upstairs and picked up my research files – and my red and black books, my cheque book and my address book. I was flustered and my hands were shaking. I couldn't think what else to take, except my tooth brush which I put in my trouser pocket. I paused to kneel by the toilet with my head

hanging over the basin, for I thought that I might throw up from sheer terror, but it was no use. Nothing came. Bridget and Felton were waiting for me downstairs. We walked down the hill. It felt like I was a prisoner being frog-marched to the gallows, with the prison governor on one side of me and the padre on the other. We climbed on the 78 bus which was supposed to take us close to St Joseph's School, but then, as the bus was pulling away from the stop and beginning to accelerate, I leapt off the rear platform and started running, heading back past Horapollo House towards Swiss Cottage Underground Station. There seemed to be no pursuit and, of course, Charles and Bridget Felton were far too old to emulate my leap. Even so, waiting on the southbound platform at Swiss Cottage, I found myself sweating with fear. I kept looking round, fearing lest a Lodge member should have followed me into the station.

When I arrived at Sally's place, I rang the bell and kept on ringing it. There was no answer, but I was out of my mind with fear and I kept ringing it for about fifteen minutes. In God's name why did she not come to the door? Then I remembered that, of course, she was at work, but I still could not remember where. It could be any one of thirty theatres. But I could not wait at her door. The Lodge will have her address on their files. Sooner or later they are bound to come looking for us here. The overwhelming probability was that she would be coming in from the West End. She usually comes out at Notting Hill Gate tube station. Having worked this out, I hurried up Portobello Road and slipped into Abdullah's Paradise Garden. I sat in the shadows with a glass of mint tea and watched the window and waited. If Sally was dressing for an actual performance, it would be a long wait, until maybe late in the evening. So I sat there taking stock. I'd had to leave most of my life behind at Horapollo House. But what was that? Changes of clothes, a fair number of sociology textbooks, some novels. The hardest things to part with are my LPs. They are going to be expensive to replace. But then I suppose that there are quite a few that I have outgrown or sucked dry of all emotional content, because of my habit of

playing records again and again and again, until they mean nothing to me. I wondered what had happened to Cosmic when he was expelled from the Lodge. Was he still alive? Then those gaiters were on my mind again. The gaiters and the spittle-smeared photograph of Sally. She did not tell me about Granville and now I could not tell her about everything which happened on the previous day. I doubted if things could ever be as open and easy between us ever again.

Abdullah's Paradise Garden has always been a good place to score and I was not surprised when I was approached by a dealer. He was dressed like a Tibetan sherpa and he seemed to be carrying a small pharmacy concealed in the heavy folds of his clothes. I could see that I was definitely going to need some chemical assistance to get me through the days and weeks to come. All the while that we were negotiating I kept my eyes on the window.

The dealer, noticing this, said,

'It's cool man. The fuzz busted us yesterday and they never do this place more than once a week.'

I nodded, but I kept watching the window. The dealer found this unnerving,

'Wow, you're really paranoid! What are you afraid of?

'Satanists.'

'Freeeeaky! Are they into drug busts?'

I think that the dealer thought he was dealing with a madman and he was about to break off negotiations, but I produced some money and ended up scoring four ampoules of methedrine, a couple of ampoules of amyl nitrate, half a dozen cubes of LSD, a tiny sachet of heroin and a couple of grams of dope. It was that dealer's lucky day.

It was my lucky day too. Towards the end of the afternoon, Sally came walking past the cafe. I grabbed her and dragged her inside. Sally had been expecting something like this to happen. Even so, it took a while to sink in how much danger we are both in. I was adamant that it was not safe for her to go back to her flat, so, after some argument, she went to a phonebox and rang Patsy, a friend, who is also a theatrical dresser, though 'resting' that day. Patsy came straight round to

221

Abdullah's and Sally offered her job to Patsy. In exchange, she got Patsy to promise to get her things out of her room and store them for her. Sally sat there scribbling the great list of vital things in her life: toothbrush, Donovan records, raincoat, Red Indian poster, paperback of *Lord of the Rings*, dowsing amulet, teddy-bear, chillum, plastic bust of J.F.K., and the vibrator. That night we dossed down at the Arts Lab. Since I had taken Granville there a couple of weeks previously, it was a bit risky, but we could not think of anywhere else. They were showing old Eisenstein films all night and I fell asleep with the nightmare image of Ivan the Terrible stooped over me.

The next day which was Thursday, while Sally went off to collect some of her stuff from Patsy, I went round to Michael's flat. That was really a bummer. I was expecting him to do something, though God knows what. Perhaps I was subliminally entertaining the hope that LSE maintained a 'safe house', for those of its sociological researchers whose lives were threatened by their research samples. However, all he could suggest was that I went to the police. But what could I tell the police? I have no evidence that the Black Book Lodge has done anything illegal. I am sure that they killed Julian, yet at the same time I am sure they did not murder him. They just told him to murder himself. Besides my own position as someone who has been participating in what were effectively black masses is none too clear. Michael just faffed around in a perfectly useless fashion. His main concern was that I had been able to come away with enough primary research data to enable me to complete my thesis. The possibility that the Lodge might not let me live long enough to finish my thesis did not apparently interest him and it seems that Talcott Parsons's methodology offers no kind of protection against being hexed or killed by Satanists.

However, Michael did allow me to use his phone to talk to Dad. I was on the phone a long time, first explaining the new situation and the possible consequences and options and then I got on to describing to him how I had been faking accounts in my diary of arguments with him and other people. When I read from the diary my ludicrous and wholly fictitious

argument with the minister at the funeral, he actually laughed. It is the first time in over a year that I have heard him laugh. I promised to get in touch again when I knew what the hell I was doing.

By pre-arrangement I met Sally in a cafe near Cosmic's pad. After all, Cosmic and I should now be allies in exile from the Lodge. I wanted his advice, plus I wanted to know if and in what manner he had been hassled since his expulsion. First, of course, I would have to apologise for having written what I wrote about him in my diary, but at that stage I obviously could not have afforded to have had my cover blown. I had had to stick to the Lodge's rules. Well, all this was irrelevant, because no one came to the door. As I kept on pointlessly ringing the bell, it came to me how much I needed him now. Then I thought that maybe he was dead, just like in that dream I had. He looked so pale and shifty when I last saw him lurking by the Lodge. Maybe an emissary of the Lodge had got to him and commanded him to commit suicide. Maybe they did not even need to do that. They might just think bad thoughts at him and he would lose his will to eat and he would starve to death at the foot of his cardboard pyramid. Death is Life's Answer to the question "Why?" Then I thought that maybe the Lodge's Adepts would go to the cemetery and resurrect Cosmic's corpse and use it as a deathly bloodhound to hunt me down. Then I thought I must be going mad to be thinking such thoughts. This is London in the summer of 67, not England at the height of the witch-craze or Voodoo-ridden Haiti. Still, it seemed risky to linger and after ten minutes more of ringing the bell we hurried away. Since then the thought has occurred to me that maybe Cosmic is OK, but very paranoid. Maybe he was looking down on us from his window and not answering the door because he thought that I was an emissary from the Lodge.

For want of a better idea, we went on to Robert Drapers's place. He has a tiny room in one of those little houses behind Stamford Street. Back in the 1870s Rimbaud and Verlaine smoked dope in Stamford Street and worked in a cardboard-box factory nearby. Through living in the same area, Robert

hopes to acquire some of their *mana*, or *baraka*, or whatever. But, as Sally pointed out, he's just as likely to catch the *mana* of the owner of the cardboard-box factory. Robert has a fuggy little room with a bed and just enough space for a record-player at the foot of the bed. Bert Jansch was playing. We crowded on to the bed, rolled a few joints and talked. I kept trying to get across the message that the Lodge was really dangerous and that no one should mix with it, but Robert was too high to take it seriously. He said that it sounded just like a novel and that he had always wanted to live in a novel. Apart from anything else, there would be more space in a novel than there was in his tiny room. I tried to get him to promise not to go near Horapollo House, but he said that I was just trying to hog all its wonderful magical powers to myself.

We had lunch downstairs in the shared kitchen. Robert belongs to the Cosmic school of chefs, so what we had was muesli, brussels sprouts and condensed milk, followed by Tizer to wash away the taste of the condensed milk. Robert was telling us about the Notting Hill Project, Rachmanism, the history of race riots in West London and stuff like that. Then Sally started talking about her dreams and how Daffy Duck has been warning her in her dreams that something pretty heavy was going to happen. Sally's dreams are always in bright technicolour and they are entirely peopled by characters like Yogi Bear, Woody Woodpecker, Dylan the Rabbit and Tom and Jerry. Until a few months ago, when we had a conversation about dreaming, she had assumed that everyone had cartoon-film dreams, just like she did. When she has nightmares about the Lodge, it's Goofy, Zebedee and Sweetpea who emerge from the shadows and with low mutterings begin to invoke the Evil One.

As I drew on the post-prandial joint, a kind of elation stole over me. Maybe Robert was right, after all. Yes, it was and is scary, but it is also exciting. At last something is happening in my life. Robert and Sally had moved on to Sobranie Black Russian cigarettes. We appeared as if dressed in smoke. It was like sitting under a volcano with little bits of ash ceaselessly

rising and falling. Here and now in a little room off Stamford Street was a node of Destiny. We are the Golden Generation and most of us will never die, because, before that happens, the skies will be rolled up like a scroll, Time will be brought to a stop and the workaday world will be replaced by the *Mysterium Tremendum*. It is because of our privileged place at the end of history that drugs are starting to circulate in society. The function of drugs is to prepare us for the end of the world. Through drugs we can commence the adventure of inner exploration and make ourselves ready for our future metamorphosis and passage to a higher state. I know it sounds crazy to say that God can be found inside a sugar cube, but being crazy doesn't stop it being just possibly true. And in the meantime, setting God aside, we can use drugs for psychic engineering and devise special cocktails to make a gentler, better society.

Robert is a bit more cynical and cautious. He is just dipping his toe into the waters of the drug culture – just like he goes around sampling meditation techniques and occult masters. Still, I hope he is careful. He has just made a mess of his finals and has broken up with a girlfriend. He was laughing at Sally's technicolour nightmares and at my ideas about the future of drugs (and the state my hair was in was pretty hilarious too), but anyone can see that fundamentally he is depressed, lonely and vulnerable. So he is exactly the right material for any head-hunting cult.

I had been vaguely thinking of spending the rest of the day with him, just shooting the breeze and waiting for someone to come up with an idea about what we should do next. Then I suddenly thought of Maud. God knows, I did not want to, but she had to be faced. I had to warn her. So Sally and I rushed off in order to reach Gear Shears before closing time. When we got there, Sally said that she would wait for me outside. So I had to go in alone. I was dreading encountering Maud. I thought she might lose her cool and maim me for life by delivering one of those wheeling reverse karate kicks. But it was worse than that. When I entered, her face lit up, just for a moment, but then when she registered how I was looking, it

225

fell again. I would have felt better if I had been given the task of slowly breaking the wings of a baby bird.

'Maud, we have got to talk. Sally and I will be waiting for you when you can get away from the shop.'

'Can't you give me an idea what this is about now? And what is Sally doing with you?'

'It is really serious, Maud. I'll explain in the pub.'

It was a rather unpleasant Irish pub, which served long-haired weirdos with obvious reluctance. Half an hour later Maud joined us there. I rose to introduce her.

'Sally, this is Maud. Maud this is Sally – my real girlfriend.'

Maud sat down heavily and turned her face away in a futile attempt to conceal from us that she was silently crying. I suppose I should have touched her and given her some comfort, but I could not bring myself to do so. Instead, I set to doggedly explaining how I had infiltrated the Lodge in order to get material for my PhD on 'Inter-group dynamics and peer-group reinforcement in a North-London coven of sorcerers', how the Lodge had forced me to pretend that I had broken up with Sally (though in fact we carried on seeing each other), and how Felton and Granville had bullied me into filling in a computer-dating form. The worst bit of all was trying to explain, without being too precise, how Felton had wanted me to lure Maud into the Lodge for some unspecified nefarious purpose. At the end of all this, it came as a kind of relief to announce that I thought that my life might be in danger.

'Now they have sussed out that I was a spy in their midst, Sally and I are going on the run. As I say, I think my life is at risk. I don't think that you are in any danger, but I thought I ought to warn you. It is just possible they might think that I have taken refuge with you or something. Does the Lodge have your address?'

'Don't be silly. Why should they?' Her voice was muffled and chokey.

'OK, that's cool. So you are probably not in any danger. But I'll ring you in a few days to make sure. Meanwhile, when you are back at your place, don't open the door unless

you are sure who – or what – is on the other side. Those people at Horapollo House are seriously bad news. The Lodge introduced me to a man called Julian. Now that man is dead. Either they murdered him, or, more likely, they told him to commit suicide and he was so scared of them that he did it. Also they are into weird sex and a lot of other stuff besides.'

Aware of the futility of the gesture, I took the rosary and crucifix off my neck and passed it to Maud. She held it in her hand, without seeming to register what it was.

'Oh Peter, what is all this shit you have landed me in?'

I had feared her anger, but she was not angry – just miserably stricken.

Without looking at me, she reached out and pleaded,

'Don't go without me. I need you. Take me with you and Sally.'

I could see Sally tensing at this, but she turned to Sally,

'Make him take me with you, please.'

'You sort this out between yourselves,' said Sally. 'I'm going to the Ladies.'

Why was I doing this? Why had I not telephoned or even written to Maud? Maybe it was because I was mad? No, that was not the reason. We were having this meeting because I had wanted Sally to see Maud and for her to know that she had no reason at all to feel jealous. But Sally was angry. The two of them sitting beside one another, one ash-blonde and the other raven-haired, but both terribly pale, had seemed to me like figures in a fairy tale. While Sally was gone, Maud reached across the table to take my hands in hers. She wanted to know where we were going. I could honestly tell her that I had no idea. Then she offered to help find us a place to hide out in and she also wanted to know if I needed to borrow any money. I kept telling her that I already felt guilty enough about involving her in my affairs. She was safe only if she kept away from me.

'Peter, are you sure that you are all right?' She was smiling bravely now. 'This all sounds so mad. I mean, isn't Satanism illegal? How can all this be happening?'

I could see Sally coming back from the Ladies, so I rose from the table.

'I really am very fond of you Maud,' I said. (A complete lie, of course.)

'Are you really?'

'I'll get in touch as soon as its safe to do so, I promise.'

We rose to leave. I nervously brushed Maud's cheek with my lips.

'You will look after him please, Sally, and see that he does not come to any harm?' were Maud's last words.

I do not think Maud herself really has any need to worry. The Satanists are not going to bother with a dim-witted, little hairdresser in Camden Town. Besides, even if anyone did track her down and started hassling her, he would run the risk of being laid out cold with a karate chop to the neck. Anyway, it's great to have finally said goodbye to Maud. These last few weeks, it has been like I was dating an albatross.

While Sally was in the Ladies, she had come up with a plan. We were going to Waterloo Station. From there we would get a train to Dover and the ferry to Boulogne. Once we got to Boulogne, we would work out what to do next. So we took the 68 bus from Camden Town to Waterloo. On the bus Sally wanted to talk about Maud.

'I feel sorry for her. She is really straight, isn't she? You shouldn't have got her involved in all this.'

'I didn't have any choice, Sally. I had to do what the Lodge told me to do.'

'Oh yeah, and you make it sound like you have been undergoing some hideous ordeal. But she is really beautiful, isn't she?'

'No way is she beautiful. She's horribly fleshy and graceless.'

'Yeah, she is beautiful. It's like she drips with feminine sexuality.'

I was not really paying much attention to Sally's fantasy. I was getting cold feet about Waterloo Station. It is the subject of a song by the Kinks, is it not? 'Waterloo Station, you're bringing me down.' If the Lodge operated like the police do when they are hunting a murderer, then its minions would

be watching all mainline stations. Waterloo is definitely ill-omened. It is described in Aleister Crowley's novel, *Moonchild*, as 'the funereal antechamber to Woking'. I just knew in my bones that any journey from Waterloo Station would be a bad trip. I could not set foot in Waterloo Station.

So then what happened next? I will have to write for a hundred days and nights to cover everything which happened and what I thought about it and what Sally thought about what I thought and how . . . Oh never mind. Writing things up is a never-ending process. In order to go out on to the street, you have to open the door, and in order to open the door you have to turn the handle and in order to turn the handle you have to grip it and in order to grip it . . . It is like digging a hole on the beach close to the water's edge and, as you dig, the water fills the hole you are digging and you try to scoop it out with your hand, but more water is coming in all the time. There is no limit to consciousness. And here I sit in the dark wood still writing. Sally has started to undress, so that she can dance without the hassle of clothes. She says that she is going to perform the Dance of the Seven Diaries.

What happened next was that I told Sally that I had a bad feeling about Waterloo, so, instead of entering the station, we went to the Hole in the Wall pub. Now what? Evening was coming on and I had had two bad nights in succession and I was getting too tired to think, but Sally was insistent that we had to get out of London that night. She said that we had to put ourselves beyond the range of the malevolent vibes of the Lodge. Then I remembered the ampoules of methedrine. It was so wonderful – like finding magic beans in my pocket. Methedrine neat tastes really nasty, so I broke the ampoules into the remnants of our beers and then we sat and waited for the stuff to hit. That took twenty minutes, or maybe half an hour. I was just beginning to get the speed feeling on my teeth, when Sally had another idea.

'We will walk out of London. It will be so cool. The Lodge won't be expecting that. We will walk out of London and, as we do so, we will be walking out from our old lives. We will

walk all night. It will be a buzz. And we will see where we end up in the morning.'

Sally was all lit up. Partly it was the brilliance of her idea, but partly it was the effect of the speed. Outside the Hole in the Wall pub, she had us stand over a gutter and discard our watches. In this way, we made a symbolic renunciation of our old lives.

'Let's follow the sun,' Sally said. 'We'll go west.'

By now, of course, there was no sun, but I think that we thought that we could catch up with it at some point on the road, for the sun is not a speedy traveller. In the city the stars are invisible, but as we headed down Lambeth Walk, I recalled how when I was working in the library of Horapollo House, I dipped into the casebooks of Simon Forman, the seventeenth-century astrologer, and read how he used to ride over Lambeth Marsh, then a favoured place for murders and drownings. London is really the Shambala of the West, a city of sorcerers – Simon Forman, John Dee, Robert Fludd, Francis Barret, Aleister Crowley – a place wherein there is no salvation.

Donovan's 'Mad John who came down from Birmingham very hastily' was silently playing in my head. The speed was really beginning to work within me. I was burning up in a pure white flame. As speed hits the jaws, there is an odd metallic taste in the mouth. I sensed that I was undergoing an alchemic transformation. I was being transmuted into quicksilver. And Sally was the same, so my speed was talking to her speed and we could not stop talking. Because this is a Night of Power, we are getting to know each other in a way that we have never known each other before and, as we walk, we talk about scientology, hairdressing, Elvira Madigan, the ego, cats' eyes, spiritual death, epilepsy, Pink Floyd, sandals, mythic journeys, déjà vu, the meaning of the mini-skirt, Persian architecture, graffiti, authenticity, the four worst things in the world, Marmite. After all those weary evenings with Maud, it was so wonderful to be with Sally and say anything I felt like saying and not to have to taper my words to her understanding. We were true peripatetic philosophers. No, we were actually gods, even though we had forgotten that that is what

we were, but now at last we had raised the whirlwind and, having done so, we travelled on it. We were and are alive.

'Why so fast, you young things?' a tramp sitting outside Vauxhall Station cried out and he lurched up and tried to grab at Sally, but Sally Speed and Quicksilver Pete, travelling on their wheels of fire, were far too fast for any lumbering tramp. All sorts of denizens of the night sought to lure us from our chosen path. As we were walking through Wandsworth, a night bus came rattling by. Its conductor stood on the back platform.

'Last bus! Room for two more inside!' he shouted to us. His grin was one huge rictus.

But I made the sign of the cross and turned away, for I had the fancy it might be the same bus that I had jumped off the day before and that, if we got on it, we should discover Bridget and Charles Felton sitting up on top in wait for us. Wandsworth was where the paranoia came on. It is definitely a place of omens. For example, there was a shop at the bottom of the hill, whose brightly-lit window was crowded with deceitful and nasty things: a mock spider, a plastic turd, an innocuous-looking whoopee cushion, an exploding pen, a fried egg with a cigarette stubbed out on it, vials of itching powder, false breasts, a stink-bomb disguised as a cigarette, a rubbery-looking 'Van Gogh's ear' and, at the centre of all these lying objects, was a big box of conjuring tricks and on its lid the image of the Father of Lies himself, Mephistopheles, who appeared to grin and gesture mockingly at me.

As we stood pressed against the window of the joke-shop, a gang of Hell's Angels went roaring by on their bikes. Ghostly riders of the way, their sockets were sheathed in steel and the emptiness of their sockets concealed by their goggles. Sally thought that they were just like the Nazguls in *The Lord of the Rings*. I thought that they might be blind outriders travelling in advance of the Wild Hunt. I had a fantasy image of a column of high-stepping runners in flowing robes emerging from Horapollo House. The Master would be in the lead and he would be carrying a black candle and behind him would follow Charles and Bridget Felton with slavering Boy

straining against his leash, Laura, Granville, Agatha and the rest of them, all carrying candles, and the Lady Babalon mounted on the padding Beast would come slowly on riding behind.

The Hell's Angels veered off towards Richmond. The tramp was a tramp. Asmodeus was not the proprietor of a joke-shop in Wandsworth. I knew that I was being paranoid, but knowing that I was paranoid did not stop me from continuing to be paranoid. I took Sally's hand and I walked on, but I walked on . . .

> *'Like one, that on a lonesome road*
> *Doth walk in fear and dread,*
> *And having once turned round walks on,*
> *And turns no more his head:*
> *Because he knows, a frightful fiend*
> *Doth close behind him tread.'*

Beyond Wandsworth we found that the roads bifurcated and bifurcated again and again and again, endlessly ramifying. It is the methedrine which is working on the psychic geography of London in such a manner that it makes every crossroad the nexus of possibilities and choices. One road leads to life. The other leads to death. A third leads to death-in-life. And yet another leads to a post office. Horapollo House nestles in the centre of a rapidly expanding and proliferating maze called London. I see the roads shoot out in front of us, and, as they do so, tendril-like smaller shoots of side roads begin to uncurl and weave their way along the ground. We wove and rewove conversational themes in just the same way as the roads and paths unravelled under our feet. Together we could conjure up a subject, digress from it, then digress from that digression, then return from the digression from a digression and link it directly to the main theme before returning to the first digression. Stuff like that is really easy on speed.

The wind was rising from the east so that garbage was blowing down the road in front of us, as if it was guiding us on our way. But were we getting anywhere? At that stage of our pilgrimage, I was not so sure. It is perfectly possible that there

are drugs which make time run backwards, for time is, after all, nothing more than a mental construct, and, if a drug can alter my mind, then it can alter my experience of time too. It was the mock Sherpa in Abdullah's Paradise Garden who sold me the magic beans that had made our escape from the dark heart of London possible – in appearance at least. But suppose he was an agent of the Lodge, and what Sally and I have taken in the Hole in the Wall is really a kind of homing drug which takes you back to wherever you started from? For although we were walking and talking terribly fast, it still seemed to me that we had not got anywhere yet.

Fired up by speed, I tried for the umpteenth time to explain to Sally about my research on 'Inter-group dynamics and peer-group reinforcement in a North-London coven of sorcerers'; how what would be seen as mad in the outside world comes to be taken for granted inside such a closed in-group, thanks to peer-group reinforcement; how the Master could be seen as the perfect incarnation of the Weberian notion of a charismatic leader, who is in the process of institutionalising his personal qualities; how magical assumptions can function effectively as the underpinning of social interactions; how, (using terminology pioneered by Ferdinand Tönnies), Lodge members had constituted themselves as an organic community, a *Gemeinschaft*, in contradistinction to the external world, which was perceived as more mechanical and utilitarian and thus constituted a *Gesellschaft*; how Lodge members have effectively adopted the watchwords 'Evil be thou my good' as a kind of group-marker. In the end, my thesis is about group folly and how people come to believe the unbelievable, but as a sociologist my aim is to take this sort of craziness out of the domain of intellectual psychology and give it a social context. Finally, over the last week or so, I have sensed that the buzz in the Lodge seemed to be building towards some kind of event with millennial associations. I wish I could have stayed in Horapollo House just that little bit longer in order to get a clearer idea of what it was that the senior Adepts were expecting to happen.

Explaining all this took some time, as there were quite a lot

of digressions and at one point we even got back onto the topic of Marmite. I cannot remember how. Oh yes, I can. I was talking about the sociology of occult elites and how Bulwer Lytton's Victorian occult science-fiction novel, *The Coming Race*, provides a paradigmatic model of such an elite in the society of the Vril-ya supermen, and how 'Vril' was then borrowed by the inventors of the beef-essence drink, Bovril. Sally immediately accused me of preferring Bovril to Marmite because of the former's occultist associations. Sally went on to argue that I was being taken over by occultist ideas. She thought that studying magic was not really any different from being a magician, because most of what magicians do is just study magic. Additionally, she thinks that people come to resemble whatever they are studying, so that sinologists behave like mandarins, entomologists resemble insects and I talked and behaved like a magus. I deny all this. I actually prefer the taste of Bovril to Marmite. The only thing of interest for me in the Lodge is the way it functions socially as a closed in-group. Sally insisted I was evading the truth about myself. Anyway, at least both of us see eye to eye on Horlicks, which we agree is terrible. As I say, digressions like this are easy on speed.

While all this was being argued over, the countryside began to appear in patches between the ribbons of houses. Street-lamps disappeared and we stumbled on through the moonless night. At some point in the night Donovan's 'Mad John' number stopped playing in my head, to be replaced by Canned Heat's 'Amphetamine Annie'. We ought to have slowed down or even stopped, but this was impossible, for it was as if Sally and I had each donned a pair of red shoes, the magic ones which make you want to dance forever until you die. Our feet were horribly blistered by now, but we had to keep on walking. Besides, Sally was determined that we had to get beyond the range of the Lodge's vibes. There was still a bad feel here at the beginning of suburbia. The bushes by the road kept rustling and, when the occasional car passed and caught us in its headlights, then we caught half-glimpses of what looked like little white faces peeping over the bushes.

Faces but with bits missing. I have noticed before that intense fatigue can give one a hallucinatory kind of peripheral vision. Sally, on the other hand, said that the rustlings and the half-faces were materialisations of the Lodge's vibes.

Sally thinks that Julian was driven to his death by bad vibes. However, I do not believe in vibes. I have never seen a vibe and Sally has never managed to explain to me how such a thing could be produced or transmitted. No, Julian's suicide (assuming it was a suicide) was not produced by mysterious hate-waves travelling out from Swiss Cottage on some kind of ether. Nor was it just some bizarrely, gratuitous act. It has to be understood in sociological terms. The concept of voodoo death is familiar to anthropologists and sociologists and Marcel Mauss, in particular, worked on the subject of deaths willed or suggested by the collectivity. It seems that the individual ego is very fragile – so fragile that it is only sustained by the collectivity which forms the ego's environment. In ordinary cases, the sustaining collectivity would include the individual's family and the business in which he or she worked, but Julian's collectivity was really just the Lodge. Only systems of social interaction keep people alive. They are as important as the air people breathe – in a sense they *are* the air which people breathe.

Sally thought about this.

'I suppose going out with Maud has to be understood in sociological terms too?'

'Indeed, yes – well, not precisely sociological . . . It has to be understood more in an anthropological framework. My seduction of Maud and presentation of her to the Master would have functioned as a kind of *rite de passage*, which would probably have given me full access to all the Lodge's secrets.'

'Fuck that,' muttered Sally.

Then we stopped talking for a bit and, without any discussion, we left the road and headed into a wood. Fucking on speed in the middle of a wood at night, we felt like rutting ferrets, completely part of the natural world, our cries mingling with those of the hunting beasts. Then we covered ourselves in leaves and lay there talking, until it was light

enough for me to think of writing. Then, since I would not talk to her, Sally had to dance. As I write, she is covered in leaves and weaving about, trying to get the trees to dance with her. Shall I compare her to a summer's day? No, I'm tired of comparing things to things. She is bathed in the ghostly soap of pale sunlight. Actually her skin is a bit yellow and she is looking a bit seedy.

In the last month or so, I have written and spoken so much about the non-existent playground and its sociologically interesting but non-existent children, that I am almost coming to believe in its and their existence and the invisible threatens to become visible. I really ought to get the true story of the last couple of months down in writing, or I will end up believing the bogus account given in my diary. The trouble is that there is so much to get down: my secret visits to my dying mother; the weekend spent with my parents instead of at an invented sociological conference in Leeds; my secret meetings with Sally; Sally's presence at the funeral; getting the advice of the Baptist minister about Satanist cults; the staging of Sally's irruption into a Lodge meeting; Michael's intense engagement in my research; the pleasures of constructing totally fictional days spent at a wholly imaginary school; the revulsion at all the boring occultist crap I had to listen to. I know that I ought to make detailed records of all of it. The trouble is that right now I am beginning to slow down a bit. Besides Sally is impatient and wants to move on. So I will put down my pen.

I have resumed writing in the evening, but, to go back to the morning, we two foot-soldiers of the Apocalypse walked for hours under a grey hazy sun through woods, fields, farms and the occasional housing estates. To walk in daylight was less exciting, but it still felt quite good. Because our feet were blistered and our mouths dry, our walk felt like a kind of shriving. There is yet time for us to be redeemed, for we are young and all our life together is before us. Cold but sweating, we were on a penitential pilgrimage away from the City of Sorcerers.

Sally had been thinking that we would walk to the sea and that we would perform a kind of purificatory baptism in

236

its waves – and then maybe have an ice-cream- but by late afternoon, I noticed that we were moving incredibly slooow-wwlllyyy. And we were nowhere near the sea. The sun was beginning to set as we entered Farnham. Stepping into this Surrey town felt like stumbling across a time-warp. It is a place which does not groove. We have left the 60s and are back safe in the 50s. No one can find us here. We have booked ourselves into a room above the pub for the night. All the local yokels in the bar looked at us as if we were itinerant lepers. It was just like that stock scene in horror films, where the people mutter and turn away. Maybe there will be a hippy lynching tonight??

Well anyway, now I can get back to writing my diary again, but I have to say that I do not feel so great any more. There seems to be a layer of dust on my face. There is dust over everything. My mouth tastes like a corroded industrial vat. My skin under the dust is yellowish. I am still terribly cold. Earlier I thought that we might freeze under the sun's rays. My fixed smile is the only part of me that is drug-free. I am crumpled up in the fist of God. As I sit here writing, I notice that my writing hand (dear old Pyewhacket!) is moving in time to the silent song in my head. It is a slow song, Procol Harum's 'A Whiter Shade of Pale'.

I keep looking at my wrist to see how late it is. There is of course no watch there now, but my vision has become so precise that I reckon I can tell the time, by the growth of the hairs on my wrist. It is more natural that way. I know it is late. Sally is now moody. She keeps saying things like, 'The Lodge sussed you out all right' and 'Are you sure that you have got enough material for your thesis on ritual rape and murder, or do you need to go back and get some more?' and 'You think you're so fucking clever, but when is it ever going to be safe for us to return to London?' We are both very, very tired, and we should not argue, but the drug still runs too strongly to let us sleep. For all that talk, for all those millions of words, I was never moved to tell her how I had read Granville's account of his magical seduction of her, nor about how Granville and I had participated in the ritual cursing of her.

I lie sleepless beside Sally and fantasise about the future that I have forever renounced . . . In it I put down my gold-tooled, leather-bound grimoire and walk from my dressing chamber back into the bedroom. She (I think her name is Annabel) looks up at me with startled doe-eyes. She is bending over a regency striped-divan to remove a straw hat with white floral decoration out of its hatbox. Platinum and sapphire earrings frame Annabel's perfect face. She is dressed for Glyndebourne in matching blue linen coat, shift dress, and blue suede shoes. I need her help with my gold cufflinks. She drops her hat and immediately comes over to assist. She has to, for my mastery of the Gaze and, indeed, all the conjurations in *Magick in Theory and Practice* gives me power over her and over any woman. The chauffeur is waiting for us, but before setting out for the opera, we take a little time torturing the little girl we keep in chains in the basement . . . Well, the Devil has taken me up to a high place and shown me the world, but I have walked away from him.

Sunday, August 6th

This morning I spent ages watching a hare sitting like a sentinel on my front doorstep. Then suddenly – God knows how – it sensed my presence and in a series of bounds it had vanished into the woods. It is five or six weeks since I wrote anything in this book and it is already getting hard to remember how freaky things were. I have arranged to have my student-grant paid into the bank in Castle Street. We have rented a cottage on the edge of some woods. Sally grooves on playing at houses. We have this pretend commuter-husband game going. Towards the end of breakfast I look up from my copy of *Rolling Stone*, or whatever, and say that I really must hurry or I will miss my train and be late in at the office. Sally dithers about, looking for an umbrella and running a clothes-brush over my T shirt. Then she kisses me goodbye on the front doorstep and I go round and creep in through the back door and set to writing up my notes on group dynamics

within a North London group of Satanists and all that load of shit.

Once I came down from speed, I put my diary away, thinking that I never wanted to see its hateful black volumes again. The strain of keeping such a record had been a massive drag. For me, writing down what I had done every day was a counter-instinctual thing, rather like trying to remember my dreams in the morning. As I say, these things just do not want to be remembered. I never sat down to write my diary without feelings of dread and aversion rising within me – except, that is, for when I was on speed, of course. It seemed to me that it was as if I was trying to support two people within one weak and skinny body. There was the Peter who did things and there was the other Peter who wrote about what was done and told lies about it. Nevertheless, in the last few days I have had to consult my diaries in order to supplement my research notes. Looking at old diaries is rather fascinating. It is like the unstopping of so many bottles of time past. Anyway, it is getting a bit boring here. So I have decided to resume diary-writing, but this time my book will not be any kind of Satanist's logbook. Instead I am going to use the diary, as Thoreau did, in order to get in close touch with nature. I am going to train myself to open my eyes to the world around me. Henry Thoreau, the American anarchist, lived like a hermit in the wilderness and wrote a two-million-word diary in thirty-seven notebooks and when he had no diary to hand he wrote on birch bark. That kind of diary-keeping will purge me of the urban sickness and of the evil memories of Horapollo House. A spirit of the wild, I will fade into the Surrey woods. It is easy to be good in the country.

This place could be any place. The Beatles might have described Farnham,

'On the corner is a banker with a motor car . . . dum de dum.
There beneath the blue suburban skies . . . dum de dum de dum
A pretty nurse is . . .'

'A pretty nurse is' doing something or other. The trouble is I cannot remember the lyrics properly. 'Penny Lane' and 'Strawberry Fields' are just two of the casualties of my flight from London. It will take me years to replace all the records I had to abandon in Horapollo House. Sally got Patsy to send on her record-player and other stuff by rail. Everything arrived OK – this despite Patsy reporting that Sally's room had been done over. Nothing seems to have been taken however. Also, talking to Dad on the phone, I learn that some odd people have been lurking about his house in Cambridge, pretending to be census takers, gas-board officials or whatever. Anyway, there is no way that the Black Book Lodge is going to suss out where we are shacked up, and, to get back to the main point, for the time being I am pretty much restricted to Sally's music which means an exceedingly heavy diet of Donovan. So far, the only records I have bought are the Pink Floyd's 'Piper at the Gates of Dawn' and a replacement copy of 'Surrealistic Pillow' by Jefferson Airplane.

We are deep in commuter-land here. Going up West Street I rub shoulders with sharp-suited young men whose greatest ambition in life is to be admitted to the local Junior Chamber of Commerce and there are women in scarves, and there are dog-walkers, market-gardeners and the odd yob who has not heard that the days of the rocker are over. Sally and I get our highs from reading the Farnham Herald. Yet the town is not quite as straight as I thought it was at first. I spotted a couple of heads trying to buy records in W.H. Smith a few days ago, but they were so obviously stoned and giggling so much that they could not quite manage the transaction and had to leave empty-handed. We sort of smiled at each other as we passed in the door. From Farnham to Findhorn, from Formentara to Katmandu, the hippy brotherhood constitutes an international freemasonry, a brotherhood of heads across the sea.

The morning after we had arrived in Farnham, Sally and I walked every street in the town. It took about an hour and a half. When we had set out walking from London our plan had been to keep on going until we reached the sea or

something, but that morning walking around in Farnham, Sally decided that Fate had washed us up here on the shores of West Surrey. So, thanks to what Sally calls 'ambulomancy', here we are marooned in the Green Belt. We were too tired to walk any further anyway. In suburbia I can lose my dark shadow and become invisible. Sally wants us to live like hermits – just like Lancelot and Guinevere did in their closing years of repentance after Arthur and Mordred were killed in the last battle at Camlann. Sally is experimenting with batik. Maybe she can sell the stuff on market days. Also she is hustling for a job at the Castle Theatre.

I told Sally about the hare. She said it was a magical animal and that witches change themselves into hares, so that they can do damage to the farmers' fields and drain all the milk from the cows. I got pretty angry at this, as I had just thought of the hare on the doorstep as being an example of how close to nature we were in this place. The last thing I wanted to hear was some ominous occult interpretation of what I had seen. Then I said that since we had had a witch at the front door, we had to be packed and out of the place within the hour, because it was obvious that the witch would report straight back to Horapollo House. Then I went into the bedroom and started throwing all Sally's things into boxes. She was crying, but I was so pissed off with all this occult rubbish that I did not care and she was shouting that the darkness was within and that the real witch was me, not the hare. Finally, I walked out of the cottage and went into town and bought a hare at the butchers. I am going to cook it tonight. Sally was pretty subdued when I came back and she did not object when I told her what we were going to have for dinner.

We have talked more calmly about things now and we are agreed that, idyllic though things are down here, they are also pretty boring. Boredom is the most important thing in life, more important than love, more important than fear of death. It is only boredom which from minute to minute drives me forward through time. It is lovely here. The August sun blazes

through the curtains and Sally and I lie in bed listening to the wood pigeons and the rustling leaves and we are bored out of our skulls. Fortunately though I have not exhausted my stock of magic beans. I still have the LSD cubes I scored off the Tibetan type in Abdullah's Paradise Garden. Tonight we are going to take a rustic trip.

I cut the hare up and cooked the joints in cider with shallots. Sally ate every mouthful without protest. Actually it tasted pretty good, but she has just admitted to me that the reason she ate so deliberately was that, by doing so, she could consume all of the morning's bad feeling as well as any ill luck which comes from it – plus, at another level, she saw eating the hare as a kind of shamanistic thing – a way of acquiring the wisdom of the hare. I pointed out that if the hare was that wise it would not have allowed itself to be caught and eaten. But it was hopeless. Sally is impossible to deal with as a rational human being. For pudding, I served up just two little sugar cubes soaked in acid. Now Sally is seated in the armchair in the tiny living room. She has carefully surrounded herself with things that are beautiful and things that will focus her on life. She says that it is dangerous to have any thoughts about death or dead people while on a trip.

So anyway another magic bean, a different type this time. Nothing is happening. It is almost an hour since I took the sugar cube, but I am not getting anything. Maybe it's a bad score. Who needs acid anyway, when the world as it is, is such a blast? I have just gone out into the garden with my notebook and I am sitting on the ground poised to observe what there is to be observed. It now strikes me that there is no need to take acid when the world looks so brilliant anyway. The grass around me glows, ripples and pulsates. Seeds popping, shoots thrusting upward, nature is exploding all around me. We just need to see the world as it is. MEMO TO MYSELF: Every morning I should take my eyeballs out and wash them thoroughly in the sink. Why look at the world through dirty windows? I could sit here forever contemplating the single blade of grass that is in my

hand. It is a truly amazingly crafted object. If only I could get everybody just to look at the blade of grass in my hand and see it as it actually is . . . If only I could see myself as I really am.

Then I have an idea and go inside to fetch the big mirror. This I place in the long grass on the edge of the woods, and, having taken all my clothes off, I am beside it like a hermit gazing into a pool of water and in its reflection I can see the branches writhing and I feel the first of my jungle jingles coming on.

Buddhist Poet on Edge of Jungle writes Home to Mother

An animated seething corpse sitting defenceless in the technicoloured garden. It is alone against the crowds who will pull it to pieces. It sits writing, head bowed, as they come up behind.

With automatic hand
The corpse sits writing
Alone in the gardens of the soul
Then down dropped
The Green and Purple Woman
And sat down a spider
Before him.
What a dainty dish for the Spider!
(Mother will laugh. Ho! Ho!)

The corpse sits writing in the garden
A part of the Spider's larder
She pops in a word
And comes out a sound
And no one was any the wiser!
(NOTE: "wiser" ought to rhyme with "Spider" and with "garden")

Try again.
First corpse-poetry in the world folks!

Mother!
Have you ever been
conspicuous as a
purple corpse in a garden?
Buddha watching, waiting
from the flower-beds?

I am just writing to pass the time while I wait for the acid to take effect. On my hands and knees I gaze down into my scrying pool and I perceive that it is indeed the Eye of the World. Beneath its surface of rippling glass, I can dimly make out my mother. She is making her way here, walking all the way from Cambridge, but her progress is necessarily slow. The shroud impedes her movements and clods of earth, as well as gobbets of flesh fall away from her, as she takes her stumbling path along the hard edge of the road. She is blind, for her eyeballs liquefied weeks ago. But now she senses that she is under the scrutiny of the Eye of the World. Alas! Alas! It was a mistake for me to have taken drugs, for my late mother has become a sniffer-corpse and as such she is employed by the Underworld to sniff out druggies. She catches my scent in the air. In time she will find me. Alas! Then, as I gaze on appalled, the witching hare leaps within me and I recoil from the pool with a terrible cry.

It is like the Temptation of St Anthony out here in the gathering dark. The garden is full of bats. At first I thought they were moths. My penis was glowing and pulsating like a lighthouse and they were fluttering round it. Much too big to be moths. Bats then. Dark things moving across the brilliant face of the moon. I fear that they will entangle themselves in my hair. A good night for raising the Devil. I begin to chant the invocation which I have heard on the lips of the Master,

'Adonai! My Lord. My Secret self beyond Self, Hadith, All Father! Hail, ON, thou Sun, thou Life of Man, thou Fivefold Sword of Flame! Thou Goat exalted upon Earth in Lust, thou Snake extended upon the Earth in Life! Spirit most holy! Seed most wise! Inviolate Maid! Begetter of Being! Word of all Words, come forth most hidden Light! Devour me!'

But there is nobody to hear me and my chant is pointless. Sally has stayed inside the cottage. Jefferson Airplane is on the record player. I can see Grace Slick's voice coming out through the window as white smoke. The smoke coils and writhes and shapes itself into something like a woman. The undulating arabesques of smoke are so very beautiful that I just have to masturbate before them. As my semen comes jetting out, it mingles with the white smoke, so that its coils gain in substance and clarity and I find that it is Maud who has made herself manifest to me.

Gazing on Maud, naked and white-fleshed under the moon, I now understand that she is indeed beautiful. And in great danger too. She writhes in bondage before me. She is shackled and cuffed and bat-like creatures hang on her nipples and flap limply between her thighs. She opens her mouth and my semen comes trickling out down her chin. Then the words 'HELP ME' briefly appear, before melting away like ice-cream.

I have to get in touch with Maud. I have to rescue her. The trouble is I cannot move. I am trapped in a total visual overload. The whole world is spread before me like a great net and the world-net ripples and bulges under the pressure of the endless play of transmutation and permutation. It is all a mighty plenum. If I let my eyes rest on a single section of the cosmic latticework, then it opens up as a funnel, down which my eyes can travel endlessly, taking in oriental scripts, giant insects, housing estates, fields full of totem poles, beached transatlantic liners, pencil shavings, centaurs and glass spheres – and there are yet more worlds within these worlds, and all of them powered by moonshine. It is all too much of a good thing. Having said that, it remains to be noted that too much of a good thing is still actually a pretty good thing.

I have to stop writing.

The rest of this report on the trip is retrospective. For over an hour, I lay there in the deep grass with my eyes fully open, but as if dead. I could not move a muscle, this despite the fact that I knew that Maud was in the very greatest danger and I

should do something about that fact. But I just lay there and I only wondered if I could go blind gazing at the moon.

At last I was able to rise from the grass, horribly cold and stiff and made my way into the house. I told Sally that Maud was in danger and asked her what I should do. But Sally was completely out of it. Although her pupils were dilated like saucers, she did not even register my presence. She just sat propped against a wall like a smirking corpse stuffed with straw. (In retrospect, I understand that this was probably the point in her trip where she was about to be raped by Bill and Ben, the Flowerpot Men.) So, grumbling and feeling very much on my own, I found some coins and then Maud's phone number and I set out for the phonebox. On my way to the phonebox, I decided it would be more convenient if I could put the coins in my pocket, but I found that I had no pockets, for I was not wearing any clothes for there to be pockets in. This alerted me to the fact that I had not come down from the trip as much as I thought I had. So when I got to the phonebox at the end of the lane, I carefully rehearsed what I was going to say, before I picked up the receiver.

Finally I was word-perfect with, 'Hallo Maud. It's me, Peter. Are you in any danger from the Devil or his minions?' So I picked up the receiver and very carefully dialled Maud's number. If a demon had answered the phone, I would have just dropped the receiver and run. However, it was Maud who answered, and as soon as she did so, I knew I was right to have rung her. She sounded terrified.

'Peter? Is that really you? Thank God! I don't know what to do. Thank God you rang. A horrible man came round to the salon last weekend and asked the strangest questions. And then someone has been leaving dead animals on my doorstep. And I think that I am being followed to and from work. Please, you have to help me.'

'OK. Keep calm. How am I going to be able to help you?'

'Can I come to you? Peter, I need you. You got me into this. You have to protect me. You owe me that. I am so very frightened. Let me come to you. Please.'

I thought about this, but not for very long, for it was clear

that she was in trouble and, besides it would be cool to have Maud with us in Farnham. So then, mustering all the straight thinking that I was capable of, I gave her careful directions about what to pack and then how to shake off any possible trail. She was to go to Camden Town Tube Station and wait on the platform for a tube. She was to get on the tube and then get out of the carriage at the last possible moment before the doors closed. Then she was to exit the tube station and take a taxi to John Lewis's department store and walk quickly through the store and out through a door at the rear and then take a second taxi to Waterloo Station. At Waterloo, she was to buy a ticket to Portsmouth, even though she should get off the train at Farnham. I told her that Sally and I would meet her at the station at noon tomorrow. Although tearful, she sounded terribly relieved. I just hope she lasts the night and that the Satanists do not get to her before she has packed and set out on her way. It now occurs to me that I never even got to say the words I had so carefully rehearsed.

Once I was back at the cottage, I put on the radio. A disc jockey on Radio Caroline informed me that it was half past three in the morning. I had no idea. Thinking about it, it was really weird the way Grace Slick's voice changed into smoke and the smoke into Maud's brilliant white body. It was like she was one of those dead spirits that get trapped in the grooves of a record's vinyl, just as in Mr Cosmic's theory. I put 'Surrealistic Pillow' back on the record player, but this time no smoke issues from the record player. Grace Slick's voice is just a voice, so I deduce from this that I must be coming down. It has been a pretty good trip and I am pleased with myself for having been able to write throughout the first part of the trip until the total overload took over. My writing hand still trembles from the force of the drug racing through its veins. I fancy that this diary of mine has something of the quality of a scientific record. Straights dismiss tripping as just a way for young people to get their kicks. One year it was a fad for skiffle and hula-hoops, the next year it's LSD, and so on, blah blah, blah. This is not fair. I always take LSD in the spirit of a psychological investigator. Drug-taking is as much serious research as

anything that a university has to offer. I have merely slipped one letter back from LSE to LSD. Sally and I are the conquistadors of inner space. We, all of us, exist on the peripheries of our own minds. Without the guidance of drugs we would be dopily unaware of the vast molten core within ourselves. As it is we are at the beginning of Humanity's greatest adventure yet. I must sleep now.

Monday, August 7th.

Over breakfast, Sally has to tell me about her trip. She is so excited that she cannot sit down, but stands over her cornflakes and rattles away. Sally does not write things down while she is tripping, for she believes that that would spoil the flow of the experience. Nevertheless, she remembers quite a lot of her visionary night-journey. There was the rape by Bill and Ben. She kept asking Ben if he thought she was beautiful and he kept saying no, which was a lie and each time Ben lied his wooden penis grew a bit longer, and, since the penis was inside Sally, the lies of the Flowerpot Man had a definite erotic charge. Then there was more weird sex with Bill, with hundreds of Munchkins and finally with me – except that the fairies had taken away my head and replaced it with the head of a hare. Apparently I liked having my long ears licked. One of the salient features of acid is the way it works on and with one's sex drive.

Sally was so excited by her long night of imaginary sex, that it was ages before I could get a word in. But then, when I did manage to speak and I explained how Maud was being menaced by the Black Book Lodge and that she needed to take refuge with us and that she would be with us in a matter of hours, Sally was instantly cast down. She reckoned that Maud was making all this voodoo stuff up, simply because she wants to be with me.

'Peter, can't you see it? This has got nothing to do with Satanism and everything to do with Maud's puppy-love for you. She is obsessive. She will eat you up if she can. Besides

this place is tiny and she's pretty tall and hefty for a chick. There is simply no room for her here.'

'She can sleep on the floor in this room, until she finds a place of her own.'

(We were in what I suppose would be our sitting-room, except that as it has no furniture, only a leaking mattress, so we sprawl about in here and it is therefore more of a lying-room.)

'I just know that she is going to spoil everything. It's you I'm thinking of, since she really gets on your nerves. She will drive you mad if you live under the same roof as her for more than a day.'

'Sally, I'm really sorry, but I have got to do this. I am kind of responsible for her. Whether I like it or not, she has become part of my karma.'

I could not persuade Sally to join me in walking down to the station, so I set off alone and arrived there just in time to see Maud step off the train. She was the only one to alight at Farnham. She was so overloaded with stuff that it was hard to understand how she could have shaken off any kind of tail – particularly as she teetered on stilettos and kept tripping over her luggage. Finally she gave up trying to move with all her cases and bags and waited helplessly until I came up to her. She was wearing a white silk blouse with mutton-sleeves, a very mini black mini, black leather gloves and lots of jangly silver bracelets. Her idea of dressing for the country, I suppose. She stood amongst her luggage clutching a handbag and a little umbrella.

I walked up to her, ready to stoop to pick up as many of her cases as I could manage, but then I just stood before her, gazing at her and not knowing what to say. The weird thing was that this morning, once I was sure that I was down from the trip, I had gone out into the garden and picked a blade of grass and gazed at it with full attention and I had seen that it was just a blade of grass. It did not pulsate or anything, nor did gazing at it offer any special help in understanding how the universe worked. That is always the way with trips and it is a real drag – except the really weird thing was that on that same trip last night I had had a vision of Maud as incredibly

beautiful and now that I was gazing at Maud in the flesh on the sunny station platform, she still looked incredibly beautiful. It was as if the LSD was continuing to act selectively on my head and heart, so that I was experiencing a hallucinatory vision of the arrival of a mighty sex goddess in this small Surrey town. I wanted to lay her there and then in front of the ticket-office.

So we just stood there silently gazing at one another. Then she suddenly burst into tears.

'Peter, dearest Peter, these last few days have just been so horrible, but now I am with you I know it will be all right.'

I stepped forward to give her a comforting hug and she practically overbalanced on her high heels, so she had to cling very tight in order not to fall right over and I almost fainted in her arms.

'You know I have been so worried about you,' she whispered, her breath cool in my ear. 'After what you told me, I was more afraid for you than anything.'

Then we broke apart and she started fishing in her handbag, for her make-up kit. She had to redo her mascara, before we could set out walking past the Maltings and up the hill between the laburnum hedges towards the cottage. Maud has become a fever in my head and a pain between my legs. I cannot think of anything except Maud. God knows how I am going to square this with Sally.

As we walked into the cottage, Maud turned to me and said, 'We can be happy here.' Then having realised what she had said, she blushed. 'I mean, I know that you and Sally will be very happy here together.'

Sally, who had been standing on her head in the lotus position when we entered, hastily untangled herself and got to her feet so that she was face to face with Maud – no that is not right, for Sally's head came no higher than Maud's bosom. Maud, somewhat startled, looked down on her.

'Hello again.' And Maud extended her hand, holding it out in a way that suggested that she expected it to be kissed. Sally muttered something inaudible (for all I know, it was a curse), but she took Maud's hand and shook it.

Then Sally turned to me and asked, 'How long is she staying?'

Maud looked at me in mute appeal.

'As long as she needs to, Sally,' I said firmly.

Then Maud broke into tears again. Between sobs, she explained to Sally how she had left her job and fled her flat. How she had no friends in the world except me, Peter, and that she hoped Sally would be a good friend too. She knew she was being a drag, coming down here when the place was so small and only just big enough for the two of us, but she had nowhere else to go and she was absolutely terrified of all this supernatural stuff, and the dead animals on her doorstep in London had had pins stuck in their eyes. Maud did not want the Satanists to put pins in her eyeballs. After a while she was unable to get any more words out even in gulps. She just stood there bawling noisily like a small child.

'Oh for God's sake!' Sally snorted and disappeared into the bedroom. I put an arm round Maud and she slowly quietened down. After about ten minutes, Sally reappeared with her sleeping bag.

'She will have to sleep on the mattress in this room, until she has found a place to move to and she will have to roll up the bedding every morning.'

And Sally busied herself in laying out the bag and pushing all Maud's luggage to one corner of the room, while Maud sat on a corner of the mattress and set about once more redoing her make-up. Then Maud started to unpack, but it was not long before she discovered that, in her panicky flight from London, she had forgotten to pack all sorts of things, including any underwear. So she set off into Farnham to do some shopping. When she reappeared hours later, she found Sally and me sitting out on the grass at the back of the cottage. Sally was still doing her yogic breathing exercises, while I was struggling to sort out some kind of filecard system for my thesis. However, Maud, who was evidently an enthusiastic shopper insisted on interrupting our peace by displaying her purchases. She put out her newly purchased items of underwear on the grass for our inspection. There were about a

dozen items: several pairs of ornately lacy panties, some bras, a basque, a mulberry-coloured camisole, a midnight-blue slip. Sally thinks that less is more where underwear is concerned and she gazed on Maud's purchases with incredulous distaste.

'What do you think?' Maud asked, looking carefully to her, as if Sally was her older sister.

Sally laughed incredulously.

'Maud, you are absurd! Put them away.'

Maud blushed crimson and hastily gathered up the under-wear and disappeared into the cottage. At length, she re-emerged with her handbag. From this she extracted a diary and, seating herself some distance away from us, she busied herself in writing it. And I too am writing in my diary, surrep-titiously looking up from time to time to gaze with bated lust on Maud, who scribbles away, biting her lips as she does so. I think that she must find spelling difficult. I had forgotten that Maud kept a diary. It obviously is a diary, one of those school-girly affairs with a heart-shaped lock. Well, at least now she has got something worth recording in it.

The afternoon, though still very warm, had turned dark and heavy. There were lots of midges about. For a long time there was no sound except the scratching of pens and the cooing of wood pigeons. Finally Sally broke the silence.

'The sun is down over the yard-arm.'

What the hell is a yard-arm? Whatever. In our new ménage in the country, reference to the yard-arm is the traditional prelude to rolling an early-evening joint or two. Sally went to fetch the ritual Indian brass tray. Then she set to work slowly melting and crumbling the hash, rolling the cardboard tips and sprinkling tobacco on the Rizla papers. Sally maintains that the preparation of the joints is as important as their consump-tion. The whole business is like a Zen tea-making ritual and has to be done with slow ceremony. Maud, who still sat at a distance from us, looked uncomfortable and I guess that she was trying to nerve herself up to make some protest about drug-taking being illegal, or dangerous to mental health, or something, but she was too embarrassed and too conscious of her status as guest to make her protest.

At last Sally was ready to light up and, having taken one big draw on the joint, she crawled over to Maud to present her with it.

Maud raised a hand in an attempt to avert the evil object.

'I'm afraid I don't smoke.'

'This isn't smoking,' Sally insisted. 'It is a kind of initiation. You don't smoke a joint. You just inhale from it and then you pass it to Peter. You have to participate.'

'Yes, we are very strong on conformity here,' I added.

Maud raised her eyebrows, but she took the joint and drew hard on it. The smoke filled her mouth so that her cheeks were swollen like a chipmunk's as she struggled to get any of the smoke into her lungs. But she failed and fell into such a violent bout of coughing and wheezing that she bent double and threw the joint away. I retrieved it and then showed her how to take the experience more coolly. Part of the trouble with Maud was sheer nerves. She was expecting violent hallucinations the moment she had ingested any of the smoke. But hash is not like that. Not usually anyway. It is mild and subtle. Not that one would guess this from reading Aleister Crowley on the subject. This thought having struck me, I went inside to fetch one of my red sorcery notebooks in which I have transcribed a quotation from Crowley's essay, 'The Herb Dangerous – The Psychology of Hashish':

'Of the investigators who have pierced even for a moment the magic veil of its glamour ecstatic many have been appalled, many disappointed. Few have dared to crush in arms of steel this burning daughter of the Jinn; to ravish from her poisonous scarlet lips the kisses of death; to force her serpent-smooth and serpent-stinging body down to some infernal torture-couch, and strike her into spasm as the lightning splits the cloud-wrack, only to read in her infinite sea-green eyes the awful price of her virginity – black madness '

In a way, Crowley was a great man, one of the forerunners of the Spirit of the 60s indeed, but this stuff was just so over the top that I had to desist from reading more. Sally and Maud were leaning against one another and giggling fit to bust. For a

few moments it was a really good scene and I felt like the Old Man of the Mountains secluded in his paradise garden with a couple of members of his harem. The laughter got madder and madder and I was laughing too and I was vaguely aware of being possessed by the laughter, as if I had been invaded by a demonic Thing. I experienced it as an entity which did not care what I did, or whether I lived or died. I was merely a vehicle for laughter, to be discarded once the Laughing Thing, hunting for another victim, had passed on its way.

This happened – the laughter passing, that is – when Maud wiped her eyes and tried to straighten up enough to talk. I believe that she was trying to prolong the mirthful spirit of things . . .

'Sally, listen to this! This is really good! A man goes into a pub and he has got an insect with him. I have forgotten what insect it was, but that does not matter. Say it was a dragonfly – no hang on a minute – the insect has got to have legs. A cricket then. A cricket has definitely got legs. So anyway he says to the man – I mean the man he has met at the bar – "I have established that insects hear with their legs." Then, the other man, the man he is talking to, asks "How have you worked that out?" Now, let me think . . . the other man says "As you can see, this cricket has no legs and when I ask it to move, it does not . . ." '

'Hang on a moment,' Sally interrupted. 'Just a moment ago, you were saying that the cricket definitely did have legs. Are you sure you don't mean that he had a dragonfly? That would make more sense.'

Maud was trying to work out why Sally was not right about this, when I tried to help her by pointing out that in fact dragonflies did have legs, contrary to what Sally was insinuating. However, this only seemed to make Maud more confused.

'No, what I meant is that crickets in general do have legs, but this particular cricket did not have legs, because the man in the pub – the first man in the pub – had taken them off in order to demonstrate that crickets hear with their legs, because they don't move when they are told to when their

254

legs are taken off. Er . . . only I think I have told it slightly wrong. The cricket had its legs on when it was brought into the pub – '

'That would make it more like the rest of the cricket species,' Sally added helpfully.

'But then the man took the legs off to prove the point . . . But anyway, you get the point. He was not thinking logically, you see.'

Sally thought about it and, having thought about it, she was seriously pissed off.

'That is just so dumb. It's a real downer. Anyway, I don't see how else the man could demonstrate that crickets hear with their legs. I certainly don't believe that they hear with their ears, because I have never seen a cricket with ears.'

Maud was cast down. I thought of challenging Sally on how many crickets she has seen in her life, for I don't believe that she has seen any, except for Jimminy Cricket in the *Pinocchio* film, but then I decided against saying anything. So, suddenly we were all silent once more and Sally set to work, rolling the second joint of the evening.

I was sleepily nodding to myself and thinking that Farnham was a good place to lie low in when I dozed off. *Yet lie how low? Deep, deep, deep below the black waters. These waters which came rushing up from beneath me and engulfed not only me but also the whole of the lost town of Farnham. Slow, silent and alone I passed between the columns of moonlight which descended through the blackness and then I floated away from those refracted shafts of brightness, down the dark submarine snickets and alleyways which were beyond the reach of any illumination and consequently, from time to time, I blundered against barnacle-encrusted walls and doors. Once I emerged again into the High Street, I noticed how the moonlight conferred a dead-white glitter on the shop-fronts. I found that with some difficulty I could shimmy my way up to roof-level and, turning backwards from whence I had swum, I observed the scarlet roof of the Maltings, shining as bright as Satan's Pandemonium. I observed everything. I remarked without regret how a filthy silt was drifting up to cover the lower shelves in the public library and how a ceaseless flow of bubbles rose from decomposing books. I visited the*

abandoned tennis-courts where shoals of minnows passed backwards and forwards through their netting. I saw without surprise that the familiar country streams and rivulets continued to flow quite unimpeded by the heavy tides of black water above them. I paddled over the foliage of the hop-fields which undulated with lazy menace, like the weed-banks of a dreadful Sargasso Sea, and beyond the hop fields I swam out to the halcyon peace of Surrey lawns. Everything was perfectly silent, except for the muffled tolling of church bells which, moved by the dark tides, never stopped and which kept time with the beating of my terrified heart. Otherwise the place was silent, abandoned, asleep in time, so that here where I am is not only now but forever August 7th, 1967. The spires of the churches and the towers of the Castle strain towards the surface so very far above. Deep, deep down below, I can only dream of flicking and kicking my way up until finally I might break through the surface and gaze on the limitless expanse of water rolling on forever under its dancing net of moonlight. The trouble is that I have water on the brain and it is this which makes me so heavy.

Such was my dream. Yet, when I come to think about it, I do not actually know whether I had this dream or not. It is only Pyewhacket, the hand which sees itself as a writer in its own right, which tells me that I had it and, once again, I fear that Pyewhacket has a mind of its own, not really mine at all. It is a warm summer evening, but I feel cold now. I had thought that I had escaped that hand, that literary voice. Somehow it has found me again. Perhaps Farnham will not be such a good place to lie low in after all.

I opened my eyes on my two beautiful houris. They were bent over the Indian tray and talking quietly to one another and I heard the raven-haired one whisper to the blonde,

'You have beautiful hair. I should love to do your hair for you.'

But then Sally, suddenly suspicious that she was being buttered up, pulled away. The second joint was now ready for circulation. We passed it amongst one another without talking. I was not feeling better for my submarine doze. Also, I think I was feeling a bit guilty at having pressed Maud to join us in smoking dope. It was as if Sally and I had colluded in

debauching this pathetically innocent girl. Maud is so eager to please and so young. But then we three are all very young. Everything is before us. The juices of youth are so fierce within us. Straights may suppose that we take dope to get high. Not so. Sally and I are high on being young – most of the time anyway. We take dope to come down.

The third time the joint came round, it was practically down to its nasty-tasting, cardboard roach, and I stubbed it out.

'Gosh! Well, that was quite fun I suppose,' said Maud as, yet again, she ferreted about for stuff in her handbag. 'And, thank you, but I don't think that I will ever take dope again. I would not like to become dependent on it. I do think that one can have a good time without being hooked on anything.'

'Maud, you are being ridiculous again,' said Sally patronisingly. 'I've been taking hash practically every day for over a year now and I'm not addicted.' Then, having thought about what she had just said, Sally got the giggles again.

Maud looked doubtfully at Sally.

'Hash is less addictive than alcohol,' I reassured Maud. Then unthinkingly, I added. 'The same goes for LSD. That's not addictive at all.'

Sally's eyes lit up.

'Yeah! You have got to trip. You'll love it, Maud. Tripping is a fantastic buzz. Tomorrow, if it's sunny, we'll all take a trip together. It's great, if it's sunny, cos' it will make the sunlight brighter.'

I can see that, on one level, Sally's enthusiasm for LSD is perfectly genuine. She is always proselytising on behalf of 'the miracle drug'. She really does believe that it is tragic that it is only a relatively small number of heads, like her and me, who have discovered what it can do. However, at another level, I know that Sally was pressing LSD onto Maud in order to wind her up and, if tomorrow, Maud did have a bad trip, Sally would not be at all displeased.

Indeed, Maud looked terrified.

'Can't I just watch?'

'No. As long as you are here, you've got to participate. You have to see what we see. Peter and I will serve as spirit guides

on your trip. LSD is a friendly drug. It is thanks to LSD that you are here at all. It was the drug that warned Peter that you were in danger. So you definitely owe it something.'

Well, those were the main events of the day. Eventually we decided that the midges were too much for us and we went inside. Sally decided to cook Welsh-rabbit. Maud went over to stand beside Sally in the tiny kitchen and told her how she wished she had learned to cook. Would Sally teach her? But Sally was not interested in talking about cooking. Instead, smiling gently, she started reminiscing about former trips that she had taken.

That night Sally was extra-demanding in bed and she allowed me little sleep. But even when Sally had her legs wrapped tight around my head, I could hear Maud weeping in the next room.

Tuesday, August 8th

I woke up before Sally and went out to the sitting room – I mean lying room. Maud was nowhere to be seen and I briefly panicked that she might have left us. But then I saw that her dresses and underwear and lots of magazines were strewn all over the place. The back-door was open. I went out and stood on its step. In the sharp-edged light of early morning, I saw Maud moving swiftly from tree to tree. She punched the air and wheeled about to kick at trees, time and again just failing to connect with their trunks. Then she abruptly plunged to her knees and started knee-walking backwards and forwards across the grass. She moved at an eerie pace, like a dwarf on amphetamines. After a while, she somersaulted back onto her feet and resumed combat with her invisible adversaries. Maud was in her karate kit, coarse white trousers and a loose jacket secured by a brown belt. In her fighting gear, she appeared amazingly relaxed and graceful – not clumsy at all.

After watching for a while, I went inside and started tidying Maud's things up. Sally emerged from the bedroom before I had finished.

'You are not Maud's slave, you know,' she said. 'Maud will have to pull her weight around here. Either that, or she will have to go. Where is she, anyway?'

I nodded towards the back door and together we went and looked out. Maud had finished her karate exercises (katas, I think they may be called) and we were just in time to see her formally bowing towards the trees.

'Weird,' breathed Sally.

Then Maud came in and changed out of her karate kit into a longish black dress decorated with a pattern of gold medallions. While Maud was in the lavatory, Sally was on the attack again.

'That dress must have cost a hundred pounds. It blows my mind. Where does a Camden hairdresser get the bread for something like that?'

'It is easy, I suppose, if you are straight,' I replied. 'Maud doesn't spend money on clubs, records, mystical treatises, or dope. What is not cheap, on the other hand, is being any kind of hippy.'

Sally did not look convinced.

'I think it's rich parents,' she said.

Maud had a huge breakfast. While she ate, she talked vaguely of looking for work in some hairdressing salon in town.

'So you are staying in Farnham then?' asked Sally.

'Oh yes.'

The trip was scheduled for the afternoon. Maud spent much of the morning looking up at the sky, visibly willing rain-clouds to appear, but to no avail. We do not usually have a cooked lunch, but since we were going to be tripping that afternoon, Sally would not necessarily be up to anything very much that evening. She was singing 'The sun has got its hat on', as she cooked us an egg-curry. We ate on the mattress with the plates balanced precariously on our knees. The curry was frightful and the grit of the curry powder kept getting lodged between our teeth, so we all had lots of orange juice to wash it down.

For pudding, Sally produced just two acid-laden sugar cubes – one for her and one for me. Maud looked relieved.

'That's good,' she said. 'I'd just decided that I could not go through with it. I know it is weedy of me. But I am utterly terrified of going mad and saying or doing the wrong things. Besides right now I am not on tip-top form. In fact I feel a bit peculiar.'

'I am not surprised,' said Sally. 'That will be the trip coming on. I thought that you would try to back off, so I put your cube in your orange juice. It's probably best that you go and lie down.' Then she added gleefully, 'You've got a date with Mr Mickey Finn.'

Maud moaned. Her hands went briefly to her throat, as if she would prevent the passage of the deadly substance into her body. Then she moved away to the edge of the mattress and sat with her arms hugging her knees. She did indeed look like she was waiting to go mad. I went over and knelt before her.

'Don't worry, Maud,' I said. 'The first trip is usually a good one.'

'Yeah, it's quite rare to get the horrors on the first trip,' added Sally.

I have gone into the bedroom to fetch this notebook, so that, as scientist of the invisible, I can record whatever may transpire on this trip. Now I am going to persuade Maud to come out into the garden with me and look at the grass. That is bound to be a good scene.

Indeed it is a good scene. Maud suffered me to lead her out by the hand and, together with Sally, we are looking at the grass waving and curving like hair on the earth's skull. Now I am aware of the first anticipatory rush of adrenalin. I pick a blade of grass and pass it to first Maud and then Sally for inspection. Words are unnecessary. The medallions on Maud's dress have become spinning sun-wheels and this is a sign that we are properly off on the trip. The sun becomes a giant factory for the production of illusions. Looking round, I can see that I am in good company. There is Pan slipping into the shadows of the trees. Just short of the wood, a Persian

peacock-prince holds court in an emerald pavilion. On the left hand there is Yama, the death-god, with a clockwork, rotating nose. On the right hand, there is Marcel Proust talking to the sharks assembled in the bay of his beloved Cabourg. A great man for sharks, Proust. Brigitte Bardot approaches in an undulating walk. Then she hitches up her skirt to reveal a stocking-top and I can see that there is another, miniature Bardot, tucked into the stocking-top, signalling madly to be let free.

Sally is topping up her acid with a joint. She needs a light, but she just holds the joint up and elephant-headed Ganesha who is sitting in the lotus posture upside-down on the surface of the sky reaches down with a cigarette-lighter. Then Sally farts and the fart comes out all rainbow-coloured and decorated with little silver stars. It is really lovely. But Maud cannot see this. She is moaning and hissing. She is clinging to me so tightly that I am going to have to stop writing.

What happened next is that Sally and I realised that Maud was having a bad trip. We were trying as best we could to straighten up. I could not move because Maud was clinging on to me so tightly. So Sally went indoors to fetch our LSD survival handbook, which is called *The Psychedelic Experience: A Manual Based on the Tibetan Book of the Dead* and is by Timothy Leary, Ralph Metzner and Richard Alpert.

'You are experiencing the Wrathful Visions,' announced Sally. 'This is a sign of bad karma, but it is a good phase to pass through, on your way to losing your ego. Not that you have any choice.'

Sally danced about in front of us with the book in her hands and read from it in a sing-song voice, ' "Thus in the Tibetan *Thödol*, after the seven peaceful deities, there come seven visions of wrathful deities, fifty-eight in number, male and female, flame-enhaloed, wrathful, blood-drinking. These *Herukas* as they are called, will not be described in detail, especially since Westerners are liable to experience the wrathful deities in different forms. Instead of many-headed fierce mythological demons, they are more likely to be engulfed and ground up by impersonal machinery, manipulated by

scientific, torturing control-devices and other space-fiction horrors . . . " '

Sally was miming the *Herukas* and the torturing machinery as she read on. Maud closed her eyes to it all. She kept whimpering, 'Help me, please. Please help me.' Although her eyes were closed, I could see her eyeballs flicking backwards and forwards under the translucent lids. The exposed parts of her body were white as the skin of a leper. Then, as I gazed on, the brightness of her pallor intensified, until it was like the white heat of a nuclear explosion. I dared not look at Maud any more.

My eyes dropped to the open pages of my diary. This was a horrid mistake, for once they had fallen there, I could not extricate them. Now I had already reached the deepest part of my trip and I was experiencing a total overload, in which I found myself locked forever in the pages of my diary. I was condemned to live in the past and only the past and the only past I had was what I had recorded in the pages of my diary. I visited and revisited everything I had taken note of. It was a tremendous gas at first, particularly the early choices – balling Sally, smoking dope with Cosmic, listening to 'Sgt Pepper' – but, in the longer run, the pleasure just drained away. It was like when I hear a record. After a while, the music loses all its emotional charge and I can no longer bear to listen to it. This deep part of my trip was like that, except that it was every single incident which I had recorded in my diary that was turning grey and becoming first meaningless, then actually repellent to me. It was like repeating the word 'dog' hundreds of times. I lunched with Maud at the Gay Hussar a thousand times and then another thousand, until I had analysed every fold of my napkin, memorised every item on the menu and counted every strand of Maud's hair.

Taking my seat in the Gay Hussar for the millionth time, I suddenly remembered how the guy in Abdullah's Paradise Garden, who sold me the drug I was now on, had been dressed like a Tibetan (indeed I re-encountered this character thousands of times and struck the same deal with him thousands of times) and it now came to me that I was in some

special kind of accursed Tibetan afterlife, in which the wrathful visions drew their lives from mine. Although, at first, I beheld this afterlife as a vast house with many corridors, I soon gained the sense that, though there were indeed many, many corridors, their number was still finite and every single one of these corridors went nowhere. Those corners I had failed to turn in real life, I would never be able to see round in my new and wearisome form of existence. Those corners which were not there in my diary were forever lost to me and I often had occasion to curse my literary idleness. If only I had written more! If only I had provided just a few more details about what I had seen and done! Just a few extra incidents would have made all the difference, I told myself.

What was especially weird was that I could visit and indeed was obliged to visit and revisit every scene recorded in my diary and this even included things which had never happened, but which I had made up for Felton's benefit. So it was that I often found myself sitting on the wall of the playground of the wholly imaginary St Joseph's primary school and there I conversed with its phantom children. I was in a sealed maze of my own construction and this maze, though vast, was all the time diminishing in my imagination, losing not only scale, but also colour and sense. I perceived that Maud, who continued to sit patiently at our table in the Gay Hussar, occupied the centre of the maze of my twilit afterlife. The woman I am condemned to love for all Eternity

Maud was shaking me awake. I opened my eyes. After aeons in my diary-scripted past, I was astonished to find myself back in the garden of the cottage on the edge of Farnham.

'Peter, wake up! Wake up!' Maud was urgent, 'Peter, your mother is here!'

'That is impossible,' I said, suddenly feeling very straight. 'She is dead.'

But Maud replied,

'Yes, I can see that,' and she pointed.

I looked to where she was pointing, but I could see only trees and little wispy, grey tendrils, which I knew were an effect of the LSD and which trembled on the edge of

becoming proper hallucinations, but which, since my trip was beginning to wear off, did not actually do so.

'I can't see anything,' I said.

'Me neither,' said Sally. She was now sitting on my other side and also looking to where Maud was pointing.

'Yes, she is standing just in front of you, Peter.' Maud insisted. 'You must see her. She wants to be seen by you. She is dressed in her grave-cloths. Say hello to her, Peter. She wants you to acknowledge her presence.'

I said,

'Hello Mum,' and I waited to see if she would become manifest.

But Sally said,

'Maud, you're tripping. Peter's mother is not here. She's just a hallucination in your head.'

Maud was obstinate,

'I know that I am tripping. But she really is here. She is stretching her withered arms out to you, Peter. And she is not alone. There is a fat man wearing a bow tie, standing beside her. Who is he? And there is another younger man with curly hair. And behind those two there are lots of people in brown robes. Your mother is their prisoner. There are lots of dogs, blind dogs – I mean that the dogs have had needles put in their eyes.'

The sun was hot on my face. I stared hard at the grass rippling and branches swaying in a gentle breeze. It terrified me that I could not see what Maud was seeing. Sally was, if anything, in an even worse state. She had scrunched herself up in a ball and was shaking all over.

'The plump man in the bow tie also wants to talk to you,' continued Maud. 'He thinks that you owe him some-thing. Your mother tells me that she is very cold, for there is almost no skin on her bones. She wants our help. What shall I do?'

'Send her away. Send them all away, Maud', I croaked. 'Please. I don't want to see any of them.'

'Very well then,' and Maud rose to her feet. She pointed to the invisible throng and spoke in a peremptory voice,

'Go away. We have no need of you. This is private property.'

She watched them go – at least I presume that was what she was doing. Then she turned back to me and saw that my face was wet with tears. She lowered herself to sit once more beside me and put her arms around me.

'They've gone,' she said. 'Though I think they will be back.'

'Save me from them Maud,' and I buried my face between her breasts. She started to stroke my hair. After a while, I began to unbutton her dress. She made no attempt to stop me, but shifted about so as to make it easier for me to get her clothes off. Over Maud's shoulder, I noticed that Sally was now pressed face-down on the grass with her arms extended, like a penitent monk meditating on the crucifixion. Once Maud was undressed, I undressed and applied myself to browsing over her body, as if it were an illustrated encyclopedia. I was going to study to become an expert on her legs and breasts. Blessed with dilated vision, I was able to take in every pore of her skin and I saw that her pores were set out in an amazing, quincuncial pattern of lozenges. Her skin had become the Net of Indira and I willingly allowed myself to be entangled in this, the World's Illusion.

'I love you, Maud,' I mumbled.

'That's good,' she replied.

She was wallowing in my affection, rolling around in such a way as to allow all parts of her body to be successively inspected and embraced. But then, when I got on top of her and tried to part her legs, she resisted.

'Not now, Peter. Not now. The time is not right. The appointed hour has not yet come. I solemnly promise that I will deliver my virginity to you, but it cannot be today.'

'I will die if I can't have you.'

'You will die anyway,' and she actually laughed at my disappointment. 'I want you too. I'm desperate for you. Feel how wet I am.'

But moments later she pushed me off and stood up. She walked over to the edge of the woods and called out,

'Peterkin! Here, Peterkin! Peterkin! Peterkin, come to me. Here I am. Come to Maud who loves you dearly.'

I crawled behind her. I was crazy with desire for her heavy flanks.

'Maud, what are you doing?'

She looked back down at me. Her drug-dilated eyes were like saucers.

'I am summoning your fucking double.'

'My double?'

'Yes, Peter, your fucking double. Don't say anything more. I need to concentrate. If I concentrate, he will emerge from the trees.'

This was all so very weird. It is true that when one is on a trip then everything seems weird. But what particularly struck me as supernaturally weird was Maud's utterance of the word 'fucking'. I had not thought that that verb was in her vocabulary.

Maud paid no more attention to me. She was panting heavily. She raised her arms as in a gesture of surrender and declared in ringing tones of absolute conviction,

'My lover comes! My true lover!'

She dropped to her knees and then with an awful cry she performed a contortionist's flip onto her back and swiftly spread her legs. I knelt a little distance away from her and looked on appalled. Of course, I could see not so much as a wisp of my simulacrum. All I was aware of was the way Maud responded to 'Peterkin'. Her back was arched, her tongue protruded and her eyes rolled. Momentarily (though only momentarily) she looked quite ugly. It was while Maud was moaning, bucking and thrashing under the invisible man that Sally gave out a deep sigh and picked herself off the ground, but she walked back into the cottage without appearing to notice either of us. A few minutes later Maud gave out a long shuddering moan, before rolling onto her side and falling into a kind of post-coital doze. I sat watching over her and, for all I know, my Doppelganger was beside me, doing the same.

When I saw that Maud was coming round again, I told her that I was going in for a few minutes to make us both some tea, but she said that she was not safe alone. So, brushing

leaves and stuff off her body, she followed me into the cottage, and while I, with the slow deliberation of the drugged, set about the reassuringly familiar rituals of tea-making, Maud stood close beside me. Sally was not in sight. Maud had found a hairbrush and worked hard on the tangles of her hair. It was as if the hairbrush was some kind of exorcism-tool with which she was brushing away the horrors. She admitted that this was the case when, over tea in the lying-room, we started talking and swapping our trippy horror stories.

I told her about my experiencing an eternity of repetitious, diary-scripted boredom in a few moments of time. In retrospect, I am amazed I ever came out of that part of my trip. I am lucky that my mind was not trapped there forever. It is not a risk I would ever take again and I told Maud that I was finished with acid. Maud looked pleased. Her own visions of my mother's walking corpse and the congregation of spectral Satanists had also been nightmarish, though in a different way.

'I do think that the drug itself was warning us that we should not take it,' she said. 'I am sure that those magicians you were mixed up with can sense you when you take drugs and it makes you vulnerable to their attack.'

This struck me as a rather Sally-like way of thinking and I spent ages trying to argue Maud out of this notion. Maud was indeed seriously confused in her attitude to what she had seen. I think that she was still suffering from some residual drug-generated paranoia. She thought that the drug was warning us that the Satanists were on our track. I told her that I no more expected members of the Black Book Lodge to turn up here than I expected to meet Yama, the Death-God with the clockwork, rotating nose, walking down Farnham High Street. Such hallucinations were just miscellaneous scrapings from the mind's detritus.

At length I asked about Peterkin and, as I did so, she blushed. (It was lovely to see how the blush spread over her body.) At first she was rather vague, but as I pressed her relentlessly, she admitted that, ever since we first met, Peterkin had

been her night-time fantasy and that she never went to sleep without thinking about him, mentally undressing him and whispering endearments to the darkness. Peterkin was just like me in every detail, except that, whereas I was obviously cool and uncomfortable with her, Peterkin actually loved her and adored her to distraction. Yet, though he was madly in love with her, she loved him even more. She worshipped him. Literally. Before getting into bed in that bleak little flat of hers, she used to kneel beside the bed and with eyes closed she used to pray to him, asking in her prayers that he make her worthy of him.

'Now you have me, you don't need him,' I said.

She just smiled.

We sat in silence gazing at one another for a long time. Then Maud thought that we ought to go into the garden and gather up our clothes, but I pointed out that it was already too dark to see outside.

'Let's go to bed, Maud.'

I took her by the hand and led her into the bedroom. I had quite forgotten about Sally, but there she was, fully dressed on top of the bedclothes asleep with the light on. Her breathing was stertorous. It was a surprisingly loud noise to issue from such a waif-like body. I turned away from the bed and tried to lead Maud back to the lying-room, but Maud removed her hand from mine and went over to the bed,

'We should be here,' she said and she picked Sally up and laid her gently on the floor beside the bed. Then she pulled back the sheet and, having got into bed, she patted the space beside her. I switched the light off before joining Maud. I had no choice really, for I was trapped by her beauty like a man in a net and besides, even if that had not been the case, I had a premonition of bad things coming and I sensed that I needed Maud's protection.

In bed it was Maud's turn to explore my body and, though she was still adamant in defence of her virginity, in all other respects she behaved as my body-slave. I taught her to take me in her mouth and, when she swallowed, it seemed a solemn and eerie moment – a kind of fulfilment of the prophecy of

the first trip. Maud fell asleep before me. I lay awake for a long while, straining to hear the Satanists and the blindly-sniffing dogs gathering outside the cottage, but all I could hear was Sally's snoring.

Wednesday, August 9th

I awoke with a sudden jerk. It was still pitch-dark. Something crashed against the door. Then there were several thumps and a lot of hissing. I reached for Maud, but she was no longer beside me. A high-pitched scream came from the next room. I was like a man in a nightmare who has to confront the object of his terror, because there is no choice, for that is what his nightmare is and for him there can be no way back down the narrowing tunnel. I groped my way out of bed, switched on the bedroom light and opened the door onto the lying-room.

Sally and Maud were locked in combat on the mattress in the middle of the room. Sally had her teeth into one of Maud's breasts and at the same time she was tugging at Maud's hair. Maud had already been bitten several times and was bleeding. Yet Sally had no chance whatsoever, for, of course, Maud was bigger, stronger and a karate brown-belt. I watched her deliver a chop to Sally's neck. Sally wheezed, and letting go of Maud's hair, staggered back. Maud kicked her hard in the stomach and Sally went down. Then Maud stood over Sally and Sally looked up at her in the half-light and Sally . . . submitted. As Sally embraced Maud's knees, Maud stroked her head. It seemed to me, as I looked on, that Sally had submitted not to Maud's kicks and punches, but to her naked beauty.

Maud turned proudly to me,

'Let's go back to bed, my love,' she said.

Sally brought us breakfast in bed in the morning. Later in the day, Maud and Sally drew up a shopping-list and Sally went into town to buy the stuff. Meanwhile we moved Sally's things out of the bedroom and moved Maud's things in. I

imagined that Sally would be stressed by this, but when she came back she was all lit-up.

'I saw Brian Jones in town,' she explained.

'A member of the Rolling Stones,' I added hastily, in case Maud might think that Brian Jones was an old mate of Sally's, or even a Satanist on our trail.

'He was standing in Castle Street, looking as though he was lost. I went up to him and asked if I could help him. He said no, he'd be seeing me soon enough, which I thought was a pretty weird thing to say.'

'It is pretty hard to get lost in Farnham,' I observed. 'It is really only two big streets.'

Sally continued to talk about her encounter with Brian Jones as if it were something miraculous, to be ranked with a vision of the Holy Virgin of Loretto, or something. However, if one thinks about it, it is not so astounding, as quite a few rock stars have big houses in Surrey. It would not surprise me to learn that some or all of the Stones are living nearby. One or two of the Beatles have settled in Weybridge, if I remember rightly.

Sally had brought back a lot of stuff from the shops. Maud had added to Sally's list of basic provisions a whole lot of other stuff, including yet more underwear, some LPs of classical music and a copy of the *Telegraph* (so that Maud could follow the fortunes of the British karate team in Holland).

Maud and I went to bed for the first part of the afternoon, while Sally busied herself in arranging her stuff in the next room. I was due to ring Dad that day and I thought it would be best to do that before I got stoned, so I went to the call-box at the end of the road. Dad was just back from work. He sounded curiously reluctant to talk to me and I was having at least as much difficulty as I usually did thinking of things to say, particularly as I did not want to get into explaining how it was that Sally and I had got Maud staying with us now. I was maundering on about how I was writing up my research, when he interrupted,

'Peter, I think you should be careful. The police came round here yesterday. They had some rather unpleasant news.

Your mother's grave has been desecrated and her body has been taken. The sergeant was talking about 'resurrection men' and people who dig up skeletons for medical research. I knew he was wrong, but I did not mention your Satanist chums.'

It was one thing for Maud on a trip to have had a hallucination of Mum in a dirty shroud, it was another for Dad to be talking calmly about police procedures for dealing with body-snatchers. Was Dad on drugs too? But I know that he was not. There is an ugly inevitability about the way things are developing. I actually do not like to think about it too clearly.

Before Dad could finish describing how he had visited the graveyard with the police, he broke down in tears and it became impossible to talk any more. I told him I would be in touch again soon and replaced the receiver.

Sally and Maud looked up smilingly as I re-entered the garden. Sally was bent over the Indian tray in accordance with the sacred ritual of the sun over the yard-arm. Maud had the *Telegraph* spread out on her lap. One of Maud's newly acquired records was playing from inside the cottage. It was 'Bach Before the Mast' and then 'The Flight of the Bumble-Bee' played on a harpsichord. Sally offered the joint that she had just finished rolling to Maud.

'Thank you, but I have had quite enough druggy horrors to last a lifetime,' she replied. 'I have no wish to see Peter's dead mother again.'

'I am not sure that we have any choice,' I said.

I told them about the conversation I had just had with Dad. So then we got into weird territory, as we discussed the meaning of Maud's vision yesterday afternoon. Apparently it was not after all, some part of her mind's detritus – something she might have picked up from my descriptions of Mum and my attendance at her funeral. In some sense – God knows what sense – it now seems possible that some sort of manifestation of my mother did visit our garden yesterday.

'Are you sure that you saw my mother? It wasn't just that you were thinking that, though my mother was dead, she could still be spiritually present in this world?'

'Oh no, I saw her – or bits of her at least, where the shroud had come apart. Her eyeballs had gone and her skin had gone all sorts of different colours. I think it was due to various kinds of mould,' Maud looked anxiously to me. 'I'm sorry, Peter, but you mustn't keep pressing me about this. It wasn't very nice for me either, you know.'

I thought it strange that Mum had been visible only to Maud, but Sally said that it was obvious that Maud was special (and Maud did not correct her on this).

My head is in such a turmoil about everything that I cannot think straight. Should we go on the run again? No point, if they can use my dead mother and blind bloodhounds to track us down once more. And then, trivial though it may be, it occurs to me to ask myself what about my doctoral thesis? My approach to the psycho-dynamics of group interaction in a North London lodge of Satanists will have to be quite different, once I have recognised the reality of a supernatural level of explanation. If I accept that Horapollo House is inhabited by demons as well as by people, then the psycho-dynamics will become that much more complex and, no matter how I dress it up, I cannot see any way that the examiners appointed by London University will take me seriously. Then there is another thing to be thought of. If the universe is as the Satanists and, for that matter, serious Christians say it is, then I have pledged my immortal soul to the Devil and I am damned forever. There is grim irony in realising that no sooner am I prepared to consider the notion that I may have an immortal soul, than I realise that I have lost it. Too grim to linger on this consideration Then it occurs to me that, if it is only me whom the Lodge wants, then perhaps Maud and Sally should leave Farnham and as soon as possible. However, when I suggested this, they were both adamant that they would never leave me.

'You are mine now and for all eternity,' Maud declared dramatically and she went in to put another record on the record-player. Smoking dope to a background of classical music is quite freaky. The next record she put on was entitled 'The Best of the Classics'. We listened to 'The Ride of the

Valkyries', 'The Nun's Chorus', 'Your Tiny Hand is Frozen' and stuff like that. What a con it all is. People who listen to classical music give themselves such airs, but why? As far as I could hear, there was nothing in the best of the classics that was as good as Jefferson Airplane or The Velvet Underground. Even Donovan, when he is on form, can produce music which is more sophisticated than the classical best. He certainly comes up with better lyrics than Verdi does. Such were my thoughts as, skimming and dipping, I began to travel on my hash high.

Meanwhile, Sally wittered on about making use of white magic to combat our Satanic visitants and to put Mum back to rest in her grave. Sally is convinced that there is a White Brotherhood – reincarnated avatars of Gandalf and Merlin – roaming Harold Wilson's Britain and doing good by stealth. Our only problem is how to get in touch with one of these white wizards. It made no difference to her when I pointed out that Gandalf was only a character in a novel. Apparently there is still some sense in which Gandalf is real – or indeed realer than real. But I was pissed-off with her for harping on our problems with the forces of darkness and not letting me drift off for even a moment on a hash fugue, so I baited her by reminding her of Robert Drapers's projected anti-Tolkien book, provisionally entitled *Kicking the Hobbit*.

Maud, listening to our argument, raised her eyebrows, but said nothing. She went back to her newspaper. Sally and I have always agreed on one thing at least and that is in not reading newspapers. Reading a newspaper is always a downer which contaminates the mind with reports of murder, rape, famine, war and the rumour of war – as today with the fighting in Biafra and the aftermath of the Six-Day conflict. Maud was like us, uninterested in politics or war, and, having read the karate report avidly, she was idly turning over the rest of the pages.

Then she let out a schoolgirlish squeal,

'Eeek, Peter! Look at this!'

And she showed me a notice in the law page of the *Telegraph*. Julian's solicitors had placed an advertisement asking

Peter Keswick to get in touch with them, for as heir to Julian Manciple he would learn something to his advantage. I had been trying to drift away on the 'The Nun's Chorus', but everything that afternoon conspired to remind me of suicide, damnation and hell. The chill was back again. It was so very freaky that Maud, who had only wanted to see the karate results, should have stumbled across precisely this appeal directed at me by solicitors, who were doubtless acting under instructions from the Black Book Lodge.

Sally and I needed to recharge our highs. The trouble was, there was not much hash left. There was still some acid, but neither of us felt like risking that in our present mental state. So that left poppers. Maud of course declined to join us. I can see that she does not like being out of control. The poppers came in mesh-covered capsules. Sally and I broke them open and inhaled simultaneously. A slaves' chorus from some opera or other filled the garden as the amyl nitrite surged through my body. I collapsed onto my back and surrendered myself to the five-minute high. My heart was beating like a butterfly trapped in a cage and my whole body was juddering in time to the vibrations of reality. This was hard-edged, fierce, demanding. With poppers there are no hallucinations or mystic glows. Everything looks exactly as it is, only more so. As on previous experiments with this stuff, for a fraction of an instant, I grokked the ultimate nature of reality, but unfortunately this ultimate truth is too subtle to be put into a notebook. Stupid drug to have taken in the circumstances. After five minutes, it just put me back more firmly in the predicament that I was in, haunted and damned.

The day which started weird, ended weird. Maud and I were eager to be in one another's arms once more, and we went to bed early. But, after an hour or two, Maud's eyelids began to droop, though I was frustratedly randy as ever. Maud smiled lovingly at me before getting out of bed and going into the lying-room. When she reappeared a few minutes later she was leading Sally by the hand. Maud watched lazily as Sally made love to me and then drifted off to sleep just as Sally and I began to fuck.

Thursday, August 10th

This day started just as weirdly as the last. I awoke to discover that Sally had moved round in the bed and it was now Maud she was embracing. Seeing how Sally now completely ignored me, it hurt me to recognise the intensity of Sally's passion for Maud. It was Maud who looked desirously at me, while she lazily stroked Sally's hair. ('We must do something about your lovely, golden hair.') After a while, however, Maud wearied of Sally's attentions and she ordered her out of bed to get the breakfast. Maud and I were cuddling one another and listening to the agreeable clink of cups and plates being put on a tray in the next room, when we heard Sally scream. The bedroom door swung open. Sally stood framed in the early morning sunlight, holding up an ominous trophy for our inspection. It was a black and silver garden-gnome clutching a fishing-rod. Sally had found it on the doorstep where the milk-bottle should have been.

Maud was at first unable to understand why Sally and I were quite so freaked out. I started out with a gabbled explanation about how Mr Cosmic believed that the plaster figures of gnomes, though degraded in their present-day functions, could still serve as the foci for the chthonic powers of the earth. According to *The Archidoxes of Magic* by the sixteenth-century alchemist, Paracelsus:

'Under the earth do wander half-men, which possess all temporal things, which they want or are delighted with; they are Vulgarly called *Gnomi*, or Inhabiters of the Mountains: but by their proper name they are called *Sylphes* or *Pigmies* . . . '

I was struggling to remember and explain Cosmic's project for the liberation of garden gnomes, when I realised that I had started at the wrong place in all this. So I let Sally take over and explain how it was that we had both known Cosmic, how he had been a friend of ours, how he had joined the Black Book Lodge and kissed the hand of the Master at

the same time as me, but how he had been expelled from the Lodge after I had denounced him in my diary.

There can hardly be any doubt that the black and silver garden-gnome is Cosmic's calling-card. But what does it mean? Is he on the run from the Satanists too? If so, how did he find us? Alternatively, have the Satanists caught up with him and made him their zombie slave? Is the gnome on the doorstep a warning? A threat? A promise? A joke? Whatever may be the case, why does Cosmic not show himself to us? The feeling that he may be hiding on the edge of the woods and watching us is not a pleasant one. Sally wants us to wait until nightfall and then, having taken speed, walk all night and day until we reach Glastonbury. At Glastonbury we shall be under the protection of its good *mana*. But Maud and I have vetoed this, for there can be no hope of reaching Glastonbury without being intercepted.

For want of anything better to do, I took a kitchen knife and spent the first part of the morning cutting and shaping a wand. Then, when I had consecrated my makeshift wand, I drew a circle of protection around the cottage and its garden, and, after I had consulted my red notebook for the right words, I invoked the protection of the spiritual prince, Israfil. Now, on the one hand, I do not actually believe in any of this stuff. On the other hand, maybe the circle of protection will work, whether I believe in it or not. Sally, who watched me doing all this, was reminded of how the Duc de Richelieu makes a protective pentacle in the film of Dennis Wheatley's novel, *The Devil Rides Out*. Then she had the bright idea that I should write to Dennis Wheatley, care of his publishers, and ask him for help and protection. That seemed reasonable. Writing this letter took most of the rest of the morning, as it was not an easy thing to draft and it took a lot of words to explain exactly how we had got into this mess: my enrolment with the Black Book Lodge, the Satanist's use of me in their quest for a virgin, Cosmic's expulsion from the Lodge, Julian's death, our speedy walk to Farnham, Maud's LSD vision of my mother, the appearance of Cosmic's gnome on the doorstep. But, if anyone can help us, it should be Wheatley, for it is

pretty clear from reading his books that he has had direct experience of what he is writing about.

Sally did us a fry-up for lunch. (Farnham's shops do not run to macrobiotic food.) The night's activities had left me a bit short of sleep and I dozed off on the lawn. I was asleep for hours and was only awoken by Sally shaking me.

'Peter, wake up! The sun is over the yard-arm and we have still got enough for two more joints.'

Russ Conway, another of Maud's favourites, was on the record-player. I stretched lazily and opened my eyes. Sally was bending over me to offer me the joint and when I looked at her, I screamed. She was bald and without any eyebrows or eyelashes.

'Sally asked me to do it,' said Maud calmly. 'She told me that she did not want your eyes to linger on her more than was necessary.'

And Sally looked at me submissively as she offered me the joint again. My hands were shaking as I took it from her. Shaven bald and with no eyebrows or eyelashes, Sally looked half-human, half-reptile. I inhaled deeply, but when I tried to pass the joint back, Sally indicated that she did not want any more and that it was all mine – as was the second joint, which was already rolled and waiting for me. She left my side and went to sit beside Maud. She was helping Maud draw up some terribly complicated horoscope. They paid me no attention as they worked away at their calculations.

So I smoked alone, and, as I smoked, I felt myself growing increasingly paranoid. The world was slipping away from my grasp and I could no longer understand anything that was happening. After a while, I asked Maud if she still had the crucifix which I had given her just before Sally and I fled London.

Maud looked up from the astrological chart which she was drawing up under Sally's advice.

'Darling, it is the only thing you have ever given me,' she said in wounded tones. 'Of course I still have it. It's in my jewel-box.'

So I went inside and rooted around until I found the

jewel-box and the crucifix in it, together with a lock of my hair. (Maud has an amazing amount of jewellery.) Then I settled down again on the grass with the crucifix and the second joint and began to meditate on the mercy of Jesus Christ. The tiny silvered figure of the crucified Christ was attached to a cross of black wood which was pendant to a rosary. After a while, once the second joint was finished, I started to rotate the beads of the rosary through my hands while intoning a low-voiced mantra, 'Lord Jesus Christ have mercy upon me, a miserable sinner.' But why, I kept thinking, should Jesus have mercy upon me? Particularly when I was not even very convinced that Jesus had ever existed? Even if Jesus did exist, what guarantee did I have that he was stronger and more powerful than the Devil? The Christians say that the mercy of Jesus will always prevail and that God is omnipotent, but they would say that wouldn't they?

And how miserable was I? It was true that things seemed a bit perilous at the moment. On the other hand, going to bed with two women last night had been pretty good and the joint I had just finished smoking made me feel absurdly, if only briefly cheerful. Was it blasphemously disrespectful to pray to God while high on dope? Then I thought that, even if Christ does not exist and there is in fact no infinite mercy on offer, I have still lost nothing by praying to the void. It could even be therapeutic to do so. But then it occurred to me that, if Christ did exist and He was reading my thoughts as I prayed, He would not be pleased by such a calculating way of praying. So I might forfeit salvation by entertaining such foolish thoughts. So I applied myself once more to humble myself before the tiny figure on the cross. I was trying to dedicate myself to a virtuous life. I thought that when I got out of bed tomorrow I should begin my new life as a Christian. The alternative was a spiralling descent to damnation and torment. But is it ever possible to pray to God? Suppose what I think of as Jesus is really evil? No man can know for sure whether he worships God or the Devil. But that last thought surely came from the Devil . . .

The twilight came on as I struggled to concentrate on my

Redeemer. The girls had finished casting the horoscope and gone inside. I do not know whether or not it was to mock me and my pious meditation, but 'The Nun's Chorus' was being played again and again at top volume. Then Maud came out into the garden once more. She was naked.

'Give that back to me, Peter. It is mine now,' she said and she took the crucifix from my hand and hung it round her neck before turning back to the cottage. 'Come to bed, my love,' she called over her shoulder and, as I contemplated her shimmering white buttocks, the Jesus mantra died on my lips.

In bed Maud allowed herself to be caressed by Sally and by me. Again I tried to enter Maud, but this time she forestalled me with the words,

'Not yet, darling. You only need a little patience and I promise you that the day after the day after tomorrow at half past four in the afternoon I shall be wholly yours at last. I swear to you that I long for it more than you do.'

'The day after the day after tomorrow at half past four in the afternoon,' I muttered doubtfully.

'What do you think we have been working on this evening?' asked Sally. 'We have consulted the ephemerides and the day after the day after tomorrow in the afternoon is astrologically the best possible time for Maud to yield her virginity to you.'

It crossed my mind that this astrological rubbish might be some trick to delay sex, but the hungry desire on Maud's face was unmistakable. She longed for it and for me. In the meantime, she actually urged Sally on me again, but now that Sally had lost her hair, I no longer found her at all attractive and so I turned my back upon her and Maud. As I composed myself to sleep, I commended my spirit to Jesus and Israfil, but without much hope in either – nor, for that matter, did I have much hope that I would sleep. Although I was mad with desire for Maud, I was beginning to realise that I was also terrified of her – and even afraid of what she might do next with those hairdresser's scissors of hers. I was afraid too that, if I slept, I might not waken again and afraid that, if I died in my present unshriven state, I should be damned for all eternity. Then, as I

continued to lie frozen in wakefulness, I thought that I could hear whistling which sounded as though it was coming from the woods. The tune seemed familiar, but it was only hours later, as I was at last beginning to doze off that I identified it as 'Yesterday All My Troubles Seemed So Far Away'.

Friday, August 11th

I dreamt of Pan running wild and whistling in the woods. I slept in late and I awoke to find myself alone in bed. Outside in the garden Maud was doing her karate exercises. Only this time she was using Sally for target practice. She attacked Sally with reverse punches, slapping blocks and roundhouse kicks. However, she was careful to pull her punches, so that, at the end of it all, Sally was only lightly bruised. Sally, for her part, made only perfunctory attempts to defend herself.

I watched for a while and then went inside and fixed myself breakfast. I noticed that a second gnome had joined the first on the kitchen table. Soon after I had started on my corn-flakes, it began to rain and Maud rushed in and gave me a big, wet, sweaty hug and, as she did so, I realised that it was entirely by my own free will that I was damned, for I prefer Maud's body to the mercy of Jesus Christ. This was a pretty freaky thought to be having while eating cornflakes.

As for the second gnome, Sally had found it on the door-step and once again our milk had been nicked. Setting aside any possible chthonic or Satanic connotations, what this meant was that we were running out of milk. Also the letter to Dennis Wheatley needed posting, as did some mail-order form which Maud had filled in. So it was agreed that Sally should go into town again. Sally tied one of Maud's silk scarves into a sort of turban to disguise her baldness and bor-rowed an umbrella, for what had begun as drizzle had turned torrential.

I have, provisionally at least, abandoned my PhD and the morning passed slowly. I have nothing to do, except write in this diary of mine. Thinking about Wednesday's blast on amyl

nitrite, it is not just the ultimate nature of reality that is too subtle to be put down in a notebook. *Everything* is too subtle to be put into a notebook. The looks that pass between Sally and Maud ... my vague sense of where Maud is taking me ... the precise smell of late summer ... None of these things can be captured on paper. Reality is not a sequence of events, not a series of verbs acted out by Maud, Sally and me. Reality is a continuum of evanescent sensations for which I can find no words at all. How things are just the way they are – the spontaneity of falling rain, the suchness of ordinary objects, the passing away of everything and the faint hint of something that lies behind all these transient sensations – I can point to these things with my mind, but there is no way that they can be trapped on paper. In my diary I can write about everything except reality.

As for the story I *can* tell – the one I am writing in my diary – it strikes me that maybe it could form the basis for a really good novel. Maybe a literary artist like Dennis Wheatley can use our story in one of his books. Of course he would have to tart it up and have us speak more eloquently. If I am going to be the hero, I will need more than an apprentice's knowledge of occultism. I ought to be handy with my fists, an expert on fine wines and a driver of fast sports-cars. Also, the story as it is at the moment lacks a properly impressive Wheatley-style villain. We ought to be on the run from a half-Jewish mulatto with yellowing teeth and a withered hand who goes under the name of the Comte de Sabarthes and who smokes Havana cigars in an ivory cigar-holder.

It is lunch-time, Sally has not reappeared and I am getting worried. Strange things are happening.

Hours passed. The sun went down over the yard-arm and there was still no Sally. It was dark when she reappeared. She was not alone.

'I saw Brian Epstein in town!' she announced.

However, the man who stood beside her in the doorway looking drenched and miserable, was not the Beatles' manager, but Mr Cosmic.

'Epstein did not say anything,' Sally continued. 'He just looked at me rather strangely.'

'I'm not surprised,' I replied. 'With no eyebrows and no eyelashes, you do look rather strange. Hello, Cosmic. What brings you here?'

'Hi man,' was all he said.

Then Maud walked in from the bedroom.

'I am David Hargreaves, but they call me Mr Cosmic,' he said.

'Oh yes, I have heard all about you,' Maud replied and she extended her hand in that slightly absurd, ladylike manner of hers and he stooped to kiss it.

'What are you doing here?' I persisted.

'What do you think? I'm looking after you.'

Before I could press him more on this, Sally danced between us and –

'Taraa!' she shouted as she ripped the turban from her head. Sally had had her skull tattooed with a coiling snake and, in the middle of the snake's coils, one could read in rainbow lettering the words, 'I AM SALLY, THE SLAVE OF MAUD AND PETER'.

'Wow! That's cool,' said Cosmic.

'That is why I was away so long,' she said. 'I had to go all the way to Aldershot to get it done,' and she looked to Maud for approval.

But all Maud said was,

'Now that you are here, perhaps we can eat.'

Cosmic went back out into the rain to retrieve his sleeping-bag and the provisions which he had stashed in the woods. Sally explained that she had stumbled across Cosmic looking fed-up and trying to shelter under a tree at the end of our road and, when she suggested that he came back with her to the cottage, he had just shrugged his shoulders and agreed. But Sally was more preoccupied with her sighting of Brian Epstein. I do not believe that she has seen Brian Epstein. Two days after running into Brian Jones, that would be too much of a coincidence. Just possibly she might have seen someone who looked like Epstein. But is she going to keep on running

into famous Brians every time that she goes into Farnham? Not that I can think of any more Brians who have become famous. The truth is, of course, that Sally has completely flipped. Presumably it is all the drugs she has been taking recently. Thank God Maud is here, for I would not like to be alone in the cottage with this mad girl, whom I now feel I do not know at all.

Sally unpacked the shopping. One of the things she had bought was a frilly apron. Before starting the cooking, she took off all her clothes and put on the apron. Maud and I ate at the table in the kitchen with Sally waiting on us. It was a weird buzz, to see a plate of pork chops displayed beneath Sally's pointy breasts. Then Sally and Cosmic ate on the mattress in the lying-room. Cosmic produced a bottle of vodka from his rucksack and, after rooting around in the kitchen, he found a jar of Bovril. So then we all drank a mixture of vodka and Bovril – Polish Bison is what it's called apparently – and Maud, who had a lot of it, was pawing me drunkenly. It flashed through my mind that what started out in this cottage as a kind of rustic idyll, is turning out to be something like a small-scale, green-belt version of the Playboy Club. It seems to be only me who does not know what the hell is going on.

Cosmic seems in a bad way. He sweats and scratches himself a lot. He was talking in a low monotone, almost as if he was talking to himself. His drone was in praise of alcohol and about how each culture has its own drug. In the Middle East it is hash. In China it is opium. In Central America it is peyote. But the great drug of Christian and European culture is alcohol.

'One should not underrate alcohol just because straights take it. It is the best, most predictable drug that it is possible to score. With hash you can never tell in advance the quality of what you have scored. The heroin currently sold is often contaminated. It is easy to have a bad trip on acid – everyone does sooner or later. But the alcohol high is fast and rock solid-predictable. Looking back over the history of the last two millennia, I think it is plain to see that it is alcohol which has fuelled the triumph of the West . . .'

Sally had crashed out. Maud and I staggered off to bed, leaving Cosmic drunkenly talking to himself.

Saturday, August 12th

Still raining. Maud was doing her press-ups and stretching exercises beyond the foot of the bed. I watched with pleasure for a while, before deciding that I really needed to talk to Cosmic and get some sense out of him. I staggered out into the kitchen, but I was too late. He had finished breakfast and he was preparing to shoot up. I had seen Cosmic skin-pop heroin from time to time when I visited him in London. But now it seemed that he had switched to mainlining. A saucepan was nestling between his legs and a tourniquet fashioned from a rubber strap of some kind was already tight on his upper arm. He gave me a funny kind of rictus smile as he plunged the needle in. First time lucky. He flushed the syringe full of blood before sending it back into the vein and gasped as the stuff began to hit. He slumped backwards with his eyes closed, but then he abruptly jerked forwards and vomited into the saucepan. Cosmic always throws up when he is on heroin. He claims to actually enjoy the experience. Be that as it may, it is definitely off-putting to be having breakfast in the same room in which Cosmic is shooting up.

It was also irritating, of course, to have listened to all that stuff about the wonders of alcohol coming out of the mouth of someone who is really hooked, it now seems, on heroin. Tanked-up the way he was, he was going to be no sort of company for the next few hours. It might have been a good scene if we had shared a trip together, but then, even if he had not been so zonked, I remembered that Cosmic does not do LSD. He is very puritanical about the subject and believes it fucks up the mind in the long term. According to him, a trip does not necessarily stop when it seems to stop and hallucinations can surge up years or even decades later. Cosmic's body is a temple, albeit a somewhat bizarrely furnished temple.

Sally said that she had shopping to do. I said that I would go

with her. If she was going to run into any more famous Brians, I wanted to be there too. However, Maud, who had gone back to bed called from the bedroom, asking me to stay with her. She said that we would both be safer if I stayed close to the cottage. I went in to see her. Maud was sitting up in bed reading old copies of *Vogue*. She patted the space beside her. So I joined her in bed and set to work stroking her breasts and thighs. But after a while, she shifted restlessly under my hands.

'Just be patient, darling. Tomorrow is the big day.'

So I got out of bed and went and fetched what turned out to be the last of my acid-impregnated sugar cubes.

'I am going to take a trip.'

'Must you, darling?'

'Yeah. I'm bored out of my skull.'

So now I am sitting cross-legged in the lotus position by the open door looking out on the spears of rain. My diary rests on my knees and I am waiting for the hallucinations to kick in. Every trip is completely different. So, whatever is going to happen this time, I know that I will not be trapped in the pages of my diary, nor will I re-encounter Proust and his conversational sharks. What I am hoping is to get into grooving on nature and discovering a more Thoreauesque mode of existence. I want to observe lesser-crested nuthatches, spotted grebes, hedge corncrakes and God knows what else and write lovingly detailed evocations of convolvuli, oak leaves and stuff like that. Rather than waste page after page of this notebook on the bizarre antics of Sally and Cosmic, I ought to dedicate myself to simply recording the shapes assumed by the dirty brown clouds as they roll endlessly by.

The rest of this is written in retrospect, as at that point the hallucinations did indeed start to kick in and they came so thick and fast that I had to drop my biro and just let it all wash over me. What happened was that I looked up at the dirty brown clouds and fancied that I could see shapes in their billowing coils. Behold, I beheld the Four Horsemen of the Apocalypse riding high in the Surrey skies! First there was skinny John with his pitchfork, the very figure of famine. Chubby-faced Paul rode beside John and threatened the

world with his balances. Behind them rode George brandishing a sword and Ringo with a bow and a quiver of deadly arrows. They went forth conquering and to conquer. I thought that they might make a landing in our garden and that I should throw myself on their mercy. So I went and lay on the grass and got pretty wet in the process, but they galloped on by. And I kept looking . . . and beheld a pale horse; and his name was Death and Hell followed with him. And power was given to them over the fourth part of the world . . . Why, I cried out, are the dead grateful?

Having received no answer and having then turned back to the cottage, I found myself confronted at the door by a handsome young man who wore a black leather jacket and a black eye-patch. He raised a hand in salutation.

'Johnny Kidd,' he said.

'Johnny Kidd of Johnny Kidd and the Pirates?'

'The same.'

'Wow! What are you doing here?'

'I died in a car crash. That was in October last year, but it feels like eternity,' he replied.

'No, I mean what are you doing here?'

'I am your appointed psychopomp,' he declared. Then, seeing the expression on my face, he added, 'Look it up in a dictionary sometime.'

Of course, I thought, I should not have to look it up in a dictionary. It must be in my mind, filed away somewhere. The whole trip comes from within my head. It is important to keep a grip on that. He gestured that I should follow him inside and I accompanied him into the kitchen. I was without fear. This, even though the total overload phase of the trip was commencing. I was well protected, as Johnny Kidd walked before me as my guide and an honour-guard of toad-headed pikemen marched with me. Now I was blessed or cursed with double vision, for I could see that I was in the kitchen, but I could also see that I stood in one of the pits of Hell. The place was a tip. Last night's washing-up had not been done, never mind the breakfast things. Rotting rubbish overflowed the bin beside the sink. Cosmic's vomit was congealing in the

saucepan. That was to start with, but then all the garbage and the kitchen implements fornicated together and produced new and Hellish hybrids.

The lower half of the egg-timer sprouted a woman's arse. Eyeballs rose up bubbling out of a half-opened tin. Tiny mites danced round a thing that was half an eggshell and half a coffee-grinder. A chunk of raw liver on the sideboard kept on emitting sulphurous farts. A kitchen knife, which used ears for wheels, rumbled across the floor seeking another damned soul to stab at. The screaming damned were in free fall and hot ash and gouts of lava fell with them in an unending stream. Why do all medieval painters show Hell as pretty much the same? Why are there so many pictures which show tormented throngs of naked men and women, monstrous hybrids, blood-red skies and demon foremen with pitchforks? It is simple. They paint Hell that way because that is the way Hell looks.

The population of Hell increases hour by hour and the place is one vast building site – scaffolding, ladders, temporary tent cities and half-finished ramparts in all directions. Evil-looking creatures scurry about with buckets of tar and hods of bricks, but despite all their business, nothing ever quite gets finished. The first person we met in Hell was sitting in a tub of excrement. Johnny Kidd introduced me to Robert Johnson, the legendary founder of Blues music. Did playing the Blues merit such punishment? Seeing that I showed compassion for the man's suffering, Johnny explained that there could be no help for Johnson, since he had sold his soul to the Voodoo god, Legba. Then, in the circle of suicides, I saw Julian come crawling out from a culvert. Julian, when he saw me, shrieked and covered his eyes. Straightaway he dropped onto all fours and ran off as fast as he could. Julian was naked and a little monster rode upon his back and sought to open up his arse with a tin-opener. The unclothed bodies of the tormented are so spongily soft and vulnerable. They are skewered, fried, flayed, sawed and gnawed.

Suddenly I had a nasty, queasy thought,

'Is my Mum here?'

But Johnny smiled reassuringly,

'In the final stages of her illness, your mother started going to services at the Baptist Church and in the last year of her life she had herself baptised, so, though her repentance came late, through the mercy of the One Whose Name We Do Not Speak Here, she is in Another, Better Place.'

Johnny went on to point out to me the Big Bopper, Ritchie Valens and the Marquis de Sade, but when I asked about Aleister Crowley and if I could meet him, my guide looked at me strangely and shook his head. He walked on a bit and beckoned that I should follow. So, thinking that I was about to meet Crowley, I scrambled down behind him, all the way down to the lowest pit. At the centre of this pit was a little hill covered with skulls and on the hill a cross and on the cross a naked person was crucified. I looked up and saw that it was not Aleister Crowley, but Maud.

Actually, if I took a grip on myself and concentrated, I could see that Maud was sitting beside me in the kitchen. She was holding my hand and worrying because she was under the impression that I was having a bad trip. It was only if I let my vision slide, that the Hellspawn came frothing out of jars and packets and the vegetables decomposed into souls in torment and I stood once more on a parody of the Hill of Golgotha.

'What are you doing on the cross?' I wanted to know.

'I am practising.'

Her exercise struck me as both bizarre and blasphemous and a very strange thought flashed through my mind.

'You are the Devil, aren't you?'

'I can be anything you want me to be, darling, but I think you prefer me as a beautiful woman,' she replied.

Somewhere in the background, Russ Conway was playing 'The Moonlight Sonata'.

I turned to Johnny Kidd, who stood beside me sombre and with head bowed in thought.

'Am I lost to the mercy and love of God?' I demanded.

'God could not love you as I do,' Maud called down from her chosen place of torment.

And I recited,

'I am counted among them that go down to the pit: I am become like a man without help, free among the dead. They laid me in a lower pit in dark places and in the shadow of death.'

No sooner had I recited those words than I became aware that the trip was fading. It did not happen all at once. I saw Clara Petacci suckling a pig and, not far away, King Farouk sprawled on an altar while a stake was hammered up his anus. I saw Ruth Ellis running on the shore of a lake of fire. Suicide-trees dripped venom. Bellies exploded. Pretty young girls in mini-skirts covered the path in front of me with their spew. However, the whole infernal scenario was losing colour and power. I was master of this place. It was my kitchen. I had the rent-book of Hell. I became increasingly aware of Maud anxiously holding my hand and of Sally bustling about to make me a cup of tea with lots of sugar in it. I was drifting into a grey, purgatorial state in which I just had to sit quiet and wait until the Hellish visions should fade entirely away.

Another hour passed before I was able to communicate coherently with my companions in the kitchen. Sally had come back from her shopping ages ago.

'Who did you see this time?' (I really wanted to know.) 'Brian Wilson of the Beach Boys? No, don't tell me . . . Brian the Snail from *The Magic Roundabout*?'

Sally looked baffled and angry.

'No, but I did run into Janis Joplin,' she replied. 'And I said how much I admired her singing and she told me where there was a pet shop.'

Flipped. Completely flipped.

Following on from Janis Joplin's alleged directions, Sally had indeed been to a pet shop and bought a dog collar, a lead, a dog bowl and tins of dog food, but, as Cosmic had perceptively pointed out, she had not bought a dog.

'I am the dog,' Sally replied.

She had also bought some more vodka and more women's magazines, plus a copy of *Melody Maker* for me. Tonight Sally, wearing the frilly apron and a spiky dog collar, cooked chilli con carne. Our domestic arrangements are becoming

increasingly complicated. Thus Maud and I had our dinner at the kitchen table and we drank vodka out of glasses like normal people. Cosmic, however, ate in the lying-room and, after he had established that we had run out of Bovril, he decided to try something new. He mainlined his vodka straight into his veins. Evidently this produced quite a blast and Cosmic passed out before he had finished his dinner. I had to check that he had not died. I think he is going to be all right, though it is quite hard to tell. As for Sally, once she had served us our food, she spooned herself out some dog-food and got down on hands and knees to eat it on the floor of the kitchen.

Now Maud and I are lying in bed and writing our diaries. I wonder what tomorrow will bring?

Sunday, August 13th

Yesterday Hell and Purgatory. Today the bliss of Paradise.

First thing in the morning Maud was out in the garden, doing her karate exercises as usual. Cosmic and Sally were nowhere to be seen. After a while Maud took a breather and explained that Sally had asked Cosmic to put a lead on her and take her for a walk in the woods. Apparently the thing is that Sally has declared that she is unworthy to use the same lavatory on which Maud has sat, so now she must shit and pee in the woods. It is a little bit freaky, but I have to think of what is happening as not so much losing an old girlfriend as gaining a new talking dog. Anyway it is a relief to learn that Cosmic has recovered from his shot of alcohol. According to Cosmic, Sally is getting her reincarnation in early.

Then Maud went inside and started preparing the bedroom. She plumped up the pillows and put out candles and incense sticks and stuff like that. Then she had a long bath and even longer session in front of the mirror with her vast armoury of cosmetics and perfumes. Cosmic and Sally came back from their walk. They both claimed to have enjoyed it, even though Sally's knees were horribly scratched and bleeding.

Although I really wanted to talk to Cosmic, he put me on hold. He had by now accumulated some half a dozen gnomes stolen from Farnham gardens and he had decided that it was urgent that they should be buried straightaway. Yesterday's rain had softened up the ground a bit and, once the gnomes had been placed deep in the ground, they could start mining away and gathering treasure.

I cannot get much sense out of Sally these days. While Cosmic is labouring away with a spade in the corner of the garden, I have chosen a spot nearby and, now that I have caught up in my diary with recent events, I have decided to get down to making nature notes – literally down to it, as I am lying on my belly at the edge of the wood with my diary in front of me and I am watching a couple of butterflies dancing through the trees. The silver birches –

While I was getting going on writing this, Sally crawled up beside me.

'An hour and a half to go,' she said.

I recoiled a bit from the smell of dog-food on her breath, but she did not notice.

'Don't you miss London, Peter?'

'Oh yeah, of course. But God knows when it will be safe to return to London – if ever.'

And I looked inquiringly at her.

'Meeting Maud and serving her has been the greatest experience of my life,' Sally declared emphatically. 'But I long for London. I miss the Mangrove and the Joyboy . . . and the King's Road . . . and curries. I have walked every street in Farnham without finding a single Indian restaurant. And I want to dance at Middle Earth. That would be such a groove. I long for it, but I do not think that I shall ever dance again.'

When will it be safe to return to London? Only after some unimaginable catastrophe has befallen the city and, in that greater catastrophe, Horapollo House is no more than a burnt-out shell and its inhabitants shall be dispersed or dead. I am seized with nostalgia for the future. In this future, Sally and I will be dancing in the streets, for the sound of the music has changed and the walls of the city have fallen. We and all our friends will be hand-in-hand and capering

through mossed-over arcades and grassy squares. Cattle shelter in the shadow of the Stock Exchange, unguarded while feckless shepherdesses and their swains make love amongst its ruins. The rubble of the Festival Hall runs tumbling into the Thames where gipsyish women sit on its foreshore, washing garishly coloured linen, while a band of horsemen canters along the remaining solitary walkway. The Dome of St Pauls is down and there are nightly bonfires in its great nave. Skulls of cattle adorned with flowers decorate the Cathedral's arches. A raggle-taggle throng of tinkers, drovers and roadies, all in the bright and distinctive robes of their crafts, like to gather there and entertain themselves with pipes and guitars. A few of those partying, more thoughtful than the rest, may gaze up at the remnants of the great stone drum of the ruined edifice and muse. Surely they were giants who built this city? The churches and public buildings are now guarded only by the enigmatic statues of forgotten generals and politicians – so many lost gods of England.

For it is not just London. All of England has surrendered to wood magic and gone wild. It is a land fit for heads and the time when people and roads were straight is only a horrid memory. Wagon-trains of gaily-painted caravans follow the traces of old tracks across the south-western plains, heading for . . .

Sally, who now knelt beside the back door, broke my reverie by calling out, 'Half an hour now, Peter.'

So then I decided to write all the above down. It was not the kind of nature note that I had had in mind, but it still seemed necessary to record it. In fact, my hand wished to write it and I let Pyewhacket get away with it again.

Then, before I have quite finished writing, Sally calls again, 'Twenty minutes.'

Just as Sally was presumably about to declare that there was a quarter of an hour to go, Maud appeared at the door and, half-shy, half-proud, struck a pose. She was wearing a black and pink peignoir, a suspender belt and shiny black stockings. She looked at me and put a finger to her mouth. I followed her into the bedroom which was now thick with incense.

Maud was still kneeling and struggling with the buckle of my belt, when Sally from the next room called out, 'Ten minutes!' but a few minutes later Maud and I were in bed. I

was resting on my elbows, poised over her, when Sally commenced the count-down proper.

'100, 99, 98, 97 . . .'

Maud looked terrified.

'Blast off!'

It was not much of a blast-off. The entry was difficult and Maud was intensely concentrated. Her nails on my back drew blood. When it was over, she contemplated the stains on the sheets and declared,

'Gosh! Isn't being human a messy business?'

The next thing was that she leapt out of bed and went galumphing into the next room.

'Sally! Sally! We did it!'

'Oh, well done!' Sally was faint.

'It didn't hurt! Well, not more than having my ears pierced did.'

Then Maud galumphed back and threw herself on me.

'Let's do it again!'

I think we did it eight times that day. Sally brought us lunch in bed and we did not actually get dressed until evening. Now it is late in the night and Maud is asleep and snoring, but I have been lying in bed and I have been thinking about what Maud told me this afternoon. After the fourth fuck, I remember that I was looking down on her and thinking that she looked so angelic with her luxuriant black hair fanned across the pillow, like the halo of a dark spirit. And the words just came tripping out of my mouth,

'When I was on acid I saw you as the Devil'

She smiled lazily.

'Yes well, that is who my Pa says I am.'

'Your Pa?'

'Robert Kelley.'

'Robert Kelley . . . the Master?'

'You silly, yes, of course. I thought that you had worked that out by now. Even Sally is faster than you! I adopted my maiden name when I fell out with Pa and went to work as a hairdresser. Boleskine is my mother's surname.'

I thought about this for a few minutes, before replying,

'OK, but being the daughter of a leading Satanist does not mean that you are the Devil.'

Now it was her turn to pause and reflect.

'I think that the time has come to tell you how it was that I was born,' she said.

It took Maud hours to tell the full story. She kept getting things in the wrong order and forgetting that she had not yet explained certain other things. Also we broke off a couple of times for more sex. However, Maud's story, as I have reconstructed it in my mind is as follows:

It all began with Aleister Crowley and the horoscopes which were cast for him on the day of his birth and the day of his death. Crowley (who, in his immediately previous incarnation had been the notorious French occultist, Eliphas Levi) was born on October 12, 1875 and christened Edward Alexander. He was born under the Crab with his Sun in Virgo and his Moon between Aquarius and Pisces. He died on the 1st December 1947, under the sign of Sagittarius and he was cremated on December 5th at Brighton Crematorium. Relations between Crowley and his disciples on the one hand and on the other hand the Adepts of the Black Book Lodge had been strained for some years. Nevertheless, it was inevitable that Robert Kelley and Charles Felton should have attended Crowley's funeral. While down in Brighton, they consulted with Gerald Yorke and other old associates of Crowley and together they drew up a detailed horoscope of the hour of Crowley's death. The leaders of the Lodge knew that they had to move swiftly. A small group of Adepts was selected and tickets were purchased for them on the first available boat to Alexandria.

The currency restrictions which were then in force were irksome and arrangements took longer than might have been hoped, and it was not until February 10th, 1948 that Robert Kelley and his party arrived in Cairo. They were cheerful – delighted to have escaped post-war Britain, smog, and the austerities of rationing, and, besides, they were young and wild and they had embarked on a mighty and dangerous adventure. 'They', were Robert and his wife, Elspeth, Charles

and Bridget Felton, Colonel Chalmers, Julian and Ronald Silvers. Julian and Ronald were very close. It was Ronald who had got Julian so interested in Egyptology in the first place. Ronald, who was thought to be a promising scholar and linguist, was a deputy curator at the British Museum, but he had negotiated an extended leave for himself. The party put up at Shepheard's Hotel and most of them enjoyed a few days of pale sun on the verandah, sipping glasses of mint tea brought to them by servants wearing tarbooshes and long white robes. Robert and Elspeth actually slept in the same room that Crowley had occupied when he stayed in Cairo on his return from the Himalayas. Meanwhile Chalmers and Silvers set about hiring servants and donkeys. (From our perspective in 1967, it is hard for Maud and me to imagine Chalmers as ever having had all his marbles and being up to organising an Egyptian donkey train, but it was so. It is even harder for us to imagine Felton as a slim and dashing young man, but he was apparently handsome in those days, though not as handsome as Ronald.) Chalmers also purchased several black cockerels.

By the third evening after their arrival in Cairo – that is February 12th – they were ready to depart for Memphis. Although the conjuration which Kelley and Felton organised in 1948 is conventionally known as the 'Cairo Working', what happened really took place in Memphis. Memphis is some distance to the south of Cairo and the pyramids of Giza. Coptic guides carrying flares led them out into the desert, heading for the group of small villages which partially occupied the site of the capital of the Old Kingdom. Though wild dogs barked and jackals howled on the horizon, the mood of those on the night-journey was crazily cheerful. Everyone was smoking hashish cigarettes. Most walked, but Ronald sat on his donkey and serenaded Elspeth with his violin. Elspeth, who wore a dark-blue priestess's robe, danced in front of him. Her beauty was ethereal and all the men were in love with her. (As I gazed on Maud, her daughter, I found no difficulty in believing this.) Correction: all the men, except Julian, lusted after Elspeth. Julian lusted after Ronald, but he had said

nothing to Ronald and perhaps he had not even admitted the truth to himself.

The garden village of Mit Rahina is situated in the heart of what was once Memphis. In the pre-dawn the sorcerers made their way between the hovels and palm groves and came at last to the area of the former temple enclosure of Ptah. (Ptah is the mummiform god of necropolises.) Servants were organised to start a fire in the vicinity of the Alabaster Sphinx. Although it was still early and the muezzin had not yet made the *fajr* (dawn) call, their arrival in Memphis had not gone unnoticed and Kelley had to pay the headman of Mit Rahina to keep the villagers and their children away from the ritual spot.

The first of the thirteen Chokmah days commenced with the rising of the sun and it was then possible to begin the invocation of Aiwass. The blood of slaughtered cockerels made the fire hiss. Then Robert, having called out the private names of Aiwass, cast Crowley's special talisman – an Abramelin square soaked in menstrual blood – on to the fire. The purpose of the invocation was to hold converse with Aiwass and to seek that mighty spirit's assistance in guiding the dead spirit of Crowley into his next incarnation. Robert and Elspeth went so far as to hope that they might be found acceptable as the future parents of Crowley in his next incarnation. ('So you are the reincarnation of Aleister Crowley?' I interrupted. 'No, it is stranger than that,' Maud replied. 'Listen.')

'Aiwass! Manifest yourself! We shall be content with none other!'

No sooner had Robert completed his call to Aiwass than a wind arose in the north-west and fanned the fire, sending sparks into the air. Felton sat closest to the fire, as he was the party's designated scryer. However, in fact all of the party saw Aiwass when he manifested himself in the heart of the fire. This demon had taken the form of a naked old man and the old man jumped on Felton and attacked his throat. But Kelley had his exorcism dagger at the ready and he used this to drive Aiwass back into the fire. Then they watched the demon writhe, for Aiwass suffered from the flames as much as any human would. There was nothing shadowy or fanciful about

the manifestation of this spirit. All six of them clearly saw Aiwass in the hard-edged light of early morning, even though to see him was to be on the outer edge of sanity.

So Robert held Aiwass in the fire and was thus able to interrogate him under duress. Everything had gone well so far. But when Robert asked for the demon's assistance in guiding them to Crowley's next incarnation, the demon told him that he was too late and that Crowley had already taken his next human form. In fact, he had been born in early January. This was an unforeseen development. The Lodge had expected that Crowley would linger for about six months in the world of shades before taking human form again. That would have been normal. Robert now had a whispered consultation with Felton, before turning once more to Aiwass and demanding that spirit's assistance in guiding them to Crowley's new incarnation. Then they saw something which no occultist has seen before. They saw Aiwass make invocation in turn to his master and they saw the old man in the fire talking to the monstrous spirit who governed him, though the spirit itself remained invisible, for they were, it must be remembered, at the outer limit of what it was possible to see and still live.

At length Aiwass replied that his master would bring the new incarnation of Crowley to them. However, his master had also decided to take human form and, shortly after the latest incarnation of Crowley should have presented himself to the Adepts of the Lodge. Then his master in human guise would hold intercourse with Crowley. Until those two had met, the Antichrist, that son of perdition who would deceive people into worshipping him, could not appear on earth. So Aiwass's master would bring Crowley to them. Then Aiwass's master would come to seek Crowley among their number. When Robert asked the name of the entity seeking incarnation, Aiwass replied that he dared not pronounce the name. Then Robert fell to his knees, for he understood who, or perhaps it should be what it was that sought to descend to earth in human form. Felton took over the conversation with the demon and, after seeking detailed directions about how

they were to assist Aiwass's master in taking flesh, he swiftly dismissed the lesser demon.

Now, of course, everyone in Kelley's party was familiar with the theory and practice of *congressus cum daemone*. Such intercourse between men, or more often women and spirits has taken place for thousands of years. Indeed, Herodotus described this practice when he came to discuss the curious dealings of the temple prostitutes of Egypt. Moreover, the Black Book Lodge had already supervised several experiments in inseminating and rearing 'moonchildren'. Nevertheless, the pact that Aiwass seemed to be proposing went beyond anything that had ever been envisaged by the Black Book Lodge or by any of their predecessors.

Therefore, the rest of the day passed in argument, as Felton and Kelley raged at one another on the threshold of the Temple of Ptah while Elspeth and Bridget sat silently listening to their dispute. It was Kelley who wished to break off. He wanted them all to return to England, where surely they would be able to research some other way of locating the infant incarnation of Crowley. But Felton replied that it would be shameful to go back to London with so little achieved. That was the least of it. Beyond that, Felton pointed out the grandeur and honour of the enterprise which had been proposed to them by Aiwass. If they performed the ritual which they were commanded to carry out, they would have decisively undermined the central pillar of the Christian faith and would have changed the history of the world in a most spectacular and terrible fashion. Surely they would be rewarded and most generously rewarded for their indispensable assistance in such an undertaking? Besides it was discourteous to refuse a request from Aiwass's master. It was certain that such discourtesy would, sooner or later, be painfully avenged.

Although this last argument carried some weight with Robert, he still would not agree that they should proceed with this terrible ritual. Then Elspeth suddenly said that she was eager to perform according to the instructions which had been dictated by the old man in the fire and that she longed to offer her body to the unseen, but Robert stopped her, saying

that, if Felton was so keen to carry this thing through, then it ought to be his wife, Bridget, who should be the vehicle of the insemination. So Felton went off to fetch Bridget from her tent and, after some more debate, Robert presented a fist with two straws to the women. Elspeth drew the short straw, which was the one she said she had wanted.

The next bit is, perforce a bit vague, as nobody in the Lodge had ever actually spelt out to Maud exactly what happened next, though by piecing bits of information together she eventually got a fairly good idea. After the dismissal of Aiwass, Ronald had gone off into the desert to amuse himself by taking pot-shots at jackals. Chalmers was sent to bring him back. Meanwhile a goat and a dog were purchased from the village.

The dog was promptly killed and their dinner that night consisted of dog's flesh with unleavened bread, washed down with a great deal of wine. Accompanied by Charles and Ronald on violins, Bridget chanted hymns by Crowley, while Elspeth made herself ready as a bride for the bridegroom. When the night was well advanced, Robert and Elspeth went off into the desert and they were accompanied by Julian who had charge of the animal, which was now consecrated as the Goat of Memphis. The possibility of bi-semination, though still widely believed in Renaissance times, has since fallen into disrepute with the scientific community. Nevertheless, it is still believed in certain occult circles that, in the right circumstances, the double seeding of a woman's womb can be successfully carried out.

It was dawn before Robert, Elspeth and Julian returned. Elspeth had to be supported by Robert. Julian had the dead goat slung over his shoulder. Its meat was consumed in a second ritual meal. Although a great deal of wine was consumed, there was little conversation. The following day, they returned to Cairo. Elspeth travelled in a litter, for she was unable to walk for almost a fortnight. In Cairo, Ronald started behaving strangely, but the Master was preoccupied with Elspeth and as for Felton, he was brooding over what he now perceived to be a lost opportunity. For if he had been

prepared to push Bridget forward, he might have become step-father of the Devil. Of course, Julian did notice Ronald's strange state and he stayed close to his friend. However, he may have seen Ronald's moodiness and his alienation from Elspeth as more of an opportunity than anything else.

Maud is not exactly sure what happened in Cairo, except that Ronald shot himself. She heard contradictory things, but what she thinks happened is that Julian attached himself to Ronald as his shadow. Ronald kept pestering Julian for precise details of what happened to Elspeth with the goat. At length Julian wearied of being evasive and told him straight out. An hour later Ronald shot himself. Julian who was only in the next room rushed in when he heard the shot. He found that Ronald had botched the job, so that, although a large part of his face had been blasted away, he was still alive. Julian finished the job with a second shot. It seems likely that he was going to follow Ronald to Hell, but before he could reload the gun, the Master and Felton came in and took charge of things. Looking backwards on things (literally that is), Julian realised that it was Ronald's death which had caused him to fall in love with him in the first place.

Three weeks after their return to Cairo, what was left of the party embarked on a boat bound for Southampton. By the time they reached England, Elspeth was certain that she was carrying a baby. From the first, it was a difficult pregnancy as she kept vomiting up hair-balls and what looked like tiny bits of gravel. Towards the end of her time, Elspeth made two bungled attempts at suicide, as she belatedly began to panic at the thought of what was growing in her womb. So Maud was actually born in a mental asylum. Robert and his associates had been expecting that the Devil would choose the male sex for his human incarnation and they had not thought of any girl's names for the baby when it came. However, Elspeth had been a devotee of Tennyson's poetry, so Maud was the name on the birth certificate – though, of course, there was also a secret baptism, in which the little girl was given the name of the Lady Lillith Nuit Ma Ahathoor.

Elspeth did not spend long in the asylum – just long

enough for Robert to make the arrangements for her to be nursed and guarded in the attic of Horapollo House. Robert himself moved out of the House, having purchased an ordinary semi-detached in Highbury and this was where Maud, reared by a foster mother and a series of governesses, grew up. From time to time, senior Adepts of the Black Book Lodge came to visit her. They respectfully asked her questions and set her tests and they performed curious little rituals which were designed to awaken her memory of her true nature and to activate her dark power. Maud sulkily submitted to these indignities and then went back to her doll's-house. Once she could read, Robert timidly put texts by Sinistrari and Crowley beside her bed, but Maud stayed obstinately loyal to *Bunty* and *Jill*. She was not an easy child and, later yet, she conducted a vigorous, though unsuccessful campaign to be given a pony. (Refused as hardly practical in north London.) The adolescent Maud was no easier. She mulishly rebuffed her father's attempts to instruct her in her true nature, for she preferred karate, make-up, clothes and dreaming about boys to all that stuff about the Devil and Satanism.

God so loved mankind that He made himself incarnate as a man and, though relinquishing none of His Divine nature, He then became fully human. Now, the Devil had outdone God by descending to earth in female form and making himself subject to all the travails of womankind, including period pains, the perils of pregnancy and a taste for fashion magazines. The dark power was in abeyance, but only for a time and for a purpose. Thus the Master reasoned to himself and, in time, he became comfortable with this way of thinking. Even so, he still had Aiwass's promise in his head and how that spirit had foretold that the Devil would bring Crowley to him and that he would bring Crowley to the Devil.

I had always thought of the Master as a terrifying figure and I had seen grown men tremble when he made one of his rare appearances at Horapollo House. Maud, however, thought of her father as one hell of a sad man. Not only had he failed to make the Devil fully manifest in the world and failed also to locate Crowley (though these concerns seemed of little

importance to her), but he had also failed to rescue her mother from madness and, above all, he had failed to treat Maud as a human being, never mind love her as his child. Their rows became fiercer and more frequent and eventually Maud found work as a hairdresser and moved into that shared flat which I had once visited. She continued to see her father occasionally and he generously topped up her rather meagre wages.

Maud had hoped that, once she was on her own, she would find it easier to meet and date boys. This was not the case. Although she was beautiful and several boys did try to pick her up, her awkward manner always ensured that the first date with any boy was also the last. Eventually she resorted to computer dating.

When, after quite a few diversions and recapitulations, she reached this point, I interrupted,

'It is unbelievable! It is one hell of a coincidence that I, a disciple of the Master, should meet his daughter on a blind computer-date. I just can't get my head round that.'

Maud looked at me with fond contempt,

'Peter, you are such a thicko! No sorry, you are lovely, but your brain does not seem to be functioning this evening. That was a set-up, you see! Granville never posted your form. Pa and Felton just wanted to bring us together and the computer-dating dodge was my idea, as I did not want you to be told by Felton or someone else that it was your occult duty to love me and then have you frogmarched by Adepts of the Lodge to your first date with me. I was right, wasn't I?'

'But why me anyway?'

'When is your next birthday?

'December 4th, but what – '

Neither of us spoke for a long time. I just lay there trying to work all the consequences out. I tried but I could not imagine that I had ever been mountaineering in the Himalayas or practised homo-erotic sex magic in Tunisia. Had I ever really worn plus-fours? Inside my slender body was there a fat sorcerer trying to get out? It was no good. I just could not imagine it. I gave up trying and let Maud finish the story.

Everyone who joins the Black Book Lodge has their natal horoscope cast as a matter of course. Mine, however, caused intense excitement and when Laura, who had done the calculations, presented my birth-chart to Felton, he immediately asked for a meeting with the Master. There could not be much doubt about the matter. Not only had I been born in December 1947, which was when Aiwass had indicated that Crowley had assumed his latest incarnation, but the chart showed that my Sun was in Virgo and my Moon between Aquarius and Pisces. However, Crowley had been born under Cancer, while my birth sign was Sagittarius. Therefore there was some doubt and debate. Finally, it was agreed that, if I was indeed the one foretold, then I was fated to meet Maud and the Master thereupon decided to give that fate a push.

A few days later he treated Maud to lunch in Camden Town. Having told her about the circumstances of my arrival at the Lodge and about my presumed hidden identity, he continued by saying that there was almost nothing he would not do for her, if only she would agree to go out with this young man with the interesting horoscope. She refused. Maud was not prepared to let her body be used as a mere vehicle for the fulfilment of ancient prophecies. But then, when her father produced a photograph of me, she hesitated, as she thought I was actually quite nice looking – sexier than in my previous incarnation as Aleister Crowley anyway. So, in a Greek restaurant in Camden Town, Maud and her father made a Satanic pact. She would date me and take it from there. As I have already noted, the faked computer-dating was her idea. However, she told her father that she would not commit herself in advance to seeing me more than once. They would just have to see how it went. When Robert hinted to Maud that the Lodge might require her to surrender her virginity to me at an astrally favourable time, Maud had exploded in fury and almost called the whole thing off. What kind of girl did he think his daughter was? But of course, the point was that he did not think of Maud as a girl at all. They had to finish their noisy argument on the pavement outside the restaurant.

The volume and vehemence of it was so considerable that a few passers-by attempted to join in, only to be baffled by the repeated references to Aiwass, ritual defloration and the Antichrist. The end of it was that Robert had to be content with what Maud was prepared to offer.

Maud, having finished her long, strange story clambered on to me and ran her fingers down my ribs,

'I have been wanting to ask you for ages. Are you really Aleister Crowley? I mean, do you feel that you might be him?'

'No, I don't think I am. I'm just ordinary.'

She looked down lovingly on me.

'I don't care whether you are Crowley or not. I just want your body. I want you inside me.'

What further revelations will tomorrow bring?

Monday, August 14th

Now I am writing this, lying in bed and waiting for Maud to return and for Sally to bring us breakfast. I believe that Maud is having Sally lick her feet while she sits on the lavatory. They both seem to enjoy that.

I think that there are quite a lot of problems with what I learned yesterday. When I was small, I used to entertain fantasies that, despite my outward appearance as a Cambridge schoolboy in short trousers, I was in fact a prince in exile. One day I should throw off my disguise and reveal myself as the true heir to the Kingdom – a bit like Prince Aragorn in *The Lord of the Rings*. Now I find that I may be Aleister Crowley in disguise – and so heavy is my disguise that even I cannot penetrate it. Well, I do not believe it.

And yet . . . and yet, it would explain one thing; the intense nostalgia I experience when I watch old newsreels or see old photos of the thirties and forties. How can I possibly feel nostalgia for a time before I was born? And why do some of the scenes and faces seem so very familiar to me? Moreover, there would be another, comforting aspect to discovering that I am a reincarnation and that is, just as I have always found it

horrific to contemplate the prospect of my death and the world going on without me, so also I have found it no less horrific to contemplate the possibility of a world existing before I was born. I really mean horrific . . . the vertiginous prospect of all those millennia and billennia which happened before I was thought of. It might actually be comforting to think of myself as once having been Crowley and, before that, Cagliostro and, before that, a temple-priestess in Crete and, before that, maybe some crustacean trying to crawl out of the sea. One of the troubles I had with the Lodge's exercises in thinking backwards was that I could not bring myself to think backwards to a time before I was conceived.

My meditation on this subject was interrupted by Maud coming back into the bedroom with a letter in her hand. It is from Dennis Wheatley! That was quick.Not only is there a letter. There is also a signed photograph of the famous author.

Dear Peter Keswick,

Thank you for your kind words about my novels. An author is nothing without his readers and his fans and, believe me, your letter is much appreciated. However, I note with concern that, if your letter is to be taken seriously, you have begun to dabble in both drugs and the occult. I cannot stress too strongly that those who do get involved in such things run the risk of encountering *serious dangers of a very real nature*. Additionally, I should hardly need to point out that the consumption of hash-ish or amphetamines without prescription is illegal in this country. After some thought, I have decided not to pass on your letter to the police, as I have decided that the rather odd activities you describe in your letter are the product of a lively imagination, rather than a true record of anything that has actually happened. Please do not feel tempted either to experiment with drugs or to take any steps at all on the Left-Hand Path. Those of my acquaintance who did so invariably came to a bad end. However, rather than end this missive on a sour note, thank you again for reading my books and telling me

how much you have enjoyed them. My next novel is entitled *Unholy Crusade*. It is an exciting thriller with occult elements in it and it is published next month by Sidgwick and Jackson, price £1.

 Yours truly,

 Dennis Wheatley.

I was getting dressed and just zipping up my jeans, when Maud called out,

'Stop that!'

'Stop what?'

'From now on, my darling, your flies stay open day and night. I want you readily available to me at all times.'

Well, it is a bit embarrassing, but Sally already knows what I have got down there and, as for Cosmic, nothing fazes him. When I showed him the photograph of Wheatley, he said that we might be able to use the image for magical purposes. If we burnt it, while making the right sort of invocations, we might be able to give the old fart a heart-attack. Then, when I told Cosmic that I might be a reincarnation of Crowley, he said that, yes, he had reckoned that it might be on the cards.

A little later, I asked Maud how it was possible to believe simultaneously in reincarnation and Hell. I mean if, for the sake of argument, I was an evil old sorcerer who kept getting reincarnated, then when would I ever meet with the Devil in Hell and experience the tortures of the damned? But Maud was preoccupied with checking that I still had a hard-on and it was Cosmic who replied,

'Why this is Hell, nor are you out of it. Wherever we are is Hell, for Hell is limitless.'

Then Cosmic, who is really well-up in all the oriental religions, described the Buddhist concept of Hell and the Wheel of Samsara and quoted from *The Tibetan Book of the Dead*:

'The mirror in which Yama seems to read your past is your own memory, and also his judgement is your own. It is you yourself who pronounce your own judgement, which in its turn determines your next rebirth.'

OK as far as it goes, I suppose. However I still have problems.

'If there were any justice in the cosmos, then, when Crowley was next incarnated, surely he would be incarnated as a toad or something like that?'

'I am afraid that Pa regards sociology students as no better than toads,' said Maud, and she swiftly gave me a consolatory kiss, before going off to have her bath.

Talking to Cosmic this morning, I now understand that he has been sent by the Black Book Lodge to watch over us and make sure that no harm comes to Maud or me. The whole business of his attempt to get me to defect from the Lodge and his subsequent expulsion from Horapollo House were all bits of play-acting, in which they were testing me.

'Right now you are a protected person. But if Maud ever ceases to love you, you will be dead meat, for you abused the Lodge's trust.'

Cosmic did not say this in an abusive or threatening manner. It is just the way things are. He was pretty laid-back about it all.

After shooting the breeze for a bit, Cosmic went off on a gnome-hunting walk and I spent a couple of unsatisfactory hours reading *The Confessions of Aleister Crowley*. I wanted to see if any of my hypothetical past life would come back to me as I read about it. I don't think it did really. Perhaps regression under hypnosis might work?

As for Sally, she put some clothes on and goofed off into town to do some shopping. This time she was lucky in that her trip into Farnham coincided with that of Jimmy Hendrix. Sally does not seem very well. I mean, apart from her Hendrix hallucination, she is sweating a lot, her skin is coming out in spots and she needs to be taken for frequent walks in the woods.

Towards the end of the morning a parcel arrived for Maud. That's really freaky. Weeks with no post at all and now two items in one day! It is something which Maud chose from a mail-order catalogue – a shiny, black, leather cat-suit, just like the one Diana Rigg wears in *The Avengers*. I help zip Maud into it. Really the suit was made for someone less voluptuously curvy than Maud, but once she was securely zipped into

it, she looked really fabulous – so fabulous that I had to unzip her straightaway and fuck her on the floor. Then she got me to zip her up again. When Cosmic and Sally returned from their respective expeditions they too were knocked out by Maud's appearance. She is like the Queen of the Underworld and I am her consort. Is Maud having me on about her father and his associates believing that she is the Devil made flesh? But no, what she said was all so artless. But then again, if she actually were the Devil, would she be able to present herself as so innocently artless? Presumably. I really don't know.

Cosmic got his gnome painted before lunch and then in the afternoon got down to burying it. I joined him in the garden and sat there trying to think what to write about nature, but I kept being put off by thoughts of Crowley and the Antichrist. I am sure that Maud is not on the pill. I was so distracted by Sally's loony count-down routine yesterday that it never even occurred to me to ask. Anyway what is there to be said about nature? The sky is blue, leaves are green, birds flutter about. It all seems to work perfectly well without me having to write about it. I was about to take this line of thought a bit further when we were interrupted by a visit from the fuzz.

They were two constables, one male and one female. They asked if we would mind answering a few questions. The way they put that made it perfectly clear that they didn't care whether we minded or not. We were going to answer their questions. Their manner was really heavy and they insisted that the interrogation had to be done inside the cottage. Once inside, they started looking all over the place. It was not a formal search, but they were certainly looking for something. Cosmic looked deathly white and, I don't know for sure, but I guess I looked at least as pale. We both had the same thought – that this was a drugs bust and, if that was the case, then we were done for, since we had not troubled to hide our stash. It was just kept on one of the shelves of the tiny larder, together with Cosmic's syringe. So had Wheatley shopped us after all? There was a tiny bit of me that was considering an alternative, equally disagreeable possibility, viz that their visit

was something to do with a nation-wide crack-down on Satanism and I was steeling myself to answer difficult questions about ritual defloration, animal sacrifice and stuff like that.

It was clear that they found us a bit much – not at all like the yokels they were used to dealing with. Cosmic was wearing his Arlo Guthrie hat and a gipsy waistcoat. I was in jeans and a T-shirt, which was OK, except it was not until the fuzz had gone that I realised that my flies were undone and my penis was dangling out. We were soon joined by Maud and Sally. Maud was in her cat-suit and she was followed by Sally who crawled on all fours, naked except for the collar and little frilly apron. Cosmic swiftly threw a sheet over her body. The two constables looked at one another. It was impossible to tell what they were thinking.

As is the general rule with police interrogations, they would not say at first what they were after. They just kept asking questions. We had to give our names, occupations and state how long we had been in Farnham and so on.

At last the male constable came to the point,

'This is by way of a warning visit. There have been a lot of thefts in the area recently and we thought we ought to warn you to be careful.'

I nodded dumbly.

'There is fuck-all to steal here,' said Cosmic.

'Mind your language, sonny. No, what it is . . . is that the thieves are after one thing and one thing only.'

They looked at us, as if they expected us to guess what the thieves were after.

Genuinely perplexed, we looked back at them.

'Money?' ventured Sally.

They looked annoyed.

'No, it's not money. No, someone has been going around stealing garden-gnomes. You may smile, but it actually isn't very funny. People are proud of their gardens in this part of Surrey and it is no joke to have some vandal come into their gardens and steal from them. The gnomes are quite expensive to replace too. If you had spent part of the morning

comforting an old lady in tears you would not be smiling now.'

But I could not keep the grin off my face. Not drugs, not ritual sacrifice, just gnomes. And thank goodness Cosmic's gnomes were safely deep in the earth, busy about their chthonic enterprises. The constables paced about the cottage peering through doors, obviously hoping to catch a glimpse of a stray gnome.

'God, this place is a tip!' said the female constable.

We, that is Maud, Cosmic and I, all looked reproachfully at Sally. So then the police turned their attention to her too. Sally gazed up at them smiling and offered her tattoo for inspection.

They took her into another room where they asked her a lot of questions in private. Apparently they wanted to know how old she was. What was the address of her parents? Was she here of her own free will? What washing facilities were available? Had she registered with a G.P.? Did the cottage have many strange men visiting it? All kinds of stuff.

Finally they left, but, just before they did so, the female turned to us and said,

'We will be back.'

It was all a real downer. The fuzz carry their own atmosphere with them and they are generous in spreading it about. Maud, thank heavens, was the least troubled. As long as she is with me, she is happy and has no fears for what may befall us.

Tuesday, August 15th

Sally was very ill in the night. Cosmic is also in a pretty weird state as he is mixing alcohol and heroin and talking madly about reincarnation and about how everything that happens gets re-enacted again and again. Specifically, we are reliving what happened in the early 1920s at Crowley's Abbey of Thelema. In Cosmic's eyes, I am the Great Beast, while Maud and Sally are the First and Second Concubines. The Wheel of Samsara has brought this episode round once more and we have to see if we can make a better fist of it this time. But

Cosmic was not making much sense as, at other times, he talked as if Sally was not the reincarnation of the Second Concubine (who was called Ninette Shumway), but she was instead Raoul Loveday, another member of the Brotherhood of Thelema. Raoul died of dysentery in Crowley's Abbey and that is what Sally is going to die of – an infection she contracted over fifty years ago in a previous life. As for me, I don't think she is going to die and, if she does, it will be from all that awful dog food. Cosmic, on the other hand, says that the tinned stuff is not that bad and, in order to be comradely with Sally, he even tried some himself. Mind you, he was so stoned, I don't think he knew what he was tasting.

I have been putting Donovan songs on the record player in the hope of cheering Sally up, but now she tells me that he is no good.

'He tells lies about the world,' she whispered.

It is raining and, since the fuzz's visit yesterday, the cottage feels like it's under siege. Despite the rain, I said I was going into town. I had it in mind that I might find a doctor and get him to come and examine Sally, but, just as I was going out of the door, Maud caught me by the sleeve,

'Don't leave me, Peter. I know I sound silly, but I have the feeling that, if you go far from the cottage . . . if you go beyond the magical enclosure that you traced with your wand, then the spell will be broken and the enchantment gone. We only have one another.'

Sally has actually forbidden me to play any more Donovan. She cannot bear to hear about sunshine, girls in lace dresses, pure white knights and jolly tinkers. So it is Dylan instead. Dylan's stuff is intense, driving. But I now wonder how good is intensity? What is the point of intensity? There is no point. Intensity is just the excess intellectual energy of youth.

Sally just lies there now, but earlier on in the day she beckoned me over to her and told me that she did not mind me having spat on her photograph and joined in the ritual cursing at the Lodge. Also that she loved me, and because she loved me – only because she loved me – she loved Maud too.

Then I went out to talk to Cosmic in the garden. It seems

311

that a bit over a week ago Sally came up to him and asked him why he thought things had started to go wrong for her recently. At first Cosmic thought that this was just her question-of-the-week, but then he realised that it was more serious than that, so he told her about how, after she had interrupted the Master's lecture, she had been ritually cursed by members of the Lodge, including me. (Thanks Cosmic.) Of course Cosmic believes that one has to be open about things, because keeping secrets and bottling up emotions is known to cause cancer. So all should be well now . . .

Wednesday, August 16th

Frightful.

Thursday, August 17th

Frightful.

Is Christ's mercy indeed infinite? And what is the sin against the Holy Ghost which can never be forgiven? At school, the rumour was that masturbation was the sin against the Holy Ghost. If so, that's me done for and, of course, more imminently Sally.

I persuaded Cosmic to go into town and look for a doctor. Difficult, because he was a bit zonked and he came back, having failed to persuade anyone that we had a really urgent problem. However, he did bring more food, vodka and diarrhoea pills plus a home-perm kit and Dr Benjamin Spock's *The Commonsense Book of Baby and Childcare*. Only after Cosmic sheepishly produced the book, did Maud tell me that she was certain that she was pregnant.

'I just know I am. I can tell,' she said, as she buried her face on my shoulder.

I said nothing, as I tried to work out the consequences of all this. How would we manage for money? Should we get married? Would the Master arrive and take the new-born

baby away so that it could be sacrificed on the altar in Horapollo House? Paranoid this last thought, I know, but that is the trouble with taking so many drugs. They make you paranoid about everything.

'What are you going to call it?' Cosmic wanted to know. 'Apart from Antichrist, of course.' Cosmic says that we must be sure to eat the placenta, because it is rich in gamma globulin, or, if we are not going to, can he have it please?

Maud has been re-doing my hair with the home-perm kit, while I sit beside Sally (who is now definitely dying) and I read out loud bits of Dr Spock to her. It is quite a groovy book:

'But strictness *is* harmful when parents are overbearing, harsh, chronically disapproving, and make no allowances for a child's age and individuality. This kind of severity produces children who are either meek and colourless or unkind to others.

Parents who incline to an easy-going kind of management, who are satisfied with casual manners as long as the child's attitude is friendly, or who happen not to be particularly strict – for instance, about promptness or neatness – can also raise children who are considerate and co-operative, as long as the parents are not afraid to be firm about those matters which are important to them.'

I think that I have definitively given up on my thesis. Come to that, apart from Spock and fashion magazines, I have given up on reading. Come to that, I have given up on thinking. I don't need any of it, when I have Maud. Devil or not, she was surely put on this planet to be worshipped.

Sally is curled up in a corner of the room. Her eyes have filmed over and she looks like a small, shivery animal.

Just a few moments ago, those two police officers were back again. They did not stay more than a moment, after taking a look at Sally. Cosmic took the opportunity of their departure to hurry to the woods and hide our stash somewhere out

there. Now Maud is at last fully aware of just how serious our situation is. She is thinking that she will have to breach the magic circle which I drew around the cottage in order to make a phone-call at the end of the road. In the meantime she is seriously panicked that our diaries may incriminate us. She says that we must hide them as well as the drugs.

So my mistress has commanded me to discontinue my diary.

Saturday, October 11th 1997

Maud died five days ago. Her funeral was today and I had a most unsettling encounter at the cemetery.

It is thirty years since I last looked at these notebooks. It was a relief to discontinue diary-writing. When I did so, my writing hand ceased to be possessed by that over-eloquent, high-styled, writing demon, Pyewhacket (or the 'Hand of Splendour', as I have since heard the Master refer to this sort of phenomenon). Now that I have reread these old notebooks, I am feeling a little wistful – even though the last few days described in their pages were pretty terrible.

Summoned by his daughter's message, Robert Kelley arrived in Farnham later on that final Thursday. He was accompanied by Granville and Laura. Although there was a tremendous amount to be sorted out, the resources that the Black Book Lodge can call upon in a time of crisis are truly impressive. By the time the Master had arrived, a whole team of police and forensic experts, excited by signs of freshly turned earth on the edge of the woods, were about to start digging and they were mentally preparing themselves to exhume what they expected to be a series of hippy corpses – probably corpses with shaven heads. However, Maud's father definitely has an impressive presence. Not only did he get the dig stopped, he even persuaded the police that it was not worth charging Cosmic with theft of the gnomes.

My own Dad arrived some hours later. We sat in the corner of a hotel lounge just off the High Street and he listened quietly as I talked and, in talking, tried to put the events of the

last few weeks in some order. I do not know what I expected from him, but, at the end of it all, what he said was,

'The Devil does not have to exist for there to be evil in this world.' Then, after a short pause, 'You are on your own now.'

I never saw him again.

The Master made all the arrangements for Sally's funeral. He also squared the police. Everything was made easy. I just had one very difficult moment. This was when the Master and his daughter had gone into town to confer with the undertaker, so that Cosmic and I were alone with the corpse.

Then Cosmic, pointed to it and looked at me,

'It was her dying wish,' he said. 'She expects you to fulfil your oath.'

It had been bad enough months ago to contemplate the idea of fucking Sally's corpse. That was when the prospect did not seem very imminent and when I imagined that the corpse in question would have Sally's fresh, pale complexion and long golden hair. But now we were looking down on this emaciated and shaven-headed thing which lay hunched on the leaking mattress and looking like a dead rat.

I shook my head. There was nothing I could say.

'I was there at her last moment, while you were pissing about with Maud. Sally really wants you now. She is watching on the astral. She waits to see you fuck her corpse.'

I still said nothing, so then Cosmic was really angry,

'You have betrayed her. You have betrayed yourself. You have betrayed everything we ever stood for. You are a total cop-out and a living lie from beginning to end.'

I walked out of the room, leaving Sally to Cosmic.

The Master had several difficult meetings with Sally's parents. He was, of course, furious with us, but his anger abated somewhat when Maud told him that she thought she was pregnant. Laura and Granville got Maud and me packed and that same night Granville delivered us to a hotel in London. Granville wept on and off throughout the day. 'I really loved your hippy girl,' he said to me at one point. But if so, why had he joined me in spitting on her photograph?

Then again, I reckon, if he had not seduced her, probably none of this would have happened.

I suppose the way things have turned out is a bit like that film I saw once, *Room at the Top*. I married the boss's daughter and, having done so, I have been doing very well ever since. Not that he took me into the family firm, as it were. Indeed, I have been forbidden to set foot in Horapollo House ever again. Since the summer of 1967, I have had as little to do with the Lodge and occult matters as I have had with academic sociology. The daylight hours have been dedicated to making money; the dark belonged to Maud. I inherited Julian's money of course, but it was thought proper that I should have a job. So I was sent into the City. I worked first for a merchant bank with strong Levantine interests. Later, I set up my own company to invest in information technology. I became a 'name' and a member of one of the livery companies. It is a hard, tough world in the City, but I find that suits me. Maud was set up with her own hairdressing salon, but after the birth of little Robert, she was happy to leave most of its running to others.

I grew up. In time I shed my 'blasted sense of humour', as Felton termed it. Furthermore I no longer believe in the possibility of interconnecting parallel universes, encountering dead parents and friends in new incarnations, the governance of the world by Hidden Occult Masters, or any of that sort of stuff. The world is exactly as it seems. As with my computer screen, what you see is what you get.

I am proud of my son's career in politics. The Lodge still nourishes hopes that our son is indeed the Antichrist. Speaking as his father, all I can say is that, for an Antichrist, his GCSEs were decidedly average. I am afraid that Maud never cared much for her son. He was looked after by women sent over from Horapollo House who answered to Laura. Later, the boy was sent to Winchester. All Maud's love was reserved for me and only me.

I have often reflected on the revelations of those August days and I am pretty sure that the Master and his trusted astrologers were mistaken. I am not the reincarnation of

Crowley they were looking for. Be that as it may, they brought Maud and me together and made us happy.

Cosmic sold out too. He now works in the legal department of the Home Office (but we never speak). Everybody sold out. I lived through years of the Great Betrayal and Sell-Out of the hippy dream. We were going to change things. We were going to set free the hearts and minds of our generation – and not just our generation. 'Insanity is hereditary. You get it from your kids.' People would cease to own people. There would have been a gentler, more generous and more colourful world. There was a lot of energy about. By the end of the sixties, we should have been witnessing the ultimate transformation of humanity. As Nietzsche put it, 'Man is a bridge, not a goal.'

But we lost. The old bankers, generals, policemen and professors prevailed. And I am they. They, the men in suits, who every morning walk across Waterloo Bridge, heading for the City are no better than war criminals. The Juggernaut rolls on. First we lost the battle and then our souls. Sally was the only one I ever knew who remained true to herself and I am the only one who seems to care for what was lost. 'First girl I loved . . .' We were young and mad as hares.

Maud was buried in Hampstead cemetery this afternoon. In the coffin she was clutching the crucifix I had given her all those years ago. The Master (it is Granville these days) and Laura were among the mourners. There was no reception afterwards, as I had no desire to spend more time than I had to with Lodge members. Having dismissed my chauffeur, I was setting out to walk back to our, now my house, when I was accosted by two strange creatures. One was cowled and one was shaven-headed and they were dressed in orange and red robes – somewhat like the pusher who sold me those drugs in Abdullah's Paradise Garden all those years ago. There was a whiff of oriental incense about them and at first I thought that they must be Hare Krishna people. These days one occasionally sees a Hare Krishna procession snaking its way down Oxford Street, banging toms-toms and jingling little bells, but they used to be around a lot more at the end of the sixties. I

317

make a point of stopping to watch these people, orange-robed and shaven-headed, because I want to try and figure out why they always look so bloody miserable. But that is by the way. These two turned out not to be Hare Krishna devotees.

'Let the dead bury their dead,' said the cowled figure lurking at the gates of the cemetery. He thrust a leaflet into my hands.

'JESUS SAVES! DON'T BE LONELY! JOIN HIS FAMILY AND HAVE A BALL, SECURE IN THE LOVE OF GOD'S FAMILY.' Beneath the big print was some comic-strip story about the sufferings of a soul in Hell, but, with the lengthening sight I have these days, I had trouble in focusing on the little print in the speech balloons.

'You are blind and do not see,' said the cowled figure. 'But you stand on the brink of a sea of fire. Once you are launched upon that sea, there will be no instant in which you will be free from pain. Your bones will be pulled out from your flesh. Your eyeballs will be squeezed from your skull. Your scrotum will be pierced by blades much sharper than those of a razor. Then, in a cauldron of boiling spittle, you will be reconstituted to suffer it all over again, but this time and the next and the next you will anticipate the pain. Your sweat will burn through metal. After a million years of this have passed, it will be as if you have yet to begin to truly suffer. Now consider how in this life how angry you are with yourself when you forget to post a letter and *then* consider how angry you will be with yourself when you find that you have neglected to take advantage of the offer of eternal salvation! Turn then to the love of your Lord Jesus and be saved.'

'We love you,' said the shaven-headed figure and, it was only when she spoke that I realised that she was a young woman. 'I love you and I want to bring you to Jesus. Cos' for you it's Jesus or the eternal torments of Hell.'

She pressed herself up against me so that I could feel her pointy breasts and she ran her fingers up and down my black tie.

'I want you to come to Jesus. I want you to come for Jesus. I can give you a really great time.'

'What about him?' I said, gesturing at her companion.

'Jesus doesn't mind,' she whispered. 'He knows that it's all in a good cause and that I'm a Hooker for Christ. He knows that, because I love you, I want to save you from the flames of Hell. Jesus has taught me that I must be ready to die for others. How much more then should I be prepared to have sex for others, in order to save their souls? Come on, it's a good deal we are offering here – some great sex, plus eternal salvation. Don't worry about anything. He likes to watch.'

Then, and in retrospect I can hardly believe it, she knelt to fumble at my flies.

'Get away from me woman! I have just come from burying my wife. If, in the circumstances, you think I am going to get a hard-on as a result of the ministrations of a bald religious fanatic in fancy dress, you are very much mistaken.'

She looked up smiling sweetly,

'Let's suck it and see, shall we?'

'Oh go fuck yourself!' and, zipping up my trousers, I turned and hurried away from them.

It was outrageous, really so outrageous and tasteless for these freaks to have intruded on the funeral of my wife in this way. Hours later, I am still quite upset. I have heard about this sort of sexual evangelising. I believe that it is called 'love-bombing' or 'flirty-fishing'. Coincidentally, I now recall that Robin Williamson in that Incredible String Band song, 'First Girl I Loved', sings about how he has heard that his old girl-friend has since joined the Church of Jesus. Probably a lot of the old hippy riff-raff have actually ended up in evangelical Christianity.

The encounter at the cemetery gates was, as they say, 'a blast from the past'. The old Peter, the 1967 version of Peter, would have played with the idea that he had just encountered some sort of astral manifestation of Sally come down to earth in a final attempt to rescue him from the clutches of Maud and the jaws of Hell. Or perhaps the shaven-headed little freak might be one of those Tibetan visions which prepare one for the afterlife, Verukas, or whatever it was that Sally used to call them. But such notions, as the actress said to the bishop, are

just a load of cock. The girl at the cemetery was not Sally, there was no tattoo on her head and the dead do not live again. What I saw was what there was – a pair of crackpot Christian evangelists. However, be that as it may, it got me thinking, in a way I have not done before, about the sixties and about how sixties ways of talking and behaving still linger on at the edges of our society. There is, I think, a metaphorical sense in which those two Christian freaks were indeed ghosts from another world.

Now, thirty years on, when I came back to an empty house after Maud's funeral, I have fetched these diaries out. Of course, I am wistful. I was thin then and I had limitless energy, but, even so, I find that I have no desire to travel back through time. Youth is rarely a happy stage in life. I was then so ignorant, Maud was so gauche and both of us were terrified by the real world. Since then, we found our place in that world and we have been happily married for thirty years.

It was painful for Maud to shed her human form and surrender to the cancer.

Her last words to me were, 'I will come back for you.'

Soon, I hope.